The Complete Guide to Painting and Drawing Techniques and Materials

A QED BOOK

THE
COMPLETE GUIDE TO
PAINTING
AND
DRAWING
TECHNIQUES
AND MATERIALS

Colin Hayes

MAYFLOWER BOOKS
NEW YORK

Consultant editor
Colin Hayes

Contributing editors
Caroline Villers

Michael Pope

Leonard Rosoman

David Tindle

Brian Thomas

Graham Cooper

Stan Smith

Guy Roddon

John Griffiths

Alistair Grant

James Trimble

A QED BOOK

Published in the United States by Mayflower Books, Inc., New York, New York 10022. Originally published in England by Phaidon Press Limited, Oxford.

First published 1978
© Copyright 1978 QED Limited

ISBN 0 8317 1615 0
First American Edition

Filmset in Britain by Vantage Photosetting Co. Ltd.
Colour origination in Italy by Starf Photolito SRL, Rome

This book was designed and produced by QED
32 Kingly Court, London W1

Editor David Reynolds

Art director Alastair Campbell

Assistant editor Alastair Dougall
Designer David Mallott
Design assistants Heather Jackson Jeremy Bratt

Illustrators Elaine Keenan Edwina Keene Abdul Aziz Khan
Sally Launder Martin Woodford Moira Clinch
Nicholas Dakin David Staples

Photographers Mike Newton Roger Pring
John Wyand Walter Rawlings

Picture research Linda Proud

Paste-up Jean Kelly

Editorial director Michael Jackson
Devised by Robert Morley

QED would like to thank the many individuals and organizations who have helped in the preparation of this book. Invaluable assistance was given by: John Wolff, William L. Ryan and David Greene of M. Grumbacher Inc., New York; Susan Jane Beers, Jean Attard, Alun Foster, Peter Waldren and John Gray of Winsor and Newton Ltd.; Ann Boreham of George Rowney and Co. Ltd.; Lionel Shapiro of Reeves and Sons Ltd.; Dick Garrett of Cumberland Graphics Ltd.; Eddie Rex of Inveresk Paper and Co. Ltd.; Sam Flax Inc.; Falkiner Fine Papers Ltd.; The DeVilbiss Company Ltd.; Paasche Airbrush Co.; Philip Poole of His Nibs; T. N. Lawrence and Son Ltd. Special thanks to Robert Lockwood and the staff of Langford and Hill Ltd. for their help and generosity in lending materials and items of equipment.

For their help and expert information, thanks are due to: Peter Moore of The British Museum, London; The National Gallery, London; the staff of the printroom at The Victoria and Albert Museum, London; The Courtauld Institute of Art, London; The Tate Gallery, London; The National Gallery of Scotland, Edinburgh; The Museum of Modern Art, New York; The Louvre, Paris.

Demonstrations of particular processes were provided by the Contributing Editors and by Sheila Robinson; Michael Rand; Bob Tipper; R. N. Crossett; and Stephen Jackson. The glossary was prepared by Rory Coonan. Other invaluable assistance was given by: Edward Kinsey; Derek Prigent; Lesley Gilbert; Sarah Campbell; Philippa Reynolds; Arthur Windsor and Lynette Ferguson.

Contents

Introduction

The essence of this book is practicality. It aims to tell the artist about the materials which are readily available to him, or which he can easily make for himself, and about their use. The contributors have touched on the history of their various subjects sufficiently to explain how the various materials at the artist's disposal have come into existence, but it has not been their purpose to enlarge on the preparation of arcane recipes of the past containing ingredients which would nowadays require a laboratory or a body of trained studio apprentices to produce.

This book explains the nature and uses of materials which the artist can reasonably expect to obtain—materials which are as available to use today as were the products of his own workshop to Rubens in the early seventeenth century.

Of course, since the days of the Early Renaissance and Cennino Cennini's famous *Il Libro dell'Arte* (Artist's Handbook) of 1390, the range of materials and methods at the artist's command has vastly increased, and also become a matter of commercial manufacture. This not only makes a compendium of materials much more formidable to produce, but presents the artist himself with the problems posed by a far greater range of possibilities.

These problems are not made any the less by the twentieth century artist's far greater freedom of expression. Renoir (1841–1919), in his introduction to an edition of Cennini, explains how different was the technical and artistic position of the painter in the Renaissance: "In Cennini's time men decorated temples; today we decorate railway stations, and it must be acknowledged that our contemporaries are less well endowed with sources of inspiration than their forebears. But, above all, for the realization of these collective works there existed an essential condition: it was this that gave them their unity. The painters were all practising the same craft. It is this craft that we none of us entirely know, because, since we were emancipated from tradition, no one has taught us.

"Now the craft of these Italian Renaissance painters was the same as that of their predecessors. If the Greeks had left a painting treatise you may be sure it would be the same as Cennini's. All painting, since that of Pompeii made by the Greeks, through that of Poussin and up to Corot seems to come from the same palette. This manner of painting everybody learnt from their master; their genius did the rest. Moreover, the apprenticeship of a painter of Cennini's time did not differ from that of other craftsmen. In the studio of the master he did not only learn to draw, he learnt to make brushes, to grind colours, to prepare panels and canvases. Little by little he was initiated into the technical difficulties of this daunting application of colours, as a faculty he could only acquire through experience prolonged from generation to generation."

Now of course Renoir, to make his case, was exaggerating in claiming that the materials and crafts of art had remained unchanged between antiquity and the lifetime of Corot (1796–1875).

Nevertheless, for our present interest, he points to an essentially different condition which the contemporary artist faces. The traditional apprentice artist had to learn about materials, indeed acquire them for use, by making them himself: as Renoir says, he had to grind his colours, and even make his brushes. In doing so, and in preparing these things for his master, he learnt what they were for, and learnt that the acquisition of unnecessary materials meant the unnecessary labour of making them.

Nowadays, nearly everything we need is manufactured for us; we

Robert D. Bruce

are presented with a vast choice of alternatives which we may by no means automatically understand the use of, and many of which we may as individuals turn out not to need. There is no single traditional craft of art to guide us.

A book of materials for the contemporary artist must therefore be seen in terms of modern-day problems. This book is intended to guide the artist through such problems. To produce a mere compendium of the catalogues of artists' colourmen and suppliers would have little point, though we state where many materials can be obtained. We have tried, rather, to demonstrate the scope and nature of the materials available, and to help the artist make his own sensible choice of what is necessary to him as an individual.

Now that the artist does not make all his materials with his labour, he pays for them with his pocket. The colourman must try to cater for everyone, and it is not his fault if there is more in his catalogue than any one artist needs. The discovery of a material's potential, and its acceptance or rejection, is a matter of experience, but the artist, particularly the student, can be guided towards experience, and this is what this book sets out to do.

It is because practical experience is needed to give such guidance that all the contributors are practising artists who themselves have had to discover and exploit a personal range of materials. Their combined professional experimenting has brought them in contact with most of the worthwhile materials that any artist might be tempted to purchase.

Of all the contributors perhaps Leonard Rosoman has learnt most by experiment. His personal experience shows how much an artist can gain from an awareness of all the media that are available to him. For many years Rosoman painted in oil, gouache and water colour; then in the 1950s he was introduced to acrylics. The result is best described in his own words: "In the 1940s and 1950s I was using gouache or a mixture of gouache and water colour a good deal. It was very important for me to lay a foundation of thin washes of colour over the whole area and then to build on top with gouache leaving certain areas of water colour glowing through so the result was a mixture of opaque and transparent colours.

"I felt there was something right about this way of painting for me and I instinctively used it, or tried to use it, with oil paint on canvas. I was very conscious of the change from the one medium to the other, but of course, this in itself was interesting. However, it seemed to me that the performance was not right, that the various stages through which my painting has to pass, gradually moving towards a possible solution, worked better in watercolour and gouache.

"I suppose at this time I was just beginning to understand what sort of painter I was, and the fact that I was introduced to acrylic paint at this moment is rather extraordinary. With acrylics I was able for the first time to deal with concepts and ideas on a large canvas in the same way, or in a very similar way, as I had used gouache on paper. There was a sudden feeling of release, which undoubtedly had a tremendous effect on me psychologically, and this was transmitted into visual terms on the canvas. I can remember the exhilaration of glazing over large areas, watching the flood of paint dry in a matter of seconds leaving a beautiful, matt, glowing surface ready for the next statement."

Rosoman has worked in acrylics ever since, and has gained a world-wide reputation as an exponent of the medium.

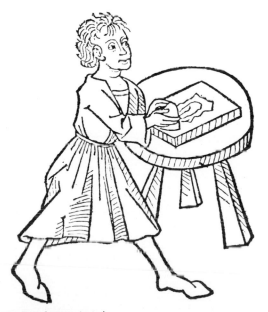

Medieval print *Artist's apprentice grinding pigment into a medium to make paint.*

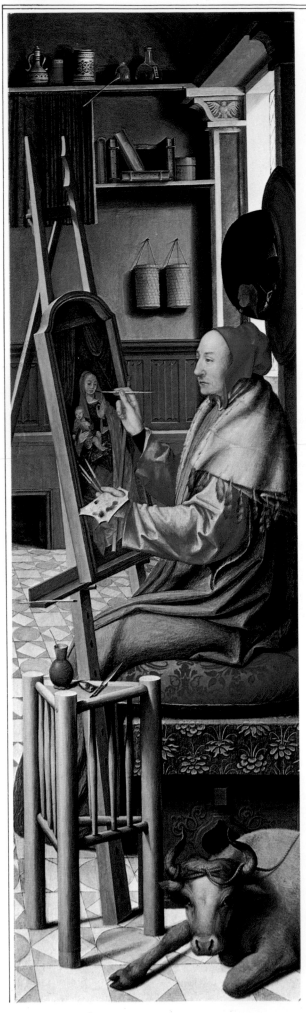

There is one sense in which advice about materials properly consists of teaching the student (or helping him to teach himself) what to do without, and this advice can be as proper for artistic as for financial reasons. Often the execution of a work of art will be more hindered than helped by an over-abundance of different materials: for some painters, too many colours on the palette is not only unnecessary, but positively harmful. It is all too easy to encumber one's self with too much studio and accessory equipment in the erroneous belief that if it is manufactured it must be necessary. It may be, but not all the available equipment is necessary to every individual; nobody finds this out sooner than the landscape painter who has been over-enthusiastic in his purchases of equipment and then discovers that he has to carry it all about with him.

However, although such negative advice is valuable, it is not in itself enough. If Renoir was right in saying that we no longer have any single common craft, then no limiting lists of suggested materials can be prescriptive, only exemplary. Where the artist, through the practice of workshop pupilage, could once hardly fail to learn the extent and potential qualities of a comparatively modest range of pigments, media, graphic and other tools, the modern student may easily miss, through ignorance, many materials which would well suit his own expressive needs.

The scope of this book extends therefore to meet the artist's experimental purposes, to explain, and often to show by illustrated demonstration, what can be done with what he can get. Often an artist nowadays may know of the existence of a material but remain unaware of its powers: or he may see, and perhaps envy, marks and qualities created by others, without knowing what materials or equipment produced them. He may be uncertain about the mutual and combined effects of materials, about which papers suit which graphic implements and so on.

We have sought to speed the artist on his path through the often bewildering series of alternatives and opportunities now on offer, so that when he comes to resolve the range of materials he really needs for his own expressive purposes, it will be from a greater knowledge of what is possible.

Each subject dictates the character of its own chapter or section. The chapters on oils, acrylics, exterior painting, water colour and the drawing, or graphic, media, reflect in general the normal availability of the appropriate materials in the commercial market. The chapter on tempera, by contrast, explains how the artist can best make up his own grounds and his preferred tempera medium from easily obtainable ingredients.

The fresco chapter is an exception; it admits to, and describes the very real difficulties of obtaining and preparing some of the traditional materials of the craft. Nevertheless, it would be unreasonable — even in a book primarily concerned with materials which can be obtained without enormous difficulty — to omit a description of the materials and techniques with which so many famous masterpieces of the past were created.

We have given little space to home-made recipes and processes for items which are both difficult to make and made as well or better by commercial manufacturers. But home labour is sometimes justified. For instance, artists' colourmen market a great range of pastels; but because the hues of this medium cannot readily be admixed like those of liquid paints, the pastel artist should know how to make up for himself some special tint which eludes him in the

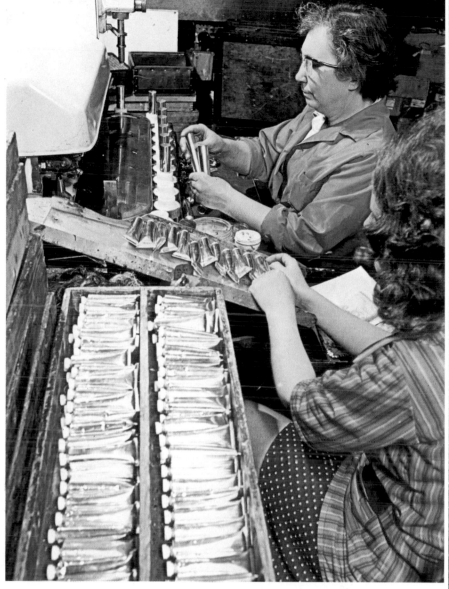

Left **Quentin Massys: St Luke painting** *An authentic picture of an early sixteenth century oil painter and his studio.*
Below **Pierre-Auguste Renoir: Portrait of Claude Monet** *Renoir regretted that painting had ceased to be a craft with established traditions, yet he, Monet and others used this enforced freedom to generate new attitudes and techniques which were to be enormously influential.*
Right **Paint tubes filled by machine at Winsor and Newton factory, Harrow, England** *The mass production of artists' materials means that artists nowadays need not go to the trouble of making their own paints, brushes and drawing instruments as their predecessors had to 200 years ago. However, it presents them with the problem of understanding, and choosing from, vast ranges of products.*

manufacturers' lists. This process is therefore explained and illustrated in detail.

A book which seeks to present information accessibly and clearly must be presented in an order and form which makes this possible. Only categorization will protect the reader from a chaos of unreachable facts. But he must read sensibly between the lines of our separate chapters to understand that while each medium has its name, there is only the common sense of chemistry to prevent him mixing them as he wishes. It is technical common sense not to paint in a water-bound medium on top of an oil-bound one, but where such caveats do not apply, he may mix his media as his needs demand. Thus there is no reason why water colour and gouache should not be mixed, and indeed elaborated with pastel or ink. It is technically sound to start a painting in acrylics and finish it in oil paint, although the reverse is not possible.

Our contributors have often indicated just such possibilities, and have exemplified such masters of mixed media as Degas (1834–1917). But the possibilities are endless, and in this, as in more specific techniques, we encourage the reader to experiment for himself.

Colin Hayes

The principles of drawing and painting

Much aesthetic theory is distinguished among its other qualities for having been propounded after the event, and its formulators have not on the whole been especially preoccupied with artists' materials. But there are, nevertheless, pictorial principles and precepts which have been invented, or at least adopted, by artists, and used as aids to making pictures.

Proportion Principles of proportion have a long history. Not only is proportion—being linear, and allied to long established Euclidean knowledge—easier to codify than colour, but, unlike most theories of colour, such codifications have emanated largely from within the arts, especially from the demands of architecture. Through history, rules of proportion have been rejected no less than they have been accepted. Nevertheless, the concept of geometry in art as a means of ordering forms and images into a unity seems to maintain a recurring, if not a continual influence.

A geometrical theme which has preserved its use since antiquity is the concept of the "Golden Mean". Its simplest demonstration is seen in the division of a straight line at a point such that the smaller part is to the larger part as the larger part is to the whole.

On the basis of this "Golden Section" modular rectangles can be built. These and other modules of proportion have been used repeatedly through the history of civilized art as a means of subdividing architectural spaces and pictorial surfaces with almost endless variety, but ordered by a unifying central principle. Such proportions have been held to possess a balance naturally satisfying to the human eye and spirit; the "Golden Mean" in particular is claimed to possess the authority of nature in that its proportions can be observed in the growth of plants and molluscs.

Colour While geometrical "rules" of proportion have been codified according to various ideals since ancient times, "scientific" laws of colour hardly existed before Newton (1642–1727). The scientists, in successively disagreeing with each other have perhaps been ready to agree in assuming that before their formulations no understanding of the behaviour of colour had existed. In fact the evidence of art shows that much empirical knowledge of this subject had existed at least since the days of the Hellenistic painters (c.350 BC– 50 AD) and probably long before.

The Venetian painters of the Renaissance show clearly, for instance, how the judicious use of warm and cool oppositions to create form and space had become systematic: such sense of system seems anticipated in surviving examples of Hellenistic portraiture, many of them mummy paintings.

It was in the nineteenth century that external

Dividing a line according to the golden section *With a ruler and compass a line of any length can be divided into the proportions of the golden section.*
1. *The line, AB, should be bisected – divided into two halves of equal length.*
2. *With the point of the compass on B, an arc should*
be drawn from the mid-point of the line to a point C, at right angles to AB.
3. *AC and BC should be joined to form a right-angled triangle.*
4. *The compass point should be placed on C and an arc drawn from B, so it cuts AC at point D.*
5. *With the compass on A, an arc should be drawn from*
point D to cut AB at point X. It will be found that XB is to AX, as AX is to AB. The line has been divided according to the golden section. A rectangle can be drawn with sides of these proportions. Further rectangles can be built on this whose proportions increase or decrease according to the golden section.

theories of colour began to impinge on the ideas of artists. Goethe's *Zur Farbenlehre*, with its mixture of the analytical and the spiritual, excited Turner (1775–1851) when it was published in England in 1840. Almost at the same time in France, the treatise on colour by the chemist Chevreul (1786–1889) was beginning to influence painters.

Chevreul's "Laws of Simultaneous and Successive Contrast" with their tabulated lists of induced colour effects attracted the attention of Delacroix (1798–1863) and undoubtedly influenced the Impressionists. Though the scientific validity of his propositions has been modified and superseded by later colour theorists, Chevreul's observations had enough workaday truth of a demonstrable sort to have commanded long attention from painters.

More recent colour investigations have been much geared to the demands and limitations of commercial colour reproduction and have postulated new sets of "primary" colours; they have not always taken account of the problems of pigmentation, form and space which daily face the ordinary painter.

So while scientific analyses of colour behaviour have had their impact on painting, it is significant that the recorded observations by painters themselves about colour—by Cézanne (1839–1906), Kandinsky (1866–1944) and Matisse (1869–1954) for instance—have dwelt on both formal and "spiritual" questions of kinds which scientists have been unwilling or unable to pose.

To quote Renoir (1841–1919): "the fact is that in painting, as in other arts, there is no single procedure small enough to be stated in a formula . . . I believe I knew a long time before the 'scientifics' that it is the opposition of yellow and blue which provokes violet shadows, but when you know that, you are still in ignorance of everything. There is much to painting which can't be explained and which is essential. You arrive before nature with

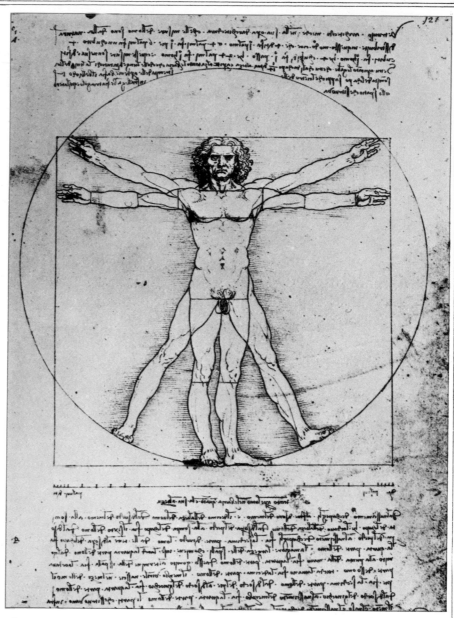

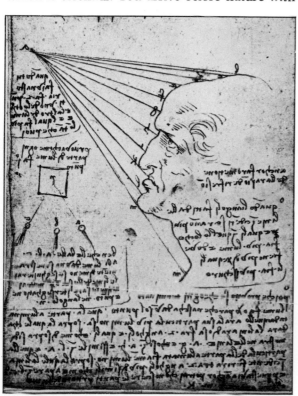

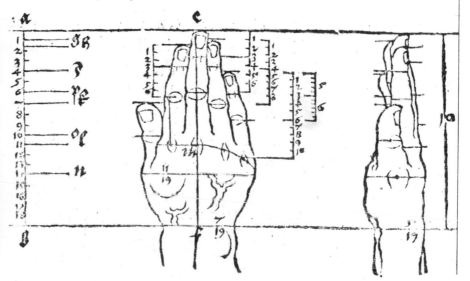

Above and Left **Leonardo da Vinci: Proportions of a man; Points of the anatomy** Below **Albrecht Dürer: Proportions of a hand** *Renaissance artists, from both southern and northern Europe, were preoccupied with the demonstration of laws of* proportion. *Nowadays most figurative painters prefer to make such judgements by hand and eye.*

theories, and nature throws them to the ground."
Perspective Design based on proportional principles might seem to be concerned with formal distribution across pictorial surfaces in an essentially two-dimensional sense. But such principles have been extended and sometimes disturbed by the three-dimensional purposes of perspective systems, which since the early fifteenth century have been used to create a sense of form and space on a flat surface in an orderly way.

The discoveries and inventions of the architects Brunelleschi (1377–1446) and Alberti (1404–72), the painter Uccello (1396/7–1475) and others, laid the basis of the "Central Perspective" systems which have been used, with modifications, by

Right **Hellenistic painter: Mummy portrait** *Painted in the second century A.D., warm and cool tonal values convey the forms. The mouth and nose display the formal modelling commonly found in the work of Titian and Veronese.*
Below **Ben Nicholson: Gouache 1936** *The subject matter has been distilled to become the geometric intervals and proportionate balance, both of area and colour, of which the total picture surface consists.*

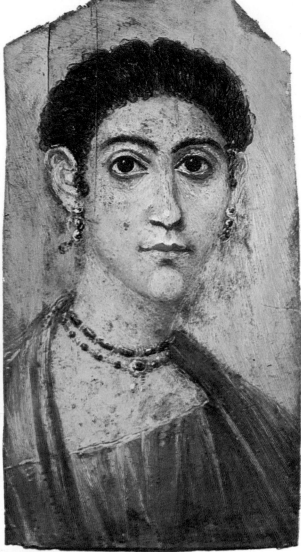

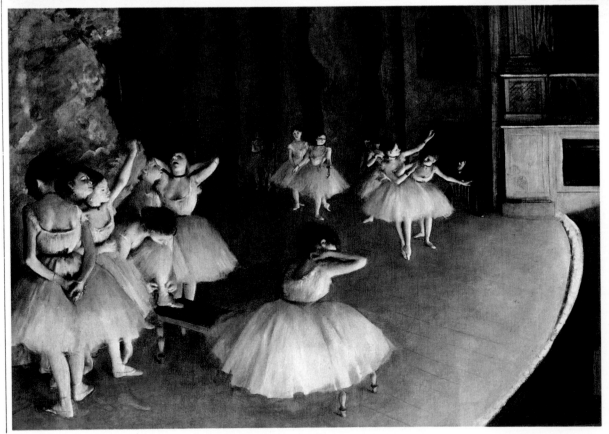

Right **André Derain: Portrait of Henri Matisse** *This is fauve painting at its height. None of the colour is literal, or descriptive in an imitative sense, but while the response to the colour of the subject is emotional, it is not arbitrary. The contrasts and accents of yellows, reds, blues and greens are a heightened version of Chevreul's simultaneous contrasts. The colour owes its debt to both van Gogh and Cézanne.*
Left **Edgar Degas: Ballet practice on stage** *At first sight there is an Impressionist immediacy of viewpoint and action "seen through a key-hole", as Degas used to say. Nevertheless, this is also a strongly controlled piece of formal design. As in Rembrandt before him, and Bonnard after him, the geometry is there by stealth. The colour has not been carried further than a rendering of cool and warm contrasts. The cooler whites and greys have been built up solidly or with scumbles on a transparent warm underpainting.*

Western artists ever since. These discoveries were an inevitable concomitant of Humanism and the demands of fifteenth century Naturalism.

Because "Central Perspective" is identified with naturalism and, within limits, with the human perception of space, it is often identified with illusionism—the technique which attempts to deceive the eye into believing that the painted image is a real three-dimensional form. This is not fully justifiable; the essence of a perspective system is that it is systematic, a formalizing of space according to a set of geometrical assumptions—and it is in this spirit that its methods—with its "eye levels", "horizons" and "vanishing points"—were applied in the Renaissance. In Illusionist Art, whose extreme form is *Trompe l'Oeil* painting, perspective certainly plays its part, but illusionism is achieved by the manipulation of surface light effects.

It is not always understood—even by habitual practitioners—that any perspective system is, and must be, a distortion, not an exact scale imitation, of natural appearances. The artist observes nature, constantly moving the direction of his eyes, on a "Sphere of Vision". He transfers this observation systematically, or by eye, to a flat surface. Now it is an axiom that the surface of a sphere cannot be turned, twisted, bent or stretched into the surface of a plane without distortion; a two dimensional map of the world is evidence of this.

In the rendering of natural space on a flat surface linear distortion is inherent and inescapable. Within small angles of vision the distortion is slight and unnoticeable; within certain limits it can be minimized by manipulating the system, but beyond these limits the distortions become obvious. In this context, perspective systems and map projections are two sides of the same coin.

Painters who have been in command of perspective as a device for rendering space, such as Piero della Francesca (1410/20–92), Vermeer (1632–75) and Canaletto (1697–1768), have always been well aware of this basic fact and have been extremely adept at concealing it. They have had no hesitation in departing from the rules when necessary and have covered the traces of such departures. Very often such painters avoided the introduction of rigidly rectangular and geometrical forms in areas towards the outer limits of paintings of wide visual angles, where distortion would show itself, and have substituted irregular forms or passages of tone and shadow in which distortion of space is not demonstrable.

In all art, the artist is wise to regard systems of any sort as his servant, not his master. This is a precept easy to state, less easy to follow. It may seem simple, but it is probably true that for most painters and artists, to whom systems are not the essence of their art, their best protection against the tyranny of systems lies in their own subject matter. If anything beyond moment-to-moment intuition should guide a painting towards a unified development, it is the subject, not the system.

Rules of colour, proportion and perspective, or any other rules, can be observed for as long as they strictly serve the purpose of the picture. As soon as they are seen to be impeding it, it is the artist's prerogative to bend them, if necessary out of recognition, to his needs.

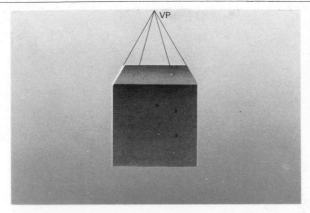

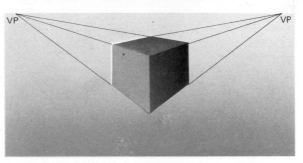

One point perspective *Receding parallel lines appear to converge and actually meet at a vanishing point. When only two planes of a cube are visible, it can be drawn in perspective using a single vanishing point.*

Two point perspective *As long as it is near the viewer's eye level, or horizon, a cube with three planes visible presents two sets of apparently converging lines. It can therefore be drawn using two vanishing points.*

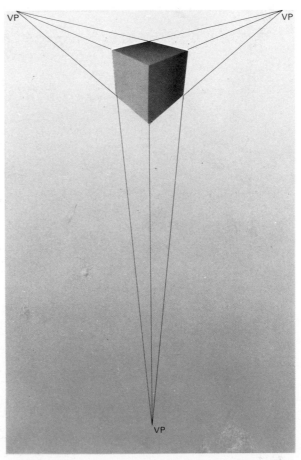

Three point perspective *If a cube is well above or below the viewer's horizon, vertical, as well as horizontal, lines appear to converge. Three vanishing points are therefore required.*

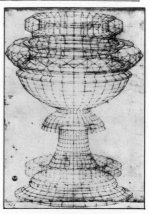

Above **Uccello: Vase** *This perspective study of a chalice demonstrates the enthusiasm with which Uccello embraced guidelines developed by Brunelleschi and Alberti. Each formal problem within the various shapes of the chalice is broken down into a series of recessive surfaces which can be submitted to the rules of vanishing points and proportions.*

Right, above **Leonardo da Vinci: Perspective study** *An example of the way in which a strong and basically simple perspective space, with its central vanishing point towards the right of the picture, can be used as a three-dimensional stage in which to introduce living and moving beings. The suggestions of humans, horses and even a camel, are readily controlled in their proportions by the formal linear framework of perspective space.*
Right, below **Michelangelo da Caravaggio: Supper at Emmaus** *This tenebroso, or low key, painting employs a linear perspective which does not substantially differ from that of Leonardo. But, if the various forms contained in the movement of the figures were to be reduced to simplified planes after the manner of Uccello's "Vase", it would be seen that he uses a multiplicity of vanishing points. In a flat sense, the design has its triangular simplicity, but it is characteristic of this stage of European painting that Caravaggio is able to cut across the contours and the linear perspective with an emphatic counterpoint of tonal masses. Also, for the sake of the picture's dramatic design, the basket of fruit appears to be tilted towards a different vanishing point from that of the table.*

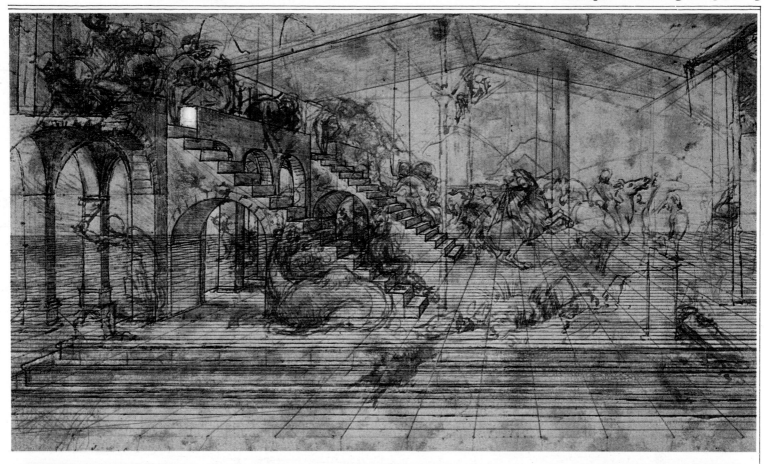

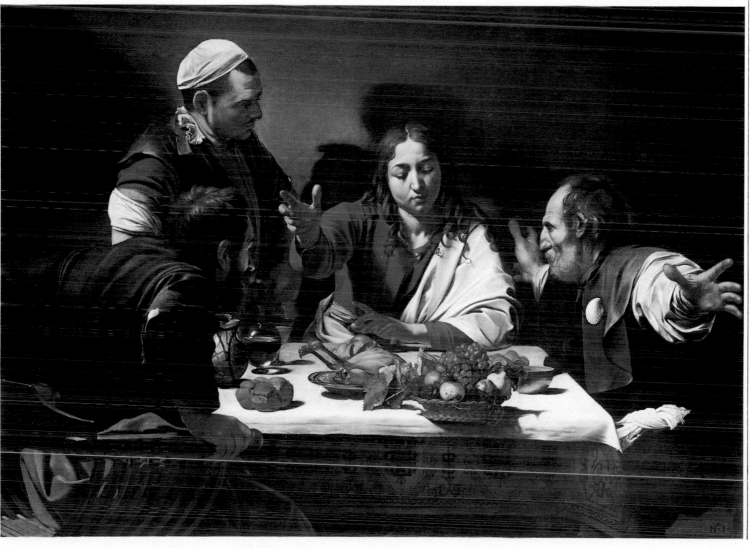

The development of artists' materials

A painting is not just a coloured surface. It is an extremely complex three dimensional object composed of a series of layers. A comparison may be drawn with a geological diagram of the earth's crust. In both there are strata of differing thickness and composition, and in both these variations account for the ultimate appearance of the surface.

In the simplest terms the structure of a painting consists of a support, such as wood or canvas; a ground which acts as an intermediary between the support and the paint layer; and the paint layer itself, which is composed of coloured pigment particles suspended in some sort of binding medium such as wax, oil or egg.

Historically an immense number of materials have been used as supports for paintings—copper, stone, paper, leather, plastics and so on—but the most common of all are wood and canvas.

Wooden supports In the Western world wood was used for easel paintings over 4000 years ago in VI Dynasty Egypt, and during the medieval period in Europe; perhaps because of its combination with church furniture, wood remained the most common support for several centuries. It had a number of advantages. It was strong but moderately light; it could be conveniently worked with hand tools, easily carved, sculpted and made into structures as elaborate as Gothic cathedrals. It was also universally available.

Wherever an artist was he tended to use local wood: chiefly poplar in Italy, oak in the Netherlands and linden in Germany. There were, of course, local variations; walnut was common in southern France and Leonardo da Vinci (1452–1519) used that, instead of poplar, on the occasions when he went there.

The medieval Artists' Guilds exhibited a meticulous concern about the quality of wood used; artists were warned not to use unseasoned, worm-eaten or knotty wood. There were fines for the use of poor materials, and frequently important commissions had to be inspected by the Jury of the Guild once the wood had been prepared but before the painting was begun.

Fabric The history of fabric as a support can be traced back to the XII Dynasty in Egypt, almost 4000 years ago, and probably existed for several centuries before that. Although fewer paintings mark its continued usage, there is no reason to believe that it was ever entirely absent from any artist's studio. Pliny (23–79 A.D.), for instance, remarks that the Emperor Nero ordered a portrait of himself on fabric 120 feet long.

In the Christian world the decoration of churches with wooden panels took precedence, but there is a twelfth century manuscript which shows a good understanding of the properties of canvas and tells how to prepare it and stretch it around a wooden frame.

The latter part of Cennino Cennini's *Artists' Handbook* (c 1390) also includes instructions for dealing with a wide variety of fabrics from clothing and banners to wall-hangings. The inventories of the Medici family record numbers of such works but most of them, being less durable and less important than altarpieces, have disappeared and left us with a distorted image of an artist's activities.

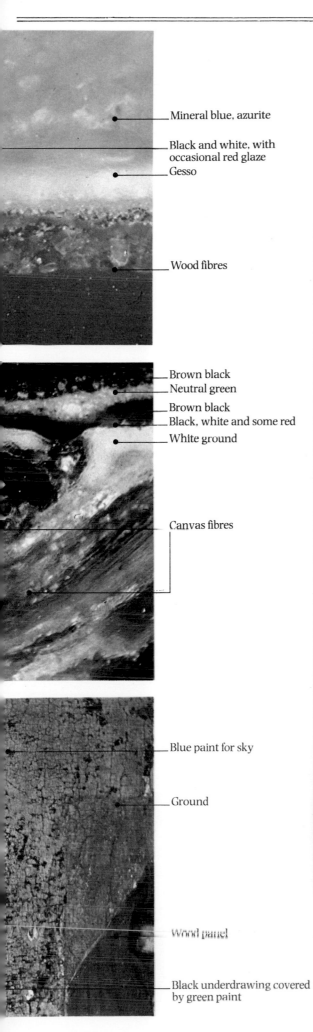

Mineral blue, azurite

Black and white, with
occasional red glaze

Gesso

Wood fibres

Brown black
Neutral green
Brown black
Black, white and some red
White ground

Canvas fibres

Blue paint for sky

Ground

Wood panel

Black underdrawing covered
by green paint

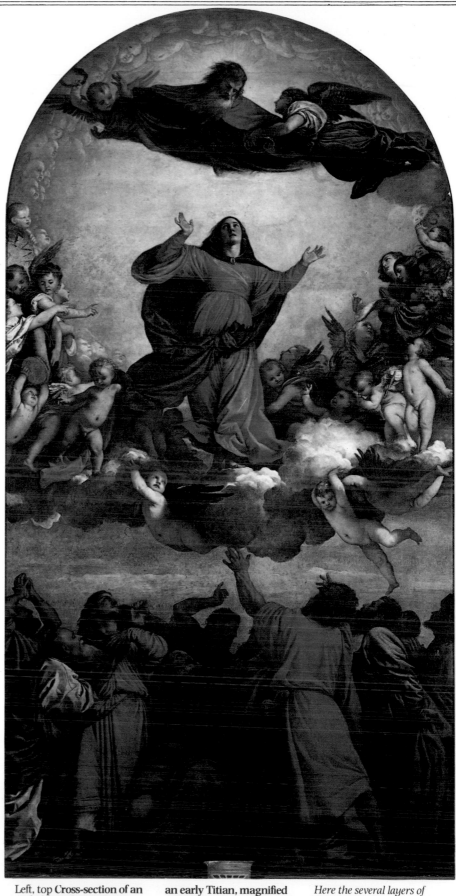

Left, top Cross-section of an early Flemish painting, magnified 200 times *Tiny samples have been embedded in resin and polished across the strata to show the layered construction. Here, a gesso ground has been laid on a wooden panel.*
Left, centre Cross-section of

an early Titian, magnified 100 times *One of the first oil paintings to be made on canvas. The white ground actually penetrates the fibres, and the neutral green under-painting is revealed.*
Left, below Rear view of painting partially transferred to a new support

Here the several layers of tempera painting are clearly revealed, including the original underdrawing.
Above Titian: The assumption of the virgin *Painted in 1518, and thought to be the first large scale religious painting on canvas.*

During the fifteenth century canvas gradually replaced wood as the standard support for religious as well as secular works, and this change must be understood in the context of the profound technical, aesthetic and intellectual developments of the Renaissance. Like oil painting, painting on cloth seems to have been first practised extensively in northern Europe where it was used for both religious and secular subjects. The religious images, probably cheaper versions of works on panel, were painted on very finely woven fabric with little or no ground.

In Italy fabric seems to have been largely reserved for secular subjects, and Titian's "Assumption" of 1518 is probably the first large scale religious work on canvas. There is a theory that painting on canvas spread from the north to Venice and then into the rest of Italy; however evidence from inventories and artists' handbooks indicates that these were probably separate indigenous developments.

Grounds Once either the canvas or the wood had been prepared the next stage was the application of the chosen ground, the final stage before painting began. The ground plays a dual role in the make-up of a picture: physically, it acts as an intermediary between the support and the paint layer, refining the surface of the wood or canvas and providing a stable consistent layer for the paint; aesthetically, its nature determines the tex-

Below and right (detail)
Titian: Tarquin and Lucretia
One of Titian's later paintings in which he abandoned the traditional smooth, white gesso ground, and used instead an oil ground into which he mixed a reddish pigment. As a result the weave of the canvas is apparent, and the light areas stand out from the shadows; the reverse is true of traditional tempera paintings, like Duccio's "Madonna and child" triptych (right and below), where shadows are obtained by overlaying dark paint on the gesso.

ture and often the colour effects of the final finished work.

The ingredients of the ground varied according to the type of support, established tradition, and individual requirements. The essential elements were, and still are, an inert filler and a binder. There are three chief types of binder—size, oil, and emulsion (which is a mixture of the first two).

In medieval painting in Italy the filler was gesso (calcium sulphate), in the Netherlands it was chalk (calcium carbonate) mixed with animal glue. These grounds were eminently suitable for panel paintings and the same mixtures, perhaps with a little pigment mixed in, were used for centuries.

At first the same type of ground was used for canvas painting, but it was brittle and less

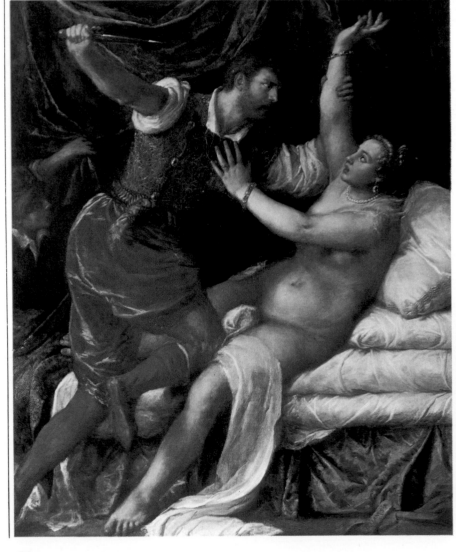

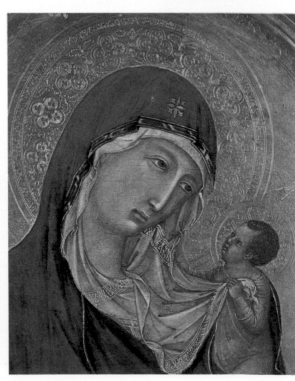

suited to a flexible canvas. "Bacchus and Ariadne" by Titian (1489–1576) has a very thin cream-coloured gesso ground, but in his later works such as "Tarquin and Lucretia" Titian used a more pliable oil-size emulsion in which the filler was combined with a reddish pigment.

To illustrate how intimately the components' colour, thickness and method of application affect the appearance of the final work, the role of the ground in a Quattrocento (fifteenth century) tempera painting and in the late Titian can be compared. In a tempera painting quite a thick white gesso ground was applied and then polished to a faultless ivory-like finish.

The smoothness of the ground was considered aesthetically desirable and the thickness was necessary for the subsequent decoration with gold leaf, the effect of which would be spoiled by any surface irregularity; the whiteness of the ground contributed to the final luminous tone of the whole work. In tempera painting the design was carefully predetermined and executed in dark linear terms, often reinforced by incised lines, on the white gesso. It was a technique that left little room for errors or changes in the composition.

During the latter half of the sixteenth century dark grounds, usually red or brown, were introduced. Their use implied a radically new technique, which was that of painting light on dark instead of dark on light. The composition tended to be worked out directly on the canvas in the paint layer itself, either building up the forms with a few sketchy white lines or with broad areas of colour. Changes in composition were frequent.

A dark ground had the advantage of aiding speed of execution, but it also had an aesthetic function in that areas of shadow or half tone were deliberately left uncovered so that the colour of the ground formed a part of the final composition.

In Venice there was a tendency to use coarsely woven canvases, and the pattern of the weave was not disguised by the ground so that its roughness also contributed to the final aesthetic effect.

Until the seventeenth century, probably all this preparatory work on the support and ground was done in the artist's studio, but from 1600 onwards there is evidence of a growing trade of independent professional men performing these tasks. Apocryphally the first professional colourman in England was brought over by Sir Godfrey Kneller (1649–1723); at first he worked for the artist alone and then set himself up independently. By the eighteenth century pre-primed canvases were available in standardized sizes according to the subject matter.

Paint All paints are composed of three constituents: the coloured pigment particles; the medium that carries those particles; and a diluent, a volatile liquid such as water or turpentine that allows the artist to control the consistency of the paint to

Below and left, below (detail) **Duccio di Buoninsegna: Madonna and child** *A typical Quattrocento (fifteenth century) tempera painting on a polished white gesso ground. The luminosity derives from the pure white gesso. The smoothness and lack of texture was necessary for the application of gold leaf, and was thought to be aesthetically pleasing.*

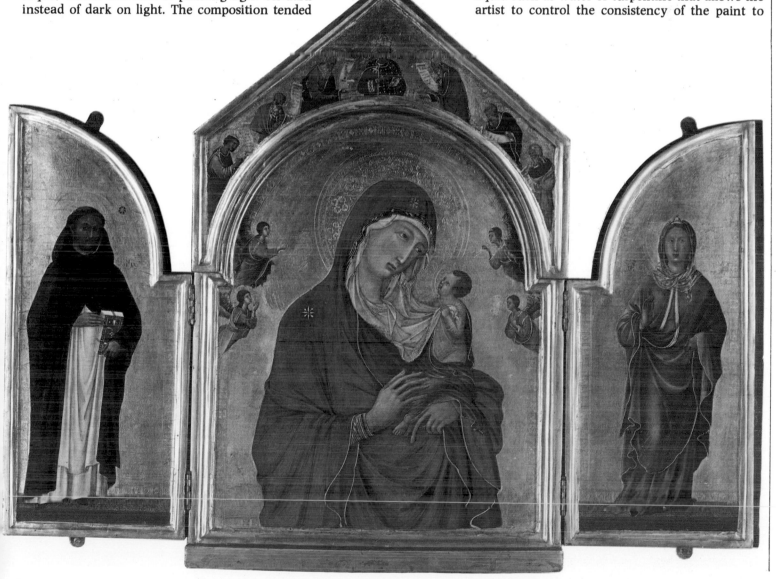

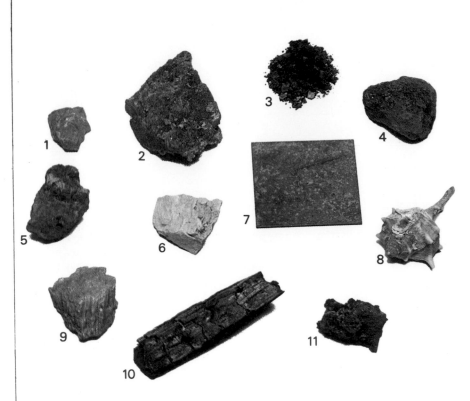

achieve the effects he desires. The intrinsic properties of each component influence the finished look and feel of a painting.

Pigments It is important to bear in mind that at any period the artist's palette was limited, partly by conscious choice and partly by availability; viewed historically the palette has a living, changing, technological and economic history of its own.

The first pigments, those known to the cavemen, required no special technology in their preparation, but were found ready-made in the earth in the form of white chalk, green earth and the variously coloured ochres and umbers, while black could be found in the fireplace.

Metal tools were required to crush naturally occurring minerals, and it was in Bronze Age Egypt (2000–1000 B.C.) that Azurite and Malachite, Orpiment, Reslgar and Cinnabar were used for painting. These minerals simply needed grinding, washing and levigation (making into a paste) to be ready for use and like the earth pigments they remained in the artist's palette for centuries.

The Egyptians also produced the first two synthetically manufactured, inorganic pigments—Blue frit and White lead. Blue frit seems to have evolved as an offshoot of the ceramics industry and, although widely used, it mysteriously disappears from the palette between 200 and 700 A.D.

White lead, produced by the controlled corrosion of metallic lead, is still in use today and is probably the most important single pigment ever discovered. It was the only white used in easel painting until the discovery of Zinc white in the 1830s and Titanium white in 1916. Its significance lies in its opacity and covering power. Previously the only white pigment available was chalk which lacks this covering power, so that a thick coat of paint was required to make a light stroke as telling as a dark stroke. The discovery of

Early sources of pigment
Early cavemen, around 25,000 B.C., were using burnt wood, 10, chalk, 6, and earths 3. In Bronze Age Egypt, cinnabar, 2, realgar, 4, azurite, 5, orpiment, 9 and malachite, 11 were ground to produce red, orange, blue, yellow and green respectively. The Romans derived Tyrian purple from the whelk, 8, and obtained a green called verdigris by deliberately corroding copper plates, 7. A method of extracting the blue particles from the semi-precious stone lapis lazuli, 1, to make ultramarine, was discovered by the Arabs soon after 1200 A.D.

Above **Vermilion recipe**
Vermilion is made from sulphur and mercury. This recipe contained in the Mappae Clavicula, *dates from the eighth century.*

Right **Cave painting, Lascaux, France** *Painted between 15,000 and 10,000 B.C. by cavemen using burnt wood and bones, chalk, and various earths to produce yellows and browns.*

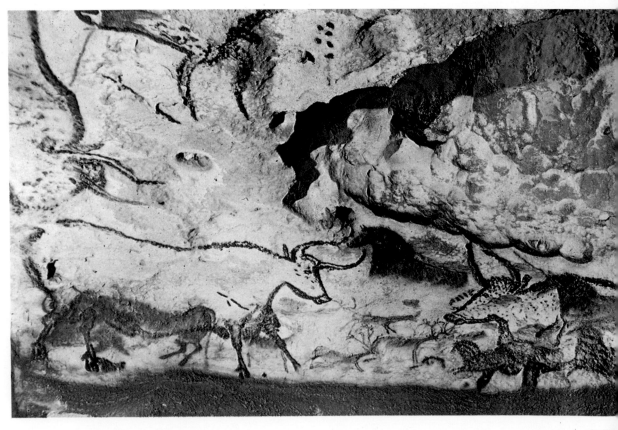

Above **Duccio di Buoninsegna: Crucifixion tabernacle** *A late thirteenth century painting which makes great use of the rich new colours, vermilion and ultramarine. Mary is dressed in ultramarine, St John in vermilion.*

White lead established a new equilibrium in the palette and with it a new range of technique and modelling. Its disadvantage is its toxicity.

Pliny confirms that the range of pigments available to the Egyptians was in use in Classical Antiquity with the addition of Indigo which had previously only been used as a dye, Tyrian purple obtained from the whelk, and a third artificially manufactured pigment, a green known as Verdigris produced by the controlled corrosion of copper plates. Verdigris was an important addition because nature is surprisingly short of greens other than chlorophyll.

Thereafter the palette remained relatively stable until, between 1200 and 1350, new or improved pigments were added that vastly expanded the chromatic range, the overall brightness of the palette. This is comparable with the colour explosion of the nineteenth century. The pigments concerned are Lead-tin yellow, Madder and other organic dyestuffs, Vermilion and Ultramarine.

Lead-tin yellow, a brilliant opaque yellow, seems to have evolved from the glass-making industry, while the improved organic pigments such as Madder resulted from chemico-technological advances, involving the use of alum, in the commercial dyeing industry.

The improvement of Vermilion and Ultramarine, on the other hand, have alchemical and Arabian backgrounds. The technique of subliming sulphur and mercury to produce a much brighter red Vermilion than could be obtained from the mineral Cinnabar, may have been brought west from China by the Arabs. The recipe is first found in an alchemical treatise of the eighth century, although it does not seem to become common practice until the thirteenth.

Vermilion's brightness, purity and opacity have meant that, apart from Cadmium red (1910), it has remained unrivalled as a pigment and is still in use today. This red had a stunning effect on the overall tonality of the medieval palette and when it was juxtaposed with Ultramarine one of the richest of all colour contrasts was revealed.

Ultramarine was, and still is, extracted from the semi-precious stone lapis lazuli which was brought to Europe from mines in Afghanistan. In the natural mineral the blue particles are mixed with impurities which cannot be removed by simple washing and levigation; the discovery of an effective method of separation seems to have been another product of Moorish ingenuity occuring soon after 1200. The deep blue Ultramarine was as precious as gold and artists' contracts exhibit anxiety about its usage, quality and cost.

After the fourteenth century the palette once again remained stable until a dyer in Berlin discovered Prussian blue in 1704. Its manufacture soon spread all over Europe virtually replacing the more expensive Azurite and Ultramarine. Other new blues followed: Cobalt blue in 1802 and synthetic Ultramarine in 1828.

The method of synthesizing Ultramarine was discovered by J. B. Guimet in Toulouse as a result of a competition sponsored by the French "Society for the Encouragement of National Industry". Its chemical composition was identical with the natural mineral, but it was manufactured from cheap

Right **Jan van Eyck:
Arnolfini marriage group**
*The Flemish van Eyck played
a large part in pioneering the
use of oil paint. His Italian
contemporaries were amazed
by his smooth, glass-like
finish, devoid of brushstrokes.
Only later was oil paint
exploited for its ability to
create texture with the
deliberate inclusion of
brushmarks. The work of
Rembrandt is an early
demonstration of this.*

Left **J.M.W. Turner: Angel
standing in the sun** *Turner
made full use of the many new
yellows which were developed
in the early nineteenth
century. Contemporary critics
were overwhelmed by the
colours and their brightness.*

Right **A chronology of
pigments** *Before 2000 B.C.
only black, white and some
earth colours were generally
used. The Egyptians produced
seven colours, and the Romans
developed Tyrian purple, indigo
and verdigris. Vermilion,
ultramarine, madder and lead-*
*tin yellow came into common
use in the thirteenth century.
Industrial development in the
nineteenth century produced,
almost as a side-effect, whole
new ranges of colours, among
them the chromes, cadmiums
and cobalts.*

2000 BC

1000 BC

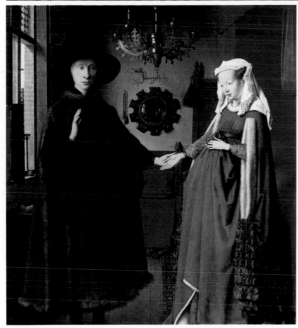

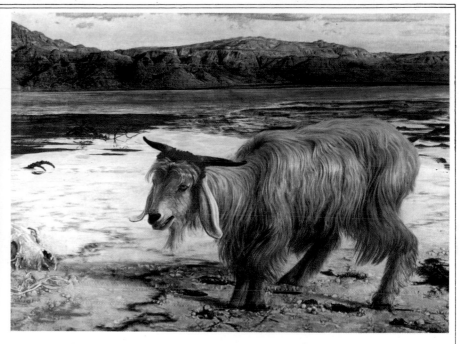

raw materials such as soda, china clay, coal and sulphur at a fraction of the cost.

The only other successful pigment to be introduced before the nineteenth century was Naples yellow which virtually replaced Lead-tin yellow in the 1750s.

During the nineteenth century, however, there was a vast expansion of the range of the palette mainly as a result of developments in the chemical and dyeing industries. In 1797 the French chemist

Above **William Holman Hunt: The scapegoat**
Holman Hunt and the Pre-Raphaelites made use of new purples which were developed from 1850 onwards. These were produced by professional colourmen and, to Holman Hunt's dismay, many of them proved to be fugitive.

Vauquelin discovered chromium; an event of major significance, because from chromium more pigments and a greater colour range were derived than from any other element.

By 1820 Chrome yellow was being mass produced and during the century at least eleven other new yellow pigments were introduced including Cadmium yellow (1817) and Cobalt yellow (1861). Interestingly an analysis of Turner's palette has shown him to have been experimenting with all

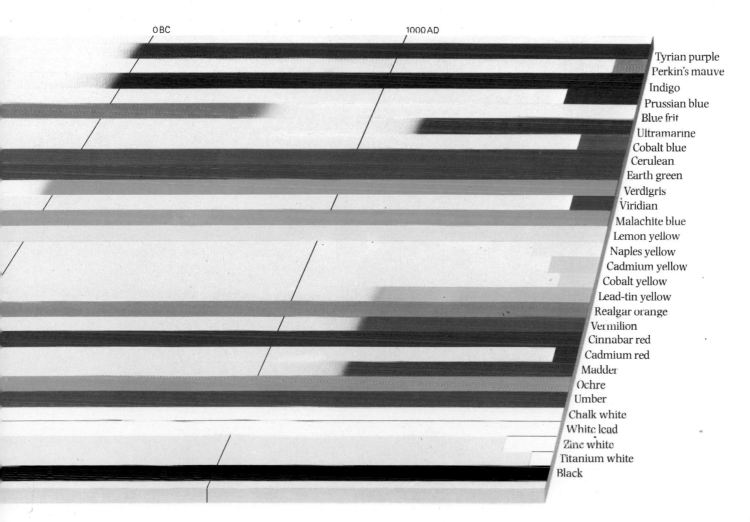

0 BC 1000 AD

Tyrian purple
Perkin's mauve
Indigo
Prussian blue
Blue frit
Ultramarine
Cobalt blue
Cerulean
Earth green
Verdigris
Viridian
Malachite blue
Lemon yellow
Naples yellow
Cadmium yellow
Cobalt yellow
Lead-tin yellow
Realgar orange
Vermilion
Cinnabar red
Cadmium red
Madder
Ochre
Umber
Chalk white
White lead
Zinc white
Titanium white
Black

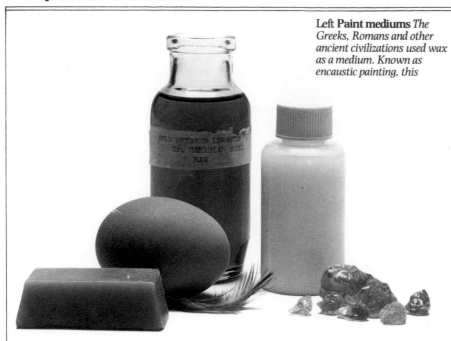

Left **Paint mediums** The
Greeks, Romans and other
ancient civilizations used wax
as a medium. Known as
encaustic painting, this

Below **Robert Campin:
Portrait of a woman** The
Frenchman Campin was
working in oils in the early
fifteenth century. He achieved
the glossy finish, free of
brushmarks, which is
characteristic of early oil
paintings.

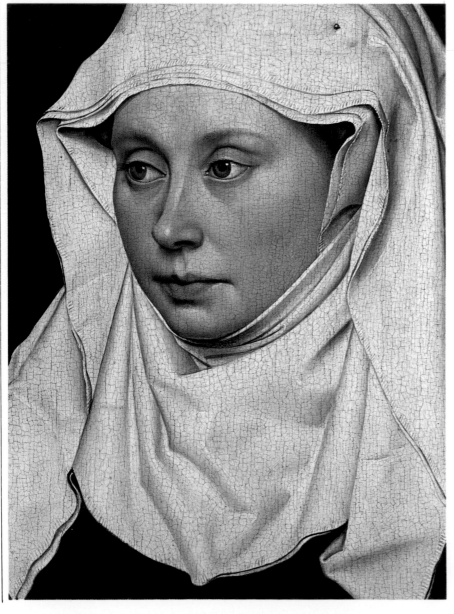

method survived into the
eighth century. An egg
medium was the commonest
form of binder until the
fifteenth century, when oil
paint, bound with linseed oil
became commonplace. During
the last twenty years, pigments
bound in a synthetic,
polymerized medium, often
acrylic, have become widely
available. Gum arabic comes
in crystalline form and has
been used since ancient times
as a medium for water-thinned
paint.

those available to him during his lifetime. Combining these yellows with Prussian blue also created a new, wider range of greens which was further amplified by the introduction of Viridian in 1838.

In the 1850s the first coal-tar dyes were introduced. The first was Perkin's mauve (1856), produced by isolating the colouring principle in the madder root and then synthesizing it, an event that caused the total collapse of the madder growing industry in France, but produced a new range of pigments. Purple became a fashionable colour; Queen Victoria wore it and the Pre-Raphaelites painted with it.

Unfortunately, many of the new dye stuffs were fugitive, and the campaign conducted by Holman Hunt (1827–1910) against the colourmen over these new pigments is indicative of an increasing concern among all artists about the quality of materials. This was the result of changing traditions. Few artists in the nineteenth century had the control, knowledge or skill at production of their medieval counterparts. Everything was bought ready-made from a rapidly expanding number of colourmen, and virtually nothing was prepared in the studio-workshop.

Media To create paint, all pigments, once prepared, have to be ground and dispersed in the chosen medium. Fine grinding is important if the paint is to be smooth-working and of even consistency; the object is to surround each pigment particle with medium so that the particles flow freely past each other and do not cling together in lumpy unmanageable aggregates.

The medium has two functions: to act as a vehicle to convey the pigment wherever the artist wishes; and, through some chemical or physical change, to bind the pigment in place. Many factors will affect the final result, for instance the method of handling, the use of a diluent, the ratio of pigment to medium and so on.

Wax Painting with pigments mixed with hot wax, or encaustic painting, was one of the principle techniques of the ancient civilizations, and the best surviving examples are the Fayum Mummy portraits dating from 1 B.C. to 3 A.D.

Pliny describes the preparation of a beeswax medium. Sticks of wax mixed with pigment were prepared and applied, while hot and liquid, with either a brush or a spatula, which could also be used to melt and mould the coloured wax after it had been applied. The technique survived until the eighth century after which only a few isolated attempts were made to revive the use of wax.

Gum Ground pigments, mixed with a gum, such as gum arabic or tragacanth, into a "cake" and then diluted with water, have been used for the technique that is now known as "water colour" from early times. The use of gum-based paint has developed along with that of paper which is

The manufacture of artists' materials *The photographs on the following pages were taken at Winsor and Newton's factory in Harrow, England.*

Pigment manufacture *There are two basic classes of pigments: natural pigments derived from earths, bark, berries or roots; and synthetic pigments derived by complex technological processes from metals and petroleum. Earth pigments such as Burnt umber, Burt sienna and Green earth, are simply dug up, washed and ground.*

Other natural pigments are derived from dyes. The dye is made into a solution with water, and suitable chemicals, 1, such as aluminium sulphate and sodium carbonate are added. The mixture is either stirred by hand, 2, in vats holding 300 gallons (1137l.), or mechanically in large vats holding up to 2000 gallons (7580l.). A chemical reaction occurs which precipitates the dye on to the base. The pigment then collects in a pulp at the bottom of the vat, and the excess liquid containing the unwanted chemicals is run off.

The pigment pulp is washed thoroughly several times through sieves to remove impurities, 3. Some pigments are passed through a filter press which squeezes out the water through coarse canvas, 4. The damp pigment is then dried on a chalk bed or in a drying cabinet, 5, before being mixed with gum or oil to make paint.

1△

3▽

4▽ 5▽

2△

27

Development of artists' materials

Preparing gum arabic for water colours *The gum in its natural state is weighed out and crushed into small pieces by an edge runner. Impurities such as pieces of wood or straw are then removed and the gum is dissolved in hot water in a mixing vessel,* **1.** *The solution is finally strained to remove impurities. The straining is done by hand through muslin,* **2.**

Making paint with a triple roll mill *Pigments for oil paints and water colours are mixed with gum solution or oil,* **3,** *and then passed through a triple roll mill,* **4,** *which exerts a pressure of up to 400 pounds per square inch (72 kg. per sq. cm.). The pressure separates the pigment particles and ensures that the paint will have even consistency. The paint passes slowly through the mill, emerging, in the case of oil paint, in a thick, glutinous sheet which collects in a bucket,* **5 and 6.**

The muller *The more delicate water colour pigments are mulled, crushed under heavy weights. Each muller weighs about 15 pounds (6.75 kg.) and is about 1 foot (30 cm.) in diameter. Gum solution and pigment are passed under the mullers,* **7,** *the resulting paint is drained off, dried and tested for consistency, colour and the dispersion of pigment particles in the paint.*

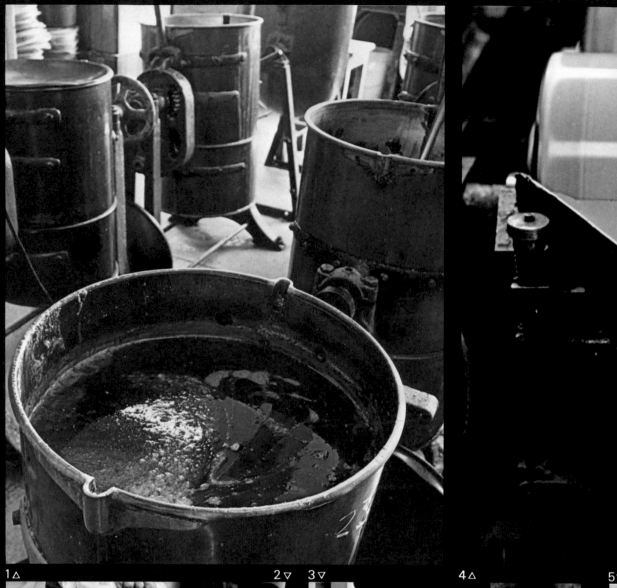

1 △

2 ▽ 3 ▽

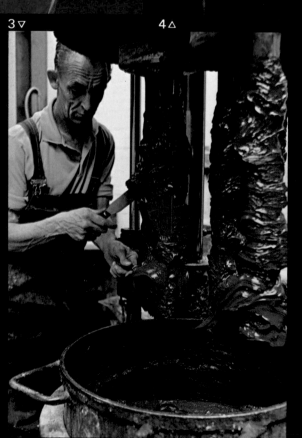

4 △

5 ▽

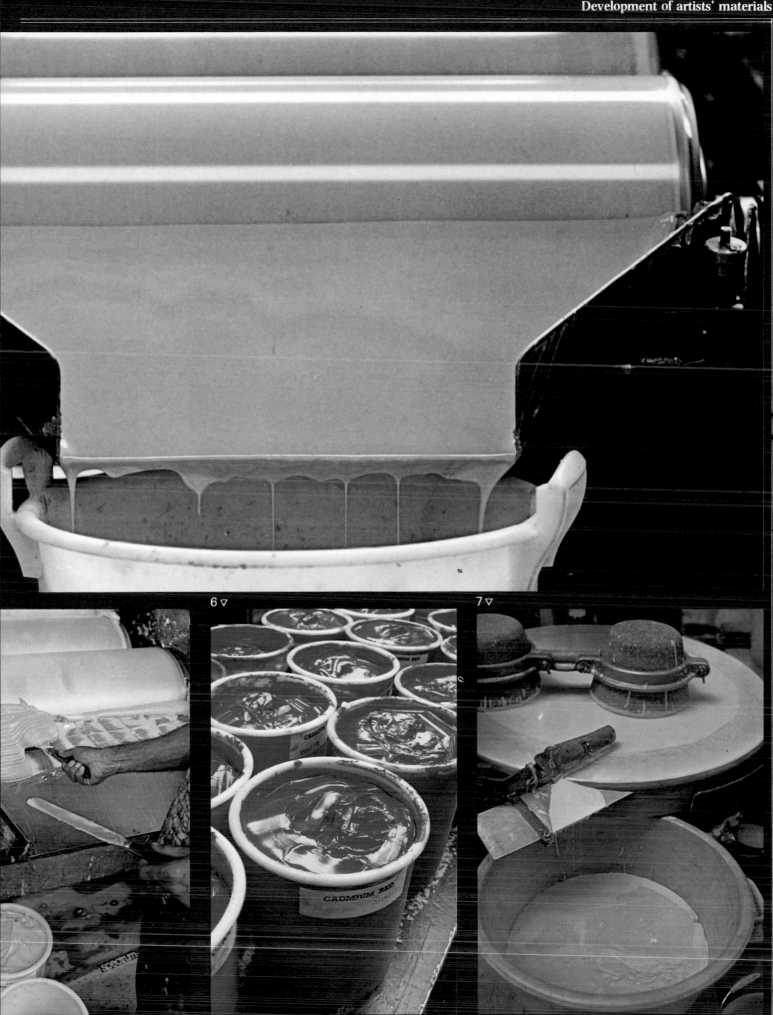

6 ▽ 7 ▽

Development of artists' materials

Filling ink bottles *Bottles being filled by machine.* **1.**
Making brush handles *The rough handles, which have been cut to size, are inspected and those with flaws in the wood are rejected.* **2.** *The selected handles are tapped down into a frame and dipped in a nitro-cellulose lacquer.* **3.** *They are then left to dry and are stamped before being fitted into ferrules.*
Making hog brushes *The bristles are carefully selected and weighed.* **6.** *Each oil brush contains a certain weight of hog bristle. The bristles are moistened and then shaped by hand.* **7.** *The assembly of the brush follows the same pattern as that described for sable brushes.*
Making paint tubes *A sheet of lead is sandwiched between two sheets of tin and rolled. This creates a single sheet, from which are pressed small circular shapes called "dumps".* **4.** *These are then punched out into tubes. Nowadays tubes are often made in the same way from aluminium, which is cheaper than lead or tin. Aluminium is non-toxic and lighter, but produces a stiffer tube which makes it more difficult to regulate the flow of paint. Some tubes may be coated on the outside with enamel. The tubes are capped and then filled by a machine which has a piston to force paint through a nozzle fitted into the open base of the tube. The inside of the end of each tube is coated with latex.* **5.** *which tightly seals the end of the tube during the final crimping process. In some cases, the tubes are capped, filled and crimped by a single machine.*

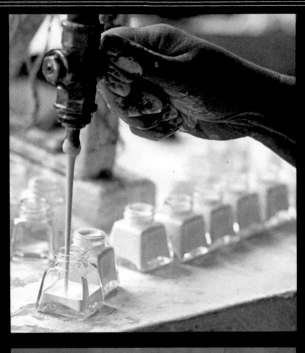

2 △ 4 ▽ 3 △ 5 ▽ 6 ▽

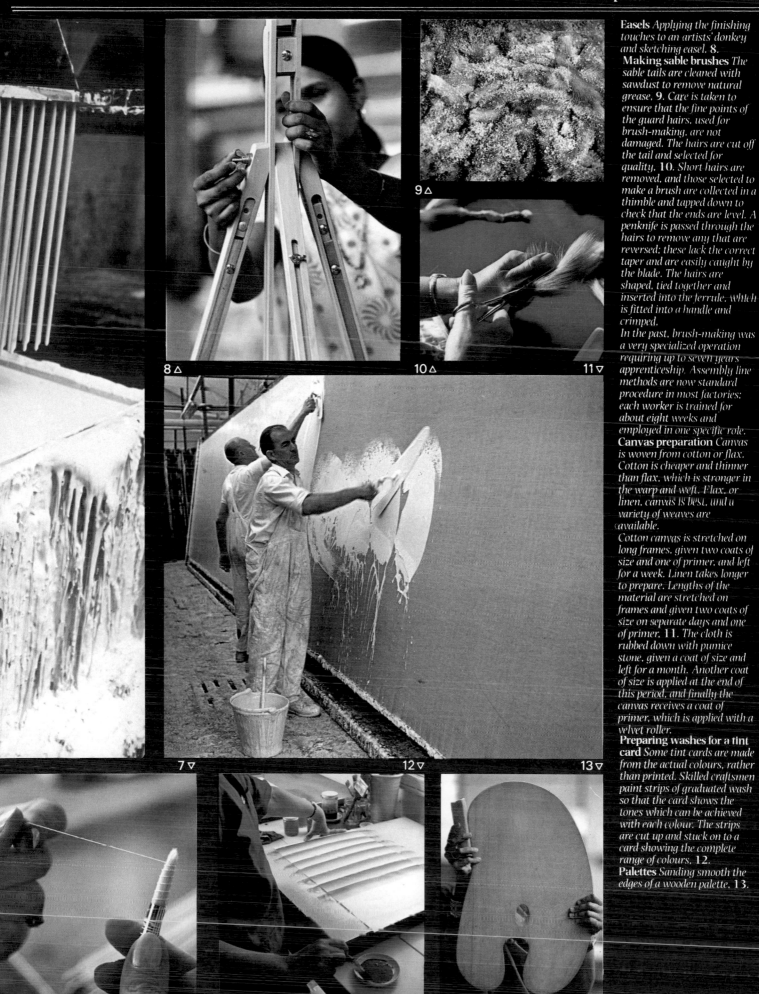

Easels *Applying the finishing touches to an artists' donkey and sketching easel. 8.*

Making sable brushes *The sable tails are cleaned with sawdust to remove natural grease, 9. Care is taken to ensure that the fine points of the guard hairs, used for brush-making, are not damaged. The hairs are cut off the tail and selected for quality, 10. Short hairs are removed, and those selected to make a brush are collected in a thimble and tapped down to check that the ends are level. A penknife is passed through the hairs to remove any that are reversed; these lack the correct taper and are easily caught by the blade. The hairs are shaped, tied together and inserted into the ferrule, which is fitted into a handle and crimped.*

In the past, brush-making was a very specialized operation requiring up to seven years' apprenticeship. Assembly line methods are now standard procedure in most factories; each worker is trained for about eight weeks and employed in one specific role.

Canvas preparation *Canvas is woven from cotton or flax. Cotton is cheaper and thinner than flax, which is stronger in the warp and weft. Flax, or linen, canvas is best, and a variety of weaves are available.*

Cotton canvas is stretched on long frames, given two coats of size and one of primer, and left for a week. Linen takes longer to prepare. Lengths of the material are stretched on frames and given two coats of size on separate days and one of primer, 11. The cloth is rubbed down with pumice stone, given a coat of size and left for a month. Another coat of size is applied at the end of this period, and finally the canvas receives a coat of primer, which is applied with a velvet roller.

Preparing washes for a tint card *Some tint cards are made from the actual colours, rather than printed. Skilled craftsmen paint strips of graduated wash so that the card shows the tones which can be achieved with each colour. The strips are cut up and stuck on to a card showing the complete range of colours, 12.*

Palettes *Sanding smooth the edges of a wooden palette, 13.*

8 △

9 △

10 △

11 ▽

7 ▽

12 ▽

13 ▽

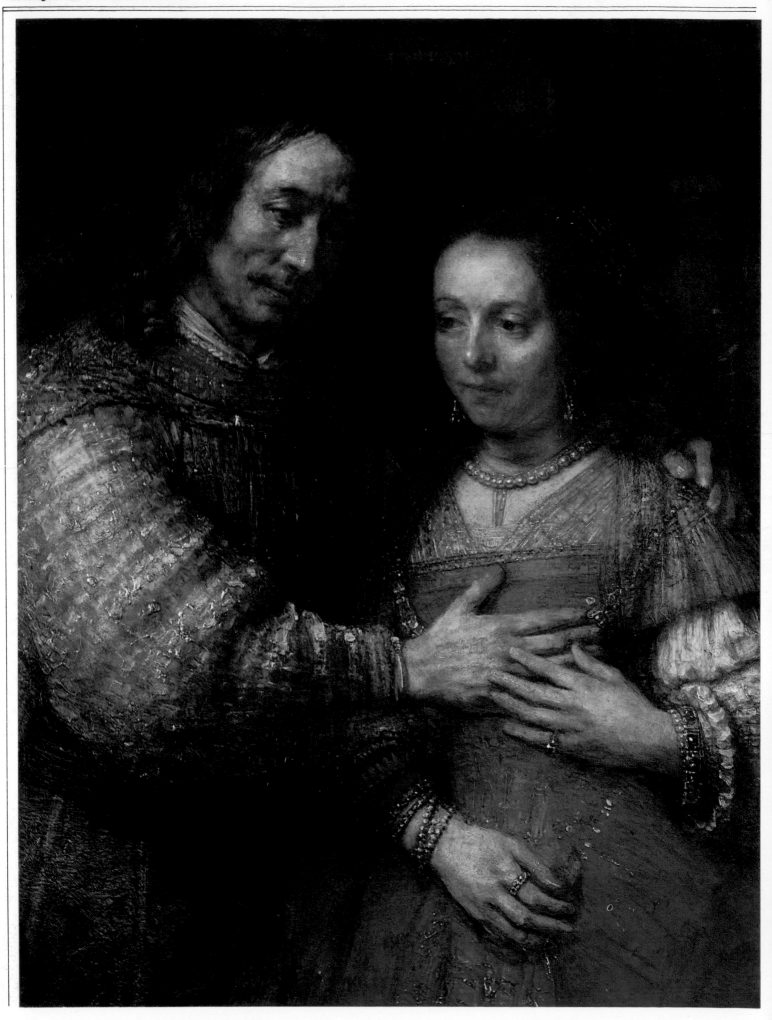

its characteristic support; though other supports such as silk and parchment have been used.

Egg During the Middle Ages gums and size-glues were used for painting, but by far the most common medium was egg and the process of painting with it—known as egg tempera—is clearly described by Cennino Cennini.

Both the white and the yolk can be used, either separately or mixed together. Fundamentally they both contain exactly the same ingredients but in different proportions; for example, the yolk contains 22 per cent oil while the white has only 0·2 per cent. The higher proportion of oil in the yolk made it fatter than the white, tougher, more elastic and ultimately completely waterproof; it was well suited to panel painting.

Egg white or "glair" was the standard medium for manuscript illumination; to make the viscous egg white usable it was beaten into a stiff white froth and left to settle. The beating tears apart the molecular structure of the white so that it is converted into a clear smooth-flowing liquid which is delicate, easy to handle and mixes well with water.

Oil Cennini regarded egg tempera painting as a "gentleman's job" which could be done even while wearing velvet, the ultimate in fourteenth and fifteenth century luxury; however almost at the time he was writing (1390) oil painting was beginning in the Netherlands, and the Italians began to marvel at the ranges of tone and blending, and the smooth finish—apparently free of brush-strokes —that was so different from tempera with its rigid system of modelling and its hatched brushwork.

Vasari (1511–74) in his *Lives of the Artists* (1568) describes painting in oil as the single brilliant, dramatic discovery of one man, Jan van Eyck (active 1422, d.1441) who while looking for varnish which would dry without being put in the sun, found these qualities in linseed and nut oil which he then used as a medium for all his pigments. Vasari maintained that van Eyck eventually passed on the secret to Antonello da Messina (c.1430–79), who, in turn, initiated Italian artists into the technique.

The process was actually more complex. Oil had been used for centuries before van Eyck for a variety of artistic purposes and the introduction of oil paint was not a process of invention, but of empirical experiment and gradual refinement.

The use of oil as a medium does seem to be a particularly northern tradition. The earliest surviving oil paintings come from thirteenth century Norway; wall paintings were being done in oil in England and France at an early date; and in a twelfth century treatise a German monk called Theophilus specifically describes grinding pigments in linseed and walnut oil.

Theophilus also states that the chief disadvantage of this system of painting was that the painter had to wait a long time for each layer to dry before applying the next, which made the process long and tedious.

From the painter's point of view there are three important factors in the nature of an oil for painting: its purity, its colour, and its drying properties. It is possible to trace gradual improvements in all these qualities, but by far the most important one was the discovery of a method of speeding up the

Left **Rembrandt van Rijn: Jewish bride (detail)** *Rembrandt developed the deliberate use of brushstrokes in his oil paintings. Here, they add depth to the tones, and assist with the rich, three-dimensional quality.*

drying process. This is described in two fourteenth century manuscripts and relies on the introduction of metallic oxides into the oil while it is being purified.

The oxides, in these cases lead and zinc, catalyze and speed up the drying process making it feasible to paint an entire picture in oil without the delay Theophilus complained about. One of the manuscripts deriving from Strasbourg says: "this oil is very quick drying and not all painters know about it and on account of its excellence it is called 'oleum preciosem' and half an ounce of it costs at least one shilling".

In 300 years then, oil progressed from a dark, slow-drying vehicle to a light faster drying and probably thinner medium. Van Eyck's contribution was the perfect mastery of this revolutionary technique, which could achieve an even glossy surface with no signs of brushwork. It was not until later that oil paint was used as a substance with textural qualities of its own, rendering the paint itself expressive by allowing signs of handling to remain in the finished picture.

Both approaches coexisted until the revolution of the nineteenth century when "direct" or "alla prima" painting came into practice; instead of building up the paint stage by stage with successive layers of drawing, glazes and scumbles, the artist laid on each patch of colour more or less as it was finally intended to appear. A stimulus was given to this direct, spontaneous approach by the introduction of collapsible tin tubes of paint which replaced the practice of tying up paint in little bits of bladder. The tin tubes were much less messy and among their other advantages allowed the artist to work out of doors directly from nature.

Acrylic The major recent contribution to media is acrylic, a polymerized resin binder which has come into general production and use since 1945. With its quick drying power, its body, resilience and flexibility of handling, it combines many of the technical advantages of oil and tempera. But it has been found to be not so much a substitute for the older binders, but a medium with its own aesthetic qualities and uses.

Artists' colourmen Many artists still make paints and pastels for themselves, because this is the only way they can achieve a particular effect. However, even in the early years of the Renaissance, specialist artists' colourmen were producing materials for drawing and painting.

In England in 1789 Thomas and Richard Rowney started a business which was to grow into the modern George Rowney and Co. And in 1832 William Winsor and Henry C. Newton started the partnership which is now world famous. In America Max Grumbacher started a small business, importing artists' brushes in the 1920s. Today Grumbacher markets over 6000 products.

These firms, and many others, now use complex modern techniques to produce a huge—almost bewildering—variety of supports, pigments, media and accessories for painting and drawing. Many synthetic materials are used, but some traditional substances have proved irreplaceable. For example, the best canvases are made from linen as they were centuries ago, and the purest ultramarine pigment can only be made by grinding lapis lazuli.

Chapter Three
Oils

Oil paint developed rapidly from the mid-sixteenth century to become for some four hundred years the most widely used vehicle for painting: only during the last twenty years has it yielded some of its supremacy to the synthetic polymer resins, or acrylic paints, but it probably remains the most popular painting medium.

Oil paint is made of dry colour pigment powder, mixed to an appropriate viscosity with one or other of a number of drying vegetable oils, usually either linseed or poppy oil. These oils dry more slowly than other media, not by evaporating, but by oxidizing; skins of pigment are formed which

Titian: Mother and child
Titian and his fellow Venetians were responsible for major developments in oil painting techniques. Here Titian used few colours, but his loose, exciting brush strokes give the painting a vibrant richness which could not have been achieved with the earlier tempera medium.

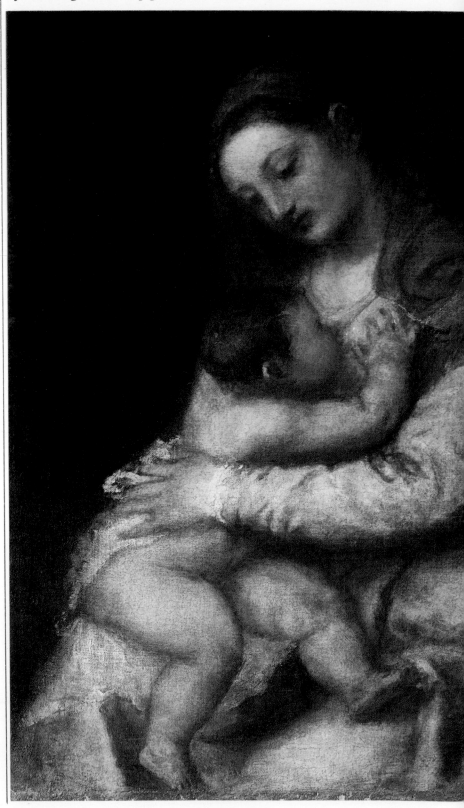

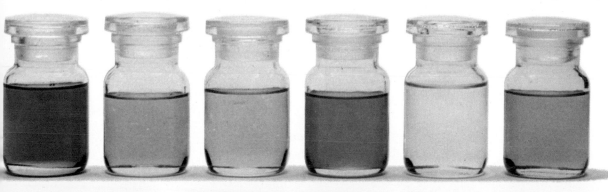

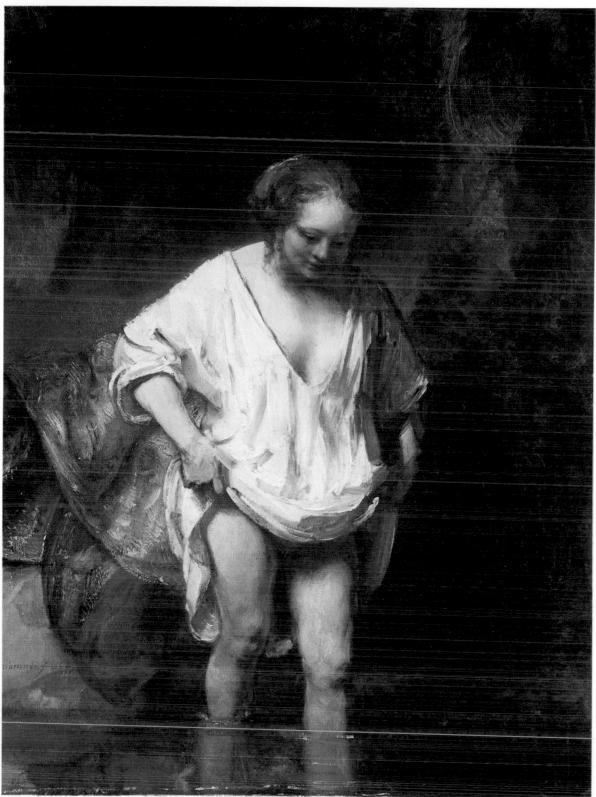

Left **Oils used as media for oil paint** *(from left): pure (cold-pressed) linseed oil; raw linseed oil; refined linseed oil; stand oil (also linseed); poppy oil; walnut oil.*

Below **Rembrandt van Rijn: Woman bathing in a stream** *The heavily modelled brushwork in the dress contrasts with the delicately glazed areas of flesh. Rembrandt's mastery of technique has had a lasting influence.*

lock into the ground, and which, if drying times are carefully observed, will lock into successive layers of pigment. This oxidizing process gives a special depth and richness to the colours of the dry pigment, and the artist can vary the proportions of oil and thinners, such as turpentine, to give the paint surface a wide range of qualities, opaque or transparent, matt or gloss.

For this and for other reasons, oil may claim to be the most flexible of the painting media. Properly used, oil paint changes its colour values little in the drying process, though in the long term oil will tend to yellow slightly. Its capacity to sustain successive layering allows the artist to develop a pictorial conception in stages—"bien amenee" as Degas called the process—and the slow drying allows him to scrape paint off the ground and re-develop whole passages. X-ray photographs show how often even the masters of oil painting made changes during the course of a painting.

The partial use of oil substances in paint has a very long history as an element in various tempera emulsions; no date could be given to its precise origin. The credit for the development of oil paint-ing towards its later pure form may be given to the Flemish Quattrocento painters, particularly to van Eyck (active 1422 d. 1441), whose influence on such disciples as Antonello da Messina (c.1430–79) spread the use of oil paint to Italy, and particularly to Venice.

The high humidity in Venice meant that fres-coes did not work well there, and painters in the city therefore welcomed the opportunities for large-

Edouard Manet: Olympia
Manet's work is characterized by a direct opposition of light and shade, with the intervening half-tones subdued or ignored. Although he was not keen to belong to any group, Manet was one of the most important Impressionists. His direct style of painting and his subject matter upset the establishment, but inspired the wave of innovation which was soon to come.

scale painting offered by the more resilient oil medium. With its lasting surface flexibility, oil paint lent itself to painting on canvas; large works could be carried out in the studio and transported, rolled up, to the site.

Titian (1490–1576), with his long and pre-eminent career in Venice, played a dominant role in developing the techniques and possibilities of oil paint. His master, Giovanni Bellini (1430–1516) had effected an astonishing transformation in conception and style; so did Titian, but he also brought an equivalent transformation in method.

From the comparative graphic tightness of his early work, he developed with the medium of oil a remarkable breadth of tonal and chromatic hand-ling. The work of his last period shows the drawing emerging from broad passages of paint applied direct to the canvas, with the tonal design travel-ling freely across the forms; it has the material fluency found in a Turner or a Monet.

The Venetians laid the foundations of fluency with oil paint: this was shortly to be built on by the Flemish Rubens (1577–1640), whose work displays the full language of oil paint. Rubens' method is historically important, since with his enormous success, and influence as a master of successful pupils and assistants, he laid down a method of procedure with oil paint which with variations was to be followed by generations of painters. The mark of Rubens can be seen in Delacroix (1798–1863) and even in Renoir (1841–1919).

The Venetians had progressed to working off a

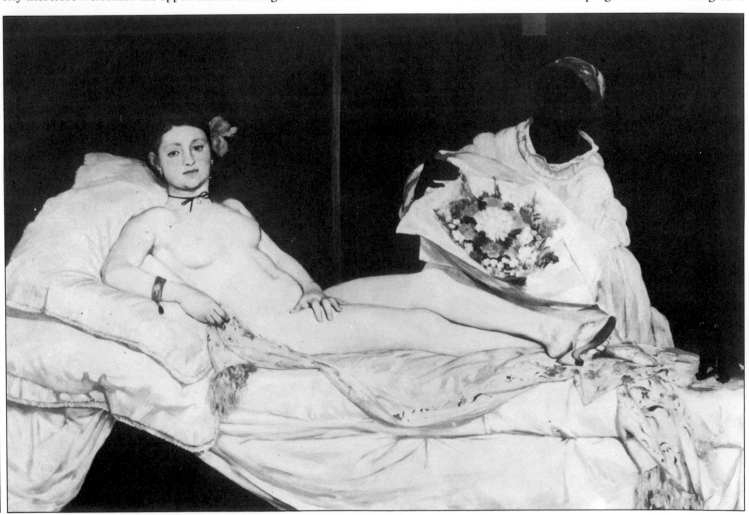

red ground, probably using a form of tempera underpainting; Rubens developed an orderly method of working from a white ground washed with thin grey. On this he would lay a broadly-swept transparent tonal design in a golden umber and would work into it the necessary linear drawing. On top of the tonal design he would develop the cool half-tones using a semi-opaque pigment which allowed the warm underpainting partly to show through. To one side of these half tones he would bring forward the darks with more strength and variety of colour, keeping the paint surface thin to allow a transparent shadowy glow; to the other side he would develop the lights and stronger local colours with more solid opaque paint, finishing off with some passages of transparent glaze.

Rubens had an immediate influence on Velasquez (1599–1660), whom he met in Madrid, and undoubtedly on the greatest of all paint handlers, Rembrandt (1606–69). Such great masters, of course, invented their own variations of technique. What they all give is a sense of extraordinary directness: however simple or complex the process of layers, each separate layer is applied with vitality and the least possible subsequent disturbance.

Rembrandt himself, though much of his method is not far removed from Rubens, often built up solid areas of modelling in a single colour, which were worked over both with glazes and opaque strokes of colour to produce a great luminosity. This method, in the form of "grisaille" (a light grey modelling which was glazed with colour) became by the eighteenth century an academic method such as may be found in the work of Reynolds (1723–92) Without an underlying directness "grisaille" painting could, and often did, become somewhat heavy, with an over-reliance on glazes. Such routine of method produced its own reaction, and in the paintings of Gainsborough (1727–88) and Goya (1746–1828) there is a return to a more direct fluency of handling in the spirit, if not quite the method, of Rubens.

Oil paint, which was already being prepared and sold commercially in skin bladders in the eighteenth century, was to be extended both in the manner of its use and its commercial manufacture in the nineteenth. The demands of open-air landscape painting, largely pioneered by Constable (1776–1837) in England, gave rise to a directness of application seldom seen before.

The increasing demand for painting engendered by the new rich of the Industrial Revolution was to a large extent met by the kind of acceptable salon painting which pursued debased forms of traditional method. Many of those painters who are now generally regarded as the best artists of their time—Corot (1796–1875) for example—worked in comparative obscurity or with only modest success. Ironically, this left such painters to work more as they pleased and less to an acceptable form demanded by traditional patronage.

The romantic idea of the artist as Bohemian, which had grown considerably by the middle of the nineteenth century—fostered by amongst others, Courbet (1819–77) in France and Rossetti (1828–82) in England—nurtured also the idea of the artist as an original, one who sought to paint not merely better than his fellows, but differently. The

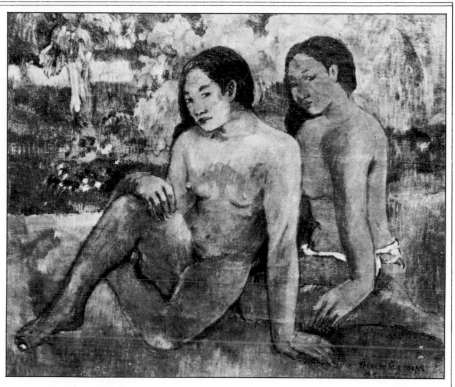

Paul Gauguin: And the gold of their bodies *The richness of Gauguin's paintings is derived from the way in which he carefully mixed and applied opaque areas of colour. The strength of this painting comes from the subtle modulations of what are basically flat areas of colour. Gauguin and Van Gogh are both considered Post-Impressionists. Their flamboyant use of colour and their new ways of handling paint have had a major influence on twentieth century painting.*

possibilities for variety and originality of method opened out greatly, and technically this was eased by the increased availability of the materials.

By the mid-nineteenth century the modern collapsible tin tube of ready-prepared oil pigment was on the market, and the old apprentice system of learning to grind and mix pigments—which had helped to preserve traditional method—was lapsing.

Impressionism is characterized by its use of solid strokes of opaque colour interwoven into a surface which abandoned much of the old approach, with its modulations of opacity and transparency, its scumblings and glazes. It was a method which answered the artistic needs of a movement which had been born in the freedom of obscurity. Such painters as Monet (1840–1926), Pissarro (1831–1903), Cézanne (1839–1906) and Sisley (1839–99) were indeed at first derided as incompetent daubers; in fact the Impressionists were mostly fine craftsmen, but craftsmen in a new way.

Nevertheless, by the early twentieth century, the example of Impressionism and Post-Impressionism and the posthumous fame of van Gogh (1853–90) and Gauguin (1848–1903), who were perhaps the most technically eccentric painters of their time, had shown that there was no longer a right way to paint.

The only wrong ways were those which would cause rapid physical deterioration, and this of course could be the price of experiment, as even Leonardo had shown. Sickert (1860–1942) describes how some of the paintings of his master, Whistler (1834–1903), darkened and dulled rapidly because of Whistler's habit of constant scrubbing out and repainting *alla prima*—quickly in one session—with an overabundance of turpentine instead of building up with ordered layers.

Since the days of Impressionism the varieties of oil pigment on the market have greatly increased, largely because of the proliferation of chemically manufactured tints; the behaviour of the commercial pigments now available is fairly consistent and

therefore predictable. Liberties can now be taken which would once have been technically imprudent, and certainly critically unacceptable in an earlier age.

Picasso (1881–1973) and Matisse (1869–1954) are outstanding examples of painters who had no hesitation in varying the quality of their paint surfaces from picture to picture, to suit their needs. The Expressionist movement has produced artists who have often embedded their conceptions in a ferocious thickness of paint, outdoing by far the impastos of van Gogh.

Tachisme, Abstract Impressionism and Abstract Expressionism have allowed painters to throw paint or to drip it on to the canvas, and much of it has been oil paint. Concurrently, makers of the most meticulously wrought thin paint surfaces, such as Salvador Dali (born 1904) and Lucien Freud (born 1922), have been at work.

Time will pass its judgement, as it always has, on artistic merit; time will also tell on the technical soundness with which oil paint has been used. Modern oil paints are criticized, and sometimes rightly, but the best of them are probably more permanent than their predecessors. There is no reason why modern oil paintings executed with technical common sense should not survive as long as those of van Eyck; museum restorers are already having problems with modern paintings in which that common sense has been scorned.

Pablo Picasso: Mandolin and guitar *Picasso mixed sand with oil paint for this painting which reflects the beginning of his "curvilinear cubism" in 1924. Picasso developed many approaches to painting, and experimented constantly with different media. Of all modern painters he has had the greatest influence on twentieth century attitudes and styles.*

Claude Monet: Water lilies. Harmony in green *Monet had an obsession about light and a remarkable ability to portray it shimmering on water by juxtaposing flecks of pure colour. Monet was the leader of the Impressionists, and a major exponent of alla prima painting, whereby the canvas was taken to the subject – often outdoors – and the painting completed quickly with little or no under or overpainting.*

Surfaces

Nowadays most oil painters work on a stretched canvas support. However, any inert support which will allow paint to adhere to it will do. Wood, metal, composition boards, cardboard or paper can all be used as supports for oil paint as long as they are primed with a suitable ground.

Canvas Nearly all the great masterpieces that have been painted in oils have been painted on canvas, and it is still the most widely used support for the medium. Canvas which has been fitted to a stretcher (see illustrations) has a unique receptiveness to the paint and the stroke of the brush.

Artists' canvases are made from linen, cotton, a linen-cotton mixture and hessian. Linen is the best, but it is expensive. The best linens are closely woven with the threads at right angles and free of knots. Properly stretched and primed, this is the ideal surface for oil paint.

Linen crash is cheaper than pure linen, but it invariably contains knots. Linen scrim is widely woven and needs much priming unless the weave is to play a part in the finished picture.

Most cotton weaves stretch poorly and they do not take primer as well as linen. However, ready-primed cotton is perhaps the best alternative to linen, although the surface can be flimsy and have

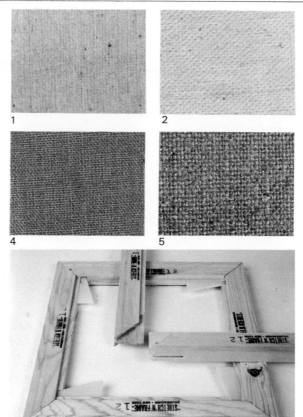

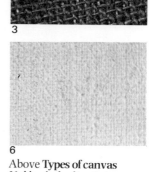

Above **Types of canvas**
Unbleached calico, 1, is a cheap cotton weave. A quality cotton canvas, 2, is the next best thing to linen. Hessian, 3, is always coarse, while linen, 4 and 5, comes in several weaves and makes the very best canvas. Linen, ready-primed with acrylic, 6, is suitable for most purposes.
Left **Stretchers** *Wood for stretchers is available in many lengths which can be fitted together to make rectangles of all sizes.*

Surfaces for oil paint *Most oil paintings are made on canvas, 5. However, many kinds of wood can be used; seasoned mahogany, 7, at least an inch thick is a traditional support. Hardboard, 2,* *blockboard, 3, and plywood, 5, make good supports, but require cradling. Chipboard, 4, requires much priming but no cradling. Heavy-duty cardboard, such as Essex board, 10, should be sized on* *both sides. Boards, prepared with a special texture to receive paint, 9, are useful for beginners. Of the metals, copper, 8, makes the best support. Paper 1, can be glued to board and sized.*

a flat appearance.

A linen-cotton mix is less satisfactory than pure cotton. However effectively it is primed, the linen and the cotton will absorb the ground, the oil and the pigment to different degrees, and as moisture is discharged into the air there will be variations of tension on the surface, causing distortion.

Hessian has a very coarse weave and requires a lot of priming. It is liable to become brittle and lifeless, thereby spoiling the quality of a painting.

Canvas can be bought ready-primed—with size and ground fully prepared—and on stretchers in a variety of sizes. This is the simplest way for an artist to acquire a support, but it is also the most expensive. Professionals and prolific amateurs will find it worthwhile to buy ready-primed canvas

in rolls. Many professionals buy rolls of unprimed canvas, so that they can prime it to suit their own requirements.

Wood Wood is a complex material, which does not absorb liquid, nor dry out, evenly; this leads to warping and cracking. Only very well-aged woods —and mahogany is one of the best—are satisfactory for work which is intended to last, and the panel should be at least one inch (2.5 cm) thick. It should also be cradled (see illustrations) to prevent warping.

Plywood Mahogany-faced plywood—preferably eight ply, and not less than five ply—makes a good support with a sound textural surface. It should be given two coats of size (see below) on each side. Plywood does not crack like wood, but it can warp

Stretching a canvas 1. *The tools required are: a ruler; a knife; a staple gun and staples; a pair of canvas pliers.*

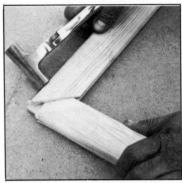

2. *Fit the corners of the stretcher firmly together. Give each a sharp tap to be certain it is secure.*

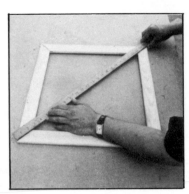

3. *Check that the stretcher is square by measuring the diagonals.*

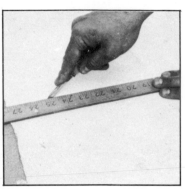

4. *Cut the canvas to size using a ruler and a knife. Allow an inch and a half overlap all round.*

5. *Lay the stretcher on the canvas. Fold the canvas over at one end and insert a staple in the outer edge of the stretcher.*

6. *Use the pliers to pull the canvas tight at the opposite end and insert a staple. Pull the other sides tight and staple.*

7. *Insert staples at three inch intervals all round, to within two inches of the corners. Fold in the first corner tightly.*

8. *Secure the corner with two staples. Repeat the process for the other three corners.*

Cradling board. *Cut two battens two inches shorter than the width of the board. Chamfer the ends, drill holes and screw to the board.*

Sticking muslin to board 1. *Cut the muslin to size, allowing two inches for folding over at each side.*

2. *Lay the muslin on the board and brush over it with glue size. Brush out any creases.*

3. *Turn the board over and paste down the edges. Fold in the corners and coat them with glue. Allow to dry.*

and should therefore be cradled (see illustrations).

Chipboard Thick panels of chipboard are in many ways a better support than wood or plywood in that they have less tendency to warp and do not require cradling. They are made either from wood chippings pressed in resinous or oily binders, or from pressed wood fibre, and therefore need to be well primed. A disadvantage is that the edges and corners have a tendency to crumble. Muslin stuck to chipboard with glue size makes a good support (see illustrations).

Hardboard Properly cradled hardboard makes a good, fairly inert support. It can be used without priming if the smooth surface is rubbed down with alcohol, but it is better to size and prime it before painting. Both sides of the board must be sized

together or it will warp very badly.

Essex board This is a laminated cardboard obtainable in large sheets from builders' merchants; it makes a good support if it is sized on both sides, and is especially good if muslin is stuck to it with glue size (see illustrations).

Prepared boards Commercially prepared boards, such as Daler board, can be bought at all art stores; some of them have a simulated canvas surface. However, they are expensive and most have an unpleasant mechanical texture and a very glossy priming which can be difficult to cover.

Cardboard A good support, with qualities very different from canvas or wood, can be made from the thickest types of cardboard or strawboard. This needs to be sized on both sides and given firm

Jan Vermeer: The Lacemaker (detail) *For this painting Vermeer used a coarse canvas and allowed it to show through the thin paint of the background and through much of the figure painting.*

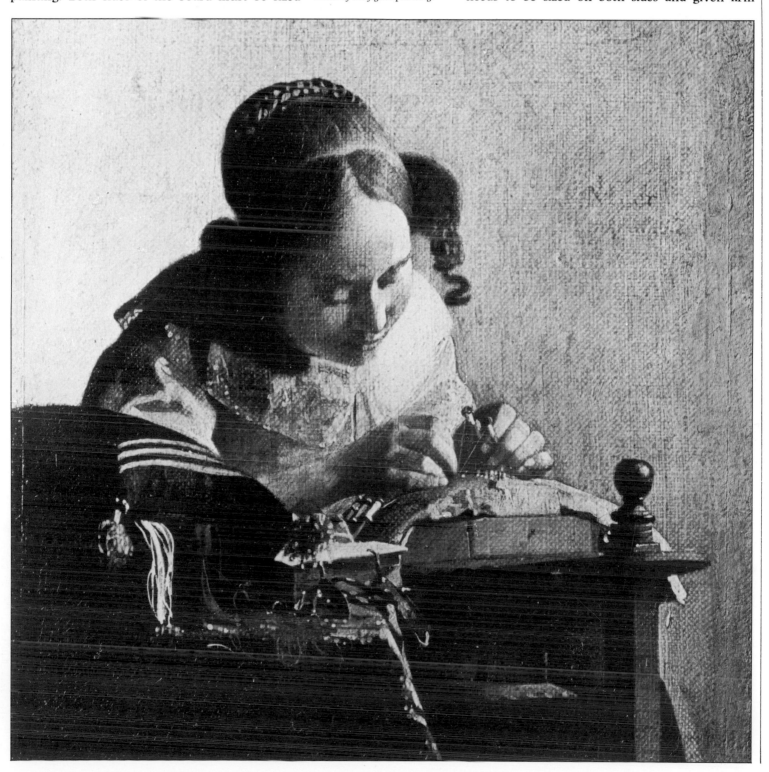

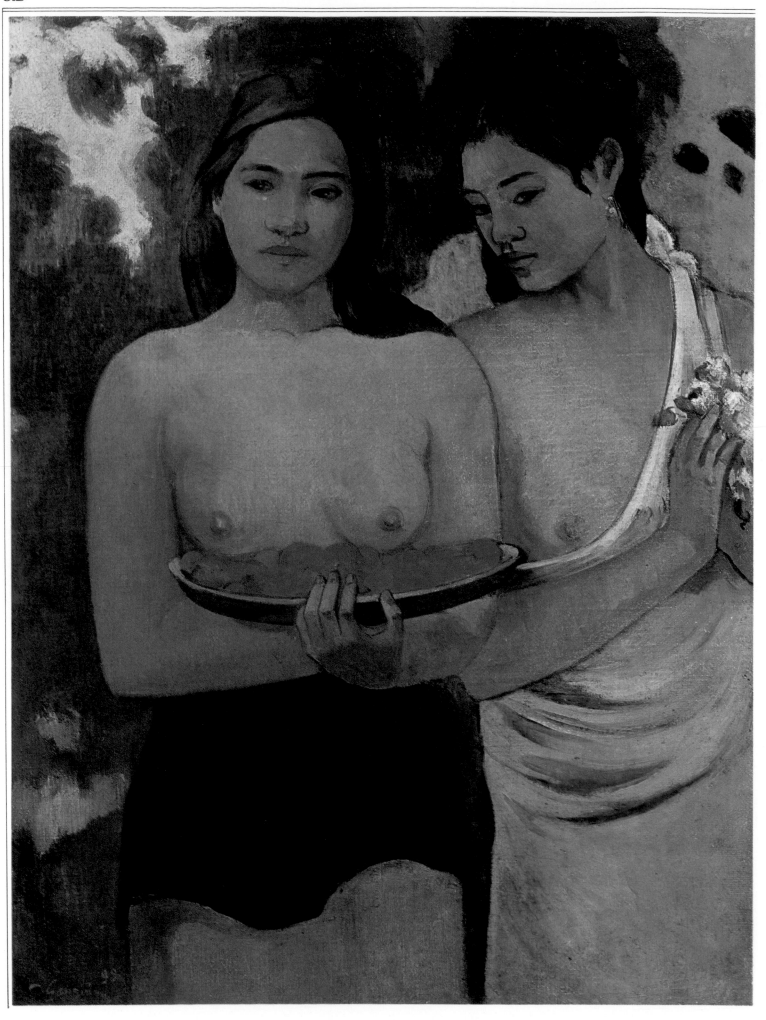

Left **Paul Gauguin: Two Tahitian women** *Gauguin was often forced by circumstances to paint on less than ideal supports. Sometimes the coarseness of the surface, either wood, or, as in this instance, canvas, shows through the paint. Gauguin's liberal use of opaque paint often disguises the support.*

Right **Francis Bacon: A study of three figures at base of crucifixion (detail)** *Painted on hardboard in 1944, this work shows little sign of wear. It does show Bacon's great facility with oil paint; the lighter areas are a good example of scumbling.*

Below **Paul Cézanne: Still life with water jug** *Although this painting is unfinished, it reveals how a white ground can be used to unify a composition. In many ways the approach is reminiscent of the artist's water colours.*

cradling to prevent warping. It is liable to grow fungus and bacteria and therefore lacks permanence. But many painters like to use its warm, brown natural colour as a middle tone. Toulouse-Lautrec (1864–1901) used cardboard for several of his paintings of the underworld fringes of Parisian music halls and bars.

Paper Rough-surfaced water colour paper, glued to hardboard and sized—preferably with casein glue—can be used as an oil painting support. Paper can also be prepared by brushing both sides with shellac varnish (see p. 52). Some artists find oiled parchment or gelatin-sized plain paper ideal for small sketches and colour notes.

Metal The Dutch used copper plates for oil paintings from the time of van Eyck, but usually only for small, jewel-like works which were preserved with great care. Few of these have survived without extensive restoration. Metal has the advantage of not needing any primer; it should be sanded down to give a surface that will accept, or hold, the paint.

Synthetic canvas Manmade fibres may provide the painting surfaces of the future, but much research and a lot of time is still needed before any confident conclusions can be reached. "Canvases" are available made from Nylon, Orlon and plastic sailcloth.

In the United States a synthetic canvas called Polyflax is made especially for painting, and comes ready-primed with acrylic primer. It is in standard canvas gradings and costs less than a third the price of the best linen. The advantages of manmade fibres are their clear colour, light weight and resistance to chemical reaction. They may, however, prove brittle as they age.

Under priming With the exception of metal, all painting supports, especially canvas, should be isolated from the oil content of the ground. Oil will adversely affect the fibres of canvas within a fairly short time and the canvas will become very brittle and rot. The most commonly used under priming is some form of weak glue size solution. Sizes are marketed by all major artists' suppliers. Artists prefer to mix their own size; it must be made with glue derived from animal matter. This is essential.

Leather waste size The purest size is made with leather waste glue—also known as rabbit skin glue, parchment glue and Cologne glue (see illustrations). This comes in sheet form, but is very expensive.

Bone glue size The most commonly used size is made from bone glue, which can be bought in most hardware stores; it is worth buying a good quality brand. This should be sprinkled into cold water and stirred constantly; sufficient glue should be added to make the mixture a smooth paste. Then 7 cups of cold water should be added for each cup of powdered glue, and the whole heated gently—not boiled—until all the size is dissolved. This size should be applied while warm.

Casein size Casein, also known as milk glue, is a cold water glue which can be bought in proprietary packs. 1 part of casein should be sprinkled into 7 parts of water and stirred until completely dissolved. It must be used on the day it is made up.

Grounds After sizing, the support should be given a ground (see illustrations). This protects the support from the effects of the oil in the paint, and provides an ideal surface to receive the paint.

Mixing an oil ground *A good stable oil ground can be made from 6 parts by measure of turpentine or white spirits, 1 part of linseed oil and some white lead paste or flake white.*

The turpentine should be mixed with the linseed oil; the resulting mixture should then be stirred into the paste until the whole has the consistency of thick cream. Two coats of

this should be brushed evenly on to a stretched canvas, and left to dry for at least a month before paint is applied. Care must be taken with white lead paste because it is poisonous.

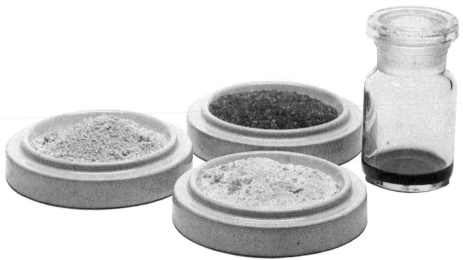

Mixing an emulsion ground *1 part by measure of glue size mixture, $\frac{1}{2}$ part of raw linseed oil, 1 part of whiting and 1 part of zinc oxide are necessary. The two dry*

ingredients should be mixed together and hot size added slowly to make a smooth paste. The linseed oil should be beaten into the paste drop by drop until it is completely

dispersed, and then the rest of the hot size added. The ground should be kept warm in a double boiler and applied to the support while hot.

Mixing a gesso ground *This is a simple mixture of 1 part by measure of whiting with 1 part of glue size. The glue size must be heated and some of it*

transferred to a container. The dry whiting should be sieved into it and stirred until a smooth paste is formed. The remainder of the hot size is

then stirred in to give the mixture the consistency of cream.

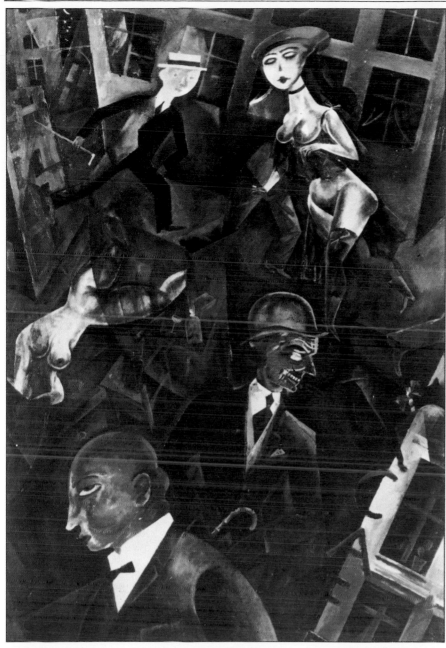

Above **George Grosz: Metropolis** *Painted on cardboard in 1917, this painting shows no signs of deterioration. As Lautrec and* *Sickert have also established, properly prepared cardboard provides a good inert support for oil painting. Cardboard suited Lautrec's paintings of* *Parisian night life; its flat qualities also worked well for Grosz's startling compositions, many of which have a radical political theme.*

Commercially prepared grounds Artists' colourmen sell stretched canvases already prepared for painting, and also canvas sold by the metre already primed and ready for stretching. These are mostly sized and primed with an oil ground or an acrylic-based primer. Oil-based and acrylic-based primers are also marketed; these can be used to prime raw canvas which has already been sized.

Oil grounds The best ground for a stretched canvas contains a reasonable quantity of oil (see illustration). This takes a long time to dry—from four to six weeks—but it gives the canvas a suppleness that allows it to stretch and contract in temperature and climatic changes. It will also prevent too much oil being absorbed from the paint.

If, after a month, the canvas has still not dried and is needed for use, it can be given a thin coat of shellac varnish and used as soon as this dries.

Gesso ground The first oil painters used a gesso ground (see illustration), because this had been—and still is—the ground used by tempera painters. For oil painting, gesso should only be used on a rigid support such as hardboard or wood.

However, gesso is not an ideal base for oil paint, because it is inflexible, dries out rigidly, and, as the oil dries over the years, a fine crackle is likely to develop over the whole surface.

Emulsion grounds Emulsion grounds consist of white pigments suspended in oil and glue size (see illustration). This is more absorbent than an oil ground and less brittle than gesso.

Emulsion can be used for canvas or board supports, and has the advantage of drying quickly; a canvas covered with emulsion will be ready for painting in a week. Time has shown however, that oil on emulsion does not have the lasting qualities of oil on oil. Some artists prefer emulsion because it has a softer, almost spongy quality that suits their way of laying on the paint. Others prefer their ground to be tinted rather than plain white, and emulsion is the most suitable ground into which to mix a tint.

Acrylic grounds for oils Acrylic primer (see p. 71) can be used as a ground for acrylic paints or oils. It is available from all artists' suppliers and can be applied without size. Acrylic grounds were developed in the 1950s and as yet have proved quite adequate, giving no indication of weaknesses such as cracking or loss of colour. Only time will establish how they age.

Applying size and ground 1. *Brush on the size while it is still hot. Apply it from all directions so that it gets right into the weave. Allow to dry.*

2. *Apply another coat of size and leave to dry for about 12 hours. Meanwhile prepare the ground. When the size is dry brush on the ground.*

3. *Apply the ground thickly and work it right into the weave. Brush from every direction and leave no brush marks. Allow to dry for a day.*

4. *Apply another coat. Leave this for at least a month before painting on it. The ground can be tinted by stirring dry pigment or oil paint into the liquid.*

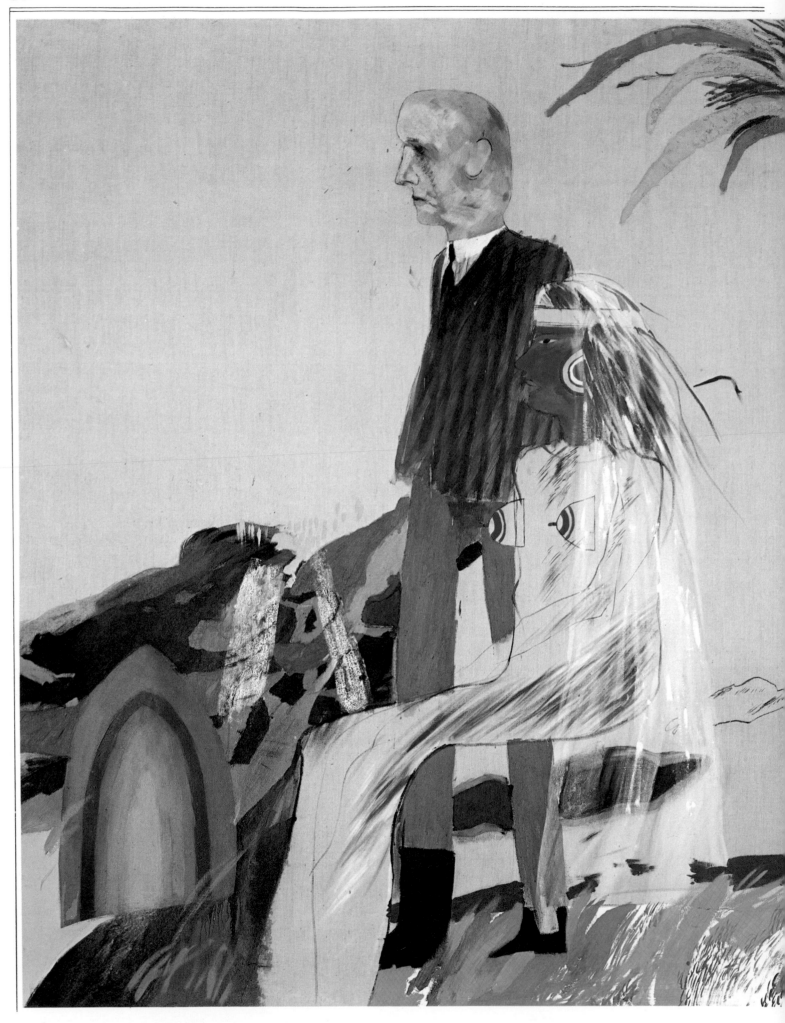

Paints

Most manufacturers produce at least two grades of oil paint. Those labelled "Artists'" are the most reliable and permanent. The other grades—sometimes labelled "Students'", otherwise given a trade name—are cheaper, but they tend to contain lower quality pigments, and are less reliable and may well be fugitive.

Pigments The pigments used in oil paints (see p. 50) are the same as those for water colours, gouache, tempera and acrylics. The perfect pigment is one which holds its colour, unaffected by acids, alkalis, heat, light or moisture. Only Viridian, Cobalt, and Carbon black come close to fulfilling these criteria.

Most pigments are susceptible in some way,

Left David Hockney: The first marriage *Raw, unprimed canvas forms an integral part of this painting, providing a subdued counterpoint to the bold colours and brushstrokes. Obviously white paint could not be laid directly on to a conventional ground; the canvas forms a base for the scumbled veil*

Right Equipment for making paint *Powdered pigment can be ground into an oil medium very easily; all that is required is a glass slab or a sheet of plate glass, a glass muller and a palette knife or spatula.*

Grinding paint 1. *Spoon powdered pigment on to the glass and pour on sufficient oil to make the mixture glutinous.*

2. Use a spatula, or for small quantities a palette knife, to blend the oil with the powder.

3. Work over the paint with the muller; use reasonable pressure and a circular motion. Continue until the pigment is evenly mixed with the oil.

4. The paint can be stored in a jar or a tube; scoop it in with a palette knife. If it is to be kept long, it can be covered with a little water.

Sulphurous fumes in the atmosphere can discolour metal-based pigments like Lead white. The yellowing of oil as it ages can change Chrome yellow into green, and strong sunlight can cause Madder, Sepia and Carmine to darken with time.

Other pigments react with each other. Sulphides, such as the Cadmiums, cause metal-based pigments to blacken. Copper, lead and iron-based paints, like Prussian blue, Emerald green and Flake white should be kept away from synthetic Ultramarine, Vermilion and the Cadmium colours.

Of all pigments the earth colours are the most permanent. These are natural clays stained with iron or manganese compounds, prepared by roasting or heating. These pigments include: Yellow ochre, Raw and Burnt sienna, Raw and Burnt umber, Terre verte, Vandyke brown, Light red, Indian red and Venetian red.

The most important pigment in any artist's palette is white. Hardly any colour is used without white mixed with it; it is therefore essential to have good quality whites.

Making paint Manufactured oil paints are obviously the most accessible source of material for the painter, but sometimes the consistency of tube paint leaves something to be desired. The amount of filler in the cheaper ranges of paint, and the excess oil which is often put into some colours to prevent their drying in the tubes means that the paint is not always of the precise consistency the artist requires.

Some artists grind their own colours, and this is not difficult (see illustrations). Most artists' colourmen carry a comprehensive range of raw pigments. A sheet of plate glass or an old litho stone, a glass miller and a palette knife are all that is needed.

Binders Pigments must be ground into a binder, and for oil paints, linseed oil, poppy oil, walnut oil and other natural drying oils are used. When bound, the pigment particles are suspended in the

oil and can be brushed easily on to the painting surface. When the oils have dried by absorbing oxygen, they seal the pigment to the surface and change into a dry, solid material which cannot be brought back to its former state.

Most manufactured paints are bound with linseed or poppy oil. Artists who wish to mix their own paints using dry pigment, may like to buy other oils which have particular properties.

Linseed oil Linseed oil is the most common binder for oil paint. It oxidizes into a tough, leathery film which remains transparent. It dries very quickly at first, but the complete drying process takes many years, allowing the paint to expand and contract with the canvas in varying temperature and climatic conditions, thereby helping to lessen the danger of cracking.

Cold-pressed linseed oil This is the purest linseed oil and therefore the very best for painting. However, it is only of use to artists, and is therefore expensive and sometimes hard to obtain. The best alternative is refined linseed oil.

Refined linseed oil This is bleached and refined to produce a pure, pale oil which makes an excellent clear, thin binder.

Raw linseed oil Flax is steam-heated before pressing to produce raw oil. As a result a greater quantity of oil is produced, but it is darker in colour. It is more durable than cold-pressed linseed oil, but few artists use it.

Stand oil Linseed oil which is heated in an air-free container to alter its molecular structure, making it darker and thicker, is called stand oil. Mixed with pigment this dries to a fine, enamel-like surface with no brush marks, and it does not yellow with age as much as other linseed oil.

Sun-thickened stand oil The old method of producing oil was to put it in loosely covered glass jars in the sun for several weeks to allow it to oxidize and bleach. Oil prepared in this way makes the paint flow more easily, increases its trans-

Oils, varnishes and media
Many types of oil and varnish can be mixed to produce media with different properties — thick, thin, glossy, quick-drying. Ready-mixed media are also available.

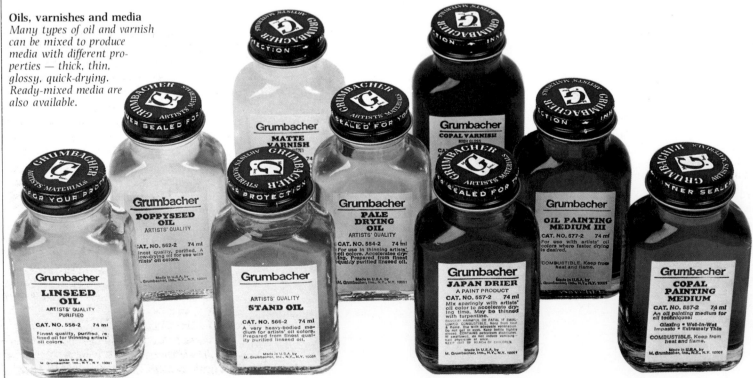

parency and causes it to dry more quickly. Rubens (1577–1640) used this oil to give a body to the light in his paintings and a thin transparency to the shadows.

Poppy oil The ground seeds of the opium poppy produce a slow-drying oil paler than linseed oil. Artists' colourmen use it as a binder for paler colours. It contains less acid than linseed and therefore does not yellow so much, but it takes longer to dry and it cracks more easily.

Walnut oil Once widely used, this is made by pressing young walnuts to produce a very pale, thin oil with good drying qualities. It is still obtainable from good artists' colourmen.

Safflower and tung oils Other natural drying oils, such as safflower and tung, are used by artists, but very few have the versatile qualities of linseed and poppy oils.

Artificial drying oils Chemicals, usually manganese or cobalt, are added to natural oils to produce oils which will dry more quickly. The artist can easily make these up himself: 1 part of manganese oxide can be added to 3 parts of linseed oil. Alternatively cobalt naphthathenate or cobalt linoleate should be added to turpentine to make a 5 per cent solution. 1 drop of this can be mixed with a table-

Above **Wassily Kandinsky: Accompanied contrast, no. 613** *Kandinsky mixed oil paint with sand to create the subtle textures of this painting. When additives of this kind are used, they must always be thoroughly mixed with the oil binder; otherwise there is a danger of them cracking and falling off the canvas.*

spoon of linseed oil.

Artificial oils are most useful in a damp atmosphere which retards the oxidation of natural oils and can cause paint to flake. However, these oils can cause discolouration, cracking and stress lines if they are not mixed and used carefully.

Painting media A painting medium is used mainly to facilitate the application of paint to the support. It is also used to thin paint while still keeping a controlled balance of the paint layers. Some media are used to hasten the drying time of paint.

If the artist makes his own paint from raw pigments, he can grind the pigment directly into any binder or medium to the consistency he requires. However, manufactured tubes of colour generally need the addition of some form of painting medium to make them easy to apply. The use of a diluent, such as turpentine or petroleum spirit, by itself is not good practice, because the binding power of the oil is weakened and this invariably leads to a cracked paint film.

Turpentine medium The most commonly used painting medium is a mixture of linseed oil and turpentine, usually in the proportions of 60 per cent oil and 40 per cent turpentine. The old truism of always painting "fat over lean" is very sound

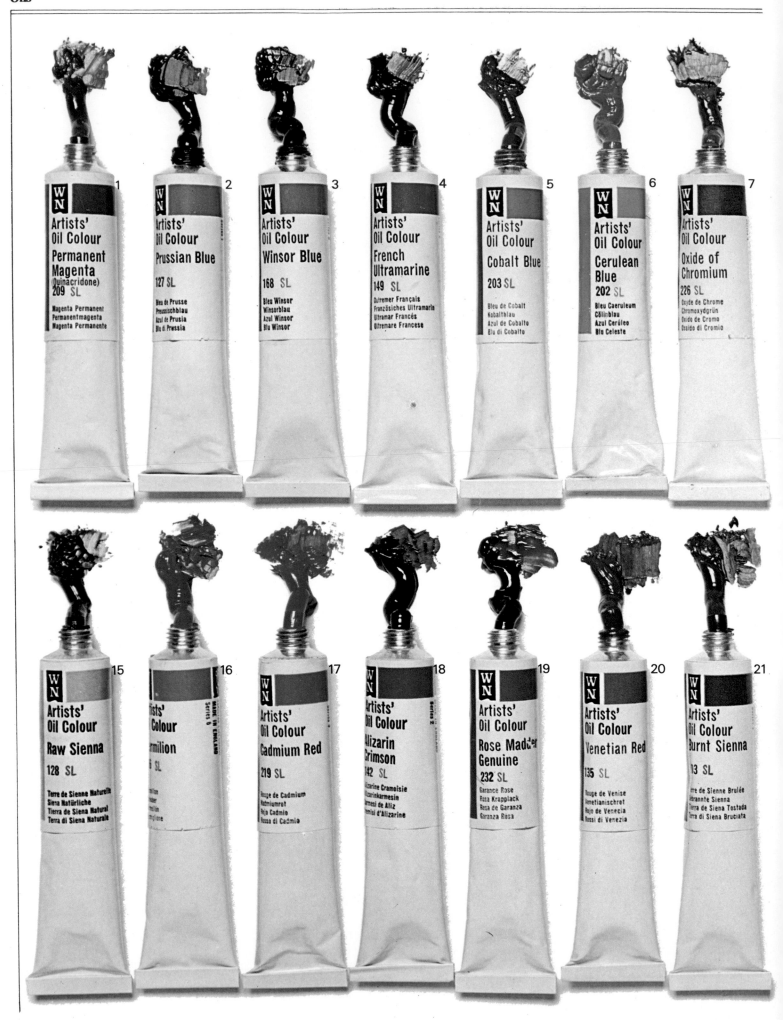

1. **Artists' Oil Colour** Permanent Magenta (Quinacridone) 209 SL — Magenta Permanent / Permanentmagenta / Magenta Permanente

2. **Artists' Oil Colour** Prussian Blue 127 SL — Bleu de Prusse / Preussischblau / Azul de Prusia / Blu di Prussia

3. **Artists' Oil Colour** Winsor Blue 168 SL — Bleu Winsor / Winsorblau / Azul Winsor / Blu Winsor

4. **Artists' Oil Colour** French Ultramarine 149 SL — Outremer Français / Französisches Ultramarin / Ultramar Francés / Oltremare Francese

5. **Artists' Oil Colour** Cobalt Blue 203 SL — Bleu de Cobalt / Kobaltblau / Azul de Cobalto / Blu di Cobalto

6. **Artists' Oil Colour** Cerulean Blue 202 SL — Bleu Caeruleum / Cölinblau / Azul Cerúleo / Blu Celeste

7. **Artists' Oil Colour** Oxide of Chromium 226 SL — Oxyde de Chrome / Chromoxydgrün / Oxido de Cromo / Ossido di Cromio

15. **Artists' Oil Colour** Raw Sienna 128 SL — Terre de Sienne Naturelle / Siena Natürliche / Tierra de Siena Natural / Terra di Siena Naturale

16. **Artists' Oil Colour** Vermilion SL — Vermilion / Rouge de Vermillon / Vermellón / Vermiglione

17. **Artists' Oil Colour** Cadmium Red 219 SL — Rouge de Cadmium / Kadmiumrot / Rojo Cadmio / Rosso di Cadmio

18. **Artists' Oil Colour** Alizarin Crimson 142 SL — Alizarine Cramoisie / Alizarinkarmesin / Carmesi de Aliz / Cremisi d'Alizarina

19. **Artists' Oil Colour** Rose Madder Genuine 232 SL — Garance Rose / Rosa Krapplack / Rosa de Garanza / Garanza Rosa

20. **Artists' Oil Colour** Venetian Red 135 SL — Rouge de Venise / Venetianischrot / Rojo de Venecia / Rossi di Venezia

21. **Artists' Oil Colour** Burnt Sienna 103 SL — Terre de Sienne Brulée / Gebrannte Sienna / Tierra de Siena Tostada / Terra di Siena Bruciata

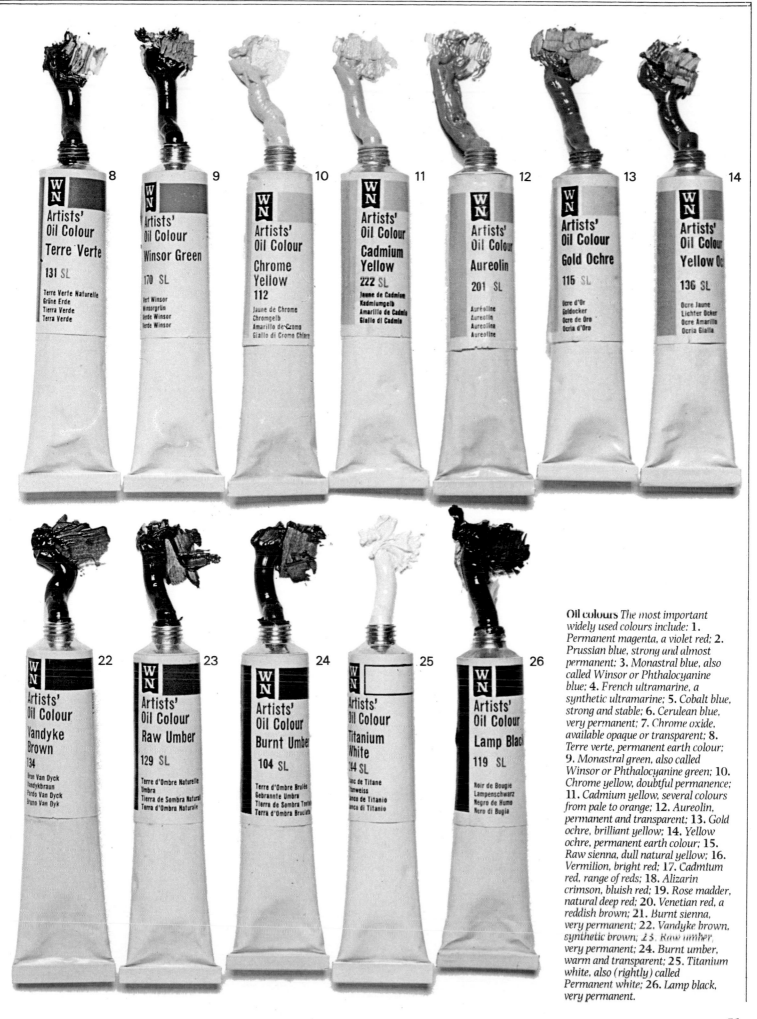

8 Artists' Oil Colour **Terre Verte** 131 SL · Terre Verte Naturelle · Grüne Erde · Tierra Verde · Terra Verde

9 Artists' Oil Colour **Winsor Green** 170 SL · Vert Winsor · Winsorgrün · Verde Winsor · Verde Winsor

10 Artists' Oil Colour **Chrome Yellow** 112 · Jaune de Chrome · Chromgelb · Amarillo de Cromo · Giallo di Cromo Chiaro

11 Artists' Oil Colour **Cadmium Yellow** 222 SL · Jaune de Cadmium · Kadmiumgelb · Amarillo de Cadmio · Giallo di Cadmio

12 Artists' Oil Colour **Aureolin** 201 SL · Auréoline · Aureolin · Aureolina · Auréoline

13 Artists' Oil Colour **Gold Ochre** 115 SL · Ocre d'Or · Goldocker · Ocre de Oro · Ocria d'Oro

14 Artists' Oil Colour **Yellow Oc** 136 SL · Ocre Jaune · Lichter Ocker · Ocre Amarillo · Ocria Gialla

22 Artists' Oil Colour **Vandyke Brown** 134 · Brun Van Dyck · Vandykbraun · Pardo Van Dyck · Bruno Van Dyk

23 Artists' Oil Colour **Raw Umber** 129 SL · Terre d'Ombre Naturelle · Umbra · Tierra de Sombra Natural · Terra d'Ombra Naturale

24 Artists' Oil Colour **Burnt Umber** 104 SL · Terre d'Ombre Brulée · Gebrannte Umbra · Tierra de Sombra Tostada · Terra d'Ombra Bruciata

25 Artists' Oil Colour **Titanium White** 104 SL · Blanc de Titane · Titanweiss · Blanco de Titanio · Bianco di Titanio

26 Artists' Oil Colour **Lamp Black** 119 SL · Noir de Bougie · Lampenschwarz · Negro de Humo · Nero di Bugia

Oil colours *The most important widely used colours include:* **1.** *Permanent magenta, a violet red;* **2.** *Prussian blue, strong and almost permanent;* **3.** *Monastral blue, also called Winsor or Phthalocyanine blue;* **4.** *French ultramarine, a synthetic ultramarine;* **5.** *Cobalt blue, strong and stable;* **6.** *Cerulean blue, very permanent;* **7.** *Chrome oxide, available opaque or transparent;* **8.** *Terre verte, permanent earth colour;* **9.** *Monastral green, also called Winsor or Phthalocyanine green;* **10.** *Chrome yellow, doubtful permanence;* **11.** *Cadmium yellow, several colours from pale to orange;* **12.** *Aureolin, permanent and transparent;* **13.** *Gold ochre, brilliant yellow;* **14.** *Yellow ochre, permanent earth colour;* **15.** *Raw sienna, dull natural yellow;* **16.** *Vermilion, bright red;* **17.** *Cadmium red, range of reds;* **18.** *Alizarin crimson, bluish red;* **19.** *Rose madder, natural deep red;* **20.** *Venetian red, a reddish brown;* **21.** *Burnt sienna, very permanent;* **22.** *Vandyke brown, synthetic brown;* **23.** *Raw umber, very permanent;* **24.** *Burnt umber, warm and transparent;* **25.** *Titanium white, also (rightly) called Permanent white;* **26.** *Lamp black, very permanent.*

Left **Varnish medium** *Adding varnish to the common oil and turpentine medium makes a thicker mixture which dries more quickly and can be thinned more efficiently. 1 part by measure of copal varnish, 1 part of linseed oil and 1 part of genuine turpentine should be poured into a dry bottle and shaken well.*

Above **Damar varnish medium** *A clear medium is ideal for thinning paint for glazing. This can be made from 9 parts by measures of damar varnish, 9 parts of genuine turpentine, 4 parts of stand oil and 2 parts of Venice* turpentine. *All four ingredients should be poured into a dry bottle and shaken vigorously until blended. One drop of cobalt drier can be added to each pint of this medium to make it dry more quickly.*

Above **Stand oil medium** *A resinous medium that dries to an almost glossy brilliance is made by mixing and shaking together 1 part by measure of stand oil with 3 parts of Venice turpentine.*

Right **Shellac varnish** *This can be used as a diluent, or it can be coated on a ground which is too absorbent. It can also be applied to drawings as a fixative. 1 part of shellac – white or brown – should be added a little at a time to a bottle filled with 7 parts of alcohol. The bottle should then be shaken until all the shellac is dissolved.*

Above **Damar varn...h** *A varnish diluent, which does not turn cloudy or yellow as it ages, is made from 1 part by measure of crushed damar resin and 4 parts of turpentine. The resin should be wrapped in muslin and tied with cotton so that it can be* suspended in a pot filled with the turpentine. *The resin will gradually dissolve into the turpentine over a period of two or three days. To hasten the process the mulin bag can occasionally be agitated gently. The muslin will strain out impurities.*

practice; the artist should increase the percentage of oil in the mixture as the painting progresses in order to prevent the lower layers sucking the oil out of the upper layers and leaving them so lean that they crack through oil starvation.

The main disadvantage with a simple oil and turpentine medium is that the paint takes a long time to dry. Also when colours are thinned for glazing, so much medium has to be added that the colours are liable to drip down the canvas. Media which contain varnish, stand oil, or—best of all—beeswax, help to overcome these problems.

Varnish media A simple varnish medium can be made from copal varnish, linseed oil and turpentine (see illustrations).

A very clear medium, suitable for thinning paint for glazes, can be made by mixing damar varnish, genuine and Venice turpentine, and stand oil (see illustration).

Stand oil mixed in the right proportions with Venice turpentine (see illustration) makes a thick, resinous varnish medium that adds exceptional brilliance to glazes.

Beeswax medium A mixture of beeswax and turpentine (see illustration) dries slowly with a matt finish, and works well on absorbent grounds.

Beeswax and oil medium Rubens used a medium made up of linseed oil, beeswax and litharge (see illustration). This is a dark medium which discolours all pigments mixed with it. However, it is extremely versatile; thick paint for impasto or thin paint for glazing can be mixed with it, and many artists feel that this flexibility compensates for its disadvantages.

Synthetic resin media Most artists' colourmen market a synthetic "gel" medium. These are usually some form of oil modified synthetic resin and are supplied in tubes. They are quite safe to use when applied thickly.

Maroger's medium This can be bought ready-made and is an emulsion of boiled linseed oil, mastic varnish, gum arabic and water. It is a pleasing medium which has stood the test of time.

Diluents It is often necessary to thin oil paints when painting—especially for glazing—and this is usually done by adding a spirit or a varnish to the painting medium. The most commonly used and safest diluent is turpentine. Other diluents, which have special qualities, are all types of varnish and many of them contain turpentine.

Turpentine Real turpentine is made by distilling the resinous gum obtained from pine trees. The purest form for artists' use is double distilled or "rectified" turpentine; all artists' suppliers sell this, but good quality turpentine can be bought more cheaply in larger quantities from decorators' suppliers or do-it-yourself stores.

Venice turpentine This derives from larch trees and is thicker and more resinous than ordinary turpentine. It also has less tendency to discolour the paint.

Varnishes Varnishes can be made by dissolving a resin either in an essential oil such as turpentine, or in an oil such as linseed. The first group are called soft resin varnishes and the second group hard resin varnishes.

Mastic varnish This is useful as a thinner, but it has a tendency to bloom and yellow. It can be made by dissolving mastic resin in turpentine.

Damar varnish This does not bloom or yellow like mastic, and it is easily made by dissolving 1 part crushed damar resin and 4 parts pure turpentine (see illustrations).

Shellac varnish This is simple to make (see illustrations) and can be used as a coating for a ground which proves to be too absorbent; it can also serve as a fixative for drawings.

Alkyd paints Winsor and Newton have recently introduced a range of alkyd paints for artists. These are like oil paints insofar as they can be thinned with turpentine and mixed with oil media. They have a synthetic resin base and dry considerably faster than oil paints, reaching the touch dry stage in 18 hours. As yet these paints have shown no signs of the cracking so common with oil paint. Only time will reveal their true permanence.

Left **Beeswax medium**
Turpentine mixed with beeswax dries slowly to a matt finish. 1 part by measure of white beeswax should be broken into small pieces and dropped slowly into 3 parts of turpentine which has been warmed in a double boiler. The mixture should be stirred until all the beeswax has dissolved. When the medium has cooled, it should be poured into a wide-necked jar.

Above **Beeswax and oil medium** *This is a thick, resinous medium which can be used with thick or thin paint. 10 parts of raw linseed oil, 2 parts of beeswax and $\frac{1}{16}$ part of litharge are needed. The litharge is poisonous; it is best to begin by mixing it with a little oil. Pour the rest of the oil into a large metal container and place it on a low heat outdoors or in a fume cupboard. When it is warm add the litharge and the beeswax broken into small pieces. Heat to 250°C and stir frequently until the mixture appears black, and brown fumes rise. Allow to cool a little, and pour into containers. Wait until the liquid has set like wax before covering it.*

Equipment

Brushes It is very important to have a good selection of quality brushes. Oil painting brushes should be either white hogs' hair or red sable hair. When brushes of good quality are made, the painting ends are never trimmed back or cut; any adjustment is made at the ends which are clamped in the metal furrule. The painting ends are shaped by the brushmaker, who shuffles and blends the individual hairs or bristles.

The best oil brushes are made of bleached hogs' bristles. Unlike sable hair, bristle has a split end, which plays a vital part in holding the paint to the brush. Some bristles are curved and it is part of the maker's skill to lay them in the ferrule with the ends curving inwards to avoid spreading.

Sable brushes give a smoother, softer stroke than bristle brushes and there is a place for them in every oil painter's collection.

The three basic shapes of brush are called "bright", "round" and "filbert". Other shapes are useful for specific purposes.

Brights These are short bristled with squared ends, and are excellent for applying thick, creamy pigments.

Rounds As the name implies, these are round-ended; small sable rounds will actually form a fine point. Rounds are used mainly for touching in small areas, for fine detailing and for applying heavily thinned paint.

Filberts Broader than rounds, these curve gently towards a point at the top. They are useful for strong, tapering strokes.

Flats These are similar in shape to brights, but the bristles are considerably longer. This means that they hold more paint, and from the heel—the part of the brush near the ferrule that lays on the canvas with normal pressure—to the tip give a longer stroke. They are ideal for bold, *alla prima* styles of painting.

Chisel-edges These are wedge-shaped or bevelled. They are not very common nowadays, but are good for painting straight edges.

Badger blenders Made with badger hair, these are shaped like an old, well-used shaving brush, opening outwards at the end. Their sole job is to blend areas of wet colour into one another.

Fan brush These are like badger blenders, but are made of red sable. They are also used for tapping over areas of wet paint, but give a more subtle, gentle effect.

Cleaning brushes Good brushes are expensive and should be well looked after. All brushes ought to be cleaned after use, or at least at the end of each day's painting.

It is not good for a brush to be left for any length of time soaking in a jar of solvent. Surplus paint should be removed by working the brush in turpentine or white spirit.

Brushes that have been left for a time caked with paint can be cleaned with a paint stripper, but if this is done too often, it will gradually destroy the brush.

Palette knives These are essential for mixing paints and scraping palettes clean. They can also be used

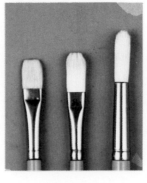

Left **Oil brush shapes** The three basic shapes, (from top) bright, filbert and round, are used in most styles of oil painting. All three can be applied in many ways; brights are good for covering large areas, filberts for shaped tapering marks, and rounds for details.
Below **Brush sizes** An adequate collection of brushes will include each of the shapes (left) in three or four sizes.

Most ranges start at 1, the smallest, and go up to 12. Extra large brushes are available, numbered up to 36.

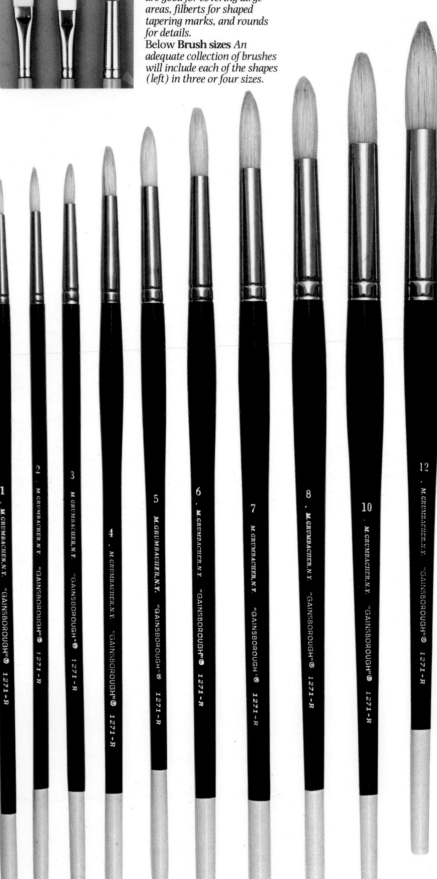

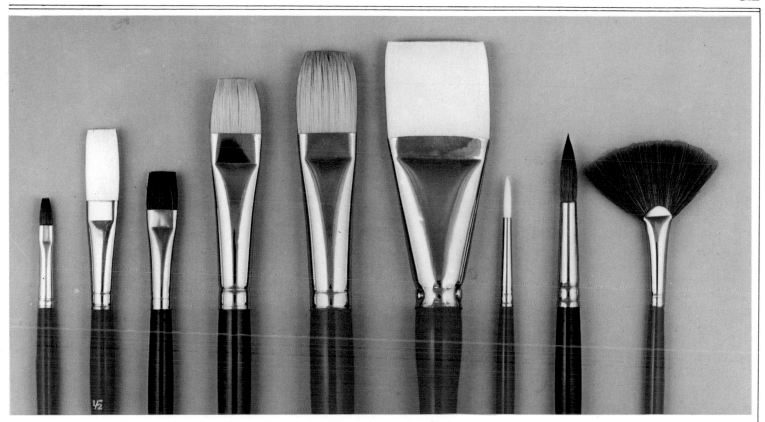

Above Types of oil brush *The best oil brushes are either hog's hair or sable, but many materials are used: (from left) red sable bright; synthetic flat; Russian sable bright; hog's hair filbert; synthetic bright; synthetic round; red sable round; red sable fan blender.*

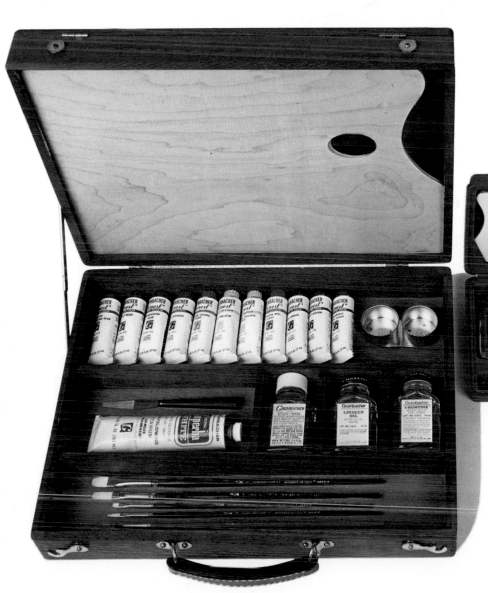

Oil painting sets *The equipment for oil painting can be carried in any container from a shopping bag to a suitcase – Stanley Spencer used a pram. A box ready-filled with equipment is a reasonable starting point for beginners, although to choose colours and brushes is more instantly involving. Oil painting sets come in many sizes.*

for building impastos and for scraping paint off the support. They come in many shapes and sizes; the choice is a matter for the individual artist.

Painting knives Paint can be applied directly on to the canvas with a knife. Palette knives can be used, but special painting knives are also made for this purpose. They have delicate blades which come in a variety of shapes.

Palettes Kidney-shaped wooden palettes with thumb holes are useful for working on a large canvas at an easel. For general indoor use any non-absorbent surface—a sheet of glass, metal, smooth wood, plastic or marble—will do.

Before they are used for the first time all wooden palettes should be treated for a few days with linseed oil so that the fibres are well saturated. Otherwise the wood will suck oil from the paint, causing it to dry out too quickly on the palette.

It is not essential to work on a spotlessly clean palette, and some painters like their palettes well-worn. But old paint which has dried can soak up some of the stickiness from newly mixed paint and lead to lack of adhesion on the canvas.

Paper palettes are useful for those who like a clean palette, but dislike the labour of cleaning it.

Cleaning a brush 1. *Immerse brush in turps, work it about and wipe on a rag.*

2. *Scrub brush on soap under running water. Work on the palm and rinse.*

Dippers These are small open cans designed to clip on the edge of the palette to hold oil and turpentine. Artists who do not work with a thumbhole palette in one hand, can use small plastic containers for the same purpose.

Mahl sticks A mahl stick is a long cane with a pad at the end, which is rested on the canvas to steady the painting arm (see illustration). These can be bought ready-made, but are easy to make with a garden cane and a bundle of rags.

Easels A vast array of easels is available, the main differences being in size and weight. These range from heavy easels with adjustable heights and cranks to tilt a five foot canvas backwards and forwards, to lightweight aluminium easels that are both collapsible and portable. Radial easels are collapsible, sturdy and versatile. The individual must assess his needs and the space available.

Painters with large studios might consider the traditional artists' donkey, an easel which incorporates a seat so that the artist can sit down with the canvas right in front of him.

For outdoor painting, a combination easel and sketch box that folds up like a brief case, is available at a reasonable price.

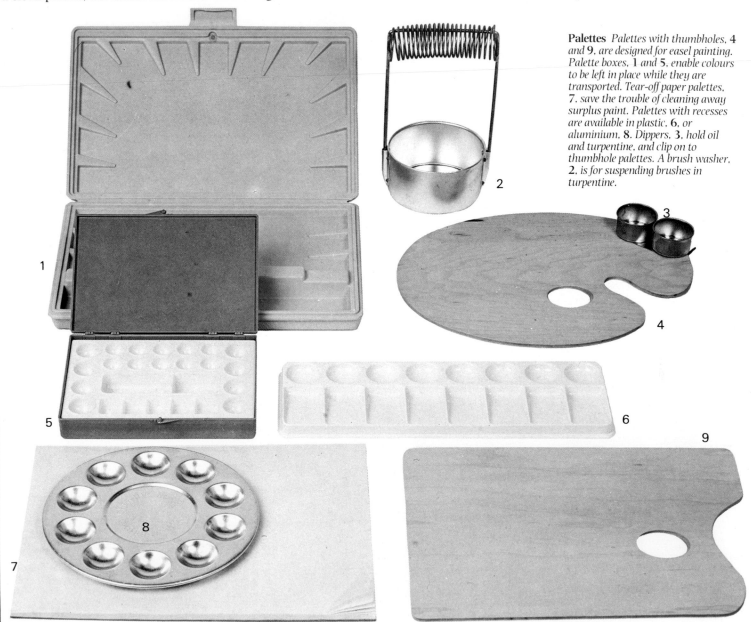

Palettes *Palettes with thumbholes, 4 and 9, are designed for easel painting. Palette boxes, 1 and 5, enable colours to be left in place while they are transported. Tear-off paper palettes, 7, save the trouble of cleaning away surplus paint. Palettes with recesses are available in plastic, 6, or aluminium, 8. Dippers, 3, hold oil and turpentine, and clip on to thumbhole palettes. A brush washer, 2, is for suspending brushes in turpentine.*

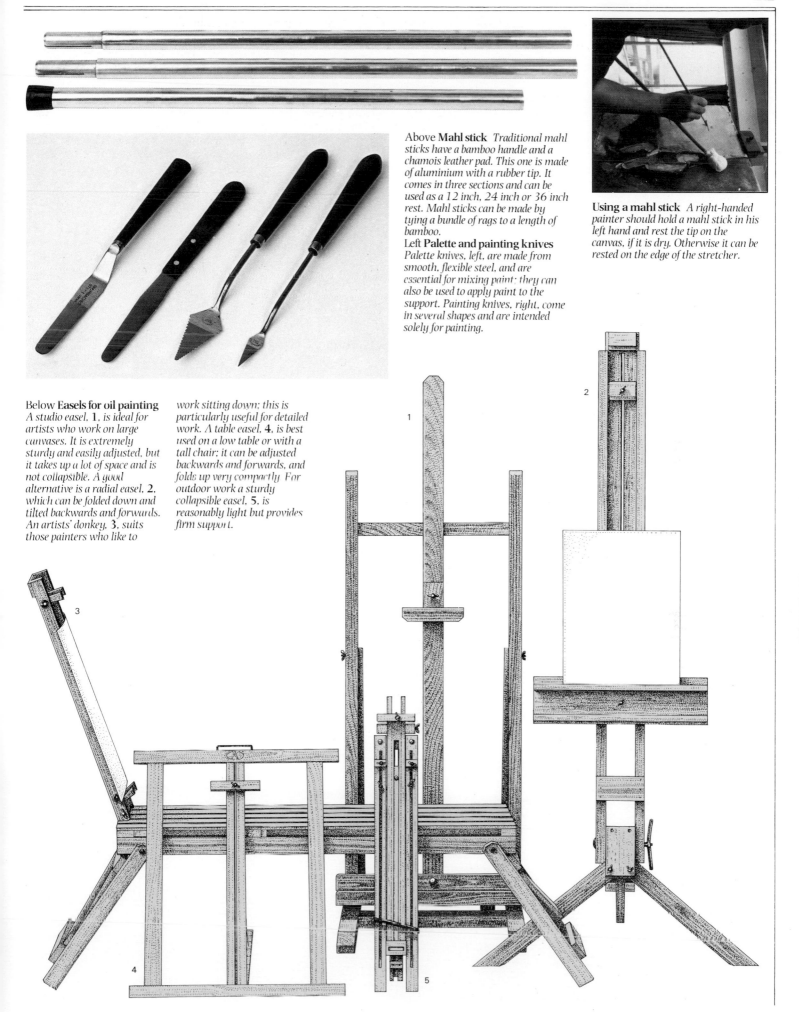

Above **Mahl stick** *Traditional mahl sticks have a bamboo handle and a chamois leather pad. This one is made of aluminium with a rubber tip. It comes in three sections and can be used as a 12 inch, 24 inch or 36 inch rest. Mahl sticks can be made by tying a bundle of rags to a length of bamboo.*

Left **Palette and painting knives** *Palette knives, left, are made from smooth, flexible steel, and are essential for mixing paint; they can also be used to apply paint to the support. Painting knives, right, come in several shapes and are intended solely for painting.*

Using a mahl stick *A right-handed painter should hold a mahl stick in his left hand and rest the tip on the canvas, if it is dry. Otherwise it can be rested on the edge of the stretcher.*

Below **Easels for oil painting**
A studio easel, 1, is ideal for artists who work on large canvases. It is extremely sturdy and easily adjusted, but it takes up a lot of space and is not collapsible. A good alternative is a radial easel, 2, which can be folded down and tilted backwards and forwards. An artists' donkey, 3, suits those painters who like to work sitting down; this is particularly useful for detailed work. A table easel, 4, is best used on a low table or with a tall chair; it can be adjusted backwards and forwards, and folds up very compactly. For outdoor work a sturdy collapsible easel, 5, is reasonably light but provides firm support.

Techniques

Every artist develops a style of painting which satisfies his own particular needs, whether they be the glass-like surface quality of a van Eyck, or the encrusted rock-like finish of an Auerbach (born 1931). Nonetheless, knowledge and skill are required to ensure that the paint surface does not crack, change colour or in any way deteriorate over the years.

Contemporary oil painters are lucky in that the trials and errors of earlier painters have enabled the formulation of a loose set of rules, which can ensure that a painting is technically sound. Within the broad limitations set by these rules a number of different ways of applying paint to obtain particular effects have developed and become commonplace, but it is worth remembering that the best painters evolve their own personal styles.

At a fundamental level there are two types of oil painting: the carefully conceived works which are built up painstakingly with many layers of paint applied over a period of time, which in some instances runs into years; and direct, or *alla prima*, painting which is usually completed in a single session using opaque colours which obscure any underpainting, if indeed any was done.

Alla prima Almost all painters who make landscape sketches use *alla prima*. The beautiful, loose studies of landscape formations made by Constable

Right **Jakob van Oost:
Portrait of a boy** *The artist
obviously worked with great
care and forethought over a
long period of time. Very thin
paint was used with a rich
resinous medium, enabling the
artist to lay a series of delicate
glazes.*
Below **Vincent van Gogh:
Bedroom at Arles** *An alla
prima painting almost
certainly completed in one
sitting, reflecting intense
momentary inspiration. The
heavy fluid brushwork
transforms a mundane
interior into a painting of great
excitement.*

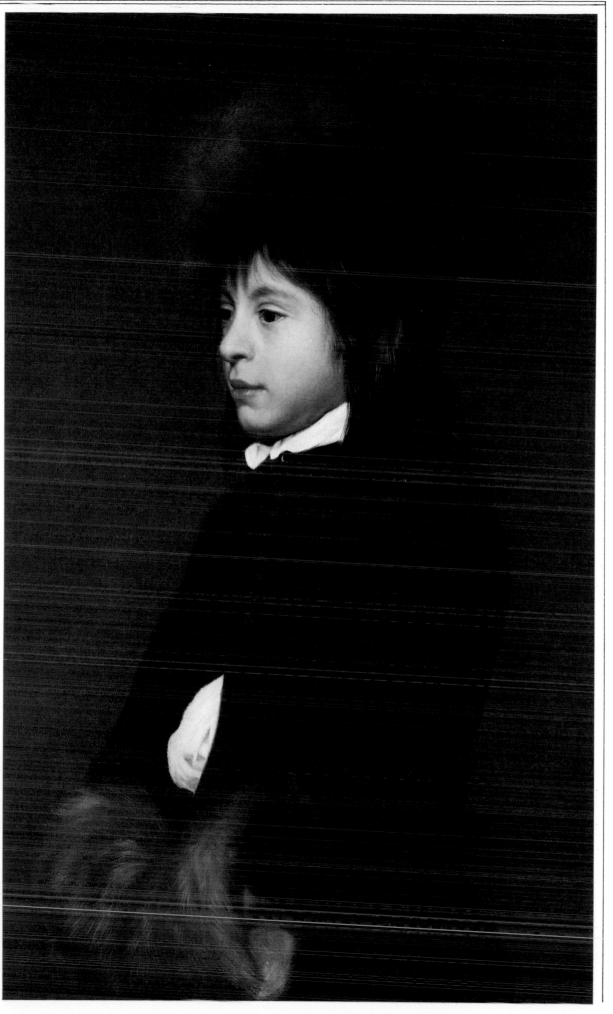

(1776–1837) show the advantages of this technique. The paintwork is freely applied and exciting, and the freshness of colour is often more expressive of the captured moment than many of his carefully worked studio paintings.

The ability to apply paint quickly and confidently is the key to this approach. *Alla prima* was exploited very effectively by the Impressionists, and perhaps the greatest exponent of the technique was Van Gogh. He would take his canvas to his subject, frequently outdoors, and in most cases complete the painting in one session, creating a mass of brush strokes and hastily laid impastos.

Planning a painting The more considered approach to oil painting has a much longer history. Many artists including van Eyck, Poussin (1593/4–1665), Rubens and even Turner (1775–1851) began many of their paintings by sketching the basic design. Outlines can be laid on the ground with charcoal (see illustrations), or lead pencil, and these can be painted over with opaque paint, or washed with an initial thin glaze, in the manner of van Eyck, so that the marks show through to be covered later. Turner sometimes drew in his subjects' outlines with thin opaque brush strokes, which were later painted over.

Squaring up (see illustrations) is a simple way of transferring on to canvas a design drawn on paper or some other surface.

Underpainting Whether a design has been drawn or not, underpainting (see illustrations) can be used to lay some fundamental colours and tones,

Staining a white ground 1. *Mix paint darker than required and add turpentine to make it very thin.*

2. Brush the paint on liberally so that the white is completely covered.

3. Use a dry rag to wipe over the whole canvas. Let the rag soak up paint until the desired tone is reached.

Squaring up 1. *Use pencil and ruler to draw a light grid over the drawing. In this case each square measures 2 inches.*

2. Draw a grid of appropriate proportions on the canvas with charcoal. This drawing is being enlarged by 50 per cent; each division is 3 inches.

3. Fix the squared-up drawing in a convenient position alongside the canvas. A stick can be fixed to the easel and the drawing stuck to it with tape.

4. Transfer the basic outlines square by square. Then fill in form and tone.

Underdrawing with charcoal 1. *Sketch in the fundamental shapes. Work freely and make corrections alongside the mistakes.*

2. Dust the charcoal down with a dry cloth. This removes loose particles and makes the black less dense, so that the paint can cover it.

Underpainting 1. *Mix paint with turpentine and oil to a very thin consistency. Neutral colours are commonly used.*

2. Keeping the paint very thin, lay in the basic shapes and areas of tone.

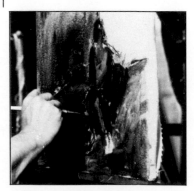

3. When the large areas have been laid, use a smaller brush to establish more detailed shapes.

Glazing 1. *Paint for glazing should be mixed with a medium, and not with turpentine. The oil content of the paint must increase as each layer is applied.*

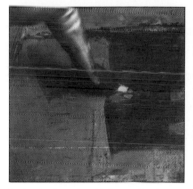

2. *Apply the paint thinly, so that it forms a transparent film allowing the colour underneath to glow through.*

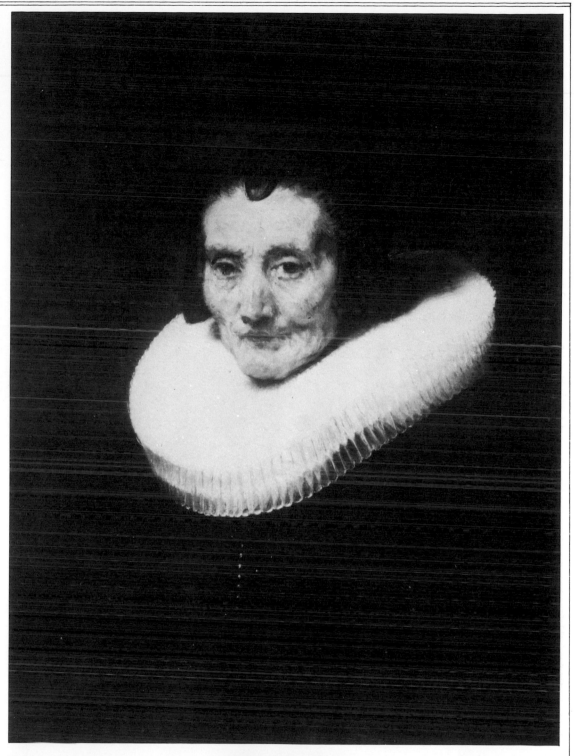

Right **Rembrandt van Rijn: Portrait of Margaretha de Greet (detail)** *Glazing was crucial to Rembrandt's technique. He would underpaint in whites and greys – sometimes laying thick white impastos – and lay thin delicate glazes over the top. He also laid dark tones for the shadow areas and glazed over these. The result is a rich translucence which heightens shape and form.*

Right **Brushmarks** *All brushes can be used in several ways to produce a variety of marks. Just the tip of any brush can be applied to the support with a stabbing motion to produce patches of texture. The dry brush technique, where the hairs are fanned slightly apart to drag dry paint across the surface, can be performed with all brushes. Paint can be laid on with a circular scrubbing motion to produce a form of scumble. When used with wet paint to make simple strokes, the different brush shapes produce characteristic marks: (from left) sable round; hog's hair bright; hog's hair filbert.*

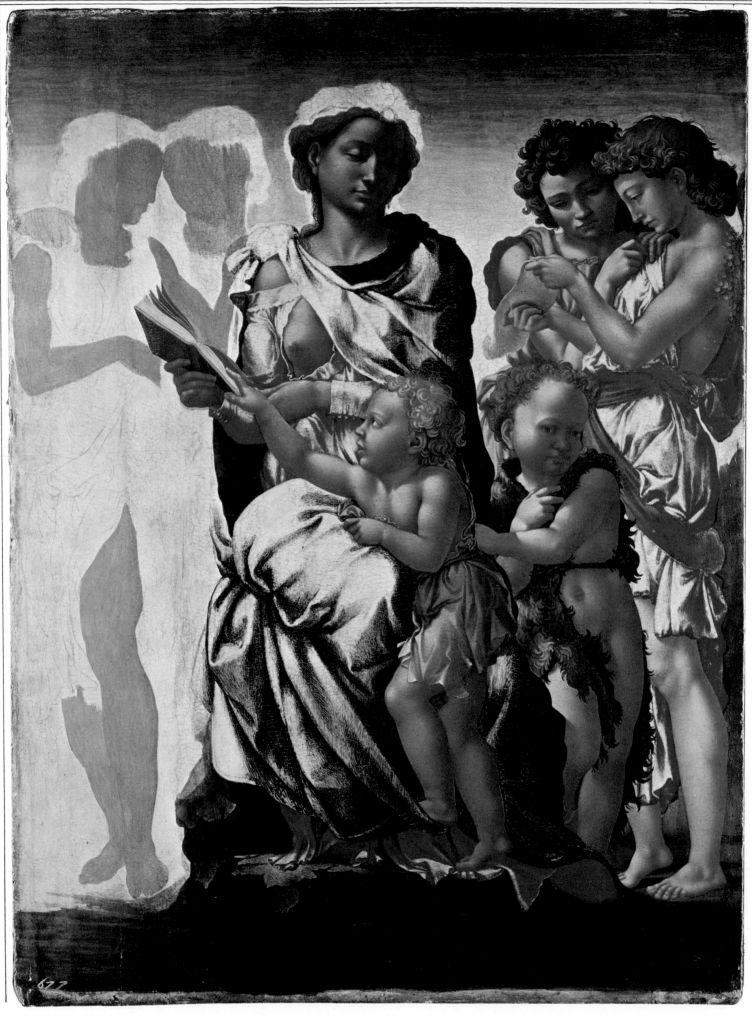

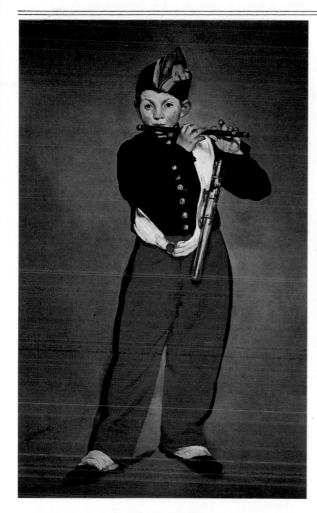

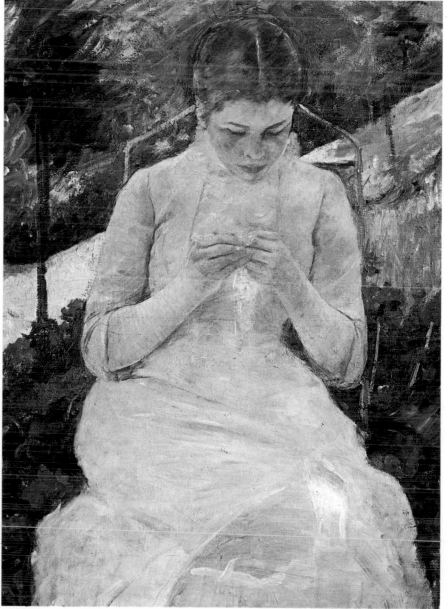

Left **Michelangelo Buonarroti: Madonna and child with St John** *Probably painted on a gesso ground, this unfinished work shows the techniques of considered oil painting as practised by a master. The areas of flesh on the right are underpainted in terre verte to provide a neutral mid-tone into which both shadows and highlights could be painted. The modelling of the folds of the madonna's cloak has been established in the underpainting.*

Top left **Edouard Manet: The Fifer** *The modelling has been brushed into the flat areas of colour using the wet into wet technique. The impasto on the sash and spats*

provide a contrast.

Top right **J. M. W. Turner: Dido building Carthage (detail)** *The remarkable luminosity was achieved by overlaying opaque underpainting with numerous, coloured glazes.*

Above **Graham Sutherland: Landscape orange and blue (detail)** *Thin oil paint can be effective when it is used forcefully. Here, the vibrancy is enhanced by the brushmarks.*

Right **Mary Cassatt: Young woman sewing** *Here, there is delicate brushwork and a subtle, controlled use of colour. Over most of the painting, brushstrokes are imperceptible; where they appear they have a purpose.*

which can be worked up later with glazes and layers of opaque paint. At this early stage in a painting it is a good idea to use few colours and to thin the paint with diluent and a little oil or medium; it is usually best to use large brushes.

Many painters underpaint in just one colour; Rembrandt and a whole school of artists that followed him, the *grisailles* painters, used grey. Others like to stain the ground with a thin wash of colour (see illustrations) before underpainting.

Glazing Oil paint is an ideal medium for laying thin transparent skins of paint, or glazes (see illustrations). These can be painted over underpainting, areas of opaque paint or impastos. The effect is totally different from what would be achieved by mixing the two colours together. A depth and luminosity are produced by the light passing through the transparent glaze and reflecting back from the opaque colour underneath.

Glazes are usually laid over light colours—especially white or a neutral grey—because these reflect light most effectively. Beside such glazed passages, opaque paint appears to recede, thereby giving the painting a three-dimensional quality.

Paint for glazing must be heavily thinned with an appropriate medium, preferably one containing beeswax. Linseed oil should not, ideally, be used for glazes, because it tends to move about after it has been laid.

The brilliant red draperies painted by Titian and El Greco (1541–1614) are the result of glazing crimson lake over underpaint. Rembrandt glazed over heavy off-white impastos to give his light areas a jewel-like brilliance which shone out of the deep tonal areas—themselves also glazed, but over thin warm colours.

Turner was perhaps the greatest exponent of glazing. He usually began a painting by laying on a turpentine-diluted wash of colour over a white ground. Into this he drew the main outlines of his subject with a neutral colour, such as burnt ochre or burnt sienna. The light masses of his subject were then built up as impastos of lead white, and almost all the rest of the painting was completed in glazes of colour, probably with a resin oil medium.

Impasto Thick paint applied heavily with a brush or knife is called impasto. This technique is often used to create texture and to give a painting a three-dimensional quality. Some painters, such as de Stael (1914–55) have built whole paintings

entirely out of impasto. However, one of the major uses of the technique is as underpainting for glazing. Light impastos—especially whites and greys—are frequently used in this way. Titian and Rembrandt are both known to have built impastos with a palette knife for this purpose.

Scumbling A scumble is opaque paint laid over another opaque layer of a darker colour or tone in an irregular way, so that some of the lower layer shows through. Scumbles are traditionally applied by using a circular motion with the brush (see illustrations), but the effect can be achieved with streaks, dabs, smudges, stipples or with any combination of marks that does not form a flat skin of paint.

Scumbles can be applied with any kind of brush; some artists use a blender or fan, placing the canvas flat on a table and dabbing the paint on with the brush held perpendicular. Others scumble with a rag, or even with their fingers, wiping off excess

Applying impasto 1. *Mix paint and medium with a palette knife. It is best to use a resinous medium (foreground, right); otherwise an oil medium can be added sparingly.*

2. Impasto can be applied with a palette knife. Scoop up some paint and lay it on the support. Spread it and shape it with the knife.

Impasto with a brush *Charge the brush with thick paint; spread and shape the impasto. Remember that the brushmarks will form part of the composition.*

Scumbling *Thin or fairly thick dry paint can be used. Apply it with dabbing strokes or a scrubbing motion.*

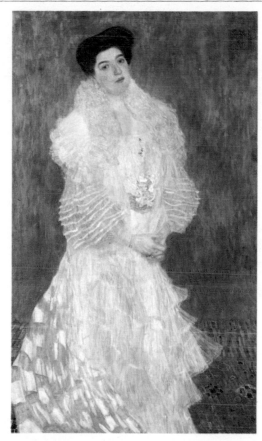

Left **Berthe Morisot: The cornfield** *Loose, fluid brushwork, with much use of the wet into wet technique, enabled the different planes to be established with alternate areas of horizontal and vertical brushstrokes.*

Below **George Seurat: An afternoon at La Grande Jatte** *Seurat laid on oil paint by stippling – applying dots and short dabbing strokes. He did this to produce an optical effect, which he believed would convey the colours of nature more exactly than other methods of applying colour. Instead of mixing primary colours on the palette to form secondary colours, Seurat laid blobs of primary colours next to one another and relied on the viewer's eye to do the mixing. The technique, which came to be known as pointillism, is very effective provided the painting is viewed from an appropriate distance.*

Left and above (detail) **Gustav Klimt: Portrait of Hermione Gallia** *Klimt mixed his colours very exactly, and then thinned the paint to give a surface flecked with loose brush marks. The brooch forms a complete contrast; it is treated almost as a sculptural feature, being modelled with impasto half an inch thick.*

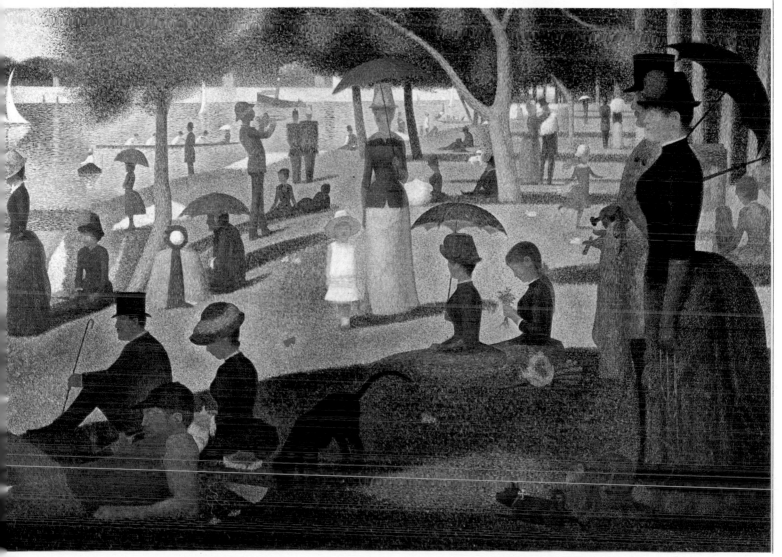

paint as they work.

Wet into wet Monet, Sisley and many other Impressionists overpainted or scumbled while the layer underneath was still wet and sometimes tried to make colours run into each other. This is a feature of much *alla prima* painting. Colours for wet into wet painting should be mixed with the same medium.

Frottage Passages of rich irregular texture can be created by the frottage technique, which was pioneered by Max Ernst (1891–1976). A patch of flat opaque colour is laid on the canvas and then covered with a non-absorbent surface, such as high gloss paper. The paper is rubbed over and then carefully removed (see illustrations).

Varnishing a finished painting. It is not essential to varnish oil paintings; unvarnished paintings will not suffer unduly if they are hung or stored in reasonable conditions. Varnish has the disadvantage that it tends to yellow with age, but it does give paintings protection from impurities in the air and it heightens the brilliance of colour. It is a good idea to varnish paintings containing thick impastos which are liable to sink.

Most paintings should be varnished between three and six months after completion, by which time the paint will have dried sufficiently, and contraction and expansion will have all but ceased. Thickly laid paint may require more than six months drying time.

It is best to use a soft resin spirit varnish, such as damar or mastic, if a glossy surface is required; or a wax varnish, if a semi-matt finish is needed.

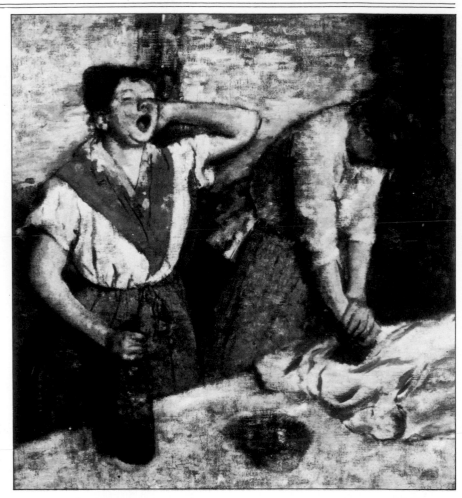

Painting wet into wet 1. *Lay a patch of colour. Before it dries, lay another colour on top and alongside.*

2. The wet colours blend into each other, but streaks of unmixed colour remain. They can be blended further with a brush.

3. If an even gradual blend is required, the brush can be charged with turpentine and drawn across the paint.

Blending with a fan 1. *Fan-shaped brushes, made with sable hair, are designed for blending wet paint. Lay patches of wet paint.*

2. Use the fan to blend the colours. Broad curving brushmarks can be created if required.

Frottage with flat paper 1. *Lay a patch of colour, using rich paint thinned with oil and turpentine.*

2. Place a sheet of non-absorbent paper over the paint. Press it gently into the paint, and then peel it away.

3. To alter the texture, the paper can be replaced, and moved about or rubbed. Predictable results are only achieved with practice.

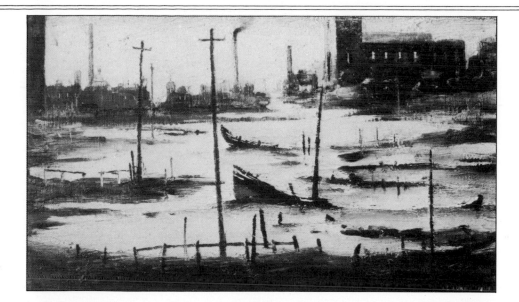

Left **Edgar Degas: Women ironing (detail)** *Here, Degas stained the ground and allowed it to show through his loose, dry brushwork. Light and shade are firmly delineated with dark lines; tones are achieved with well controlled scumbles.*

Above right **L. S. Lowry: Seascape** *The entire painting was created with impastos laid with a brush. The water is depicted with thick white paint; the ground does not show through. Thick wet colour was skilfully blended with the white, while all was still wet.*

Below right **David Hockney: We two boys together clinging** *In this early Hockney, oil paint was applied to board. Areas of thick and thin paint are juxtaposed and overlaid. The composition depends heavily on the line work.*

Frottage with crumpled paper 1. *Crumple a sheet of paper into a ball. Unfold it a little and press into a patch of wet paint.*

2. Carefully pull the paper away. A series of irregular marks will have formed.

Varnishing a finished painting *It is not strictly necessary to varnish an oil painting, but it is worth doing if thick paint is beginning to sink. Varnish heightens the brilliance of oil colours, but is liable to yellow with time. Hold the brush flat against the support and apply the varnish as thinly as possible without brushmarks. Work the brush in all directions, and stop as soon as there are no brushmarks evident.*

Chapter Four
Acrylics

Any paint made from pigment bound in a synthetic resin is commonly known as an acrylic. This term is normally used by artists irrespective of whether the resin employed is actually an acrylic or, for example, a polyvinyl acetate (PVA).

The development of acrylic paint as an art medium came about as the result of a pressing social need. In the 1920s a group of painters in Latin America, mainly in Mexico, and notably Orozco (1883–1949), Siquieros (1896–1974) and Rivera (1886–1957) wanted to paint large murals for public buildings, some of them on exterior walls exposed to the open air. They found that oil paint was unsuitable because it would not last long in such conditions, and they therefore experimented with fresco, but this also proved impractical.

They needed a paint which would both dry quickly, and remain stable in changing climatic conditions. In fact they needed something which had already existed for some time in the industrial field, but had never been developed as a vehicle for pigments, namely plastic resins. Moulded plastic was being used for domestic utensils, and perspex, or plexiglas, was a substitute for glass in trains and aircraft. Plastic in liquid form had been used as an anti-corrosive agent.

Commercial laboratory research for a range of artists' colours began, and it is important to realize that this had to centre on the development of an appropriate medium. With certain variations the pigments remain the same; what is new is the use of polymerized media which bind them. The word polymer refers to the linking of identical small molecules to form a larger molecule, thus giving greater strength to any substance made by combining such molecules. The two synthetic resins which have been developed by this polymerizing process and adapted to make artists' colours are acrylic and polyvinyl acetate (PVA).

Acrylic resins are made from acrylic and metacrylic acids. With suitable additions they make a medium soluble in water, so that pigment bound in acrylic can be thinned with more medium, with water, or with a mixture of both, according to the surface finish required. Of primary importance is the fact that acrylic paint dries as fast as water evaporates and once this happens—and it is only a matter of minutes—no further chemical action takes place. This means that the artist can add more paint to a surface that is completely sealed; any glazing or over-painting is perfectly safe.

At the same time the chemical structure gives the layers a porosity which allows complete evaporation. Research indicates that the paint is resistant to oxidizing and chemical decomposition. It is also a strong adhesive, each layer of paint gluing itself to the one underneath and forming strata that are almost indestructible.

In the mid 1930s the Siquieros Workshop in

Right **David Hockney: Mr and Mrs Clarke and Percy** *Here, Hockney used Liquitex paint, which gives a flat, even surface with a lot of body. The paint is laid in a tightly controlled way, except on the walls and the view through the window, where it is applied slightly more freely. The* *flowers have a transparency which is best achieved with acrylics. Hockney has said: "The great way to paint with acrylics is the very old fashioned method of glazing with washes which you can do with acrylics of course, marvellously".*

Right **Bridget Riley: Interpretation of Seurat's colour wheel** *Here a hard edge effect has been achieved with masking tape. The colours have been diluted with water and applied with soft brushes to obtain a smooth surface.*
Far right **Leonard Rosoman: Girl lying in a hammock** *Painted on a primed wooden panel, this work is built up entirely with layers of thin paint. The background colour was put in first and covered the whole panel; the remainder was drawn and painted over it. The masses have a great luminosity produced by glazes of bright colours glowing through each other, a method which works especially well with acrylics.*

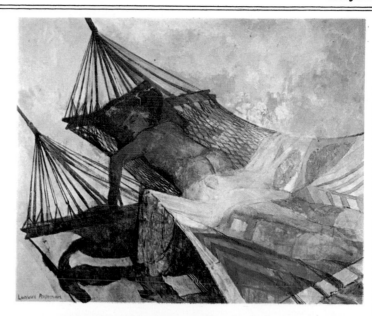

New York was experimenting with new formulae, and a close relationship was set up between artists and scientists. Many interesting murals and paintings were carried out, including some for the WPA (Works Progress Administration) project. But this was just a beginning.

Experiments continued in the United States and painters began to realize that the possibilities of the new media went far beyond the needs of exterior murals. Laboratory tests were so successful that it seemed likely that the scientists had come up with something that was very nearly stable. In 1945 another workshop, the National Polytechnic Institute, was started in Mexico City; established artists and students worked with acrylics and some interesting murals were painted on the walls of the Institute itself.

In the 1950s acrylics were on the market in the United States and they played an important part in the techniques of artists like Pollock (1912–56), Noland (born 1929), Rothko (1903–70) and Motherwell (born 1913). These painters applied their colours in very different ways. Pollock used a wild variety of glazes and impasto, sometimes placing the canvas on the floor and pouring on the paint. Noland builds up even areas of colour with a clean hard edge, while Rothko stained enormous panels with thin, transparent washes. Motherwell also works horizontally, but mainly using a full, direct brushwork, with strong gestural qualities. The development of acrylics in Britain came much later. A good deal of research went on during the 1950s and a number of painters including Michael Ayrton (1921–76), Peter Blake (born 1932), Josef Herman (born 1911), Bridget Riley (born 1931), Leonard Rosoman (born 1912) and others were asked to test the new material. This they did over a number of years. Some of the experiments took the form of charts: making simple squares of different colours, comparing them with each other, noting drying speeds, changes in colour from wet to dry state and so on.

Researching, testing and experimenting are slow processes and it was not until the mid 1960s that acrylics became available in Britain. Since then they have been used by innumerable British artists including David Hockney (born 1937).

By the late 1960s the other form of synthetic resinous paint, PVA, was also available. Both paints are emulsions and can be diluted with water or acrylic media. Both dry evenly and there is none of the sinking that occurs with oil paint, and therefore no tonal or colour changes. The paint is opaque, but can be diluted to any kind of transparency if the artist needs it. Normally both will dry quickly, but the rate of drying can be slowed with the addition of a retarder.

Above right and right (detail) **Leonard Rosoman: The Exterminator. New York** *Here, Rosoman's theme is violence and fear. The subtly textured areas that form the arch are applied with heavy washes of crimson and ultramarine. This contrast with the harsh, light room in the background, which is painted in medium-dark greys and ochres, and over painted in opaque off whites. The figures are carefully drawn in line with a fine water colour brush and flooded with thin and thick washes. The carpet is covered with hundreds of tiny hatched lines giving it a rich texture, different from any other part of the painting.*

Surfaces

Acrylics are compatible with a wide variety of surfaces, and are simpler to use in the initial stages of painting than any of the more traditional media. They can be applied to almost any absorbent support—canvas, wood, hardboard, strawboard, card or paper—without an isolating ground intervening between support and paint, though an acrylic primer can be, and normally is, employed.

There are two important exceptions: the synthetic resins, being water-suspended, will not take on an oil-based ground; grounds made with ordinary emulsion paint should also be avoided, since although water-thinned they may form a ground which is not chemically compatible with acrylics.

Canvas A variety of textures from a coarse hessian

to a finely woven flax are available, and all work well with acrylics. A coat of glue size—normal practice with oil paint—is not needed whether acrylic primer is to be applied or not. But if a hessian has a very open weave, it is as well to give it a coat of acrylic medium.

When stretching an unprimed canvas it is important to remember that the primer, or if primer is not used, the paint, will cause the material to contract, so a bit of slack should be allowed.

Paper and card Acrylics will take on almost any card, artboard or reasonably thick paper, and they again may be primed or not. Primer can be a little too heavy for paper; if the paint is not to be applied direct, a single coat of acrylic medium can be a good compromise.

It is best to stretch paper (see p.121) especially if it is lightweight; otherwise flooding the surface with big washes of colour will make it buckle.

Wood Wooden panels make very good grounds for acrylics. Natural woods, plywoods and block-boards can be used. Hardboard is a good ground but it should be battened at the back because it is liable to warp. If a smooth finish is required on hardboard, the smooth side should be used, but it is best to sandpaper it and apply primer.

Metal Metals have very smooth, non-absorbent surfaces and there is no grain or tooth to help the pigment to grip. With oil paint this is a problem because it is a bad adhesive, but acrylics have been used on metals—principally zinc and copper—very successfully. It is advisable to roughen the surface with a coarse sandpaper and apply primer.

Murals The painting of existing wall surfaces of plaster, concrete, stone or brick poses special problems and in their open-air context these are considered in Chapter 7, Exterior Painting (p.106). It may be said however, that acrylics stand up to acids, alkalis and damp in such supports to a remarkable extent, and indeed much better than oil paint; it has already been stated that this was the sort of problem which initiated the adaption of synthetic resins to artists' colours.

Acrylics are excellent for indoor murals painted on plaster because they dry to an even matt quality. Oil paint is less suitable for such a surface, because, though some colours dry matt, others dry to a gloss and reflect light. Also any impasto laid with oil on plaster will sink, changing very noticeably in colour and tone.

It is a good idea to sandpaper plaster smooth before applying primer or paint. Where a wall or panel is for some reason unsuitable as a ground, and therefore has to be covered with canvas, the flexibility of acrylics will stand up very well to the rolling and unrolling of canvas.

Applying primer Any absorbent surface which is unprimed will absorb the pigment and dry to an even matt finish. Primed surfaces will produce a slight egg-shell gloss, although this effect can be counteracted, if desired, by mixing the acrylic paint with water.

It is essential to use acrylic primer; ordinary primer will not bind with acrylic paint. Acrylic primer is simply acrylic medium mixed with inert Titanium white, but it is inexpensive to buy ready-made. Two or three thin coats should be used, each being allowed to dry before the next is applied.

**Left Leonard Rosoman:
Detail of Mural in the
Graduate School of Business
Studies, Sussex Place,
London** *In many ways acrylic
is the best medium for murals.
Unlike many oil colours, all
acrylic colours dry to a matt
finish which causes no
problems with reflections. The
quick-drying qualities of
acrylics minimize the dangers
of dirt and dust settling on the
paint, and acrylics can be
applied thinly to create an even
surface which is less likely to
accumulate dust over the
years. The paint can be washed
quite safely with soap and
water. For this mural a
detailed study was made in
acrylic gouache. This was
squared up, transferred to the
wall and drawn in a neutral
raw umber with a half inch
hog's hair brush. Large areas,
like the sky, were washed over
using three inch brushes;
stiffer paint was then added.
The mural is 10 feet high and
30 feet long; painting it took
about three months.*

**Left Terence Millington:
Sofa** *Here, acrylic paint was
applied in thin washes to
rough water colour paper. The
paint was allowed to dry, and
a dense film of tinted
polyurethane varnish, similar
in colour to burnt umber, was
laid over the top. The varnish
was then wiped back to give
the various brown tones.*

Paints

Artists using acrylics for the first time should experiment to discover which brand suits them best. There are subtle differences between certain brands of acrylics, just as there are between certain makes of oil colours. PVA colours are cheaper, but lack reliability and permanence. Rowney's Cryla, Winsor and Newton's acrylics, Liquitex and Aquatec are all made in extensive ranges of colours. The traditional names are there—Yellow ochre, Raw umber, Venetian red, Cobalt, Ultramarine and so on—but there are a number of strange new names like Naphthol crimson, Phthalocyanine green, Indanthrene blue and Dioxazine purple. The reason for this is that these pigments are the direct result of years of laboratory research and scientists have produced chemical formulae that are absolutely new. Liquitex has a particularly impressive list of new colours, and it is up to the individual artist to decide whether he wants to add these colours to his palette.

Of course, a large number of colours on the palette is not necessarily an advantage, whatever medium the artist is using. From twelve to fifteen colours provides an infinite variety of colour and tonal possibilities and a lot of painters use fewer colours than this.

Each painter eventually acquires his personal range of colours. The choice will reflect his personal vision over the years and it is interesting to imagine the state of Picasso's palette during his pink period compared with his blue period. The following is the palette used by Leonard Rosoman for some years: White; Lemon yellow; Yellow ochre; Raw sienna; Venetian red; Cadmium red; Deep violet; Coeruleum blue; Cobalt blue; Hookers green; Monastral green; Bright green; Raw umber;

Below Acrylic colours
Acrylic paints are made with the same pigments as oil and water colours. All the established colours are available as well as a considerable range of new synthetic pigments. It is best to settle on a small range of colours and use them consistently. The colours used by Leonard Rosoman are shown here; these are all reasonably permanent and can be mixed to produce an infinite variety of colours and tones.

Deep violet | Ultramarine | Cobalt blue | Cerulean blue | Monastral green

Hooker's green | Bright green | Lemon yellow | Cadmium red | Yellow ochre

Raw sienna | Venetian red | Raw umber | Mars black | White

73

Ultramarine; Black.

A certain amount of care must be taken of the caps on tubes of paint. Constant squeezing allows the paint to collect around the nozzle; this hardens and makes it difficult to replace the cap, air then gets inside the tube and turns the contents rock solid. Wiping the nozzle with a soft paint-rag will prevent this.

Media Standard acrylic paints dry to a semi-matt quality; when they are used without the addition of water the finish has a slight egg-shell quality. The various manufacturers make several types of acrylic media which are added to the paint on the palette to produce different finishes.

There are media which provide a gloss finish; others which enable the artist to get a matt finish without diluting the paint with water; and others— often called "glaze media"—which make the paint transparent.

Gouache and acrylics Rowney produce a range of gouache colours which can be mixed with an acrylic medium on the palette. These work well on stretched cartridge paper and there is a large range of colours. The major difference between this and conventional gouache is that layers of colour can be superimposed without picking up pigment from the layers underneath.

Equipment

Normally acrylics are applied with the same types of brushes and palette-knives as oil paints (see p.54). If acrylic is to be diluted and used on a small scale, water colour brushes (see p.128) are re-quired—sable is ideal.

Extra care has to be taken of brushes used for acrylics, because the paint dries very fast and will go rock hard in a very short time. As soon as an area of paint has been applied to the canvas, the brush must be washed in water very thoroughly, so that no pigment is left among the hairs. Warm water dissolves the paint more readily.

If the paint in a brush does go completely solid, the brush may be saved by soaking it in methylated spirits for at least twelve hours and then working the paint out between the fingers. It should then be washed in soap and water.

The palettes, easels and drawing boards used by oil painters (see p.56) and water colourists (see p.130) are perfectly suitable for acrylics. White plastic palettes are also available, a d dried acrylic paint can be removed from them a little more easily than from wood.

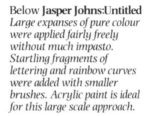

Below **Jasper Johns:Untitled**
Large expanses of pure colour were applied fairly freely without much impasto. Startling fragments of lettering and rainbow curves were added with smaller brushes. Acrylic paint is ideal for this large scale approach.

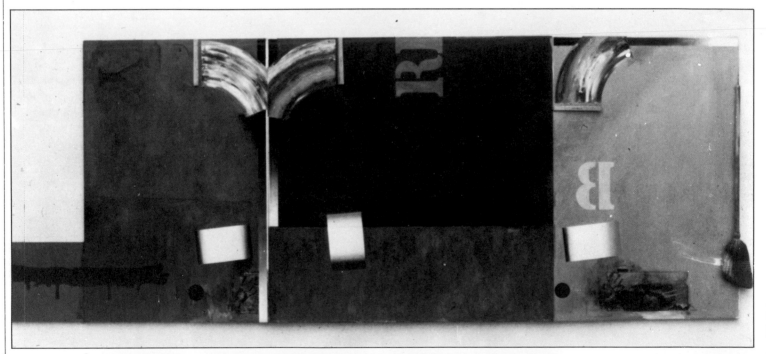

Mixing medium with one colour 1.
Squeeze some paint on to the palette and make a small depression in the middle. Drop in a small amount of medium.

2. Mix paint and medium with a brush or palette knife. The paint can be thinned further by adding water.

Mixing medium with two colours
1. Drop a small pool of medium on the palette. Squeeze out a little of each of the two colours.

2. Mix the colours together with a palette knife first. Scoop up some medium and work it into the paint.

Techniques

Before acrylics reached Britain, the architect Sir Basil Spence once commiserated with Leonard Rosoman—later one of the pioneers, and now a major exponent, of acrylics—because artists had never experienced the excitement of coping with a new medium as architects had. In the nineteenth century the introduction of cast iron had had a tremendous effect on architectural design, and new shapes and forms were created that were physically not possible before. Reinforced concrete made a similar impact later on. It is salutary to remember that until the appearance of plastic resins, artists had used the same materials for four hundred years.

Just as the introduction of oils all those years ago opened up a whole new range of possibilities to artists, now the different nature of acrylics has led to the exploration of new techniques, with the added advantage that the new medium is chemically safe and durable. When the colours first appeared artists were inclined to use them in the same way that they used existing media. However, acrylic colours have now been shown to have certain strong characteristics of their own and it is a waste to exploit them by simply imitating other media.

Acrylics have advantages and limitations, and it is up to the painter to decide whether he can use the one and respect the other. As a medium acrylics have nothing in common with oil paint; the substance and body of the colours are closer to water colour, gouache, and tempera. The Florentine tempera painters would have used acrylics, but not the Venetian oil painters like Titian (c.1487/90–1576) and Tintoretto (1518–94), who sought a glowing, shiny finish. There is a lightness and a delicacy in acrylics that invites dilution, either with water or acrylic medium.

Using the ground Acrylics lend themselves to a bonding of colours, applied separately one over the other, and this approach benefits from the ground on which the paint is laid; a white canvas can glow through a layer of Venetian red, for example, and give it a quality that can never be obtained by further overpainting with white. In this respect acrylics are very close to water colours. The paint's ability to appear transparent when mixed with water or acrylic medium is one of its major assets.

Glazing With acrylics, glazing—laying transparent layers of paint—is not only safe, but brings out one of the most attractive aspects of the medium. It is especially useful in the early stages of painting.

Acrylic paint for glazing can be mixed with water or with a glaze medium. The colour should be mixed with the water or medium on the palette with a wet brush or knife (see p.74). If the colour is to be strongly diluted with water, some gloss or matt medium should be added to maintain the binding properties of the paint.

Opaque colour Undiluted acrylic paint has a fairly stiff consistency, although this varies from colour to colour; only a few colours can be brushed out easily without dilution. Areas of opaque colour can be laid with undiluted paint in these cases, but

Applying layers of glazes 1. *Mix the paint with a palette knife. Dip a brush in water and work the paint to a thin consistency.*

2. *Brush the paint on to the canvas. If it is applied thinly, the ground will show through.*

3. *Allow a few minutes for the first layer to dry, then apply the second layer using another colour thinned to the same consistency.*

4. *There is virtually no limit to the number of glazes which can be superimposed. Opaque paint can of course be used to cover part of a glazed area.*

Laying flat colour without brushmarks. 1. *Pencil lines were drawn to reflect the paint's opacity. Apply a layer of paint and work it well into the canvas.*

2. *Rub over the paint with a dry rag, to work it into the weave and leave a flat surface free of brushmarks.*

3. *Allow to dry for a few minutes and apply a second coat. If necessary, this can be lighter or darker than the first coat. Allow this to dry.*

4. *Apply a third coat. The colour is now sufficiently opaque to obliterate the pencil lines. Lay the paint evenly and avoid brushmarks.*

usually the paint should be mixed with a little water or acrylic medium.

To achieve deep flat areas of colour, with little or no signs of brushwork—like the sky in Peter Blake's "Tarzan"—several coats of fairly solid paint can be applied. Opaque colour can be applied with brush or palette knife.

Rowney make a variation of their standard Cryla colours, called Flow Formula. This has a more liquid quality, brushes out more easily and is especially good for covering large areas with flat opaque colour. Another way of achieving a very even flat surface without brushmarks is to mix a "water tension breaker" into the pigment on the palette. Paint mixed in this way and Flow Formula are ideal for hard edge abstract painting; the straight edges can be obtained by sticking down masking tape and painting up to and over it.

Far left **Peter Blake: Tarzan** *The strength of this painting lies in the contrasting ways in which the paint has been laid. Strong, lively brushstrokes are evident in the painting of Tarzan's head, while a deep flat blue, devoid of tones or brushstrokes, depicts the sky.*

Left **Jackson Pollock: Painting**
Pollock worked with the canvas flat on the floor and either poured or threw on the paint. He would then work it with knives, pieces of wood, sponges and rags. He used thin and thick paints which dry at very different speeds. Acrylic paint will survive this sort of treatment better than any other.

Below **Tom Phillips: Benches**
Phillips worked from postcards to produce this painting which is concerned with mortality. Acrylic paint was used with a variety of techniques to reproduce the postcard images – stippling, hatching and dry brush are used extensively. The vertical and horizontal stripes of colour represent the colours used to paint each postcard image. The painting is almost nine feet long and four feet high, and is made up of three separate canvases. Nineteen Aqua-Tec colours were used, and almost all the paint was applied with long square signwriters' brushes.

A combination of glazes and opaque colour gives a painting an interesting surface with great variety of texture. With acrylics a glaze can be used to cover parts of an opaque area – or vice versa – with great ease because the paint dries so quickly.

Brush strokes A finish which makes deliberate use of brush strokes can be achieved with acrylics just as easily as with oils. The paint should be used undiluted or with just a little water or acrylic medium. In Peter Blake's "Tarzan" the giant's head reveals strong directional brush strokes which create a live surface strongly contrasting with the flat colour of the sky.

The dry brush technique, familiar to oil and water colour painters – where the brush is kept dry with its bristles fanned slightly apart – works well

Flow Formula *Compared with ordinary acrylic paint, Rowney's Flow Formula is very liquid, yet it retains a similar density of colour. It is very useful for covering large areas with flat colour.*

Staining raw canvas 1. *Mix paint thinly with water or medium.*

2. Apply the paint and work it well into the weave. Brush the paint from every direction.

3. Lay on the next colour and work it well in. The whole canvas can be stained with a single colour for overpainting later; a large brush should be used.

Adding retarder *To slow the drying time of acrylic paint, add a few drops of retarder to the paint on the palette.*

Applying impasto 1. *Mix the paint with a little water or medium to a fairly stiff consistency.*

2. Dab the paint on with a brush and shape it as required. Impasto can be laid and shaped with a palette knife.

Using masking tape for a hard edge design 1. *Draw in the overall shape with pencil, and stick masking tape along the edges.*

2. Paint over the desired area, taking the brush up to and over the masking tape.

3. Carefully peel away the masking tape to reveal a shape with hard edges. Allow the paint to dry.

4. To elaborate the design with a series of horizontal bands, stick a strip of tape across the dried paint. Lay paint up to and over the tape.

5. Use tape to cover the area just painted and a thin strip of dried paint alongside. Stick another strip of tape lower down and paint over the area between the strips.

6. Work on down the design. Each time stick down two strips of tape – the top one always covering a thin line of the dried colour. Lay paint between the strips.

with both thick and thin acrylic paint.

Impasto Acrylics are the best medium for all types of impasto, from subtly raised textured surfaces to paint squeezed straight on to the canvas from the tube in the manner of Jackson Pollock, John Bratby (born 1928) and many other contemporary painters. Impastos can of course be achieved with oil paint, but the process is awkward and time-consuming; the slow drying time causes problems such as dirt collecting on the surface and cracking paint. Acrylic paint applied straight out of the tube will take a while to dry, but not nearly so long as oil, and it will stick fast to the support immediately.

Texture paste is manufactured especially for building up impastos. It is applied to the support, dries very quickly and can then be painted over with any kind of paint including oils, although it binds more efficiently with acrylics. Many painters feel that impastos work best if they reflect the artist's personal way of handling paint and that the use of paste, which does not handle in the same way, detracts from this.

Painting into wet paint Acrylics are sometimes criticized by artists experienced with oil paint because they dry too quickly. For those whose style of painting depends on working into a wet surface, or being able to scrape or wash off paint with turpentine, quick-drying paint obviously has drawbacks. However, the problem can be obviated to an extent with retarders, which are made especially for adding to acrylic paint on the palette in order to slow the drying process.

Drawing with line One of the properties peculiar to acrylic paint is that it lends itself well to drawing with line: either underdrawing to establish a design, or fine line drawing as part of the completed painting. The paint should be thinned and applied with soft sable brushes.

Many of Leonard Rosoman's acrylic paintings have a strong linear quality. He uses crisp dark lines, and often draws over and into the image several times until he has an accumulation of forms that are quite dry, ready either to be flooded with washes of thin colour or to be used as areas to receive more solid paint.

Staining canvas The weave of a canvas can remain as an element in a finished painting, if paint greatly diluted with water is used on an unprimed canvas; Flow Formula is especially good for this. In effect the raw canvas is stained by the paint. Water tension breaker added to the water helps to retain the intensity of the colour.

Varnishing and cleaning It is not essential to protect an acrylic painting with varnish, but in the case of a mural in a public place it may well be worthwhile. A matt acrylic varnish should be used as this will not refract light over a large area, and if necessary it can be removed with white spirit or turpentine.

An unvarnished painting can be cleaned very easily with soap and water because the paint surface and the primer are waterproof. A soft sponge should be used; once clean the painting should be sponged down again with clean water.

Below **Leonard Rosoman: The Rabbit** *Here, Rosoman has applied the paint fairly thickly to primed canvas; glazing is used only in the shadows of the garden surrounds and of the rabbit, with the result that these areas appear to vibrate slightly.*

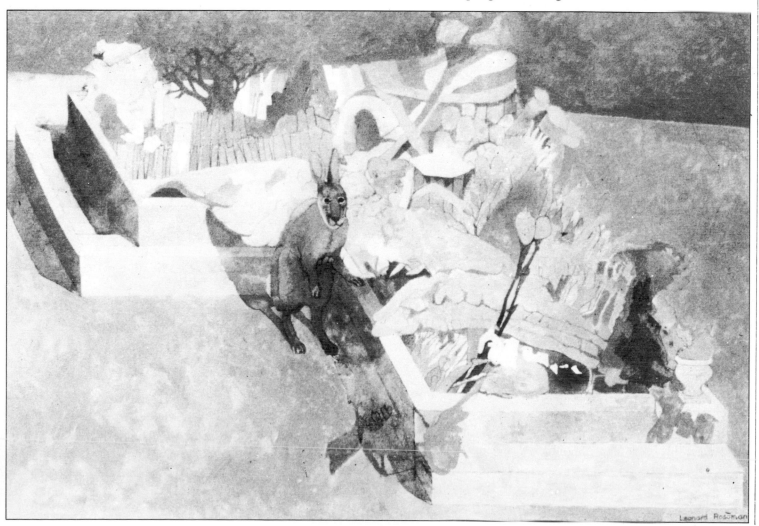

Tempera

Taken literally tempera means any substance which is used to bind powdered pigment. In practical terms the word describes a binder, or tempera, made from egg; and it is with egg tempera that this chapter deals. Tempera dries almost immediately, can be scraped down very easily, and can be built up in ways which would be technically dangerous in most other media. It therefore offers great flexibility of technique.

Traditionally egg yolk is mixed with water, but it can be emulsified with oil or even with wax. The medium is very versatile, more so than oils where fat must be laid on top of lean—meaning that extra oil must be added to each layer of paint to prevent

Right **Unknown Byzantine painter** Far right **Duccio di Buoninsegna: The calling of the apostles** *Early tempera technique was simple, but painstaking, and frequently made use of gold leaf. Duccio would draw in the design and paint directly on to it.*

Below **Sandro Botticelli: Birth of Venus** *Botticelli's technique is used by many modern painters. He laid cool neutral washes over underdrawing and gradually worked up to the final tones.*

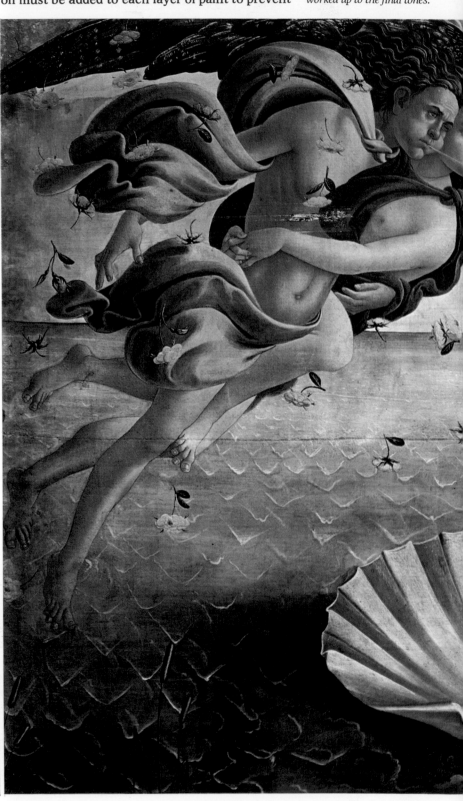

the layers underneath from cracking. With tempera it is possible to work safely fat over lean, and lean over fat.

Tempera also offers exceptional opportunities for mixing media; an egg-oil emulsion can be worked into wet oil paint, for example. But since the problem of emulsions and mixed media is that their constituents are prone to varying drying rates, the basic and traditional mixture of egg yolk and water, which dries in seconds, is the safest one.

Artists who are used to oil paint will need to adjust to the different demands and possibilities of tempera, but it is essentially no more difficult to handle. It is rather closer to acrylics in some of its

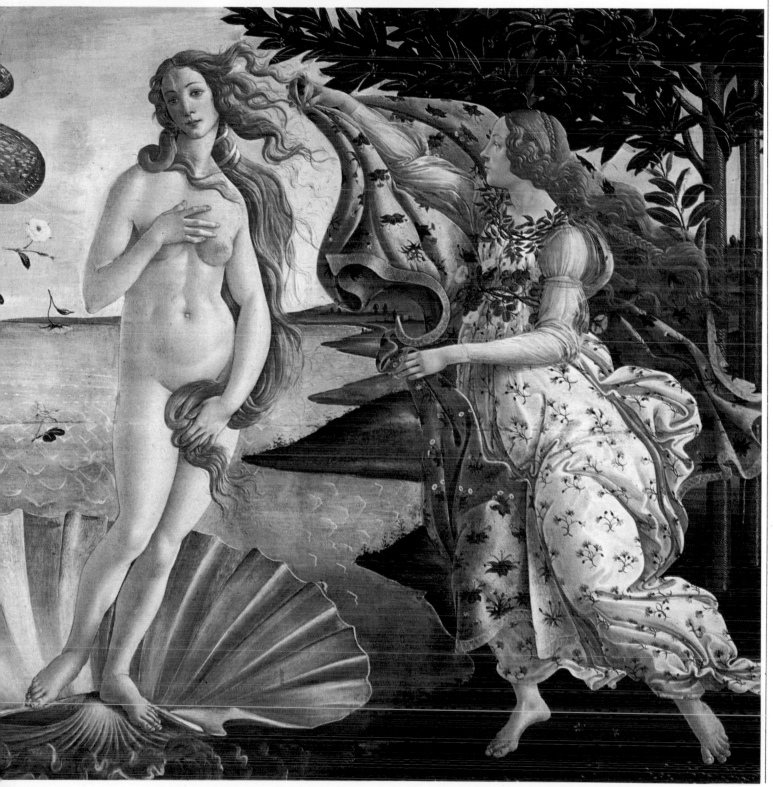

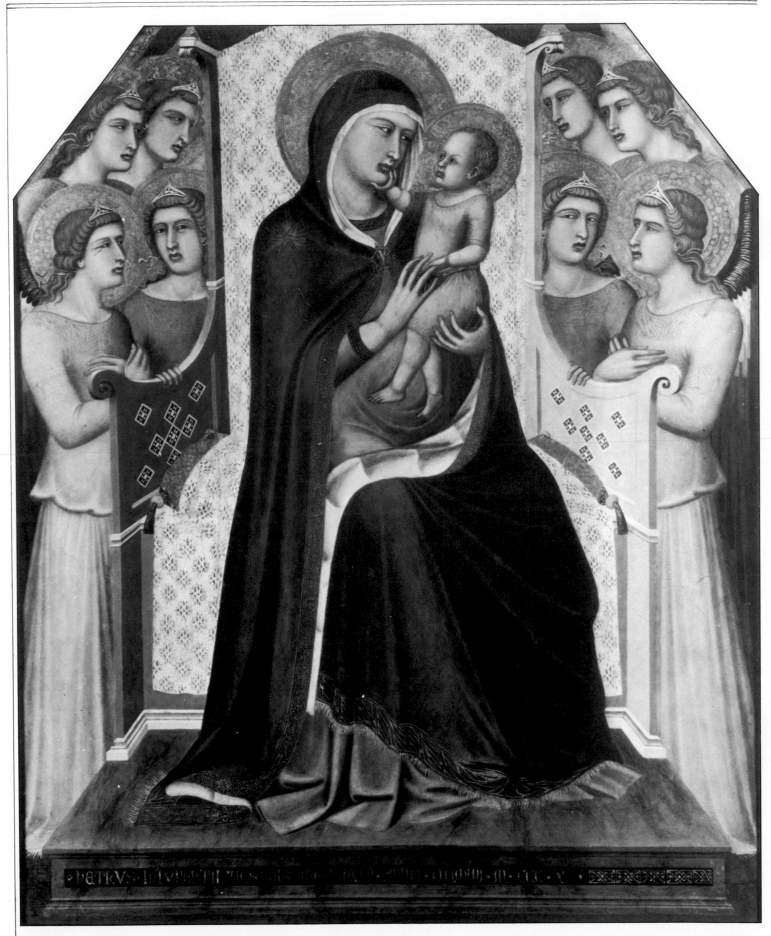

Above **Pietro Lorenzetti: Madonna with child** *An early fourteenth century altarpiece with colour built up over drawing and pale washes.*

Right, above **Piero della Francesca: Nativity** *Piero drew with terre verte and then laid faint washes in the same colour; this is evident in the* dress of the figure on the left. *Most of the colour was then painted directly in a single layer.*

Right, below **Fra Angelico:**

Deposition (detail) *The technique is similar to that of Piero. The thin, fresh painting of the figures, which is intended to make them stand* out from the more heavily worked background, is evident in both paintings.

behaviour, but produces different optical effects. The way tempera flows from the brush has been likened to drawing with a soft pencil. It imposes a discipline on the painter, which is not necessarily a disadvantage; once he has prepared his paints and started painting he must keep on at his work, or the paint will dry up.

The surface of egg yolk tempera is soft, very fine, and does not darken with age like oil paint, though an egg and oil emulsion has more tendency to do so. The main difference between tempera and oils is that for the best results the tempera painter must make his own paints from fresh eggs, water and dry pigment, but there is no mystery about it, and it is in fact simpler to make paints with tempera than with other media.

The origins of tempera are uncertain, but in Europe it seems to have supplanted earlier media, such as encaustic (hot wax), as a vehicle for panel paintings—easel works and altar-pieces—by the tenth century AD.

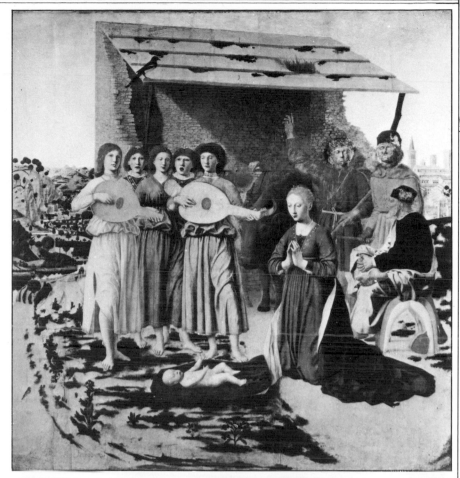

Tempera emulsions for painting and for medieval manuscript illustration developed side by side. Manuscripts of importance were generally made on sheets of vellum or skin, and a tempera emulsion lent itself naturally to a base which contained animal oils. The mixture of gold leaf and tempera colour is characteristic not only of decorated manuscripts but of medieval panel painting. It is in use in later Byzantine and Romanesque art, and survived into the fifteenth century.

With the rise of naturalism the use of gold leaf fell away: gilding is incorporated as a base in the paintings of Fra Angelico (c.1387–1455) and in the early works of Piero della Francesca (c.1410 –92). In a more mature Piero such as the "Nativity", the gold has been abandoned and a pure tempera emulsion has been painted straight into a gesso ground.

Manuscripts were illustrated with an egg-white emulsion, but it is probable that the standard medium for painting was an egg-yolk and water emulsion. Indeed the transition to oil paint introduced to Italy and elsewhere from the Netherlands during the latter part of the fifteenth century was itself partly a modification of tempera, and the oil-painting of van Eyck (active 1422 d.1441) and such Italian disciples of northern techniques as Antonello da Messina (c.1430–79) almost certainly developed through the addition of oil to an egg emulsion. The egg, oil and varnish emulsions described are characteristic of that period.

Authorities disagree as to the precise variations in the use of tempera at different periods. It seems that the pure egg method described by Cennini (c.1390) may have come from the studio of Giotto (1266–1339) and it can be assumed that it was at its height, side by side with true fresco, in the thirteenth and early fourteenth centuries. An unfinished painting by Cima de Conegliano (1459–1517) shows clearly the stages by which the egg tempera layers were built up from the gesso ground, starting with the typical green earth underpainting. "Christ Healing the Blind Man" by Duccio (1255–1319) and the "Madonna and Angels" of Pietro Lorenzetti (active 1320–45) are extremely good examples of pure early fourteenth century tempera.

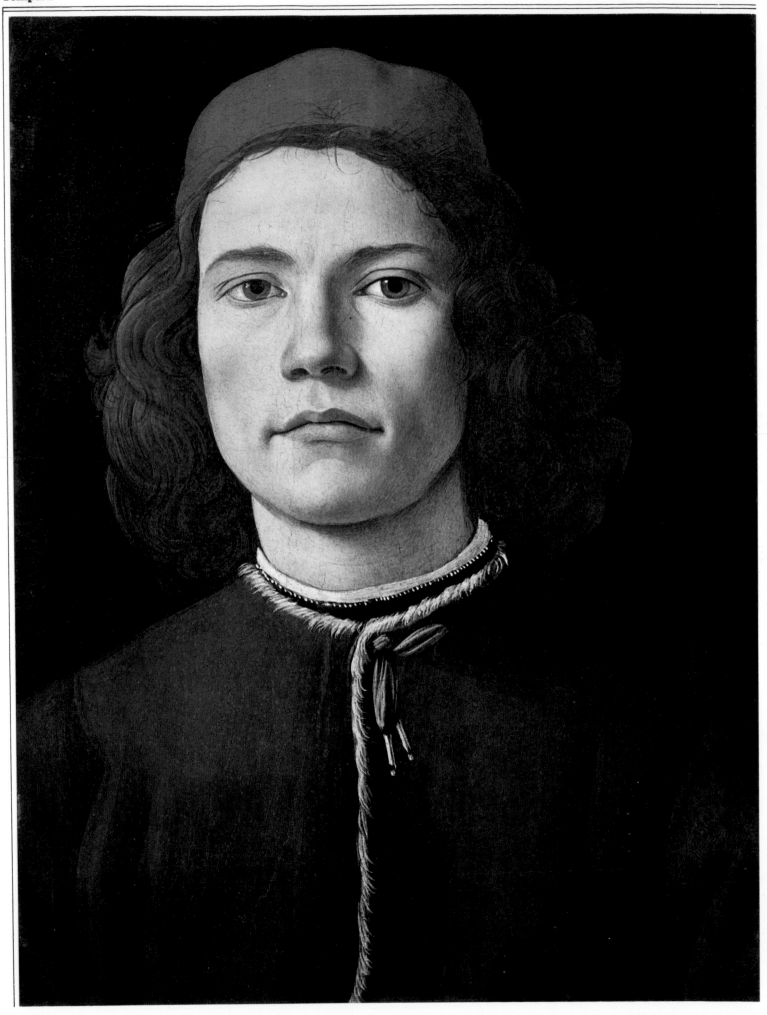

Left **Sandro Botticelli: Head of a boy** *Cool ochre and terre verte washes were laid over very careful drawing. This was painted over meticulously with some extremely fine cross-hatching to achieve the subtle tones. It is interesting to compare Botticelli's treatment of the face with Andrew Wyeth's similar approach to the figure in "Christina's world" (below).*

Right **Samuel Palmer: Coming from evening church** *Palmer built up thick layers of paint to imitate textures, like that of a tombstone or the bark of a tree. To portray the moon, Palmer scraped the paint away down to the gesso and applied new layers of thick paint.*

Below **Andrew Wyeth: Christina's world** *Wyeth is the foremost contemporary exponent of tempera in the United States. Here, it is likely that he painted the landscape and then scraped some of it back to make way for the figure, the luminosity of which derives from the gesso underneath. Wyeth exploits the properties of the medium to produce texture by interweaving lines of colour.*

In fifteenth century works there are likely to be oleaginous or resinous additions: in Fra Angelico perhaps and in Piero della Francesca probably. Piero is said to have practised the technique which was to become widespread and continue in the same form into the seventeenth century, of starting with a tempera medium, and glazing over this with a more oily emulsion, even with oil alone.

Pure oil impastos on an oil ground, of the type now thought of as oil painting, were not standard practice until the days of Hals (1580/5–1666) and Rembrandt (1606–69). Van Eyck in the fourteenth century may have used pure oil, but such fifteenth century northern painters as Holbein (1497/8–1543) and Dürer (1471–1528) were almost certainly working over some kind of tempera base, as were the Florentines of that period.

The practice of tempera was eclipsed by oil, but only partially, and even in the eighteenth century large scale tempera works—such as Rossi's ceiling in the Villa Borghese in Rome were undertaken.

Tempera has remained popular in North America for two hundred years. In nineteenth century Europe its use was revived in Germany, notably by Bocklin (1827–1901). The Englishman Samuel Palmer (1805–81), the Frenchman Moreau (1826–98) and the Austrian Klimt (1862–1918) all produced several works in the medium. Tempera has been used by many contemporary painters including Ben Shahn (1898–1969) and Andrew Wyeth (born 1917) in America, and the Englishmen Edward Wadsworth (1899–1949) and Bernard Cohen (born 1933).

Surfaces

Canvas Tempera requires fine canvas of the best quality. Ideally it should be glued on to a panel (see illustrations), but it can be used stretched as for oil painting. Panels to take canvas are traditionally of seasoned wood, but these are difficult to obtain nowadays, and a good untempered hardboard is a satisfactory substitute.

The back of the board (the rough side) should be sized, or even better have a sheet of paper glued on to it to prevent the board bending and warping as it dries. If this precaution is taken it is not necessary to use a very thick board.

Panels Tempera can be applied to suitably prepared wooden panels. Good untempered hardboard, Masonite and chipboard are the best surfaces readily available nowadays. Wood panels should only be used if they are well seasoned, and have not been treated with protective chemicals.

Masonite and hardboard should be cross-sanded with fine sand-paper and thoroughly brushed in preparation for the ground. They need not be thick as long as they are sized on the back when the ground is applied.

Chipboard is clean, and has a surface that pro-

Preparing a panel 1. *Bevel the edges of the panel with a rasp and sandpaper to prevent them chipping.*

2. Cross-sand the panel to open up the surface. Sand in one direction, then the other; do not use a circular motion.

3. Paint the panel with methyl alcohol, working the spirit well into the surface.

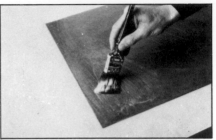

Gluing canvas to a panel 1. *Paint the prepared (previously sized) panel with glue, which should be free of lumps.*

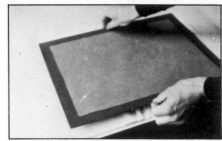

2. Smooth out the canvas. Turn the board over, sticky side down, and place it on the canvas.

Below **Size** *Supports for tempera must be sized before the ground is laid. The size is made from 10 parts of water and 1 part of rabbit skin glue or Artists' size.*

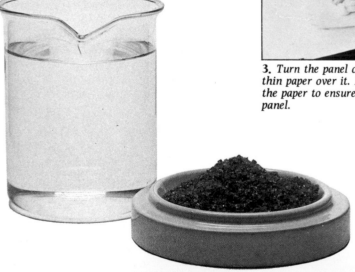

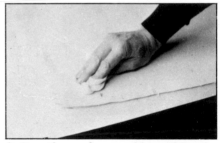

3. Turn the panel over and lay a sheet of thin paper over it. Rub the canvas through the paper to ensure it is stuck flat to the panel.

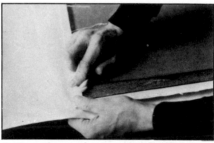

4. Turn the panel over and apply glue to the edges at the back. Stick down the overlapping edges of canvas.

Making size 1. *Pour water over the size crystals, using 10 parts of water to 1 of size. Leave overnight.*

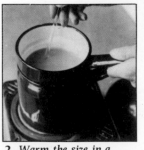

2. Warm the size in a double-boiler, stirring with a glass rod. The size should not exceed blood temperature.

3. Apply warm size to the surface and edges of the panel. Dry in a flat position, then coat the back of the panel.

vides more bite than hardboard should this be required. Chipboards vary in smoothness; their surfaces will open a little when sized and become rougher. The thinner chipboards are fragile and can be glued to sheets of Masonite or hardboard to add strength; a small overlap of hardboard should be left to protect the edge of the chipboard.

Plywoods and blockboards are unsuitable. Their surfaces ripple or split, and they may have been treated and glued in ways which reject natural glue. Softboard is far too fragile, even as a backing.

Size Whether the surface is canvas or wood, it must be sized before the ground is applied. Basically the size is a layer of a glue made up of 1 part of either rabbit skin glue or Artists' size and 10 parts of water (see illustrations). Rabbit skin glue is the best quality size, but is about three times as expensive as Artists' size, which should be quite safe. Cheap size powders may contain impurities and bacteria which cause mould.

Gelatine size Gelatine as purchased in leaf form from delicatessens can be substituted for size. Powdered gelatine should not be used. Soak 6

leaves of gelatine in 1 pint of water for 15 minutes in a double-boiler until the gelatine swells. Then heat gently until the gelatine dissolves. Do not heat further. Coat both sides of panels with this solution and leave to dry overnight.

Grounds The preparation of the ground is extremely important, and is technically the most difficult process in tempera, since all depends on a well-made ground. It is vital to avoid air bubbles. The ground is laid with gesso, which the artist must make himself. It is best to prepare grounds in a warm room, so that the size element in the gesso does not set too quickly.

Gesso for panels Gesso is made by mixing Gilder's whiting with size or gelatine size made as described above. It is better not to follow rigid proportions of size liquid to powder, or attempt to add liquid to powder like a sauce. Materials vary and it is therefore best to allow the whiting to absorb what it needs.

Zinc white powder can be added to give extra smoothness and whiteness, but it is expensive. If used, it should be thoroughly incorporated with the whiting to make a homogeneous powder. Gilders' whiting used by itself has the advantage that when it is put to soak it absorbs only the liquid it needs (see illustrations).

Four to six coats of gesso must be applied to the panel and allowed to dry for a few days. The surface must then be sanded and polished with a damp cotton cloth. After grounds have been applied, panels should be stored in clean paper—such as newsprint—and stacked or laid tight together to prevent warping. Printed newspaper will leave its print on the gesso.

Gesso for canvas The same mixture and method of preparation should be used as for a panel ground, but to each half pint of gesso one level tablespoon of raw linseed oil should be added drop by drop, and stirred until it is thoroughly amalgamated. This prevents the ground from cracking when applied to stretched canvas. The mixture is very smooth, and only two coats are needed. They must not be applied too thickly or they will crack, and they must be brushed out rapidly, because the gesso sets quickly. It is essential to avoid air bubbles whatever happens.

On canvas it is a good idea to include Zinc white powder because the zinc content makes up for discolouration caused by oil. 1 part of Zinc white powder can be added to 2 or 3 parts of whiting; some authorities suggest equal amounts, but this mix produces a very intractable substance.

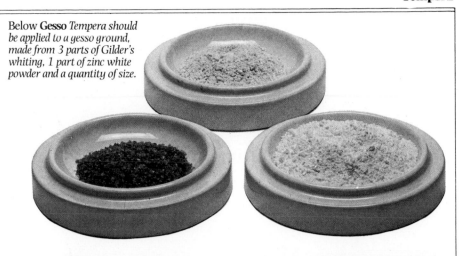

Below **Gesso** *Tempera should be applied to a gesso ground, made from 3 parts of Gilder's whiting, 1 part of zinc white powder and a quantity of size.*

Making gesso 1. *Mix zinc white with Gilder's whiting; 3 parts of whiting to 1 of white.*

2. Sift or shake the mixture into a bowl filled with tepid size until no more powder can be absorbed.

3. Stir the mixture with a stick to dissolve sediment.

4. Remove any bubbles that collect on the surface of the mixture with a spoon.

Gluing paper to a panel
1. Coat the surface of the panel liberally with glue.

2. Lay paper on the glued surface. Leave a border of about ¼ inch (60 mm) around the paper, and rub it flat on the panel.

5. Strain the mixture into a pan through muslin to remove any sediment. Squeeze out the cloth into the pan.

6. Apply the gesso to a panel, using a damp brush to prevent air bubbles forming. Spread evenly, using 6 to 8 coats. Allow each coat to dry for 20 minutes.

Paints

Tempera paint is made by mixing powder pigments with an egg solution in roughly equal parts. Paints can be bought ready mixed in tubes, but these do not seem to dry as quickly as hand-made paint; so if they are handled as rapidly during the course of working, they will tend to pick up undercoats and suffer from sinking, both of which are normally problems with oil paint rather than tempera.

Ready made paints are suitable for certain kinds of painting and it is worth experimenting with them, but they lack the flexibility of the real thing. Hand-made tempera gives a wider and more personal choice of colours.

Pigments There is a very large range of powder pigments of artists' quality available—at least fifty colours—as well as others of lesser quality. Even earth colours, if they are of good quality and not cut (extended by the addition of another substance), especially not with gypsum, can be very bright and strong.

Some colours are unsuitable for tempera. Flake white should be avoided; it is too heavy and is also poisonous, which makes its handling in powder form risky. The chrome colours are also poisonous. Monastral blue, an excellent colour with other media, is difficult to amalgamate with egg.

An adequate and inexpensive palette need contain no more than: Titanium white; Yellow ochre; Indian red; French ultramarine; Burnt umber; and Lamp black.

Pigment Paste So that they are ready for use and easy to handle, powder pigments are best kept in a solution of distilled water (see illustrations). A brush filled with egg solution should never be put into a jar of pigment; the whole lot will go bad.

Most pigments mix well with water. Some synthetic colours are too lightly ground and do not mix properly, in which case it is best to avoid them in any case. The whites are exceptions; for the sake of body and cover they are best not made into a paste, but mixed as powder directly with the egg yolk. French ultramarine should be made into a paste only when it is needed, since it sets into a cake if left in a jar.

Some pigments, such as Alizarin crimson, Prussian blue and the various blacks, do not mix readily into a water paste. A suitable amount of alcohol depending on the pigment, must be added. An alternative is to add the solution sold as water-tension breaker for acrylics. This works very well and does not upset the drying of the colour.

It is of course possible to put dry colour in powder form straight on to the palette and mix with a little distilled water before adding the egg solution. Except for large quantities of paint this is a messy process; it is no more difficult to take paste out of a pot than to squeeze it out of a tube.

Pigment pastes should be stored in glass jars with firm stoppers. Screw tops with cardboard seals, which dampen and encourage mould and rust, should not be used.

Egg yolk tempera The tempera is the binding medium before the pigment is added. Egg yolk tempera should be made with the yolk of a fresh

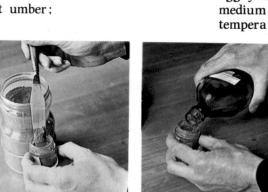

Pigments for tempera *Suitable colours, which are easily obtainable, are listed with the approximate proportion of egg needed to 1 part of pigment.* **1.** *Zinc white, slightly transparent, $\frac{3}{4}$ parts of egg;* **2.** *Titanium white, very opaque, $1\frac{1}{4}$ parts of egg;* **3.** *French ultramarine, opaque, 1 part of egg;* **4.** *Cerulean blue, gritty but opaque, $\frac{3}{4}$ parts of egg;* **5.** *Viridian, transparent, $\frac{3}{4}$ parts of egg;* **6.** *Cadmium yellow, fairly opaque, 1 part of egg;* **7.** *Scarlet lake, gritty but opaque, 1 part of egg;* **8.** *Cadmium red, fairly opaque, $\frac{3}{4}$ parts of egg;* **9.** *Venetian red, very opaque, $1\frac{1}{4}$ parts of egg;* **10.** *Indian red, fairly opaque, 1 part of egg;* **11.** *and* **13.** *Burnt and Raw sienna, gritty but opaque, $1\frac{1}{4}$ parts of egg;* **12.** *Burnt umber, opaque, $1\frac{1}{4}$ parts of egg;* **14.** *Yellow ochre, fairly opaque, 1 part of egg;* **15.** *Raw umber, fairly opaque, 1 part of egg;* **16.** *Ivory black, opaque, 1 part of egg.*

Making pigment paste 1. *Put some dry powdered pigment in a small jar.*

2. *Add enough distilled water to make the pigment into a thick paste. The amount required will vary because some pigments are more absorbent than others.*

3. *Put the top on the jar and shake vigorously.*

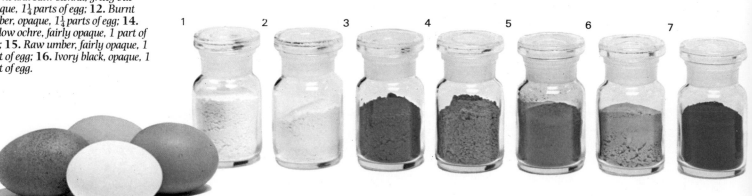

hen's egg and distilled, or cold boiled, water (see illustrations). It is the purest tempera medium, and can produce the freshest and cleanest results.

The properties of egg-oil emulsions and recipes for making them are described at the end of this chapter (see p.96).

Mixing tempera with pigment Tempera colour should be mixed on a sheet of glass or a paper palette pad (see illustrations). Both the pigment paste and the egg yolk temper should be placed on the palette with eye-droppers in more or less equal proportions according to the nature of the pigment. They can then be mixed together with a plastic palette knife. If a large quantity of one colour is needed, the mixing can be done in a dish.

The resulting paint can be thinned down with distilled water (impurities in tap water may effect

paint) for washes and transparent work, but enough egg yolk should be added to maintain the binding properties.

The binding test is to put a little paint on clean glass. When it dries it should peel off in a skin. If it crumbles, it needs more egg. Paint which passes this test should be technically sound.

Once the paint is mixed with the egg it should be used straight away. All egg-mixed paint should be disposed of at the end of the day; if stored, it will go bad.

Never put a fresh egg in a receptacle that has old egg adhering to it; indeed a requirement of tempera is that all utensils, palettes and brushes must be kept scrupulously clean. Detergent is better than soap, which leaves a heavy deposit and can make colour dry to a sticky consistency.

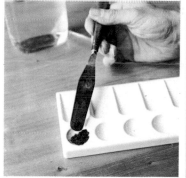

Alternative method for pigment paste 1 *Place a little pigment on a mixing palette with a palette knife.*

Making egg yolk binder 1. *Crack an egg and separate the yolk by allowing it to drain through the fingers into a bowl.*

2. Dry the yolk by rolling it in the hand or by placing it on a sheet of absorbent paper. Hold the yolk and slash the sac, letting the liquid run into a glass jar.

3. Add distilled water and stir. The mixture should reach the consistency of thin cream. If it is too thick, add more water. Strain into a glass jar.

2. Add distilled water with an eye-dropper and mix with a glass rod.

Mixing pigment paste with egg yolk binder 1. *Mix pigment and binder on a paper palette with a plastic palette knife.*

2. To test whether the mixture will bind adequately, put a little paint on a clean piece of glass.

3. When the paint is dry, peel it off with a palette knife. If it forms a skin it is ready for use. If it crumbles, add more egg.

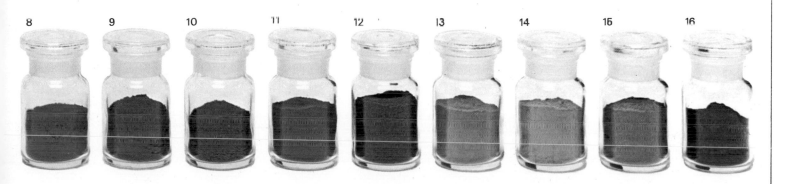

Equipment

Brushes Any kind of brush can be used as long as it will lay the paint moderately thinly and is not so harsh that it scratches undercoats. Sponges and rags can also be used.

Paint containers Non-rusting cake tins, or enamel or porcelain dishes can be used for mixing paint. It is best not to use plastic dishes; they do not clean so easily or keep the paint so cool. Artists' colour-men stock porcelain dishes that stack on top of each other. These are useful because colours awaiting use can be stacked to delay their drying.

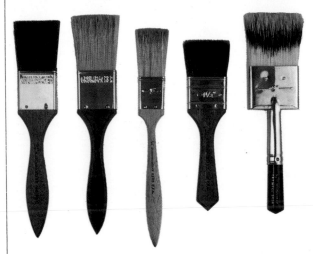

Left **Wide brushes** *Tempera paint can be laid with water colour and oil paint brushes (see pp 128 and 54), as long as they are reasonably soft. Size, gesso and large patches of paint can be applied with wide brushes. These are made from many materials including: (from left) ox hair and bristle; white bristle, 1½ inch; white bristle, 1 inch; camel hair; badger hair.*

Techniques

Under drawing Some painters like to draw in line before starting to paint. It is best to use silverpoint, which responds well to gesso, or fine charcoal, which should be dusted down before painting. Ordinary graphite pencil can make a mess of the gesso surface and may strike through the painting.

Applying paint Tempera has to be applied thinly, although any number of coats can be super-imposed. Any single layer which is more than 1/32 inch (1 mm) thick is liable to drop right off the support.

It is normal practice to begin a tempera painting by applying thin washes to seal the panel. These can be laid even over very fine drawing, and if the colour is kept transparent the line will show through quite adequately.

It is a property of tempera that the paint surface can always be scraped back to the gesso. A round bladed scalpel-shaped knife should be used and it must be kept meticulously clean: rust and tarnish

Below **Equipment for mixing and applying tempera** *It is best to use a glass or paper palette, so that egg residue can be removed easily. Pigment paste and egg* *should be put on the palette with eye-droppers and mixed with a plastic palette knife. Large quantities of paint can be mixed with brushes, and kept/in china bowls.*

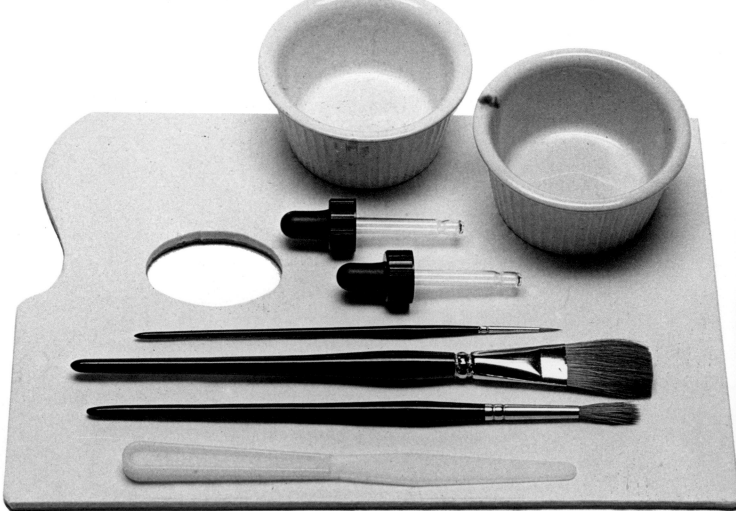

are a danger to the paint. Care must be taken not to damage the gesso surface, and areas which the knife should not touch must be protected.

In general it is best to work broadly and go right over lines and edges. The work can always be cleaned with a knife; as it progresses the painting may well appear fresher if it is scraped down and painted again in some passages rather than over-painted excessively.

If paint is to be applied very thinly, the artist should prepare a dish of 1 part egg to about 15 parts distilled water to add as a medium while he works. This maintains the binding properties and keeps the thin passages even. It is possible to coat a whole painting in this way to give it unity.

A jar of boiled water should be kept handy for washing out brushes as work proceeds. They must be washed quickly after use, because the paint will soon dry. It is useful to keep distilled water for adding to paint in a squeezy plastic container. Sponges and rags for applying paint should of course be clean; they should be damped so that they take the paint without soaking it up.

Varieties of mark Tempera paint can be brushed, hatched, stippled and scratched through over and over again. The painter need not think like a water colour purist, and indeed some deep textures can only be achieved by much working; the paint cannot by its nature be laid on thickly all at once.

Glazing Tempera is ideal for the glazing technique whereby one layer of paint is covered by another transparent layer. There is virtually no limit to the

Above **David Tindle: Still life with telephone** *An egg yolk, stand oil and damar varnish emulsion was used. This was thick and sticky, and was laid on solidly like oil paint.*

Below **John Armstrong: Dreaming head** *Armstrong probably used an emulsion made up with egg, linseed oil and vinegar. The large areas of colour – sky, sea and cliffs –*

have a flat quality like gouache or thin oil paint.

Tempera techniques

Tempera is extremely versatile, but quite easy to handle. The paint must be applied thinly – otherwise it will drop off the support – but it dries very quickly and any number of layers can be superimposed. The paint can easily be scraped back to the gesso, and this can be used positively, not just as a means of correcting mistakes. Opaque paint can be applied with brush or palette knife; transparent washes can be laid and used as glazes; and any kind of graphic mark can be made including hatch, stipple and dense areas of interwoven lines.

Washes of cobalt blue laid over other colours.

Two colours laid over each other several times.

Cross hatching: umber and ochre with white.

Some areas scratched back and sanded. Paint dragged across the surface.

A blue wash covered by a yellow wash with a creamy white laid unevenly on top.

Lines scratched into opaque colour, with washes laid over.

Blue paint gently sponged over with more paint.

Raw umber applied with a palette knife and washed over with cadmium yellow.

Colours splattered over one another on a warm ground.

Far left **David Tindle: Chair, coats, mirror, knotted curtain** *Pure egg tempera was used, and the graphic possibilities offered by the characteristic loose quality of the paint were exploited. A rich texture was acquired with numerous tiny, interlocking marks. The denim texture was achieved with delicate and painstaking cross hatching and weaving. To get the light effects in the mirror and doorway, paint was scraped away and the areas overpainted. In many parts of painting 30 or 40 washes are laid over one another, with cross hatching, stippling and other forms of texture applied as well.*

Left **Bernard Cohen: Floris** *Cohen uses tempera because it produces the particular effects he requires better than any other medium. This is a superb example of how tempera flows and allows for the drawing of continuous lines in a graphic manner, more efficiently even than gouache.*

Right **Ben Shahn: Passion of Sacco and Vangetti** *Here, Shahn used tempera in a graphic way, rather like gouache, painting directly with opaque colour. As he worked Shahn changed his designs and colours a great deal, although he would begin by planning and drawing on the gesso. He did a great deal of scratching back, sanding and repainting. Here, there is evidence of lines scratched out on the door and the coffin.*

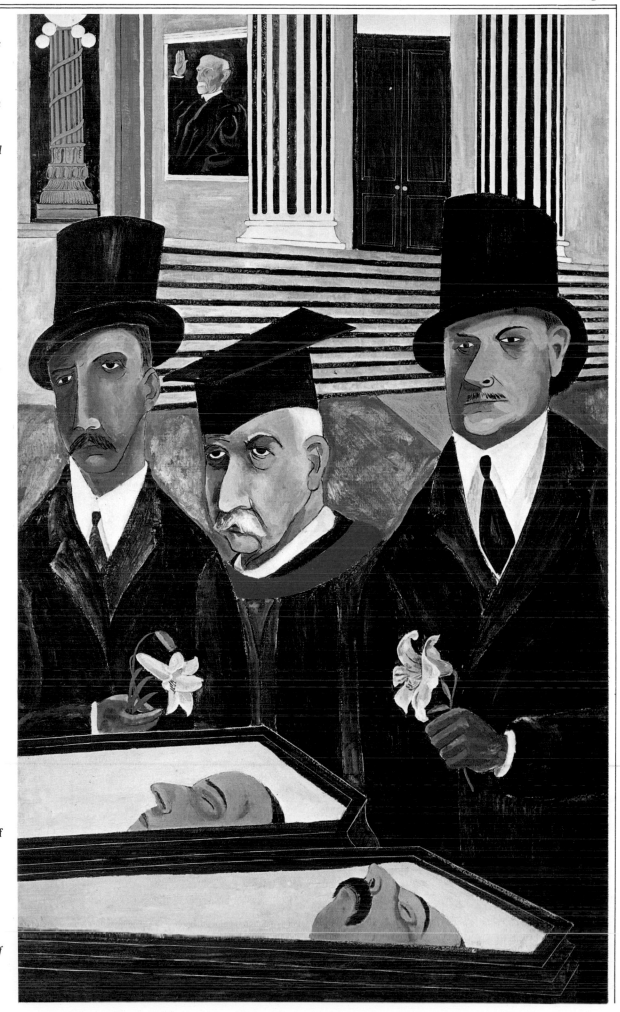

number of layers that can be applied, but to produce thick transparent glazes the artist has to work quickly because the paint sets so fast.

For glazing it is best to damp the surface first so that the paint flows easily and without streaking. Large pools of wet paint should be avoided because they may damage the gesso. But a pool of liquid paint can be made to run downwards—like a water colour wash—to an edge where it can be controlled and mopped up with blotting paper or gauze.

Dry brush The dry brush technique can be very effective. It is achieved simply by wiping most of the paint off the brush first so that what paint is left can be dragged out in parallel lines.

Hatching The traditional technique of hatching—shading with parallel lines—reveals how well tempera colours sit together. It produces fresh optical effects and builds up interesting colour relationships of a quality different to that of colours laid flat. It is also technically sound; old paintings show how well the interwoven nature of the surface produced by hatching and cross-hatching withstand the test of time.

Stippling and splattering Shading and texture can be achieved by stippling—applying a patch of fine dots—or by splattering (see illustrations). Both these techniques are useful to the tempera artist because they produce a stronger, more dense surface than a plain wash.

Splashing Paint can be splashed straight from the dish on to the surface; it is best to place the work on the floor to prevent drips. Mask all areas not to be splashed, with paper templates. The splashes must be worked with a rag or brush to make them thin; thick layers of paint will drop off the support.

Removing paint A newly laid patch of paint can be taken off with a piece of damp gauze. This must be close at hand; if the artist has to go and fetch it, the paint will have dried by the time he gets back. Dried paint can only be scraped off with a knife.

Design corrections Once paint has been laid, any additional under drawing is best done with more paint; anything with a point will scratch the paint off, because it remains chemically soft for a long time, even though it becomes surface dry almost at once. A thin mid-tone paint is best.

Above **Tony Barrs: Charity (detail, work in progress)** *Several layers of gesso have been applied and sanded perfectly smooth. The form has been drawn in with neutral grey colours applied with a fine brush. Some tones have been established with hatching and cross hatching.*
Right **David Tindle: The view** *Egg yolk tempera was used. The gesso was coated with an ochre wash and the outlines laid in a darker tone. The wall was splattered from all directions and some of the brick formations were applied using masks. The coat and*

chair were scraped right back to the gesso and repainted very meticulously. Over 30 delicate washes were laid to add richness.

Right, below **David Tindle: Still life with plastic cup and spoon** *Painted with egg yolk tempera. Splattering and splashing applied with elaborate shields are very evident. In some areas paint was removed while it was still wet, and more paint was applied gently with a sponge.*

Splattering 1. *Lay the panel on the floor and place newspaper masks as desired. Splatter by hitting a brush loaded with thinned paint against the flat of the hand.*

2. Remove newspaper masks. Fine splatter may be achieved by hitting the brush against a block of wood. Splattering from different directions and angles creates different effects.

It is also possible to introduce linear corrections by using tracing paper. This should be laid lightly over the work and the correct lines drawn on very gently. The back of the paper should then be rubbed with white chalk or charcoal so that the drawing can be lightly traced on to the surface.

Templates and shields Tracing paper can be used to make templates for painting specific shapes, and to make shields to protect parts of the surface while painting is in progress. If an artist is working very finely with his hand on the surface, that part of the surface should always be covered with a shield of tough paper to protect it from grease and moisture. Cuffs and watch straps must not touch the surface; the painting is easily scratched, just as an oil painting can be smudged.

Protecting finished works Although the tempera surface is touch dry in seconds, it stays soft for some months and must be treated with care. It is best to cover work with glass, about a quarter inch from the surface, for at least a year.

Egg-oil emulsions

Egg-oil emulsions Egg-oil emulsions produce a more glossy finish than pure tempera. The more oil and varnish is added, the heavier the gloss. Initial drying time may be less certain than that of pure tempera, but these emulsions dry out harder.

Egg yolk and linseed oil When mixed with pigment paste an egg yolk and linseed oil emulsion produces a paint which can be used like egg tempera, but has more of the qualities of oil paint. No more than a level teaspoonful of oil should be mixed with a single egg yolk (see illustrations); more than this makes the emulsion sticky. A leaner mixture can be made by including less oil. As with egg yolk tempera, roughly equal parts of this emulsion should be mixed with pigment paste.

Egg, stand oil and damar varnish A blend of stand oil and damar varnish is mixed with egg using the same procedure and proportions as for egg and linseed oil (see illustrations). The resulting emulsion should be mixed in roughly equal parts with pigment paste.

The paint should be applied very thinly to start with. It dries very hard, and when dry can be polished to a shine with a silk pad—or a pad made from paper handkerchiefs—and does not need varnishing. It can be used like egg tempera, glazes well and can closely resemble oil paint. It may not dry evenly, and should not be considered so for thirty minutes. Once dry it is very stable—perhaps

Egg yolk and linseed oil *Not more than 1 level teaspoonful of linseed oil is mixed with 1 egg yolk (see illustrations, right).*

Egg yolk, stand oil and damar varnish *1 egg yolk and 1 level teaspoonful of blended stand oil and damar varnish, are mixed like egg yolk and linseed oil (right).*

Whole of egg and linseed oil *Mix yolk and white of 1 egg. Add 1 teaspoonful of linseed oil drop by drop. Mix in 4 drops of white vinegar. Strain the mixture.*

Whole of egg, damar varnish and oil of cloves *20 drops of oil of cloves is added to 1 whole egg, and a quarter of the egg's volume of damar varnish (see illustrations, right).*

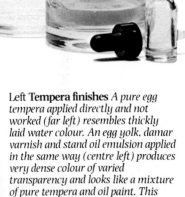

Left Tempera finishes *A pure egg tempera applied directly and not worked (far left) resembles thickly laid water colour. An egg yolk, damar varnish and stand oil emulsion applied in the same way (centre left) produces very dense colour of varied transparency and looks like a mixture of pure tempera and oil paint. This covers well and has a slightly fat quality. A whole of egg, damar varnish and oil of cloves emulsion, applied directly and unworked (left), gives a flat denseness of colour and even the washes have a strong gritty quality.*

Left **David Tindle: Gordon (detail)** *An egg, stand oil and damar varnish emulsion was used on canvas. Pure egg tempera is likely to crack if applied to canvas. The wall is broadly cross hatched to create the illusion of light; warm and cool colours are superimposed to create an optical vibration. A similar effect is achieved with the blue black of the suit. Dry brush is used on the head, hands and newspaper. Because an egg and oil emulsion was used, the white paint was applied solid and opaque.*

Right **David Tindle: Still life with chair** *The support is canvas and therefore an egg yolk, stand oil and damar varnish emulsion was used. This was laid on thickly, a little like oil paint. The painting reflects the firm character of egg and oil emulsions, and the way that the paint can be easily controlled in a way that pure egg tempera cannot.*

more so than oil paint—and is just as strong.

This emulsion can be used to paint fine lines into wet oil paint without "picking up". Its advantage over oil paint is that it dries quickly and sets in seconds. It works well on stretched canvas, and withstands damp better than egg tempera. On the other hand its oil content makes it more prone to darkening, it is less easy to scrape back, and it lacks the matt high key quality of pure egg tempera.

Whole of egg and linseed oil Paint made with a whole egg and linseed oil emulsion (see illustrations) dries hard and fast. It is not so clear as pure egg tempera, and does not polish up like the stand oil and damar varnish emulsion. It should be mixed with pigment paste in roughly equal proportions, and diluted when necessary with distilled water.

Whole of egg, damar varnish and oil of cloves Once mixed the three ingredients are diluted with distilled water to form a thin emulsion (see illustrations). Unlike the other solutions and emulsions, this one should be mixed with dry powder pigment into a paste, which can only be diluted by adding more of the mixture. This emulsion is very useful for working on a large scale with thin paint; thick paint is liable to drop off the support.

Making an egg yolk and linseed oil emulsion 1. *Add linseed oil to egg drop by drop with a teaspoon: 1 part of oil to 3 of egg. Stir with a glass rod.*

2. *Add the same volume of distilled water as egg yolk with an eye-dropper. The water must be added drop by drop or the mixture will not emulsify.*

Making a whole of egg, damar varnish and oil of cloves emulsion 1. *Crack an egg into a glass jar. Mark the level on the jar, put the top on and shake.*

2. *Measure the distance from the bottom of the jar to the first mark. Quarter this measurement and make another mark above the first. Fill to this level with damar varnish.*

3. *Add oil of cloves with an eye-dropper—20 drops per egg is adequate—and shake. If the emulsion is to be used at once, the oil of cloves may be omitted.*

4. *Make a third mark 12 times the height of the mixture and fill to it with distilled water. Put the top on the jar and shake. The emulsion is now ready for use.*

Chapter Six

Fresco

The term "fresco" is often misused to describe many forms of mural painting. This chapter discusses true fresco, or *buona fresco*, the great traditional medium.

True fresco is to modern painting techniques what Latin is to modern languages. A knowledge of it is especially relevant in the latter half of the twentieth century, when after a long period of stylistic experimentation there is a growing tendency among painters to look back on and learn from the origins of their art.

Frescoes from all periods since Roman times can be seen in Italy, and these include many of the greatest masterpieces of western art. Many of the pre-Renaissance, Renaissance and Baroque masters worked in the medium. Of the many exponents perhaps the greatest were: Giotto (1266/7–1337); Masaccio (1401–28); Fra Angelico (c.1387–1455); Piero della Francesca (1410/20–92); Signorelli (1441/50–1523); Michelangelo (1475–1564); Raphael (1483–1520); and Pietro da Cortona (1596–1669).

The technique continued to be used with excellent results in the eighteenth century, especially by Tiepolo (1696–1770). Frescoes were made in England and Germany in the last century, and by Diego Rivera (1886–1957) and others in Mexico in the present century.

Late medieval works in superb condition are accessible in the mountain monasteries of Jugos-

Right **Michelangelo Buonarroti: (detail, Sistine chapel ceiling)** *The whole ceiling was painted from a scaffold which made it difficult for Michelangelo to appraise the work as it progressed. All the painting was done by the artist himself and took two and a half years to complete.*
Below **The Delphic sibyl, (detail, Sistine chapel ceiling)** *Here, the contours of the figure are unified by being placed within a single, oval-shaped outline.*
Far right **Jacopo Pontormo: The virgin annunciate** *This suffered from dampness and damage, and was removed, restored and cleaned to recover the original brightness of the colours.*

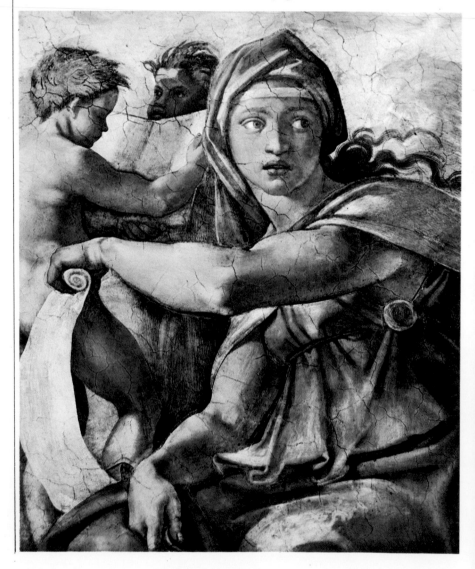

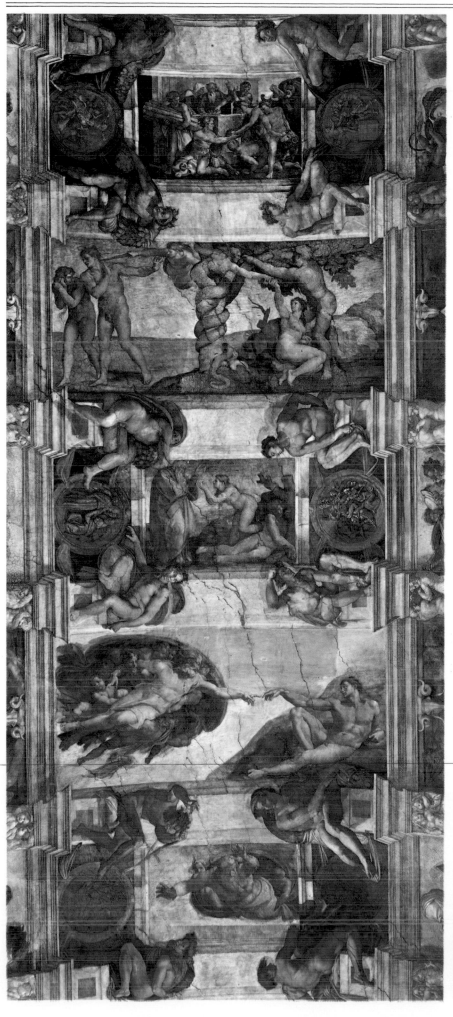

lavia. In Spain, medieval frescoes from the churches of Catalonia have been collected in the City Museum of Barcelona, and there are major decorations by Tiepolo, Giordano (1632–1705) and Goya (1746–1828) in Madrid. Spirited works of the Rococo period are spread throughout South Germany and Austria, and some of the greatest frescoes outside Italy can be seen in Würzburg in Bavaria. In Moscow, inside the walls of the Kremlin itself, are two cathedrals fully frescoed in the late Byzantine style. The only notable medieval example in England is a fragment from a decorative scheme in Canterbury cathedral by a Byzantine craftsman.

The technique of fresco is based on a chemical change. Powdered earth colours ground in pure water are painted on a freshly-laid lime and sand plaster, while the lime is still in the form of calcium hydroxide. Due to carbon dioxide in the atmosphere, the lime very soon becomes calcium carbonate, so that the pigment is crystallized into the wall it decorates.

Frescoes can be made outdoors as well as indoors; they will last outdoors as long as they are in a reasonably sheltered site and are not subjected to smoke or fumes.

The procedures involved in painting walls in fresco are simple, but laborious and extremely time-consuming. The preparation of the lime constituent of the plaster takes two years.

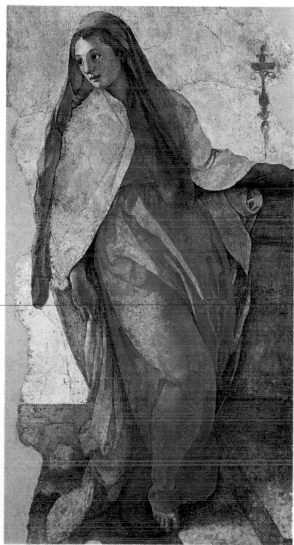

Surfaces

Any artist wishing to work in fresco nowadays will have great problems in finding and preparing the materials—tasks which in earlier times would have been performed by a well-manned workshop.

Preparing the plaster The first necessity is an absolutely pure and well-fired white quicklime. This dangerous powder must be stored outdoors in a brick-lined lime-pit, sunk in the ground in a shady spot, and protected by a wooden cover. The lime must be kept flooded with pure water, and stirred at frequent intervals for two years before it is pure and smooth enough for use. "Clean" dirt like dead frogs doesn't matter; the enemy is chemical impurity. The second problem is to find pure brook-sand, or sand from an inland sand-pit. Sea-sand or even river-sand are no use, because salt ruins a fresco and can never be completely washed out. The sand must also be free of mica. A fresco made with sand from a builders' merchant is unlikely to last more than three years. Any impurities in the sand will cause efflorescence, cracking, discoloration, or chemical reactions.

Below **Preparing the wall**
The surface of the wall, 1, is given a key for the first rough-cast layer of plaster, the trusilar, 2, which should be about half an inch (12 mm) thick. The middle layer, the arricciato, 3, is then applied just over a quarter of an inch (6 mm) thick, and allowed to set. The slightly thinner third layer, the intonaco, 4, is smoothly trowelled on to an area which can be painted in a single day. The design is traced over the fresh intonaco and the paint is applied, 5. The pigment particles are drawn into the porous plaster and become bound into it as it sets and dries.

Preparing the wall Before work begins the wall has to be meticulously prepared so that it is equally absorbent all over. Any old plaster or over-fired bricks must be cut out and replaced. The wall must be prefectly dry and well ventilated, and there must be facilities for shading it from the sun while painting is in progress. It is all but impossible to produce frescoes on concrete, because concrete exudes chemical impurities. Before it is plastered, the surface of the wall must be chipped with a hammer and wedge to provide a key. Then the wall must be thoroughly soused with clean water.

Laying the plaster Three layers of plaster must be laid. The first is the rough-cast, which in old Italian treatises is called the *trusilar*. This is the leanest in lime, and is made up of three parts clean coarse sand and one part slaked lime well trowelled together with enough water to make the mix stand up on the mortar board. The plaster must be hurled at the wall with a wooden float. If it is smarmed on like butter, pockets of air will be trapped in the pitted surface. It should then be pressed roughly flat with the float, but not patted, because this will make too smooth a skin. For this coat, there is no harm in laying rather more plaster than can be covered in one day's painting provided it can be

Making a key *The surface is chipped with a hammer and wedge.*

Wetting *The surface is soaked with clean water to wash off loose particles.*

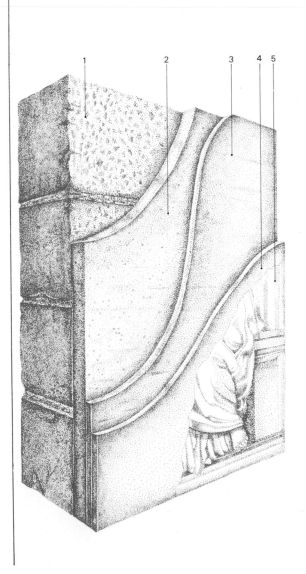

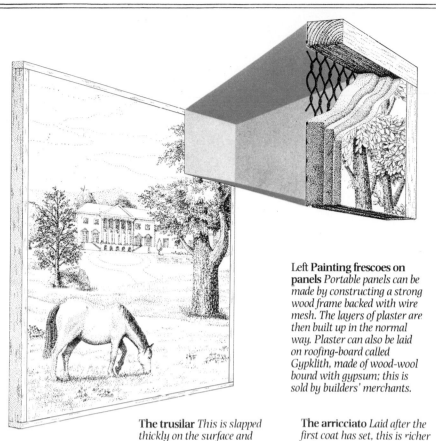

Left Painting frescoes on panels *Portable panels can be made by constructing a strong wood frame backed with wire mesh. The layers of plaster are then built up in the normal way. Plaster can also be laid on roofing-board called Gypklith, made of wood-wool bound with gypsum; this is sold by builders' merchants.*

kept wet with a damp cloth. This is the thickest coat and should be about half an inch deep.

The middle layer, the *arricciato*, can be laid with a float in the usual way, as soon as the first coat has set but not dried. This coat must be richer in lime—two parts coarse sand to one of lime—and should be just over a quarter of an inch thick. Only enough plaster for an estimated day's work should be applied. Any excess must be cut away when painting stops.

The third layer, the *intonaco*, can be laid about half an hour later, as soon as the middle layer has set but not dried. This should be rendered fairly smooth, but should be washed down with water thrown with a ladle or played with a soft jet, to remove much of the surface lime. This coat should be the richest in lime—one part lime to one part fine sand or possibly ground marble—and should be slightly thinner than the previous coat, about a quarter of an inch thick. If any part of a fully plastered area has not been painted by the end of the day, the plaster must be removed with a sloping incision from an ivory or plastic palette knife.

Small simple frescoes can be made on board in a wooden frame. These make handsome decorative panels with a pleasing tactile finish (see illustrations).

The trusilar *This is slapped thickly on the surface and flattened.*

The arricciato *Laid after the first coat has set, this is richer in lime.*

The intonaco *The richest in lime, this is applied on the day of painting.*

Washing down *Excess lime is sluiced away from the final coat of plaster.*

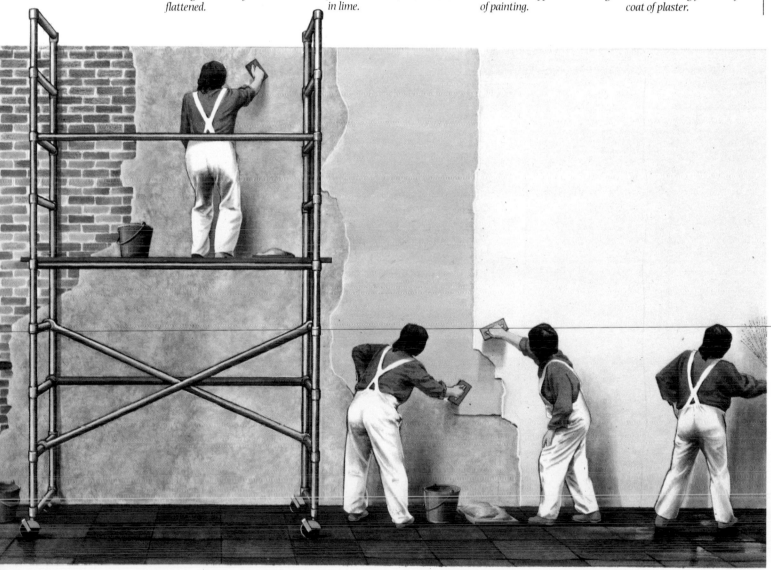

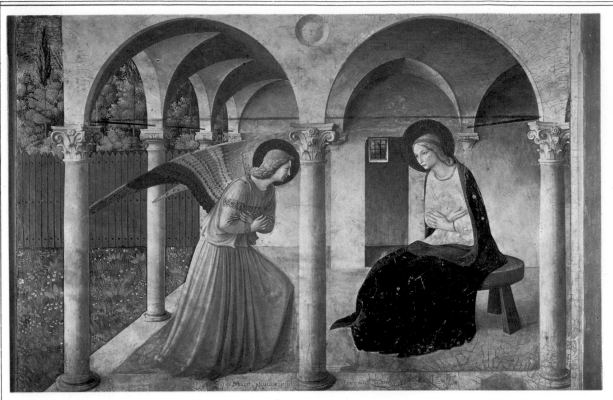

Left **Fra Angelico: The Annunciation** *Fra Angelico was a pioneer in the use of perspective to organise design, as is shown by the "trompe l'oeil" effect of the small window in the cell in the background.*
Right **Masaccio: The tribute money** *The drama of the incident is reinforced by setting the tight knot of figures against a distant landscape, while the separation of the two figures from the main body is emphasized by placing them against foreground buildings.*

Below **Painting a fresco** *A cartoon of the day's painting must be made and the lines traced into the wet plaster with a slate pencil. Paint is then applied in thin washes and the lines of the drawing redefined. Areas of middle tone are best laid first and modelled with light and dark tones. Work must proceed quickly and precisely.*

Tracing through the cartoon *The lines of the cartoon are traced into the plaster.*

Applying washes *Thin washes are flooded into, and absorbed by, the plaster.*

Drawing lines *The outline of the drawing is then redefined.*

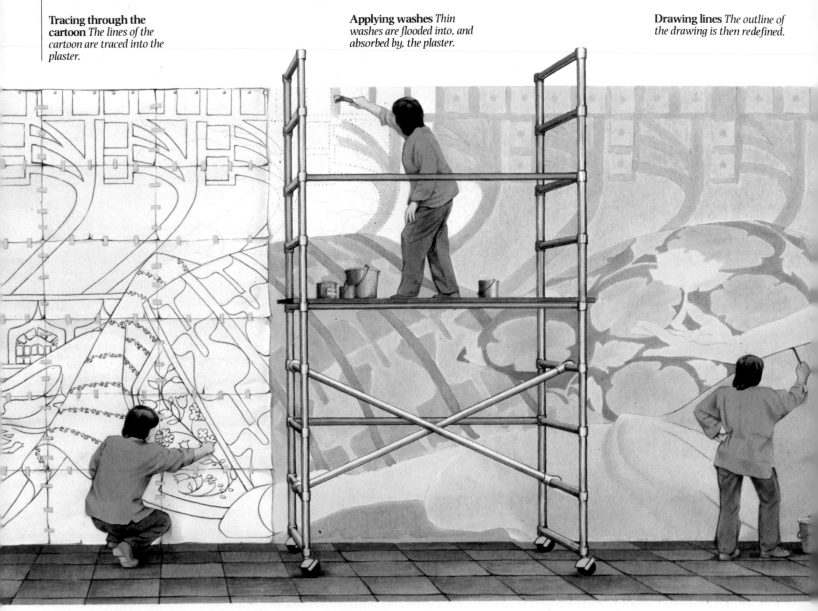

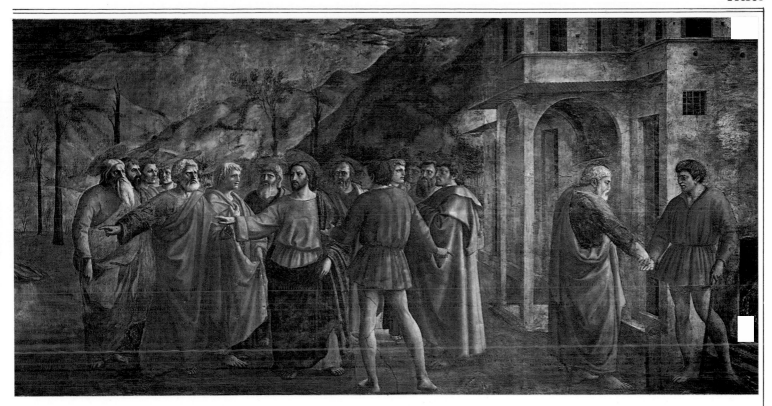

Adding highlights *Bianco-sangiovanni may be used over a light mid tone.*

Darker tones *These are added with a dark shade or complementary colour.*

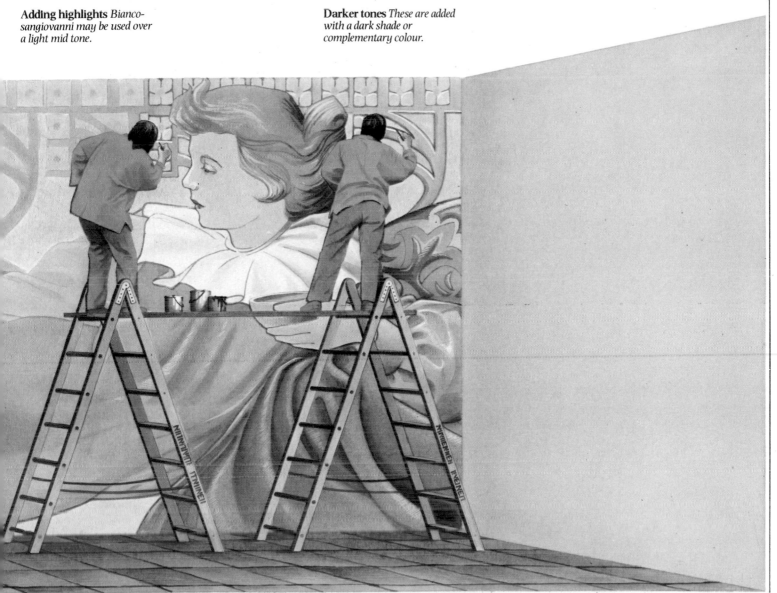

Paints

Frescoes work best if the artist's palette is reduced to a few colours only. The chemical make-up of the pigments is important, as some pigments do not combine well with lime. Artists intending to work in fresco are well advised to discuss their proposed palette with their artists' colourman's chemist. The following pigments are suitable for fresco: Biancosangiovanni (pure white lime); Yellow ochre; Naples yellow; Cadmium red; Indian red; Caput mortuum; Red ochre; Potter's pink; Terre verte; Viridian; Cobalt green; Raw umber; Brown ochre; Perigord (raw and orange); Cobalt; Cerulean; Ultramarine; Black oxide of cobalt; Iron oxide black; Manganese black.

Below **Giambattista Tiepolo: Ceiling in the Würzburg Palace** *The unusual brightness was achieved by the skilful overlaying of thin washes of colour.*
Bottom **A cartoon** *A full-scale drawing must be made before work begins. From this, a separate tracing is taken of the estimated area of each day's painting. The borders of these areas should be organized so that joins in the plaster will be inconspicuous.*

Techniques

Making cartoons Before painting or plastering begins, the artist must make a full-scale cartoon, and must plan his colour scheme exactly. For example, he must decide whether any outlining or tonal modelling is to be done with a darker shade of the same local colour, with a complementary colour, or with a mean colour used for shadows throughout the fresco. With a plaster fast drying out, there is no time for indecision. Making alterations will raise the plaster, and by mixing lime from the plaster with the pigment will cause a patchy effect when the fresco dries. Errors can only be remedied by cutting the plaster out and replacing it, which is a very tricky operation.

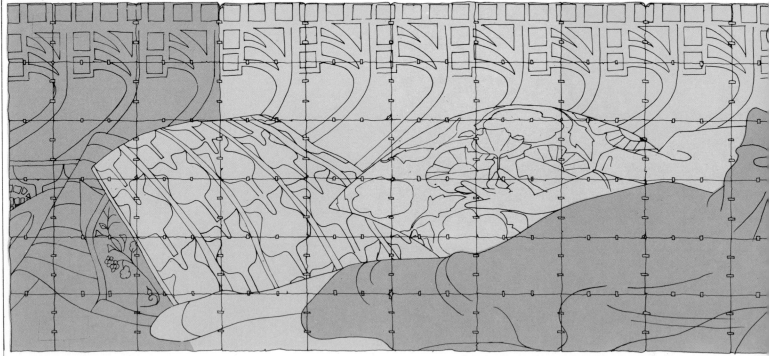

The cartoon should indicate the areas to be covered by each day's painting. The borders of each area should follow a line where a join in the plaster will not be conspicuous. Of each of these areas a separate tracing must be made, and key outlines scored through this on to the wet plaster with a slate pencil before each day's painting begins.

Applying the paint Paint can then be applied with soft animal-hair brushes. Powdered pigments in pure water should be arranged in small saucers, and mixed on a palette—ideally one with a white celluloid surface.

The painting technique which fresco encourages is a flooding-in with thin transparent colour like a water-colour wash, and then an incisive drawing-in with lines to define form and outline. It is useful to remember the old Italian principles of a middle tone decorated with a darker tone to model it, leaving a lighter tone to provide the main body. The light tone can be given extra body with the addition of a little biancosangiovanni (white lime), though it must be borne in mind that this will dry lighter than it appears on the palette. A still paler highlight and a few accents of extra-dark are effective for representational frescoes. The early Italians used hatching or shading to model forms, and Tiepolo's far later—eighteenth century—frescoes reveal how even a style of painting which from a distance looks realistic, is in fact simplified into broad tones with accents judiciously placed.

Above **Michelangelo Buonarroti: The Libyan sibyl (detail, Sistine chapel ceiling)** *The ceiling's surface area was divided into triangles and rectangles before the outlines of the figures were traced.*

Right **Giotto di Bondone: Lamentation over the body of Christ (detail)** *This shows the divisions between the areas of plaster applied for each day's work. The haloes were built up in plaster and gilded.*

105

Chapter Seven
Exterior painting

Exterior wall paintings provide an art form which can be seen, discussed and enjoyed by a wider audience than any other branch of contemporary art. The main object of many of these paintings is to enhance an environment, but they often convey information as well. Paintings can of course decorate the walls of private gardens, and where a window looks out on an otherwise blank wall, a painting—especially a landscape—will obviously improve the view and enlarge the apparent space.

Decorating the exteriors of buildings is as ancient a practice as building itself, and has continued throughout history—from the coloured walls of Mesopotamia and the garish exterior friezes on the Parthenon, to the modern murals in Mexico City and the recent outcrop of wall paintings in the United States.

In Europe the cathedrals and abbeys which survive from the Middle Ages reflect the pre-Renaissance attitude that painting, architecture and sculpture were all part of one process: making buildings. The increased specialization which followed the Renaissance led to paintings being made on canvas for individual collectors instead of on walls for everyone.

After the Renaissance, most parts of the western world saw comparatively little exterior painting until the 1960s, when they quickly became popular in the United States. The wall of "Respect" painted in Chicago by Black artist William Walker was one of the first of a stream of murals to appear in the big cities. Many of these were painted by

Below **Fifth century AD wall painting, Sigiri, Sri Lanka** *These figures are protected by a rock overhang, and were painted on to plaster at least one inch thick by a method similar to true fresco. They have never been retouched, although the edges of the plaster have been maintained.*

ethnic minority groups, and by bodies concerned to improve their drab surroundings. In New York an organization known as "City Walls" hired professional billboard painters to enlarge abstract designs made by artists on to the walls of multi-storey buildings.

In the British Isles, until a few years ago, Belfast and Derry—with their murals of the Unionist hero King Billy (William of Orange)—were the only cities with a tradition of wall painting. However, during the 1970s the idea has become increasingly popular with much support coming from public bodies as well as local residents. There are well over one hundred major wall paintings throughout the country.

Left and below (details)
**Ken White and the
Thamesdown Community
Centre: Golden Lion Bridge
– Swindon, England** *The
design was derived from old
photographs and drawn on to
the wall using a squared-up
grid. General purpose
emulsion paint was used
throughout. The project took
three months to complete.*

Walls

An ideal wall is easily seen, even at night, in good clean condition sheltered below a parapet or secure trough and on the side of a heated inhabited building. For a minimum of weathering, it should face east away from the strongest rays of the sun, and should be sheltered from the prevailing winds.

Exterior paintings almost always have to be made on existing walls, rather than on walls specially built with painting in mind. An outdoor painting is only as secure as the wall on which it is painted, so if durability is required, it is likely that the wall will require treatment before painting can begin. However good the surface, it is best to prime a wall either with a proprietary stabilizing solution, or a thinned coat of paint before beginning the painting proper.

Paint will usually last between three and ten years, after which the original surface tone and characteristics, such as mortar lines, cracks and organic growths will reappear. External walls are subjected to a highly destructive concentration of ultra-violet rays and to chemical attack from such materials as acids and sulphur derivatives. They are continually bombarded by gritty airborne particles, rain and snow, all of which are highly abrasive and can cause quick deterioration.

Cleaning walls No matter how good the paint is, it will not adhere to damp, oily, sooty or excessively dusty walls. Surface preparation will often involve scraping, brushing, re-pointing, rendering and the removal of natural growths. Extra attention will be required for the sheltered sections beneath gutters and window sills which readily collect dirt. Oil residue which is liable to remain on concrete surfaces after shuttering (the casting process in building) must be removed with solvents or neutral detergents, or by abrasion.

With masonry surfaces almost all problems are caused by moisture. It is usually advisable therefore to wait until the early summer months when the wall has dried out before beginning to paint. Moisture causes a general loss of adhesion, blistering, flaking, patchiness and staining. Any water which causes splash or flow stains should be diverted. Beginning the painting at least a foot above the ground can reduce splash and lessen the effects of rising damp. Extra care must be taken when painting on to a retaining wall which backs on to earth or water, because the constant damp will quickly destroy the paint layer. It is best to use extra sealing coats, or very porous coatings, such as mineral paints.

Alkali and efflorescence Alkali, which is present in all masonry materials and especially troublesome in new constructions, can blister, bleach or discolour a paint surface. It must be brushed clear before the wall is primed with one or two coats of alkali-resistant stabilizer.

The stabilizer should seal the surface and prevent the patchiness which can result from uneven surface porosity. It will also seal rust stains from iron structures attached to the wall.

In the spring, efflorescence or lime bloom — white, fluffy crystals — may appear. This is left on the surface by absorbed water which has dried in

Right **Preparing a wall**
Unless paint is to be applied to a newly built wall, some preparation of the surface is essential. First, any loose particles must be brushed away. Then natural growths, such as mould and moss, *should be removed by brushing over with a bleach solution. Brick walls should be repointed if necessary. All surfaces should, ideally, be primed with stabilizing solution.*

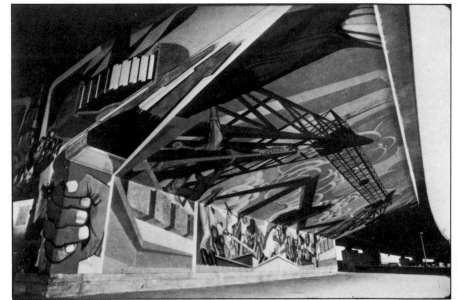

Rendering 1. *Scrub the wall with a bristle brush. The surface may be scraped to provide a key or given two coats of P.V.A. adhesive, applied with a paint brush.*

2. *Apply the first coat of render – 4 parts of sand to 1 of cement – evenly with a trowel, before the second coat of adhesive dries.*

3. *Make scratches in the render to give it a key and allow to dry. Then apply the second coat, smoothing it out with a float to give a flat surface with a good key for paint.*

Above **David Binnington: Royal Oak mural – Paddington, London**
Painted underneath a multi-lane flyover, this mural is protected from rain and sun by an extensive overhang. It is painted with silicate paint which penetrates the surface and will last as long as the wall itself.

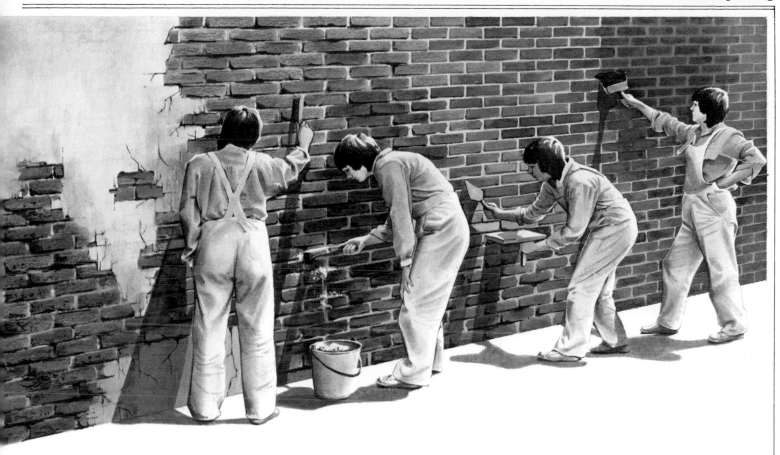

Left **Deterioration** *All exterior paints, except silicate, will deteriorate after a few years unless they are retouched.*

Removing mould 1. *Apply a solution of bleach – 1 part bleach to 8 of water – with a bristle brush. Protect hands with rubber gloves.*

2. Allow the wall to dry, then rub off any remaining mould with a stiff bristle brush.

the warmer weather. It can stain or push the paint film off, and must therefore be brushed away. In more extreme cases, wait a few days and if efflorescence reappears brush it off again before applying a coat, or coats, of stabilizer.

Natural growths Moulds, algae, lichen and mosses are a major threat: as they grow they will tear the paint film off the surface. Moulds are often difficult to identify and can be mistaken for soot, grime, or a natural stone surface. Most growths can be removed by a mixture of one part household bleach to eight parts water. Indoor emulsion paints will encourage natural growth: but most exterior colours contain fungi stabilizers.

Covering old paintwork If paint is superimposed on existing paintwork, the new film will shrink on drying and the force exerted may detach the orig-

inal coats. A stabilizer or binding down sealer is a useful safeguard, but it may not be able to pen etrate several layers of old paint. Areas of peeling paint should be cleaned right off, at least up to a strong edge of secure paint. Manufacturers will recommend seals for awkward existing paint which is difficult to cover.

Stripping paint Steam can be used to remove large areas of emulsion paint; solvent paint remover (methylene dichloride) will lift other paints. All types can be removed by mechanical sanding or blasting. A product called "Graffitiklens" should remove all kinds of scrawling. When it has been stripped, a wall should be cleaned down with a neutral detergent.

Rendering Rendered walls provide a good painting surface, but if the render is crumbling or patchy all loose areas must be removed, and the surrounding render scratched and scraped until there is a secure surface with a good key. To make a render, mix enough porous cement, lime and sand for two coats (undercoat and finish coat). The lime makes the mix more workable and elastic. Never attempt external rendering when there is a risk of frost.

For high density backgrounds—a hard brick or smooth concrete surface with low suction—a key must be made by bush hammering or chiselling. A render of one part cement to three parts sand applied with a woodfloat will produce a smooth finish. For weak wall surfaces—old bricks or lightweight concrete—the render must be weaker than the background because shrinkage can cause the original wall surface to break up. A mixture of one part Portland cement, one part lime, and five parts sand should be used.

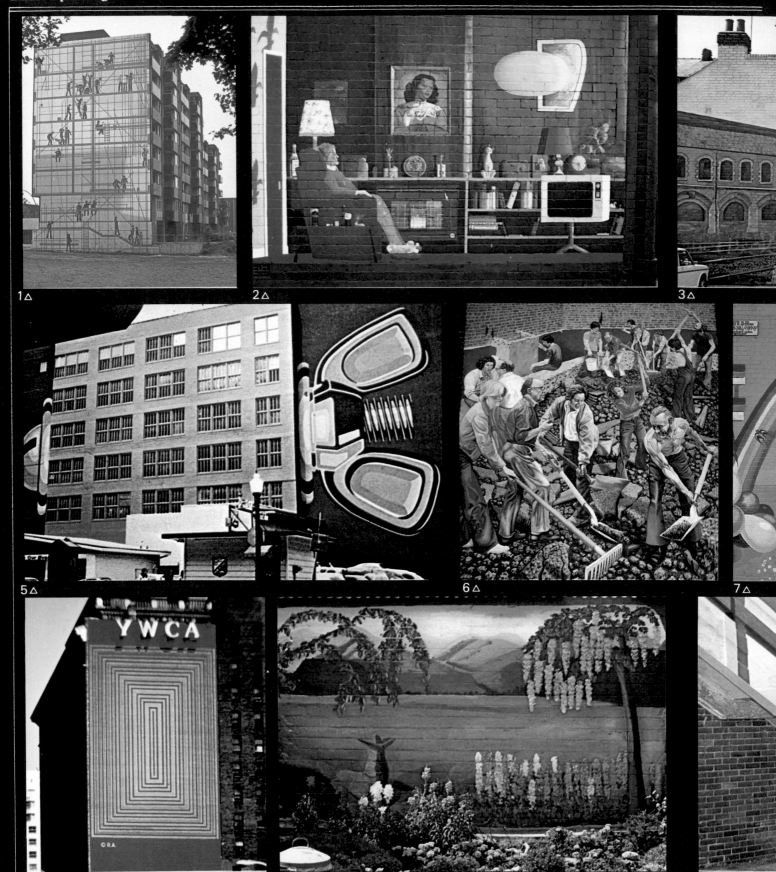

1△ 2△ 3△

5△ 6△ 7△

10△ 11△ 12△

1. The Horizontal Group: Mural – Hamburg *A carefully planned design painted by a number of people, requiring considerable organization.*

2. Walter Kershaw and Olive Frith: Rochdale interior (detail) – Lancashire, England *Painted on the end wall of a terrace with general purpose emulsion paint. The perspective is designed for viewers walking along the adjacent main road.*

3. Thamesdown Community Centre: Great Western Works 1843 – Swindon, England *Exterior emulsion paint was used to produce this mural which is based on a photograph.*

4. Chilean Group: New University mural – Bremen, West Germany *Painted in the style of the Chilean Brigade, who painted murals illegally at night in Chile. Only flat colours were used, because tones were difficult to differentiate: each member of the group applied a single colour.*

5. Paul Levy: Bolt – Cincinnati, USA *The graphic design was transferred to the wall either by projecting a slide, or with a squared-up grid.*

6. Steve Pusey: Garden mural –Covent Garden, London *The realistic qualities were obtained here by drawing lines round projected photographs, taken during the construction of the garden below.*

7. Bryan Barnes and Wandsworth Mural Workshop: Morgan's Walk

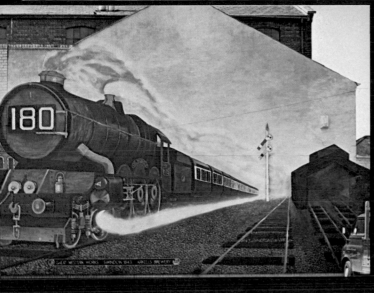

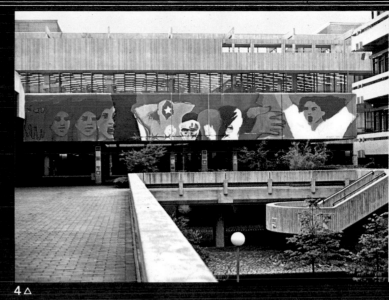

4 △

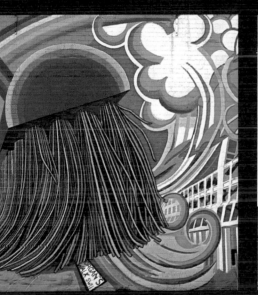

8 △

9 △

13 △

14 △

(detail) – Battersea, London
*Gloss paint was used over a
white undercoat.*
**8. Noel Millar: Brief
encounter – Londonderry,
Northern Ireland** *The paint
was applied to a rendered
surface, and the border was
painted brown to emphasize
the envelope.*

**9. Robert Lenkiewicz:
Barbican mural –
Plymouth, England** *An
extremely detailed painting
made up of a large number of
portraits of Elizabethan
personalities with
contemporary local children in
one corner.*
10. Richard Anuszkiewics:

Y.W.C.A. Mural – New York
*City Walls Incorporated
employs artists to design
murals and billboard painters
to transfer the design to the
wall.*
**11. G. Naldrett: Distant
view – Cardiff, Wales**
*Emulsion paint was used on a
garage wall close to a living*

*room window. The apparent
space of the garden is
considerably increased.*
**12. Graham Cooper:
Stairway – Bury, England**
*General purpose emulsion
paint was applied to a cast
concrete staircase; the shallow
relief of the concrete is the
basis of the open fence design.*

**13. Ken Watts: Seaman's
General Stores –
Sunderland, England** *The
painting begins above ground
level to protect it from rising
damp and splash stains.*
**14. Mural – Amsterdam,
Holland** *Existing
architectural features are
incorporated in the design.*

Paints

Exterior paints should be durable, of consistent colour and provide a good even coverage, without peeling or running. They should have a chemical resistance to alkalis and salts in the substrate and a weathering resistance to rain, ultra-violet rays, industrial fumes and microbiological attack from the environment. The paint should prevent rain-water from penetrating the wall, yet allow moisture to evaporate outwards through the film. It should not retain dirt, but allow it to be washed away by rainwater.

Exterior paints should be easy to apply by conventional means and not toxic or odorous. Good adhesion on difficult chalky surfaces, on fresh concrete or mortar, and fast drying qualities with a good film formation at all temperatures are needed.

Darker paints reflect scratch marks more readily and often dull with age—lighter colours tend to become bleached. Most exterior paints cannot be applied at temperatures below 41°F (5°C), or when it is raining.

Paints for surfaces The characteristics of the wall surface may well govern the choice of paint (see chart). For Portland cement rendering, stucco and concrete, cement paints can be used soon after the surface has been laid; acrylic emulsions or other porous alkali-resistant paints can be used after four week's drying. If gloss paint is to be used, an alkali-resistant primer should be applied first. Paint—especially gloss—is liable to delay the drying of a new wall when both sides of a wall are painted, or when one side is painted and the other is tiled.

New and repaired brick and stone work require alkali-resistant paints, because of the presence of Portland cement. Surfaces which combine brick and stone vary in porosity—bricks and mortar contain soluble salts which cause efflorescence—and should therefore be given an undercoat of paint stabilizer. If engineering, glazed or other imporous bricks are to be painted, a strongly adhesive paint, such as chlorinated rubber, pliolite or polyurethane, is best.

Imporous exterior surfaces such as steel and iron alloys will receive better protection from solvent-thinned paints than from water-based paints (some PVA emulsions actually encourage corrosion).

Emulsion and gloss The most popular general purpose emulsion and gloss paints have a wide colour range and on a good surface under reasonable conditions a three to six year life can be expected. All water-thinned paints will absorb water, become tacky, and over a period of time will expand, causing movement which results in tearing. Vinyl distempers, water paints, matt or low quality emulsion paints are unsuitable for exterior use.

To reduce weathering and pollution effects, colours with a high light fastness and good alkali and acid-resistant qualities should be used. The availability and wider range of colours make general purpose emulsions ideal for more temporary decorations, such as advertisements, brightening up old districts, hoardings and construction site fences and murals with a quick, popular or political message.

Exterior paints The more durable exterior paints are expensive, have a very limited variety of colours and are usually only available in five litre tins. They dry to a matt finish, which camouflages surface and textural irregularities more effectively than gloss paint; it also provides porosity in the paint film which allows moisture to exude from the wall. Imporous paints are likely to blister under the pressure of moisture from inside the wall.

Exterior paints are ideal for architectural decoration and newer property, but pigments (see chart) may have to be added to produce a rich palette. It is best to use either highly dispersable pigments of the same base as the paint, or "universal" pastes, which can be used in any base.

The pigment should have good light fastness and strong resistance to alkali. Organic earth pigments tend to be safe whereas the inorganic oranges, yellows and violets are liable to be fugitive. Reliable pigment manufacturers, such as Ciba, Geigy, S.C.C. Colour Ltd and Bayer, will provide information on the properties of the various colours. Add the pigment gradually, stirring well to avoid streaking and over-saturation. The binder can only accept a certain amount of pigment; more than this will cause mottling.

Silicate paint Silicate, or silicon-based paints—also known as mineral paints—adhere strongly to plaster, tiles and Portland cement, but the paint layer is porous and does not protect the surface from moisture and decay. The silicon binder hardens like a cement, as the alcohol evaporates, fixing itself on to the surface.

If the painter mixes his own base, he can adjust

Paint	Thinning agent	Durability (years)	Drying time between coats (hours)	Other qualities
General purpose emulsion	Water	3	4	Low alkali, efflorescence and mould resistance.
Exterior emulsion	Water	4–7	2–6	Good porosity. High alkali resistance.
All acrylic	Water	5–10	2–6	Expensive, but superior to emulsions.
Sandtextured	Water	4–10	2–6	More durable if applied thickly.
General purpose gloss	Turpentine, white spirits	3–6	16–24	Hard-wearing and easily cleaned. Low porosity. Makes uneven surface conspicuous.
Polyurethane	Turpentine, white spirits	3–4	6–8	Very brittle. Poor porosity.
Exterior masonry	Turpentine, white spirits	4–7	16–24	Limited colour range.
Rubber resin masonry	Turpentine, white spirits	7–12	12	Good adhesion. Limited colour range.
Cement based mineral	Distilled water with alcohol	5–7	24	Excessively porous. Tends to retain dirt. Limited range.
Silicate	Distilled water	2–100	2	Thin and transparent. Fixative should be applied after final coat.

the coverage either by using opaque colour, or by building up the image with layers glazed on to each other. A silicon paint base can be made by stirring together: 80 parts of ethyl silicate 40; 18 parts of 190 proof denatured alcohol; and 2 parts of dilute hydrochloric acid (0.4 per cent in water). Allow this to stand for at least 12 hours, and then add 5 parts of water.

Mixing and thinning Different brands of paint should not be mixed together, because each manufacturer has a different formula. Similarly, mixing pigments of different qualities produces unstable colours which will eventually reduce towards the quality of the stronger pigment in the mix.

Most paint can be applied straight on to the wall, but the first coat will penetrate the surface better if it is thinned—up to 25 per cent clean water for emulsion paints, 10 per cent genuine white spirits for solvent paints—and applied with a brush. Expensive failures can be avoided by painting a trial patch and testing its adhesion.

If it proves difficult to obtain a satisfactory result, most companies will recommend their own stabilizing solutions or masonry primers which are designed for high penetration, to bind dusty and crumbly surfaces and to control suction and uneven porosity.

Stabilizing solutions Stabilizing solutions are primers, which bind and neutralize surfaces: they are not thinners for mixing with paint. They often have a low flash point, and should be kept in a cool place away from naked flames.

Varnishes Special varnishes for exterior paint work are rare, and the more common ones are not

usually porous, so that blistering or peeling is likely to occur after a few years. Acrylic emulsion glazes and polyurethane varnishes will provide coverage for a limited time. "Chemseal" will provide a seal for masonry and concrete and should last for between five and seven years outdoors.

Concrete stainers Exterior surfaces can be coloured with concrete stains such as "Stone Tones". These stains penetrate the pores and fix their colour by reacting with the cement particles. They are suitable for marble, limestone and concrete surfaces, but not for slates, sandstone, bricks or clay products.

Coloured renders Colour can be added to render, by incorporating pigment (see below). For structural reasons, no more than ten per cent of the weight of cement in the render should be added as pigment. White cement and white sand will provide richer colouring; grey cement will deaden the tones. For a quicker and more even dispersion make the pigment into a paste; avoid using too much water, because this will weaken the render.

To increase the surface colour further, it is possible to brush more pigment on to the surface before the render has dried. This fresco-type technique will be most successful on a smooth surface using highly dispersable pigment. If powdered pigment is used, a little soap solution will aid the dispersion of the colour.

Plastic renders There are resin-bonded coloured decorative and protective renders available, which are designed for application with a trowel on to a smooth surface. These have a lower coverage rate and less versatility than most external coatings.

Pigments for mixing with exterior paint *The palette provided by the available ranges of ready-mixed exterior paints is rather limited. For elaborate colour schemes, or to achieve subtle tonal variations, it is usually necessary to mix pigment with an exterior paint base. Powdered pigment is widely available and can be mixed into a white or coloured base. Some common pigments, useful for exterior work are shown below.*

Yellow iron oxide *A greyish yellow*

Hansa yellow *Poor opacity*

Yellow titanium dioxide *An opaque light yellow*

White titanium dioxide *A strong, opaque white*

Red iron oxide *Several tints available*

Brown iron oxide *Available in light and dark shades*

Black iron oxide *Dense and opaque*

Violet carbizole *Startling, but expensive*

Phthalocyanine blue *Likely to bronze as it weathers*

Phthalocyanine green *Good light and chemical fastness, even when diluted*

Green chrome oxide *Opaque and resilient*

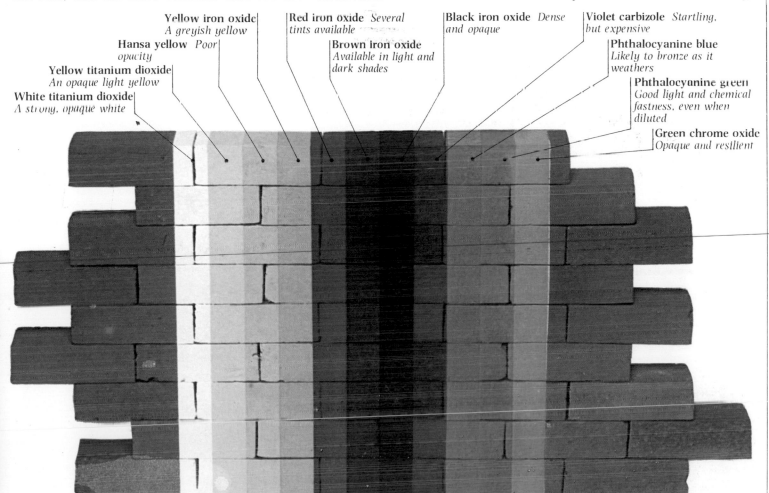

Equipment

Some equipment will almost certainly have to be bought, hired or borrowed, so it is worth keeping it simple, but safe. Ladders are the most economical way of reaching one small area on a high surface.

A ladder should always be kept at about 70° to the ground and the user should lean into the ladder and never overhang too far. A hook should be used to hang the paint tins from a rung, so that both the painter's hands are free.

Scaffolding is safer and more convenient, particularly if a number of people are involved. The roller tower type can be used; otherwise scaffolding should be erected by experts who can advise on safety. It is dangerous to use ladders to gain extra height on scaffolding, and it is advisable to use a pulley for lifting materials. More complex equipment, such as painter's cradles and hydraulic platforms are expensive, but ideal for large walls.

Below left **Dog shop mural— Notting Hill, London** *An example of how architectural features can be elaborated and enhanced.*
Below right **Bryan Barnes: Morgan's Walk —Battersea, London** *A detail showing work in progress. Scaffolding is safer and more efficient than ladders.*

Techniques

Making a design Record the wall and its surroundings accurately, either photographically or by sketching, from the point where it will be viewed most frequently. Observe the dimensions and shape of the wall, and the atmosphere and features of the surrounding district.

Examine the wall in detail, because ideas may come from the architectural features, such as windows, chimneys and drainpipes, and the shadows they cast. Such features can either be reinforced, absorbed or optically obliterated. Corners can be eliminated with projection lines continuing around them, but relating the forms on the different planes. The surface texture, and the way building materials have been laid can also be exploited very effectively.

The scale of the elements in the picture should usually be related to the viewing distance and the

relative size of the wall and its background. Reducing the proposed size of the picture components can increase the apparent dimensions of the wall. Enlarging or reducing some picture components can also emphasize importance or priority. Areas furthest away from the viewer may have to be enlarged to maintain a balanced composition.

Useful or informative elements such as sign posts, sundials, natural vegetation or goal posts can be introduced into the design. This idea has been used in playground areas for measuring and graph calculations, mazes, and for exercises in letter and word recognition.

The type of paints available and the corresponding palette must be considered early in the design process. Transferring a design on paper in one colour medium to a large expanse in another medium can alter the whole emphasis of the original composition. Bear in mind that large scale decorations can be achieved more easily if stencils or repeated patterns are used.

A number of successful decorations have intro-

duced warm shades into cold areas: in hot climates cool colours will be effective. But an abundance of a particular colour, especially dark, or light, tones on a large scale may overwhelm detailing in another colour. A black, or dark, border around a decoration will increase the apparent strength of the colours.

Applying a grid When the design is ready it should be enlarged to a scale of at least 1:20 full size, so that details can be included. Draw a grid of squares over the enlarged design so that everyone involved can see at a glance the relative positions of the picture's components. Transfer the grid to the wall using chalk, charcoal, or thin paint lines.

Putting on the paint Paints should be mixed thoroughly and the manufacturer's recommended time allowed between coats. Work from the top downwards so that the inevitable drips can later be covered over. Wipe off any splashes immediately with a damp cloth or sponge. The first coat must be completely dry before another is added.

It is best to paint the whole length of the wall without elaborate detail first, rather than completing some areas down to the smallest detail leaving other parts untouched. In this way the whole effect can be evaluated, and altered if necessary, at an early stage.

Above **Hoarding mural 1—Covent Garden, London** *The corner of the wall has been optically obliterated with a design continued on both planes.* Right **Steve Pusey: Garden mural— Covent Garden, London** *A painter's cradle is ideal for exterior painting.*

Above right **Ken Billyard: Preparatory drawing for mural (below)** *An accurate scale drawing which could be transferred to the wall by squaring up, or, in this case, by using the angular architectural forms.*
Right **Walter Kershaw: Mural— North Western Museum of Science and Industry, Manchester, England** *Here, work is in progress. Kershaw completed the mural to Billyard's design after the latter's death. The difficulty of transferring a design made on paper to a wall, with the inevitable change of medium, is clearly shown.*

Water colour

Water colour paints are pigments ground very finely into gum arabic, which is obtained from acacia trees. The gum is easily dissolved in water and gives a firm adherence when laid on to paper. In addition, it acts as a light, thin varnish, giving greater brilliance and luminosity to the colour. Originally gum arabic was used alone, but later honey, glycerine and syrup were added to retard drying and aid transparency. Most of these refinements came about when artists' colourmen like Winsor and Newton, Reeves and Newman began producing consistent and reliable paints. Since then other additives have been used, not all introduced into the paint, but often added by the artist into his water as an aid to a particular technique.

Many people think that water colour painting was invented in eighteenth century England, but it was in fact a fully developed art form long before that. The English water colour painters of the eighteenth century reached such heights, that this form of painting became known as the "English

Right **Albrecht Durer: The Monumental Turf** *Durer was the first major artist to use water colour. Here he used carefully laid transparent washes, linear work and opaque colour.*

Below **Thomas Girtin: The White House, Chelsea** *One of the first English water colourists, Girtin used a palette of just five colours. Here washes are overlaid, one above another, and by carefully organizing the composition he has left white paper to portray twinkling highlights.*

Bottom **John White: The Indian Village of Pomeiooc** *Painted in 1585 on an early voyage to the Americas, this accurate descriptive painting relies on wash and thick line.*

The towne of Pomeiock and true forme of their howses, covered and enclosed some with matts, and some with barcks of trees. - All compassed abowt with smale poles stock thick together in stedd of a wall.

Art'' and Paul Sandby (1725–1809) was dubbed the "father of English water colour"; but we need to look elsewhere for the true origins of water colour. The German artist, Albrecht Dürer (1471–1528) could more truly be dubbed "father", for he used the medium extensively, creating hundreds of works in water colour long before Sandby and his contemporaries.

The medieval illuminators were highly skilled in the craft, the earliest of them using pure, meaning transparent, water colour, the later ones adding opaque or body colour (see Gouache), partly to make a ground on which gold leaf was laid.

Some artists, such as Van Dyck (1599–1641), Gainsborough (1727–88) and John Constable (1776–1837), used water colour to make swift

Below **Paul Klee: Motif of Hamammet** *Klee's most important work was done with water colour. Here his interest in proportion, colour and design is revealed in a series of loosely, but carefully applied, washes. The texture of the rough paper shows through and gives unity to the whole painting.*

notes of an atmospheric kind—a rainbow, rapidly moving clouds, shifting reflections and so on—that would later be used as information to feed bigger oil paintings. However, most artists who used the medium at all used it in one or other of its characteristic ways, and as an end in itself. Men such as John Crome (1768–1821), John Varley (1778–1842) and John Sell Cotman (1782–1842) differed widely in intention and results, but nonetheless used water colours as a very expressive and sensitive art form.

William Blake invented his own method of painting which involved spreading paint on to an impervious surface and transferring the image to paper by applying pressure to the back, working over this initial paint surface in body colour to

Klee

Left **Chinese, late eighteenth century: Archery scene** *Painted on silk, this drawing displays fine linear detail and a clever use of colour – the reds recur to form a pattern. A range of marks is employed including strokes, dots and dabs.*

Right **Bamboo brushes** *The Chinese water colourists use long tapering brushes with extremely fine hairs and bamboo handles. Brushes of this kind are manufactured in the west, and are useful to water colourists who want to add delicate flecks of wash or colour.*

elaborate and enrich it. Thomas Girtin (1755–1802) used a strictly limited palette, as did a great many of his contemporaries, and applied the paint in thin washes which, once dry, were overlaid with other washes until a strongly tonal picture was achieved. J. M. W. Turner (1775–1851) used the medium to convey ideas which seem to deny paint at all, let alone the restrictions imposed by Girtin's method. He splashed, scratched and moved the wet paint about until the paper glowed back with brilliant sunlit images of Venice and Vesuvius, or quieter descriptions of mountains, rivers, lakes, fields and towns.

Water colour has continued to be a popular medium. Several Victorians, especially Millais (1829–96) used water colours to make saleable copies of larger oil paintings. Winslow Homer (1830–1910), Thomas Eakins (1844–1916), Edward Hopper (1882–1967) and latterly Andrew Wyeth (born 1917) have ensured that the tradition flourishes in the United States, while Edward Burra (1905–76), David Jones (born 1895) and Paul Nash (1889–1946) are perhaps the major British exponents. Paul Klee (1879–1940), a founder member of the Bauhaus, produced his most significant work in the medium.

The chief characteristic of water colour is its transparency, and in "pure" water colour painting this is exploited to the full. The lightest tones – highlights, bright skies, whitish details – are given by the untouched paper, which is usually white but sometimes toned by the artist before he starts painting. Unlike the painter in oils, who can lay lighter paint over dark tones, the water colourist must work through from the lightest tones to the darkest. Even a very light tone laid over a dark one will darken it still further by covering more of the white paper underneath. It is this quality of the paper shining through the transparent pigment which gives pictures in water colour the brilliance and sparkle which sets them apart from other styles of painting.

Water colour and gouache can be used together very effectively. Chapter 9 (p.142) discusses gouache and how to use it.

Above **J. M. W. Turner: Tintern Abbey (detail)** *An excellent example of white paper left untouched to create highlights. Turner used a limited palette for this painting to lay flat and broken washes with strong tonal contrasts.*

Left **Superimposed washes in a single colour** *Tonal gradations can be achieved by laying washes of the same strength on top of one another. Each wash must be allowed to dry before the next is laid. A similar effect can be gained by laying washes of different strengths side by side, but this can be harder to control.*

Surfaces

Paper The surface on which the artist makes his picture is known as the support. The most usual form of support chosen for water colour painting is paper. This has the advantages of being relatively cheap, easily transportable and available in a great range of colours, weights and textures. The choice of paper is a matter of personal preference, depending very much upon the artist's style of painting and the particular subject in question. There are three standardized types available.

Hot pressed paper This is often called H.P. It has a hard smooth surface suitable for drawing with pencil, pen and ink, or line and wash. Most artists find this surface too smooth and slippery for pure water colour painting although a few find it suits their style.

Cold pressed paper This is sometimes referred to as "not", meaning not hot pressed. It is a textured, semi-rough paper which is good for large, smooth washes and for fine brush detailing. It is the most popular of the three surfaces and an ideal paper for less experienced painters.

Rough paper This has a definite tooth to its surface. When a colour wash is laid on it a speckled effect is achieved because the pigment is precipitated into the deep cavities of the paper, filling some, but leaving others untouched. This leaves a sparkle of white to illuminate the wash. This quality is used by experienced artists, but may be daunting to the less experienced because it is difficult to control with precision.

Weights of paper The second consideration when choosing paper is weight. The weight of paper refers to the weight of a ream, which is 480 sheets; thus a paper referred to as 70 pounds is a thinnish paper, 480 sheets of which weigh 70 pounds. Weight is of great importance: the heavier grades of paper show less tendency to wrinkle than the lighter weights. Wrinkling can occur when thin paper is wet, causing the fibres to stretch and the surface to become bumpy and irregular. It is desirable to stretch lighter weight papers before starting work. Heavier grades of paper, say 140 lbs plus, can be worked on without prior stretching, but if the painting technique is a wet one this may still be necessary.

Stretching paper Paper should be stretched on a board either with gum-backed tape or drawing pins. Pins are slightly less satisfactory than tape because there is a greater tendency for the paper to tear as it dries. There are also special stretching frames available, not unlike those used for stretching canvas. These are good for the more robust papers, but not suitable for lighter weights because, once the paper is stretched, it has no support from behind. Paper stretched on a frame can be a very sympathetic surface on which to paint because like canvas, it has a certain spring, but once it gets wet with paint it becomes all too easy to put the brush straight through.

 Boards for stretching paper need not be especially heavy. Paper can be stretched on to hardboard, or even cardboard, but the danger of flimsy boards warping as the paper dries is considerable.

Hot pressed paper *Smooth, hard paper which is ideal for pencil and pen and ink drawing, and suits some approaches to water colour. Washes may run unpredictably, but line work will dry crisp and dense.*

Cold pressed paper *Frequently called "not" paper, meaning not hot pressed. This is the most common paper used for water colours. Its textured, slightly rough surface will receive washes and line work equally well.*

Rough paper *A strongly textured paper, very useful to water colourists. If a wash is laid sparingly, pigment will catch in the pits of the surface only, leaving a speckled effect with clear white paper showing through.*

Stretching paper 1. *Place a sheet of lightweight paper in water. Soak it for a few minutes, keeping it flat.*

2. When the paper is well soaked, lift it out, hold it by one edge and shake off the excess water.

3. Lay the wet paper on the drawing-board. This should be at least 2 inches larger than the paper.

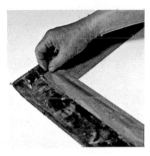

4. Beginning with opposing edges, stick all four sides to the drawing-board with gum strip. Ensure the paper lies perfectly flat.

5. Push drawing-pins into the taped corners of the paper, to fix it more firmly to the board, and prevent it wrinkling as it dries.

If, for reasons of easy transport, weight is a matter of importance, then it is advisable to stretch another sheet of paper on to the back of the board. This will prevent it from bending and if a protective sheet of stout paper is laid over the reverse side it too can be used as a support at a later date.

Hand-made paper The very best papers are those with a high linen rag content and these are usually manufactured by hand—the work of skilled craftsmen. Care is taken to eliminate all impurities and the paper is given a sized surface expressly for the water colourists' needs. These hand-made papers, which tend to be the most expensive, can be recognised by the manufacturer's watermark, which also indicates the correct side of the paper. All papers have a right and a wrong side and this is important, not only because the right side is sized, but also because the surface texture is carefully controlled.

Rice papers Well worth considering, although much more delicate and fragile than those listed below, are the excellent Japanese rice papers. These are hand-made from vegetable fibres boiled to a pulp with rice and veni root, which act as a binder for the fibres. Kozo, Mitsumata and Gambi—all vegetable fibres—are the three most popular types of rice paper. The one most useful to the water colourist is Kozo, because it is more robust and resilient although, in common with all such papers, it is highly absorbent. If a technique is devised to make use of this characteristic it can give very fine results, often of an elegant and delicate nature.

Paper manufacturers There are a large number of established manufacturers whose papers are readily available. The following are all reliable and most are obtainable from artists' colourmen: Arches, Arnold (200 lbs plus), R.W.S., Bockingford (240 lbs plus, and therefore suitable for direct painting without prior stretching), Creswick (tinted), Crisbrook, David Cox (tinted in three values, light rough, medium rough and dark rough), De Wint (coarse, slightly absorbent, textured and grey tinted), Fabriano (hand-made Italian), Green (pasteless, suitable for direct work without prior stretching), Michallet (slightly ribbed, light weight,

The two sides of the paper
All quality water colour papers have a right and a wrong side. The texture of the right side is carefully prepared and coated with size.

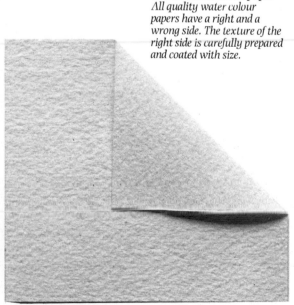

Hand-made paper *Papers containing a high proportion of linen rag are the very best for water colours. These are usually hand-made and therefore free of impurities. The makers size one side – coat* *it with an animal glue solution, which is extremely receptive to water colours. Many of these papers can be recognized by the manufacturer's watermark, which presents a mirror image* *when the wrong side of the paper is facing the user. Two of the best known papers are Saunders and Fabriano (above).*

Papers for water colours *A wide variety of papers suitable for water colours is available. A representative selection is shown below; most of these are readily obtainable. Weight, texture and tint are the principle considerations. Heavy papers, like the Arches, 5, are less likely to wrinkle when wet; light weight papers, such as the de Wint, 7, the Crisbrook, 8, and all rice papers, 11, should be stretched before use (see p. 121). Strongly textured hand-made papers, the de Wint, 4, the Arches, 5, and the Fabriano, 6, suit a wet style of painting where washes predominate and details are introduced in a loose manner. Where accurate details using*

fine lines are desired it is best to use a smooth paper with less texture, such as the Schoellershammer, 2, the Crisbrook, 8, or the Saunders, 12. Because water colour is transparent, any tint the paper has will show through. This is why white paper is most commonly used; highlights are obtained by leaving areas of paper untouched. Tinted papers, such as the Ingres, 1, the de Wints, 4 and 7, and the Canson and Montgolfier ranges, 3, 9, 10 and 13, inevitably give a water colour an overall background tone. This can be useful, because it gives the painting a unity; gouache paint is often used with water colour, or by itself, on such surfaces.

good for line work in pencil and crayon), R.W.S., Van Gelder, Kent Turkey Mill (fine strong white paper); Ingres (soft textured paper available in a range of colours), Saunders (good range for water colour painting).

Many others are also on the market, and in addition to papers made specifically for the artist, it is always worth experimenting with various, even unlikely papers.

Prepared boards Besides paper, a variety of prepared boards are available as supports for water colour paintings. These are simply thin water colour paper mounted on to stout card and, because they require no stretching or other preparation, are very convenient. Boards can be easily prepared, using papers of your own choice, simply by gluing the paper on to pasteboard very securely. If it is not sufficiently secure, the paper will lift off when dampened. Another sheet of paper pasted on the back will prevent warping.

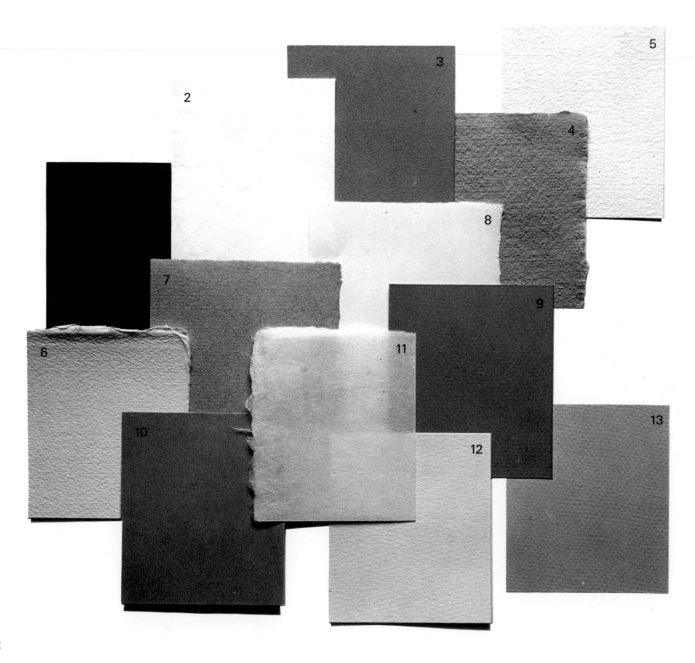

Paints

There are many qualities of paint available to the water colourist and a box of water colours can be bought very cheaply. However, in general, the purchase price unfortunately reflects the quality. Only paint labelled "Artists" is entirely reliable and it can be very expensive. Paints that do not retain the value of their colour and pale away very easily are called "fugitive", and cheaper paints have a much greater tendency to be fugitive. All water colours will pale if exposed for too long to bleaching sunlight, but the permanent colours as supplied by reputable artists' colourmen like Winsor and Newton, Reeves, Rowney and Grumbacher will retain their qualities if treated reasonably.

Making paint It is possible for an artist to make his own colours, but this is a time-consuming exer-

Forms of water colour paint
Water colours come in dry cakes, semi-moist pans and half pans, or in liquid form in tubes and bottles. Cakes, like the Pelikan range, 4, and pans, such as Winsor and Newton's Artists' Colours, 3, and the same manufacturer's pocket water colours, 6, are economical in that little colour is likely to be wasted. Cakes and pans have to be carried in tins or boxes, but these have the advantage of providing an instant palette. Pans or half pans, 7, can be bought as individual items. Bottled water colours, such as the Luma range, 1, and Dr Martin's, 2, usually come complete with eye droppers for applying the paint to the palette. Water colours in tubes, like Winsor and Newton's Cotman range, 5, need simply to be squeezed on to the palette. It is advisable to drop or squeeze only small amounts of liquid water colour on the palette; it takes no time to add more colour if necessary.

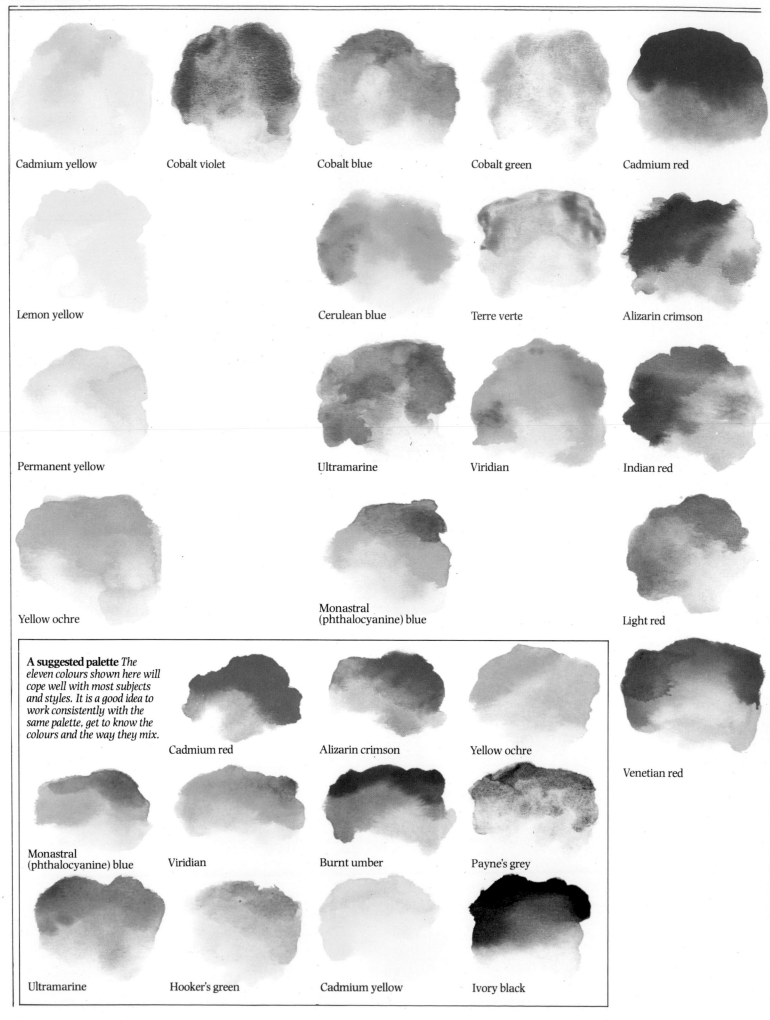

Cadmium yellow

Cobalt violet

Cobalt blue

Cobalt green

Cadmium red

Lemon yellow

Cerulean blue

Terre verte

Alizarin crimson

Permanent yellow

Ultramarine

Viridian

Indian red

Yellow ochre

Monastral
(phthalocyanine) blue

Light red

A suggested palette *The
eleven colours shown here will
cope well with most subjects
and styles. It is a good idea to
work consistently with the
same palette, get to know the
colours and the way they mix.*

Cadmium red

Alizarin crimson

Yellow ochre

Venetian red

Monastral
(phthalocyanine) blue

Viridian

Burnt umber

Payne's grey

Ultramarine

Hooker's green

Cadmium yellow

Ivory black

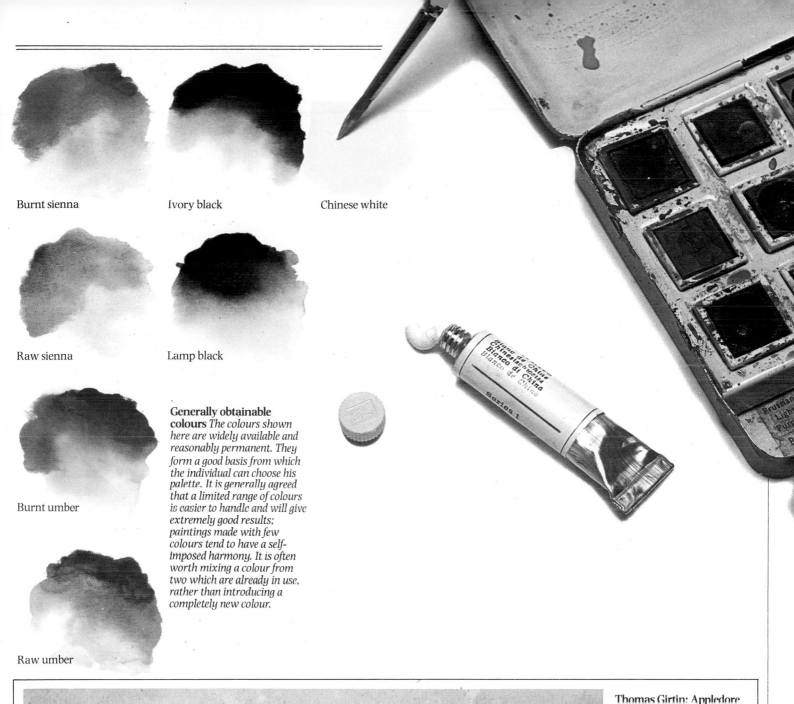

Burnt sienna

Ivory black

Chinese white

Raw sienna

Lamp black

Generally obtainable colours *The colours shown here are widely available and reasonably permanent. They form a good basis from which the individual can choose his palette. It is generally agreed that a limited range of colours is easier to handle and will give extremely good results; paintings made with few colours tend to have a self-imposed harmony. It is often worth mixing a colour from two which are already in use, rather than introducing a completely new colour.*

Burnt umber

Raw umber

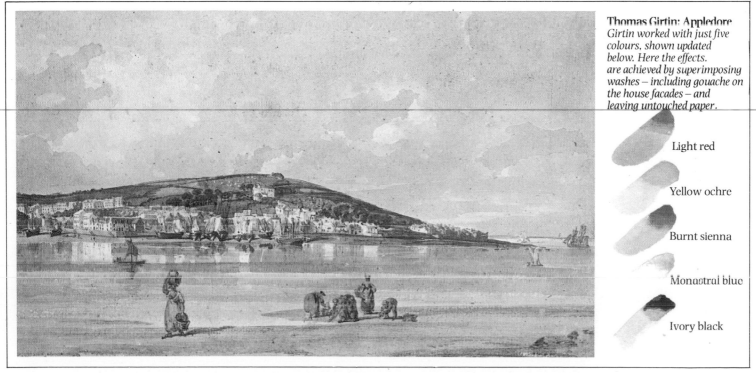

Thomas Girtin: Appledore
Girtin worked with just five colours, shown updated below. Here the effects. are achieved by superimposing washes – including gouache on the house facades – and leaving untouched paper.

Light red

Yellow ochre

Burnt sienna

Monastral blue

Ivory black

125

cise. Finely ground high quality pigments, some gum arabic, a plate glass slab and a muller – a tool for grinding – are all that is needed.

Ready-made paint Manufactured paint comes dry, in cake form; semi-moist, in whole or half pans; and as moist colours in tubes and bottles. Half pans are the most commonly used; they have the obvious advantage of being easy to carry about in great numbers, and being half the size of whole pans are cheaper to buy. The pan is a block of solid colour set into a small dish. Each is separated from its neighbour and can be used without disturbing other colours. The colour is released into the wet brush with a brisk stroking movement: the wetter the brush, the lighter the tone because the paint is suspended in more medium.

For tubed water colours, a clean palette of adequate size is essential so that a quantity of paint can be squeezed out before the brush is brought to it. Some wastage must be expected at first, because it is very difficult to judge the required amount. Unlike colours mixed on the palette from two or more pans, it is always better to make up too much rather than run out; colour straight from the tube can readily be squeezed out in greater quantities as required.

The choice of make-up is a matter of personal preference. The pan – or the even harder "cake" which is now largely obsolete – is probably less

Below **Ingredients for making water colour (left to right):** *glycerine; distilled water; ox gall; gum arabic; carbolic acid solution; sugar solution; dry pigment.*

wasteful. Pans need to be carried in a proper water colour box with slots made for them. It takes perhaps a bit longer to lift colour from a pan in quantity than to squeeze it from a tube, but pans have the advantage that while in the box they are already a palette range *in situ*. Squeezes of tube paint placed out on a palette have a tendency to run into each other as they are used.

When pan paints harden too much, they can be softened with the brush or resuscitated with a few drops of water left in them. When tube paints harden – and some pigments harden sooner than others – the colours can only be used by slitting open the tubes and using them as make-shift pans, which is messy. On the other hand, if the artist does not want to carry a box about but only a separate palette, tubes are much easier to transport.

Colours There is always a wide range of water colours available on the market, some more permanent than others. While a limited palette is usually enough for any one work, an artist may not always want to use the same palette. However, there is little need to extend a palette beyond the colours which are permanent (see p.124).

Most subjects can be tackled with a palette of ten or eleven colours, and as Thomas Girtin and other eighteenth century water colourists have demonstrated, masterpieces can be created with

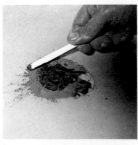

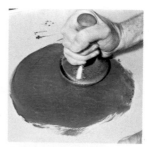

Grinding colour 1. *Place the pigment on a glass slab. Beside it pour 1 part of sugar solution and glycerine, mixed with 2-3 parts of gum and a few drops of ox gall.*

2. *Use a plastic palette knife to draw the pigment into the gum mixture.*

3. *Work the pigment into a paste. If necessary, use a plastic spatula as well. If the paste becomes too stiff, spray lightly with distilled water.*

4. *Grind the paste with a muller to ensure that each particle of pigment is dispersed in the medium.*

5. *Scrape up the water colour with a plastic spatula and press it into a pan. Leave to dry.*

Left **Paul Cézanne: La Montagne Sainte Victoire** *Cézanne had an exceptional sense of colour and tone; both of these are used here to impart a feeling of pattern and continuity. The strong sense of structure in the house contrasts with the abstract quality of the rest of the painting.*

Right **The tonal range of water colour** *As more water is added to it, water colour paint becomes increasingly pale. The degree of dilution is the water colourist's principal way of achieving tonal effects. When the bare minimum of water is added, the paint is thick and dense, but nonetheless slightly translucent. A very thin wash which retains just a hint of the basic colour results from a high degree of dilution. All the mid-tones are achieved by adding just the right amount of water.*

just five basic colours (see p.124).

Sources of pigments The great difference between the prices of water colour paints is due to the cost of some of the pigments. Many pigments are used: earth colours, which are reliable and permanent, tend to be the cheapest, whereas, at the other end of the scale, real ultramarine is made from pure ground lapis lazuli and can cost a small fortune. Another reason for the expense is that many pigments are still ground by hand as they can be easily spoilt by over grinding.

All manner of raw materials figure in the manufacture of pigments and they can be divided into two main groups. The first, the inorganic pigments, include all those made from non-living material, such as the ochres, siennas, oxides and umbers, all of which are earth colours. The second group are the organic colours: chemical compounds of carbon combined with other elements usually derived from vegetable or animal sources. The madders, saffron and lamp black are long established veg-

etable colours and such basic ingredients as burnt tar and cow's urine have been used in the manufacture of organic pigments. Nowadays more sophisticated and complicated chemical processes are used to achieve the same results. Derivations of coal tar and synthetic pigments of all kinds constitute the bulk of organic colourants available. In general they exhibit more permanent characteristics than natural organic pigments but nevertheless remain notoriously fugitive.

Some pigments of chemical dye base which are quite sound in permanence will tend to behave like dyes when applied to paper—that is, they will sink in and permeate the paper with their tint instead of remaining as a surface layer. With these paints the quality of transparency, with the white paper shining through, will be somewhat lost. This may or may not matter, depending on what effect the artist requires. An artist can make a simple test to discover which of his colours have this staining power (see illustrations).

Testing for stainers 1. *To test which colours will stain paper, lay out a blob of each colour on the chosen paper.*

2. Allow the blobs of colour to dry and then work over each in turn with a wet paintbrush.

3. Rinse the paper under running water and leave to dry.

4. The blobs of colour that resist being washed off will stain the paper.

Equipment

Brushes Like the best paints, the best brushes tend to be the most expensive. The best red sable brushes are bound to cost a lot, but they will last a long time and do the job for which they are made much better than any cheap substitutes. The finer the hair of the brush the greater its ability to sustain heavy pigment loadings. Sable brushes are made from the tail hairs of the Siberian mink, whose scarcity contributes not a little to the price of good brushes. Cheaper and far less resilient brushes are made from squirrel and ox hair; these simply do not compare with pure sable brushes.

The brushes used for water colour are either round or chisel ended, the hairs being firmly held in a metal ferrule which is attached to a polished wooden handle.

Trial and error will determine which brush sizes suit the individual, but it is usual to keep a couple of larger brushes for the laying of flat washes, and a few small ones for the application of finer details.

Consideration must be given to the storage of brushes. If they are in daily use they should be rinsed in clean water, reshaped with the hand, and kept upended in a pot or jam jar. If they are to be stored for any length of time, then they should be thoroughly dried and stored, preferably in a moth-proof box. The traditional brush tin is a japanned metal cylinder with a close-fitting lid, but any box

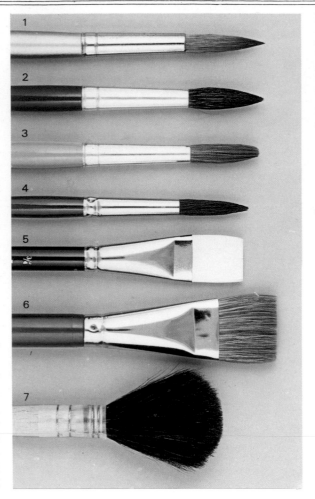

Brushes for water colour *It is essential to have a selection of chisel-ended and round brushes. The former are used primarily for laying washes; the latter will produce small areas of wash and fine details. It is also useful to have a blender, 7, for scumbling and applying texture. The very best brushes are made from red sable, 1, but these are expensive. Ox hair, 4, camel hair, 2 and 7, and squirrel hair are reasonably priced substitutes. Brushes made from synthetic hairs, 3, 5, and 6, are used mainly by students and beginners.*

Below **Brush sizes** *For most purposes four or five rounds of different sizes and two chisel-ended brushes, large and fairly small, will be quite adequate. Manufacturers make rounds usually in eight, ten or twelve sizes. The smallest are normally designated 0, sometimes 00 or 000; 8, 10 or 12 usually represents the largest.*

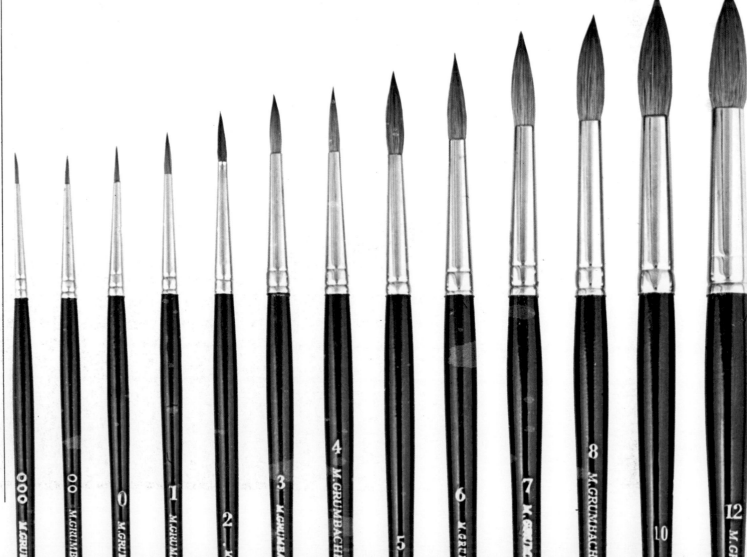

or container will do, so long as the hairs of the brush are not cramped or squashed in any way.

Of course, the brush is not the only means by which paint can be applied to paper. Most artists use a variety of sponges, rags, and even their fingers. However, it is most unlikely that the versatility of the brush will ever be surpassed and those who use other methods of applying the paint usually do so in conjunction with the brush.

Easels and drawing boards Besides paper, paint, and brushes, there is a variety of equipment available to the artist, from drawing boards and easels to water pots and bottles. How much of this equipment is actually necessary is again a matter of individual preference.

Easels are available in lightweight sizes especially for water-colour painters and are made so that they can be tipped to a great variety of angles. This facility is very useful to the water colourist. It is possible to tip the board to lay a flat wash, follow it up with finer detail on a horizontal plane, and add the final touches with the paper standing almost vertically.

A wide variety of easels is readily available from artists' suppliers and it is worth the artist giving careful thought to his requirements before purchasing what can prove to be a costly piece of equipment (see p.130).

A device for sketching comprising a board with a long strap attached, which passes round the neck of the painter leaving the hands free for work, is another possibility well worth considering.

Not all artists use sketching or studio easels and many prefer to carry paper and board and improvise in the chosen situation. Whatever he prefers, no artist can manage without a drawing board, and to choose one suitable for its purpose is important. Drawing boards are available in several sizes, ranging from double elephant ($26\frac{1}{4} \times 40$ in)

Cleaning a brush 1. *Rinse the brush in a wide-necked jar of clean water.*

2. *Take the brush out of the water. Reshape it by drawing it backwards through the palm of the hand.*

3. *To allow the brush to dry, store it up-ended in a jar of convenient size.*

to quarter imperial (15×11 in), and it goes without saying that the larger they are the heavier they will be. Those planning long jaunts across open countryside are well advised to choose one of the smaller, lighter variety. Conversely, elaborate large scale studio paintings are better executed on one of the bigger boards.

Containers for equipment For those who anticipate often working away from the studio, it will be as well to have a convenient container to carry paints, brushes and so on (see p.130). This need not be specially designed for the purpose: if the equipment to be carried is not especially elaborate, a small suitcase, brief case, or even a shopping bag, may serve the purpose perfectly adequately.

Paint boxes The commonest paint box is made from japanned metal with two rows of divisions, each division big enough to take a half pan of paint. Each half pan is contained in a ceramic tray so there is no likelihood of spilling paint over from one pan into the next. Usually the lid, when folded out, is used as a palette and has a series of indentations for mixing quantities of paint. The size of the palette is extended by means of a further flap, the same size as the lid, hinged on to the box along the opposite edge. Beneath the box is a conveniently mounted thumb ring so that the whole box can be held in one hand, giving an adequate area for mixing and matching colour, while leaving the other hand free to wield the brush.

Water containers Some system of transporting a supply of water (distilled if possible, because it is absolutely pure and will not cause chemical reactions) is necessary and there are a number of containers designed for this purpose. In fact a plastic bottle with a screw top, like those used for fruit squashes, is perfectly adequate. A plastic beaker or a jam jar can be used for water when the artist is working.

Sponges and rags *Sponges can be used for laying washes, or, with drier paint, for applying areas of texture. Small sponges, especially for artists, are widely available. Irregular washes and scumbles can be applied with a rag; the material can also be pressed to the paper to imprint its texture.*
Paint boxes *These come in several sizes. The best are made of enamelled metal, and open out to provide mixing trays on either side of the colours.*

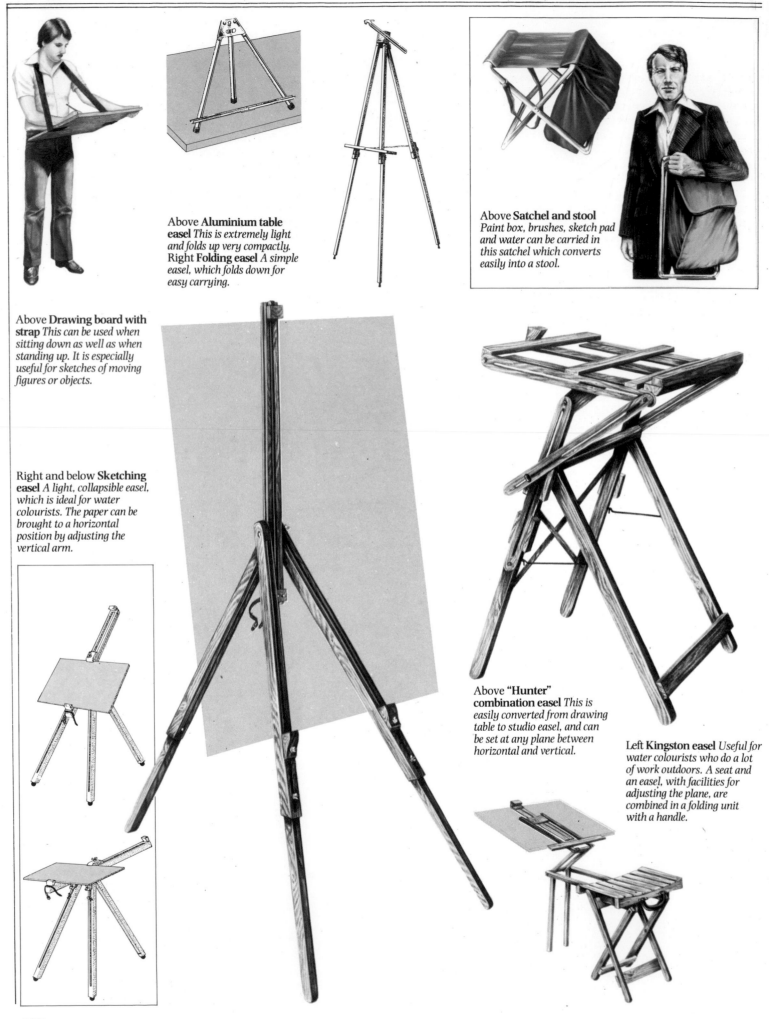

Above **Aluminium table easel** *This is extremely light and folds up very compactly.* Right **Folding easel** *A simple easel, which folds down for easy carrying.*

Above **Satchel and stool** *Paint box, brushes, sketch pad and water can be carried in this satchel which converts easily into a stool.*

Above **Drawing board with strap** *This can be used when sitting down as well as when standing up. It is especially useful for sketches of moving figures or objects.*

Right and below **Sketching easel** *A light, collapsible easel, which is ideal for water colourists. The paper can be brought to a horizontal position by adjusting the vertical arm.*

Above **"Hunter" combination easel** *This is easily converted from drawing table to studio easel, and can be set at any plane between horizontal and vertical.*

Left **Kingston easel** *Useful for water colourists who do a lot of work outdoors. A seat and an easel, with facilities for adjusting the plane, are combined in a folding unit with a handle.*

Techniques

Pure water colour uses the white of the paper for its white colours and as the lightening for tones in the picture. Thin skins of colour called washes are laid on good, strong, stretched paper and, when dry, are overlaid with further washes until the final tones are established. The ability to make positive assessments of tone and to put them down firmly so that they retain freshness is vital to successful painting in water colours. Nothing loses enchantment more quickly than an unnecessarily laboured water colour. The lighter areas should be left with fewer washes, the darker should have more, and any white objects should be left as untouched paper. If, after finishing a painting, an artist feels that some tones or colours should be reduced, then clean water can be applied with a sponge, blotting paper or tissues. A sharp-pointed knife or craft blade can be used to scratch in highlights and a fine brush or pen filled with indian or coloured ink to draw in additional detail.

The character of water colour allows for a line, which in another medium would be less than bright, to shine with brilliance because of the white paper glowing through, and if such a line is contrasted with duller darker colours, its brilliance will be accentuated further. Many painters work with a severely restricted palette and yet achieve such effects, and it is a good discipline to try. A small

palette also has the advantage of being easier to take into the field and of imposing an inescapable unity, since the blues, greens, yellows, and so on will all have derived from the same source, and will be found to work well together. A good limited palette to try would be Thomas Girtin's (see p.124). This is very much a matter for personal preference, and a little experiment—substituting one yellow for another or deleting one colour altogether—is well worth the effort.

Flat wash The basis of all pure water colour painting is the wash, by which is meant colour laid over an area too big to be covered with a brush stroke. In order to lay an even wash without showing variations of tone and to achieve flatness, it is advisable first to dampen the area to be painted, to choose a large brush in good condition, and to mix more paint than you think will be needed. When the area of paper to be covered by the wash has been dampened with very clean water, the paint when it leaves the brush, instead of being hard and legible becomes dissolved one brush stroke into another, thus allowing the wash to be put down without showing the seams. The board or stretched paper should be tilted slightly to allow gravity to aid the process and the brush, fully charged with paint, brought to the previously dampened paper (see illustrations).

When it is complete the wash must be left as it is and as it left the brush; flat, transparent and fresh, the strokes melted together and the clean wash shining out from the paper.

Below **Stan Smith: Linda**
Several media are used here: water colour, gouache, pencil and pen and ink. The three fundamental water colour methods are employed: wet on dry; wet into wet; and dry on dry. The window was thought important and was therefore strongly painted. The figure is more incidental, the striped dress being treated as a series of lines encompassing the form beneath; the face is elaborated with pencil work over washes suggesting form.

When the wash has a complicated edge, for example travelling round the skyline of a row of houses with chimneys, television aerials, street furniture and other intricate forms, the paper should be placed in such a position that the wash begins at that edge. If this means turning the board upside down or sideways it makes no matter, so long as the first strokes do the complicated work to allow the wash to end in a flat, transparent and untroubled way.

Graduated wash The flat wash is the basis of water colour techniques, but it is by no means the only form of wash. Others can be very effective. The graduated wash is similar in technique to the flat wash, but the colour is made slowly darker from halfway through (see illustration). To do this the colours must be mixed before the wash is begun, two or even three versions of the same basic colour, varying in tone rather more than might appear necessary, since water colour tends to look darker when wet than when it dries out. Lay the wash like a flat wash, but introduce the darker tones as they become appropriate.

Variegated washes These are washes which use different colours, rather than tones. They require the same discipline as flat washes, but the system used is quite different (see illustrations). On the dampened paper the previously mixed colours should be laid side by side and allowed to melt together, finding their own soft shapes within the area to be covered. Leave them well alone—no corrections or fiddling—until they are dry, when,

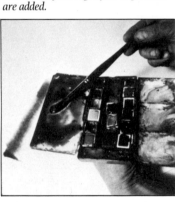

Water colour washes *Washes are the very essence of water colour technique. They should be laid on damp paper in a free relaxed manner. The object is to allow the white paper to glow through the colour; washes should not therefore be overworked, and when they are completed, they should be left to dry before any details are added.*

Laying a flat wash 1. *Dampen the area to be painted with clean water, using a large brush. This is important if the wash is to be without tonal variation.*

2. Mix the paint in the palette. It is wise to mix more than seems necessary, as it is difficult to duplicate the proportion of paint and water.

3. Fully load the brush and draw it across the paper. The board should be tilted to allow one brushstroke to merge into another.

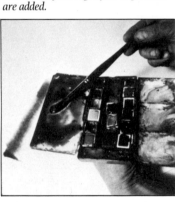

4. Reload the brush from the palette; it is important to keep the brush well charged with paint.

5. Bring the loaded brush back across the paper, beneath the first stroke. Do not touch the wash once it is laid or it will be spoiled.

Laying a wash against a complicated edge 1. *Carefully dampen the area around the edge with clean water, load the brush and begin at the edge.*

2. Work over the dampened area, pulling the wash back from the edge.

Laying a graduated wash *Mix different tones of the same colour. Damp the paper and apply strips of progressively lighter or darker tones.*

Laying a variegated wash 1. *Mix a wash of different colours in the palette – three is an easy number to handle.*

2. Dampen the area to be painted and lay the first colour, allowing the paint to flow freely from the brush. Lay the other two colours side by side with the first.

3. The finished wash, showing the running and mixing of the three colours. Do not touch the wash until it is dry, when necessary alterations can be made.

if desired, additions or deletions may be made.

Stippling This technique is akin to that employed by the Impressionist painters in nineteenth century Paris. It comprises dots of colour touched to the surface of the paper and is often used to describe textures, in which case it can be laid over washes. Used alone on white paper, it amounts to a well controlled method of covering an area of paper and offers a contrast to the washes.

Scumbling This is a method whereby the pigment is applied to the paper with a scrubbing motion so that the paper is covered from all directions. The technique is especially useful for picking up the texture in the paper.

Dry brush Paint is applied with a minimum of water in the brush. Dry brush demands precision and concentration because it is often used to put in the final details of pictures. Artists like Andrew Wyeth use dry brush technique after first sketching in the main forms and establishing the tones by using freely applied washes. The dryness of the paint can vary a good deal, and only by gaining experience will the artist be able to do full justice.

Stippling *Use the tip of a fine brush. Keeping the pressure consistent, begin at an edge of the area, and work inwards towards the centre.*

Left Beatrix Potter: Design for greetings card *The stipple technique is used here with thick water colour. In the umbrella, colours are juxtaposed to make a dense solid area.*

Scumbling *The brush should be fully loaded and not too wet. Apply paint with the flat of the brush, using a vigorous circular movement.*

Dry brush *Place the thumb and fingers over the base of the bristles of a dry, flat brush to feather the bristles out.*

J. M. W. Turner: Kilgerran Castle (detail) *Turner was as adept at sketching in this fresh, free manner as he was at building carefully considered paintings. Here, he used washes, frequently laying wet into wet. Scumbles have been laid with dark paint in the foreground, and dry brush marks are evident in the cliffs on the left.*

Eric Ravilious (1908–42) used a form of dry brush: he feathered the brush by holding the top of the hairs just below the ferrule and then opened the brush by flattening and separating the hairs. Using dryish paint, he was then able to drag lines of colour across the picture so that each fine delicate skin alternated with untouched paper. By this means, he achieved a control and quality very appropriate to his studies of English landscapes and interiors.

Wash and line Line alone is useful for putting in final details and adding darker tones where these are needed. The technique of wash and line is another thing altogether: the line is used to draw the whole scene or feature, and the washes are used to amplify or unify the picture. Sometimes the washes are laid over the line and sometimes the line is used to key the washes, emphasizing the shapes and adding stronger drawing. Many artists make notes in monochrome line and wash, but some very good results can be obtained using colour wash and black line, or indeed black wash and coloured line.

Sponge A flat wash can be laid with a sponge instead of a brush and in many circumstances it is a better tool to use. It can also be used to remove unwanted washes from a painting. Using clean water, the sponge—also impeccably clean—should be soaked, then squeezed half dry, and brought to the area of paint to be removed. Great care must be taken to avoid dropping spots of water on to other parts of the painting. When the paint has been loosened by gentle massaging of the surface, it should be left untouched for a few minutes. It is

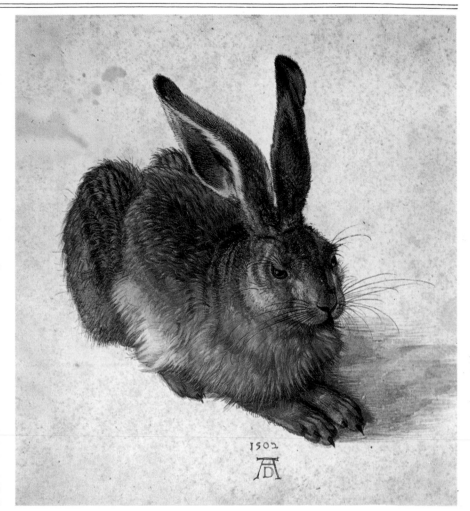

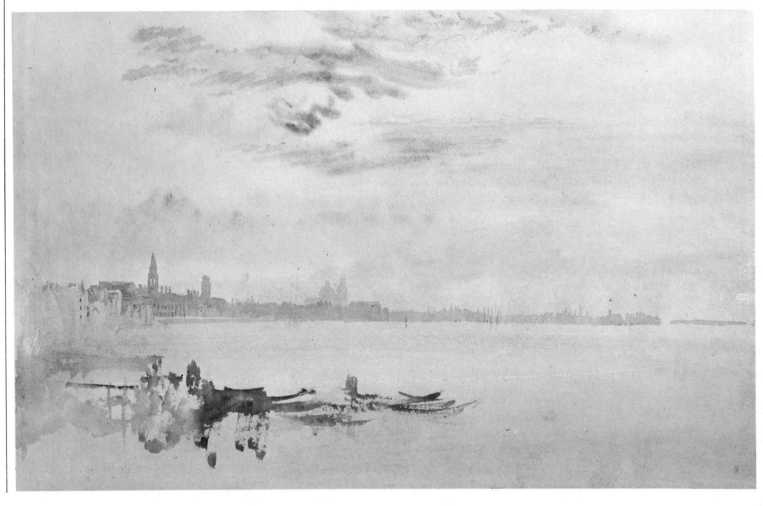

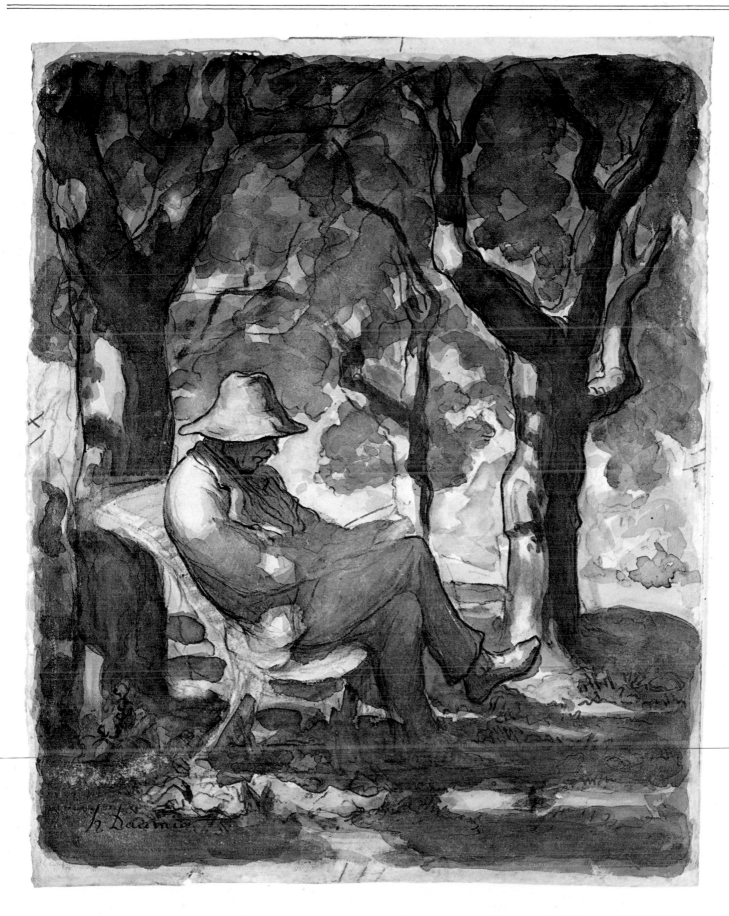

Left above **Albrecht Dürer:**
Young hare *An extremely*
fine, detailed study. Dürer
probably began by laying dark
and light washes to establish
the fundamental form. Over
this, fine water colour lines

were laid to a well planned
tonal design. He would have
used white gouache for the
highlights.
Left **J. M. W. Turner: Venice**
from the Giudecca *Here*
Turner has used water colour

with ultimate economy. Thin,
wet washes from a limited
palette were laid to a carefully
planned design. Subtle touches
of opaque colour elaborate
form.
Above **Honoré Daumier:**

Man reading in a garden *A*
very limited palette is used
here to remarkable effect.
First, the design was drawn in
black chalk with varying
intensities of line. Colour
washes were then added to

amplify the image by creating
a tonal organization in which,
light, shadows and subject are
a mass of contrasts. In some
areas several washes are laid
on top of one another.

135

Feliks Topolski: Hampstead Heath 1940 *Tone washes were built up before the defining ink lines were drawn and worked upon.*

Wash and line 1. *Lay a wash with broad strokes using thin wet paint.*

2. Use pen and ink to draw the line; depending on the dryness of the wash, a crisp or feathered line can be obtained.

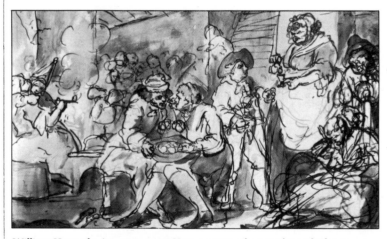

William Hogarth: **A tavern scene** *Here, a water colour wash was laid over the ink line to give the drawing form.*

Line and wash 1. *Use pen and ink to draw the lines; a crisp or feathered line may be achieved by using waterproof or non-water-proof ink.*

2. Washes are usually applied thinly to contrast with the ink line. A softer effect is gained by working over wet ink.

important to keep watch, however, to ensure that no "runs" of water occur; these can make rivers of white paper through finished parts of the painting or carry diluted paint across light areas. When the time is judged right—with a little experience the artist will be capable of determining this—blotting paper should be applied, gently at first, and then increasingly firmly, to the wet paper. If the wash is not removed or reduced sufficiently by the first sponging, repeat this process until the removal is complete or the area is sufficiently reduced in tone.

A sponge can be pressed, fully loaded with paint, on to the surface of the painting, producing a mottled effect of white paper interspersed with paint. By pressing and dragging the sponge, another type of mark is made, controlled and yet loose, since the paint strikes the paper only from the raised parts of the sponge; the holes, carrying no paint, leave channels of untouched paper.

Eraser The intensity of a wash, or of an area deemed to be too dark, can be reduced with an eraser. Make sure that the paint surface is perfectly dry and that the rubber is clean. Working across the surface steadily and consistently, the tonal value will be seen to lighten. Sometimes the texture of the paper is picked up and emphasized in this way, and this too is a technique worth exploiting.

Blade A blade can be used to scratch white lines and ticks back into dry paintings. Also it can be used like an eraser to reduce tone and reveal the texture of the paper. This is done by stroking the paint surface with the flat edge of the blade. The blade can be also used to lay on paint, like a palette knife in oil painting. This generally works best with opaque paint, but can be used effectively with wet transparent colour.

Splatter The splatter is not to be dismissed lightly as an aid to picture making. This effect requires the use of an old but clean toothbrush and a kitchen knife. Getting the correct consistency of paint is the problem and for most purposes it should be a stiffish mix, like medium cream. Dip the toothbrush into the paint, hold it carefully three inches or so above the surface and draw the knife blade firmly and rapidly across the bristles. This will release the paint in a series of dots which strike the paper and show as a fine speckled patch. With careful masking, pictures can be built up entirely of such splattering and can be strengthened later with other techniques or left as they are.

Additives and their uses J. M. W. Turner sometimes used water into which he had put white paint; this changed the appearance of his painting and was appropriate to some subjects, the slightly clouded washes giving a bloom to the normal transparent effect. Gum arabic can be added to paint and is especially effective when added to inks. Scratching back into paint treated in this way before it dries is really spectacular; the white paper is easily found as the colour slips aside, making way for the scratching implement.

Adding soap to paint is a trick used by artists in order to apply paint to surfaces that would otherwise reject it; surfaces affected by grease or oil, some thin plastics and even glass. Soap is also interesting when used like gum arabic for scratching back. But perhaps the most interesting use of soap is the technique of coating real objects—leaves, flowers,

Erasing a wash with a sponge 1.
Dip the sponge in clean water and squeeze it out so that it is damp.

2. Gently massage the area to be erased – in this case part of a variegated wash – with a sponge. Leave the erased area untouched for a few minutes.

3. Apply blotting or tissue paper first gently and then firmly to the erased area. Repeat the process, if necessary, until the desired reduction in tone is achieved.

Applying a flat wash with a sponge
Follow the same method as that described for a brush (see p. 132). Ensure that neither sponge nor paint is too wet.

Laying sponge texture *Load the sponge with paint and press it on to the surface of the paper. Paint strikes the paper only from the raised parts of the sponge.*

Adding soap to remove grease marks *Grease can be removed from paper by adding soap to the paint. Soap is a useful additive for painting on acetate with water colour or gouache. Ox gall can be used for the same purpose.*

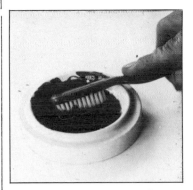

Splattering 1. *Push the tooth-brush around in the paint to ensure it is fully loaded.*

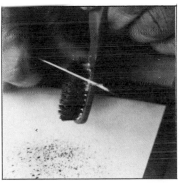

2. Hold the brush at an angle to the paper, with the thumb at the back of the brush head to keep it steady. Draw a knife up through the bristles.

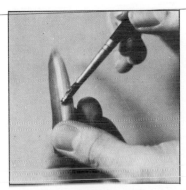

Taking a soap print 1. *Coat one side of a leaf with soap – liquid for washing dishes is suitable.*

2. Apply paint evenly over the soap. The paint will cling to the greasy surface.

3. Lay the leaf, or several leaves, on the paper – painted side down. Smooth flat under a sheet of tissue paper.

4. Raise the tissue paper and carefully peel the leaves off the paper.

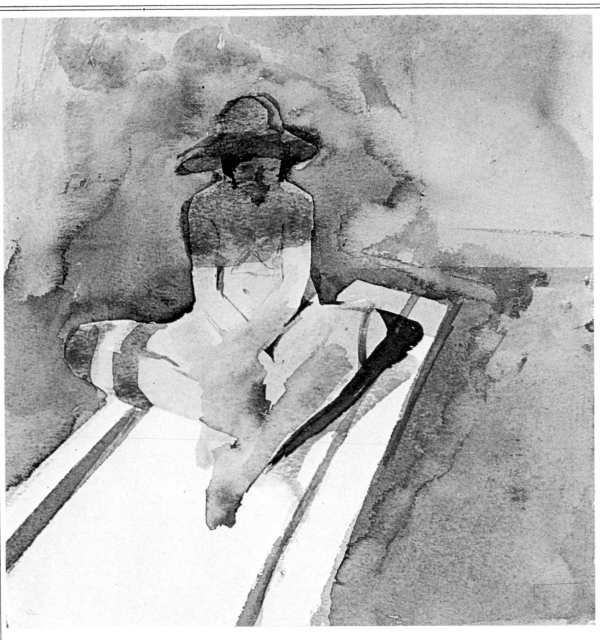

Left Stan Smith: Italian sunlight *The girl was sitting in sunlight coming from a window, but was sketched as if in flat daylight. Shadows were laid over with washes of cool and warm blues, as used in the background.*

Below left Terence Millington: Fireplace *The background is water colour sprayed on with an airbrush. To obtain the marble effect fine lines were drawn on to damp paper. The coal and embers are transparent water colour washes. There is a lot of pen work in the fireplace, and the cast iron was painted with thick gouache.*

feathers, grasses, for example—on one side with soap, covering that surface with paint (not too wet) and, by means of pressure applied to the reverse, transferring the image on to paper or board. Combined with other ways of working water colour, this can create attractive and unusual results. Like many of the techniques described here, this one will benefit from rehearsal and experience.

For working out of doors in cold weather, alcohol can be mixed with the water to prevent freezing. Paul Sandby is known to have used gin for this purpose. To slow the drying time of the paint, glycerine is useful, and starch, salt and sand added to paint, create unusual effects all well worth trying.

Masking devices and resists Even the most experienced painter feels a surprised satisfaction when he removes a carefully applied mask over which

Below **Hans Holbein: Ship with armed men** *An early sixteenth century water colour showing great fidelity to detail. Washes were laid to indicate colour and tone, with fine line drawing applied to elaborate the form.*

a wash has been laid. The objective is to leave areas of untouched white paper amid the coloured wash. Until recently artists had to use rubber solution to mask such areas. This was difficult to manipulate and many painters simply could not master the technique. The advent of new masking techniques has therefore been much welcomed. Masking fluid is a substance containing latex which can be applied to the support with a brush or pen prior to painting. After drying thoroughly, it will readily resist the water colour and, when the paint has dried, can be removed by gentle rubbing of the surface.

Masking tape is a robust self-adhesive tape which will attach firmly to paper, board and other such surfaces, but can be easily peeled off with a little patience. Masking tape is available in "high-tack" and "low-tack" forms: the latter is less

Masking with fluid 1. *Spread masking fluid with a brush as required. Wash out the brush immediately and let the fluid dry.*

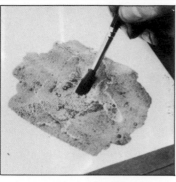

2. Lay a wash over the fluid and the surrounding area. Allow to dry.

3. Rub off the dried masking fluid with the tip of one finger and peel it away. Note that if the fluid is old or left on too long it may stain the paper.

Masking with tape 1. *Stick masking tape in the required position.*

2. Lay a wash over the tape and surrounding area, and let it dry.

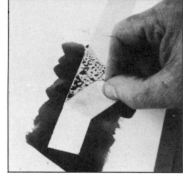

3. Raise one edge of the tape and peel it off; hold the tape close to the paper, to prevent tearing of the surface, and pull the tape gently back along its own length.

Masking with candlewax 1. *Rub a dry wax candle over the paper as desired.*

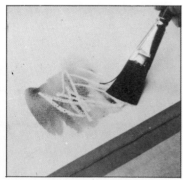

2. Paint over the wax and the surrounding area. The wax will reject the water colour.

sticky and therefore more useful to the water colourist. Transparent adhesive tape can also be used for masking off part of a picture, but it can be awkward because its adherence is very strong and the top surface of the paper or board can easily be torn when it is removed. To obviate this, the tape can be opened out and rubbed gently back and forth over the edge of the drawing board to reduce its stickiness. Tapes usually leave hard edges, but by tearing, cutting and crossing them, a softer feeling can be introduced.

Candle wax can be used as a resist. It should be put on sparingly to suggest, say, the lights across dappled fields or to create textures. When transparent colours have been laid over the marks they remain as untouched paper but with crumpled and textured edges. The candle wax cannot be removed; it becomes part of the painting itself. However, be warned: this is a good servant but can too easily become a tyrant, appearing endlessly and tediously in all contexts.

An extension of this idea, which is not used so often, is to lay shapes in oil pastels (see p.159), work over them in ink, water colour or gouache and then when they are dry, scrape back to them with a flat blade held vertically so as not to damage the surface.

The "wash-off" is an agreeable effect which is well worth perfecting (see illustrations). A design is made with oil pastels, which are painted over with gouache. Indian ink is then spread over the paper and the whole thing is flooded with water, until the top two layers have been partly removed.

Offset printing Offset printing as practised by William Blake, can be a useful tool. Spread paint on an impervious surface, such as glass, plastic or a resistant card or paper, and apply to the paper by pressing on the back. Designs created in this way can then be elaborated.

This leads on to a system of painting introduced by Francis Towne (1740–1816) and used by him and his followers as an aid to picture making. Random blots are spread on to a support and transferred by pressure to another surface, where they are read and studied in order to find interest and material capable of development. The blots can be transformed by the addition of marks,

Tearing, cutting and crossing *Tear or cut the tape and lay it down in the required pattern. Lay a wash over it; when this is dry, carefully peel off the tape.*

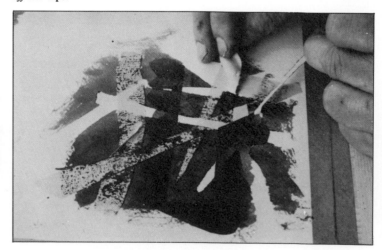

Masking with oil pastel 1. *Lay a shape with an oil pastel. Work over it with water colour, which will be rejected by the oil pastel.*

2. The finished effect. If any paint clings to the pastel, it may be scraped off with a flat blade.

The 'wash-off' 1. *Lay down patches of gouache over a pastel or water colour design. Leave spaces between the blocks of colour.*

2. Paint over the entire image with waterproof ink. 3. (right) Run warm water over the ink. This dissolves the paint under the layer of ink, causing both layers to be partly washed off.

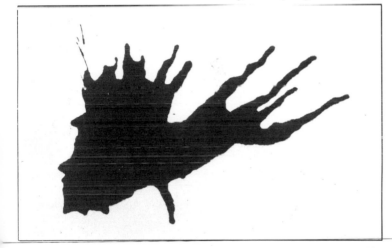

Blowing blots 1. *Load the brush with paint and put down the blot.*

2. Blow the blot: a straw may be used if more directional control is desired. The direction and strength of the blow largely determine the final effect.

washes, lines, stippling and so on, into magical and mysterious landscapes or subtle pictures.

Blown blots Blowing vigorously on to wet blots from above will send rivulets of paint travelling wildly north, south, east and west in thin snakes, and these accidental images can also be elaborated.

Mixing techniques To mix techniques and to break a few rules can be remarkably rewarding and often takes the artist by surprise. Unexpected results can be achieved by spreading coloured inks on to paper in order to sketch in the broad fundamentals of a design and then amplifying this base with washes of opaque colour, carefully blotted back to reveal both the paper surface and the transparent ink beneath. Another interesting approach is to work over carbon paper on top of washes.

The quality of paint surface varies greatly according to the support used, and to spread the same consistency of paint on to rough, hot-pressed and not papers can surprise and delight. The scratchy bubbling appearance of the paint on the smooth support will contrast markedly with the dryish buckled washes on rough paper. To use more than one paper in an overall design can be very effective.

Introducing a medium alien to water colour, such as turpentine, causes interesting things to happen. This oil, rubbed on to the surface, acts as a kind of resist, albeit an unpredictable one; the paint adheres, coagulates and is rejected in whichever way the turpentine has affected the paper. If this is used in association with masking, care must be taken not to dissolve the adhesive on the tape by leaving the two in contact for too long.

Chapter Nine
Gouache

Gouache is also known as "body colour". It is an opaque water colour, made from less finely ground pigment than that used for transparent water colour. Like pure water colour, its medium—or binding agent—is gum arabic, although many gouache paints now contain plastic. The medium is extended with white pigment, which makes the paint opaque. This means that some of the limitations imposed by transparent water colour are removed; it is possible to lay light paint over dark and build up a picture in more solid colour.

Gouache painting has less luminosity than pure water colour, but is extremely good for painting subjects that require a lot of elaboration, since the artist can work "from the darks"—lay darker colours and then add lighter details—a process which does not work well with water colours.

Body colour was used by the manuscript illum-

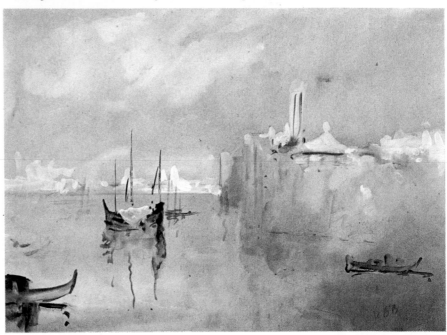

inators of the Middle Ages and by several seventeenth century artists, notably van Dyck (1599–1641), Gaspard Poussin (1615–75) and van Huysum (1682–1749). It is likely that Joseph Goupy (1689–1763), a French painter who lived in London, brought gouache to England.

The Venetian Marco Ricci (1679–1729) and the Florentine Zuccarelli (1702–88) both lived in London for long periods and used gouache to make landscape paintings of fine quality. Zuccarelli had a great influence on Paul Sandby (1725–1809) who, as well as pioneering water colour techniques, was the first major exponent of gouache. Like water colour, gouache enjoyed a great vogue in England at the end of the eighteenth century.

Many modern painters have used gouache: these include Picasso (1881–1973), Henry Moore (born 1898), Graham Sutherland (born 1903) and Peter Blake (born 1932).

Nowadays gouache is also used extensively for commercial illustration intended for reproduction in books and magazines, and several ranges of colours are labelled "Designer's colours". The opacity of gouache enables flat clean areas to be laid, which reproduce extremely well with modern methods of printing. Gouache is commonly used by airbrush artists (see p.178).

Above **Hercules Brabazon: Venice moonshine** *Free use of gouache, with solid colour worked into wet washes and laid over dry ones achieving a careful and vivid assessment of tone.*

Surfaces

Paper All papers recommended for pure water colour (see p.120) are suitable for gouache, but the reverse is by no means true. The opacity of body colour makes it possible to use darker toned papers such as Ingres and Michallet.

Gouache also works well on coloured poster papers and Manila wrapping paper. Lightweight papers should be stretched as for water colours.

Boards Prepared boards as used for water colours (see p.120) are suitable for gouache, and here again the darker colours can be used. Good results can be obtained on rough, unsized cardboard; the paint may tend to sink in, but this can be prevented by applying a thin coat of gum.

Below **Graham Sutherland: Plant and tree shapes before hills I** *Here, gouache, chalk, brush line and wet and solid colour were employed, using primary and secondary colours to achieve a romantic interpretation of landscape features.*

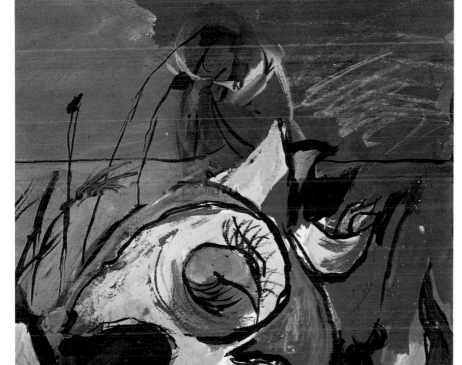

Paints and equipment

Gouache Ranges of gouache colours come in tubes and bottles; those in bottles are often labelled "Designers' Colours". A huge variety of colours are available, but for many styles of painting a limited palette is adequate.

A palette containing the following colours will be suitable for most subjects and styles: White; Yellow ochre or Naples yellow; Cadmium yellow; Emerald green; Cadmium red; Burnt sienna; Raw umber; Cobalt blue; Black. Cadmium and cobalt colours are expensive; many manufacturers make cheaper substitutes which are reliable.

Poster and powder colours Like gouache, poster colours are made with white pigment which ren-

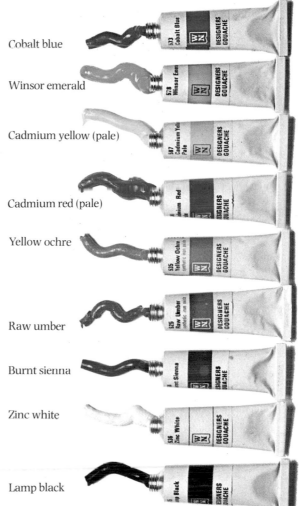

Cobalt blue

Winsor emerald

Cadmium yellow (pale)

Cadmium red (pale)

Yellow ochre

Raw umber

Burnt sienna

Zinc white

Lamp black

Left **Elaine Keenan: Commercial illustration** *Commercial art is often done in gouache; it suits modern printing methods.*

Gouache colours. *These colours are suitable for most purposes. A limited palette gives an inevitable uniformity to a painting.*

ders them opaque. However, they are less reliable than artists' or designers' gouache, and are not recommended for fine permanent painting. Powder colours, as used in schools are also opaque, but they too lack permanence and reliability.

Brushes and easels The brushes, drawing boards and easels used for water colours (see p.128) are equally suitable for gouache. Round, bristle brushes are useful for applying the paint thickly.

Techniques

The principle characteristic of gouache is its opacity, and it is this which largely dictates the way it is used. It allows for overpainting and great subtlety of tone. Light colours can be laid over dark, and this means that toned or coloured papers can be used very effectively. From the initial laying in of the design, the colour and tone of the paper can unify the elements of the composition and greatly assist the artist in organizing his next marks.

Gouache paint is entirely different in weight and feel from water colour. Beginners with this medium will do well to practice by making a variety of marks, with an assortment of brushes, before starting on a painting.

The paint can be used in several different consistencies: as wet as water colour; thick but wet—this approaches the feel of oil colours; fairly dry; and entirely dry and solid.

It is tempting to think of gouache as a quick-drying oil paint. This is a mistake; it has factors in common with oils, but to confuse the two does both a disservice. Gouache has a very definite character, and qualities which are all its own. These should be exploited as much as possible.

Flat solid patches The flat, thickly painted area covered by a consistent skin of colour is a common characteristic of gouache paintings. This is, of course, an effect which cannot be achieved with water colours. The secret is to obtain precisely the right consistency of paint, and this requires both experience and skill; it must be thicker than that recommended for a flat wash.

Unexpected things can happen to gouache as it dries; colours tend to lighten and thicker patches will not reach the same tone as the rest. Tickling wet paint on to dry often causes patchiness, and any unnecessary touches are likely to spoil a promising, albeit less than perfect, flat colour.

The best thing is to leave such areas well alone. Even what seems a badly flawed patch of colour is likely to appear better fresh and crisp, than painstakingly corrected. Often the marks which offend when first laid, diminish in importance when surrounded by other detail.

Washes A flat wash can be laid with gouache in substantially the same way as with water colour (see p.132). The difference is that the consistency

Laying an area of flat colour
1. *Mix plenty of paint, load the brush, and, starting at the edge of the area, lay the first stripe.*

2. *Lay further stripes parallel with the first. If the paint is the correct consistency, the stripes will merge together. All should be laid before any dries.*

3. *The finished area of opaque, flat colour. It is usually a mistake to try to correct flaws in tone, as the freshness of the area is likely to be lost.*

of the paint must be absolutely right, and this is difficult to assess. It must be at once thick enough to cover the paper without directly revealing any of the surface, but thin enough to melt easily, edge into edge, along the brush strokes.

Graduated and variegated washes (see p.132) work as well with gouache as with water colour, but again the paint must be mixed to exactly the right consistency.

Overpainting There are several ways of laying one colour over another, and skill with these techniques is essential to successful painting in gouache. Often paintings are built up with thick dry colour which will not run, laid over dry opaque or transparent washes.

It is common to begin painting with a flat mid-tone ground laid as a wash. This enables the artist to use the full flexibility of gouache—to develop the image both towards the darks and towards the lights. The major shadows can be laid on the mid-tone ground with an appropriate darker tint. Then, increasingly lighter tones, all the way up to the highlights, can be introduced, and of course the colours can vary as required. The scumble is an effective way of applying light dry paint across a dark base.

Solid colour worked into flat or variegated washes, while the washes are still wet, is another way of using the opacity of gouache. The edges of the flat area will merge softly into the wash once the paint dries. Gouache dries very rapidly, so, to facilitate this technique, it is a good idea to soak the back of the paper and keep it wet, thus preventing the wash from drying.

Splattering A patch of fine dots can be obtained with gouache as with water colour by splattering (see p.137)—dragging a knife blade across a toothbrush loaded with paint.

Scratching in Detail or texture can be added to a gouache painting by scratching into the paint with a craft knife blade, a single-edged razor blade or a scalpel.

Textures If paste is added to gouache, a comb or similar sharp implement can be drawn across the paint surface so that it leaves a very definite three-dimensional texture.

String or rope can be dipped in thick gouache and pressed on to the paper to make interesting shapes and textures. Thin bank paper or cellophane can be made into a ball, rolled in thick paint and applied to the paper, either to add tex-

Elaborating with dark, mid and light tones 1. *Lay down a flat, mid-tone base. When it is dry, lay the major shadows with dark tone.*

2. Elaborate further with mid-tone.

3. Apply highlights over the base, working between the mid and dark shadows.

Working solid colour into a flat wash *Lay a flat wash and allow it to dry. Load a brush with thick, dry paint and work over the wash.*

ture or to suggest a theme for further development.

Obtaining a sheen If gum arabic is added to gouache—or to water colour or coloured ink—the paint will dry with a very pronounced sheen. This enhances the colour values, but the effect should be used with care because the results can be overpowering and ruin an otherwise pleasing picture.

Masking Areas of paint with sharp, straight edges can be obtained by sticking strips of masking tape around the borders of the desired area and painting up to and over them.

It is often effective to leave an irregular shape or some fine detailing as untouched paper. The design is first painted with masking fluid. When this is dry, paint is spread over the mask and the surrounding paper. The mask is then peeled away to reveal the untouched paper.

Gouache with other media It has long been common practice to use gouache in conjunction with water colours. Many artists make pictures with pure water colour and add highlights and details with gouache.

Pencil lines are useful for adding shape and form

Scumbling *Lay down a base and allow it to dry. Load a dry brush with paint and scumble over the base with rapid strokes of the flat of the brush.*

to gouache paintings, and they work well on flat solid colour or on washes. Pencil lines crossing from a transparent wash over to an area of opaque colour will add cohesion to the painting, and provide contrast; the lines will appear darker and smoother on the solid colour.

Pen line cannot be applied to thick gouache as readily as it can to water colour. However, a useful technique is to lay the general design structure with coloured inks and then flood this with wet gouache. This keeps the whole painting in a state of flux; alternative developments can be tried before the final resolution is decided.

The wash off (see p.141) works as well with gouache as with water colour.

Removing mistakes A craft knife, single-edged razor blade or scalpel can be used to scratch off mistakes. An alternative is to apply clean—ideally, distilled—water with a sponge and then soak up the paint with fresh blotting paper. The tone of a colour can also be reduced in this way; the blotting paper can be manipulated to soak up some, but not all, the pigment.

Obtaining a texture with paste and comb 1. *Mix a few drops of paste with paint in a palette.*

Working colour into a wet wash 1. *Soak the back of the paper, to prevent the wash drying, and lay the mid-tone base.*

2. *Lay an area of paint, and while it is still wet, drag a comb over it.*

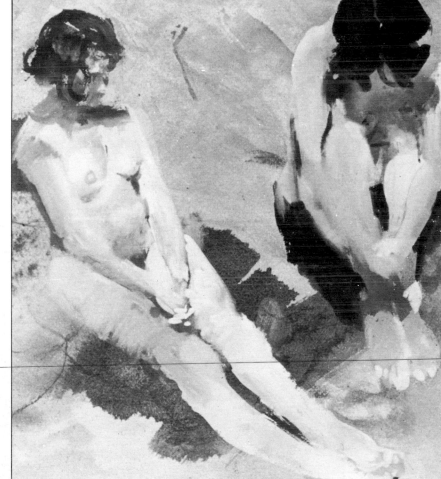

2. *While the base is still wet, apply a second colour, allowing it to merge softly into the base.*

3. *The finished effect, showing the definite, three-dimensional texture obtained by this technique.*

3. *Apply a third colour. The opacity of gouache permits the artist to develop the image both towards the darks and lights.*

Above Stan Smith: Study of a girl *Here, Payne's grey was used to tone the paper, and the figures described over the mid-tone base with a limited palette of Naples yellow, Light red, Cobalt, Hooker's green and White.*

Chapter Ten

Pastels

Pastels are powdered pigments mixed with just enough gum or resin to bind them together. The word pastel is derived from the resultant paste, which is moulded into the familiar pastel sticks boxed up by manufacturers or made by the artist himself. The charm and freshness of pastels, their purity of colour and their immediate response when applied to paper, are part of the nature of the medium and distinguish it from oil painting.

An artist can paint or draw with pastels because the medium has some of the qualities of each approach. There are pastels by Degas (1834–1917), who was constantly experimenting with the medium, which come close to being classified under the general heading of graphics, and others which move nearer to oil painting. At their most successful, pastels combine both these qualities; they tend to lose their attraction when they over-strain the possibilities of the medium and attempt to imitate an oil painting.

Pastels are often confused with the harder chalk medium, where the pigment is mixed with oil or wax, and eighteenth century pastels have occasionally been listed as crayon drawings. Drawings made with coloured chalks on coloured paper and tinted with white, such as those of Fragonard (1732–1806) and Watteau (1684–1721), use similar techniques to those of pastel. Chalk can be used to produce a preliminary key drawing, or under-painting, to be developed later into a pastel.

The history of pastel painting is comparatively short, and it was in eighteenth century France that some of its earliest and finest exponents worked. However, the real pioneer of the medium was a Venetian woman, Rosalba Carriera (1674–1757), one of the few female artists to achieve fame before the nineteenth century. She had a tremendous vogue when working in France during the regency of Louis XV. It was during this reign also that Quentin de la Tour (1704–88), the greatest pastellist of his time, was to mirror the rococo world, the silks and satins of the age of Madame de Pompadour, Louis XV's mistress.

In France pastel painting became a craze and by 1780 there were two thousand five hundred pastellists working in Paris. The freshness and spontaneity of pastels allied to a Gallic wit brought the best pastels of this period close to the spirit of French Impressionism which was to develop a century later. Degas, the principle pastellist among the Impressionists collected the work of la Tour and developed the medium far beyond the traditional formulae of the eighteenth century masters. Any artist anxious to use pastels should study the works of la Tour and his contemporary Perronneau (1715–83), the more serious pastel portraits of Chardin (1699–1779), and the innumerable techniques employed by Degas.

These masters clearly establish that pastels, which are sometimes considered lightweight and inferior to oil painting, are well capable of making profound statements. No doubt the recent neglect of pastels is partly due to its association with over-sentimental portraits of children. Although this particular genre was admirably exploited by Mary Cassatt (1845–1926), the range of possibilities with this expressive medium is much wider. The pastellist should consider landscape, still life and

Below **Edgar Degas: The tub**
Here Degas used pure pastel without, it appears, any other medium, and there is little evidence of charcoal drawing. The unblended open strokes of the pastel move across the form in some cases, and with it in others; this gives the drawing life and variety.

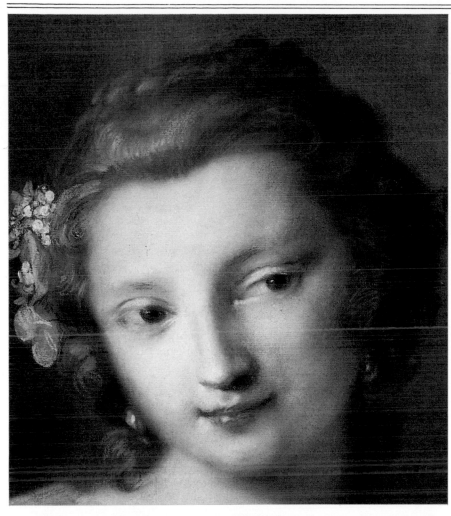

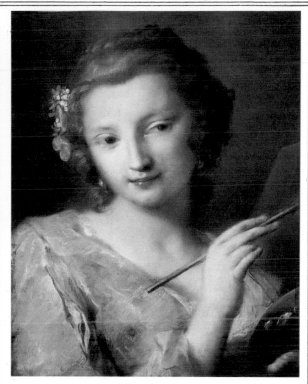

Above and left **Rosalba Carriera: Allegory of painting** *Carriera, the pioneer of the medium, used a very simple, soft and fused touch which in no way overstrains the medium. The delicate interaction of the strokes can only be seen on close inspection.*

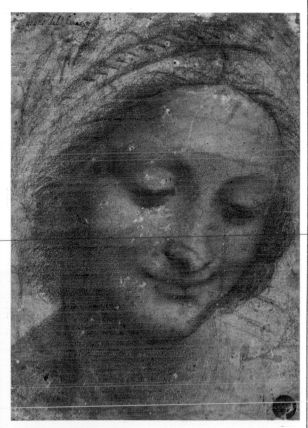

Above **Leonardo da Vinci: Head of St Anne** *Leonardo frequently drew with red chalk, a medium very similar to pastel. The way in which he* used a mixture of blended strokes, and isolated lines is an example to every pastellist.

imaginative composition, for which the pastels of Redon (1840–1916) may well serve as inspiration.

Pastels allow the artist to draw and paint in full colour without the disadvantages of varying drying speeds or sinking paint which are associated with oil painting. However, if a mistake is made in oil painting, it may be eliminated with a turps rag and the artist is free to begin again. This is not so with pastel where alterations require more elaborate surgery. Mistakes can be brushed off with a hog hair brush or lightly removed with a putty rubber, but the surface may lose its grain and its ability to hold the particles of colour. This is the main disadvantage of pastels: second thoughts cannot be expressed easily.

Sound draughtsmanship is therefore essential for anyone who wishes to use this tricky medium successfully: the kind of draughtsmanship that is based on the selection of essentials and the ability to discard unnecessary detail. Pastels are best when not overworked or overloaded, since their charm lies in their delicacy of touch and in the spontaneity that most graphic work possesses.

The type of drawing most useful for the pastellist is that which exploits chalk or crayon, often on toned buff paper, and here the work of Watteau is particularly valuable. An artist's first experiments in portraiture, human or animal, should be with this type of drawing. Red or black chalk, tinted with white on a toned paper provide a first step with limited colours and can be controlled without too much difficulty.

The crayon drawings of peasants and landscape by Millet (1814–75) are a valuable source for the pastellist. They suggest atmosphere and even colour and are beautifully designed. His pastels, too, abound with detail and information without being fussy.

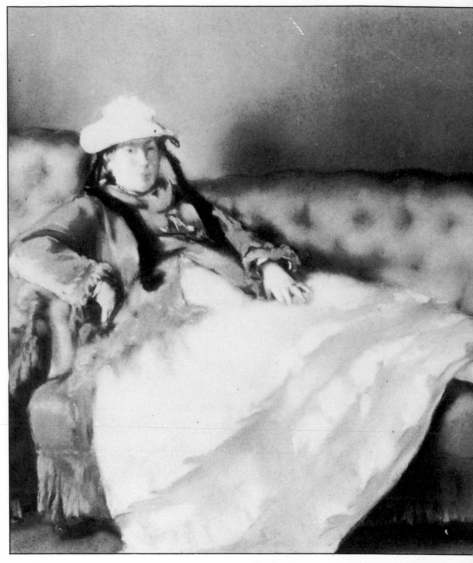

Above **Edouard Manet: Madame Manet** *Here Manet fused the tones with great skill, and in many areas rubbed them gently into one another.*

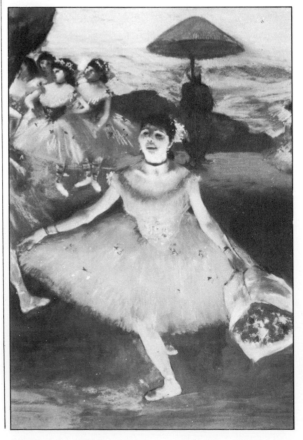

Left **Edgar Degas: Ballet dancers on stage (detail)** *Here Degas came closer to painting than drawing; brush strokes are particularly noticeable in the foreground. It is difficult to establish whether Degas used distemper paint as a base here, or whether he sprayed the vapour from boiling water or milk over the drawing to turn it into a painting. In the final layer, strokes of pure unfixed pastel can be seen, notably in the skirts of the dancers on the left.*

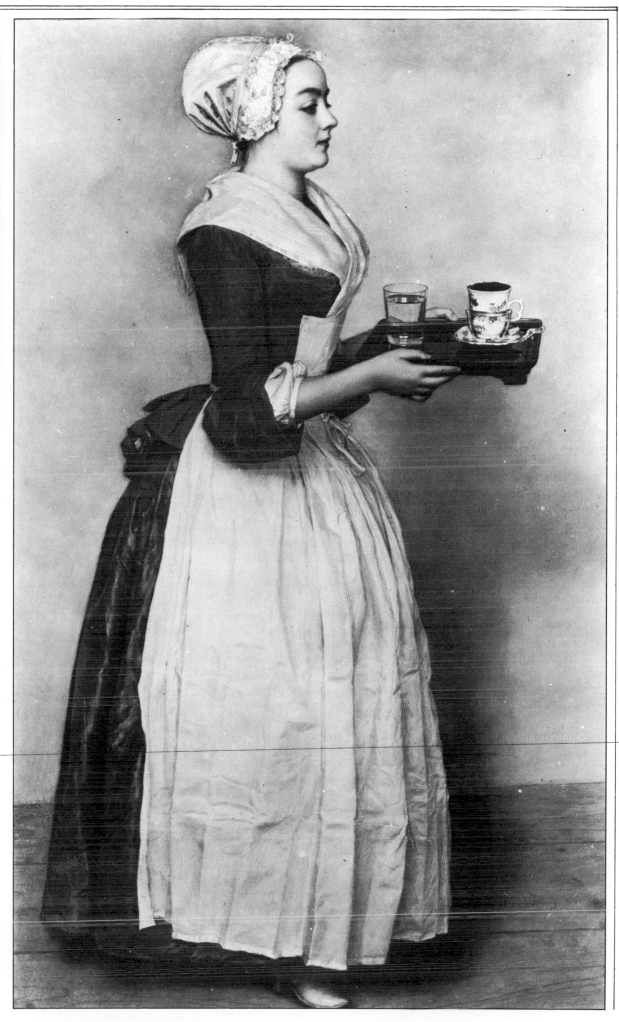

Left **Jean Baptiste Chardin: Self portrait with eye shade** *Chardin's works contrast with those of his more fashionable contemporaries, la Tour and Perroneau, in that they are more solid and reflect the painter's search for realism. Of this portrait Cézanne wrote: "This painter was as cunning as a fox! Have you noticed how, by means of light, transversal lines across the nose, he brings his values into clearer focus?" Open strokes are very much in evidence in the modelling of the face; the fused and blended approach is left to the background.*

Right **Jean Etienne Liotard: The Chocolate Girl** *A classic example of pastels used in imitation of oil painting. Liotard's technique, with its tight and realistic handling, was formidable, but he failed to exploit the unique potential of the medium.*

Surfaces

The colour and texture of the support, whether paper, card or canvas, will play an important role in the final design and will often be left showing where this will assist in the general colour scheme. The support should be chosen not only for colour but for weight, durability and above all texture, for with soft pastel the support must be able to retain the grains of colour.

Papers A pastellist should familiarize himself with the various paper surfaces and supports in much the same way as he should become acquainted with colour charts. Paper manufacturers will supply sample swatches and with these the artist can test for colour and texture and find a paper sympathetic to the particular subject he intends to portray.

Ingres type papers have a grain which is agreeable to the touch, and a wide range of colours. Ingres Fabriano is manufactured in two weights, 90 and 160 grams; 604 stone gray, 607 fawn, and 617 mid gray are tints especially useful for pastellists. Ingres Swedish Tumba and Ingres Canson are papers with a range of 15 to 20 different colours and very distinctive textures which are especially effective if lightly drawn over and allowed to show through.

The middle tone Tumba papers—blue grey, purple grey, mid green and pale jade, for example—allow for subtle colour harmonies. The darker tones—the rusts and browns—require vigorous contrast and firm drawing with charcoal. Whistler (1834–1903) often used a brown paper, as can be seen in his pastels of Venice, and he was very particular in choosing the exact shade of colour required for this subject. Many of Degas' figure drawings are on strongly coloured paper and Eric Kennington (1888–1960) frequently worked on black paper for his pastels of World War One, thereby forcing the contrasts dramatically. Vellum is useful as a surface for delicate work.

Preparing paper The artist may find it best to prepare his own paper grounds. Since tinted papers from artist's suppliers tend to fade, the advantages to the artist of tinting his own papers are obvious. He can prepare a colour or blend of colours suitable to his needs (see illustrations). In a letter written in March 1777 la Tour refers to having

Papers for pastels Tinted papers with definite textures are the most common support for pastels. Mid-tone papers, such as Ingres Fabriano stone grey, mid-grey and fawn, **2**, are suitable for many subjects and styles. Ingres Canson, **1**, and Ingres Swedish Tumba, **3**, are manufactured in a large range of colours. The mid-tones are useful for gentle

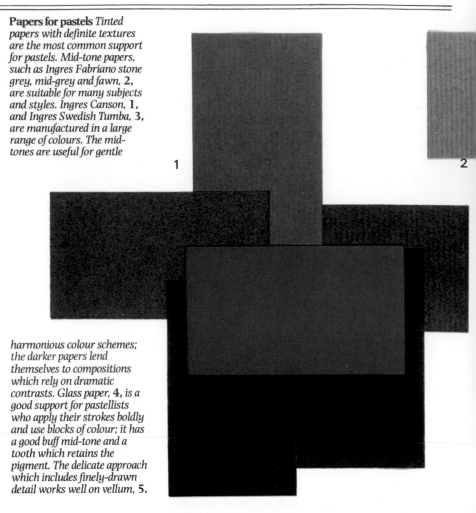

1 2

harmonious colour schemes; the darker papers lend themselves to compositions which rely on dramatic contrasts. Glass paper, **4**, is a good support for pastellists who apply their strokes boldly and use blocks of colour; it has a good buff mid-tone and a tooth which retains the pigment. The delicate approach which includes finely-drawn detail works well on vellum, **5**.

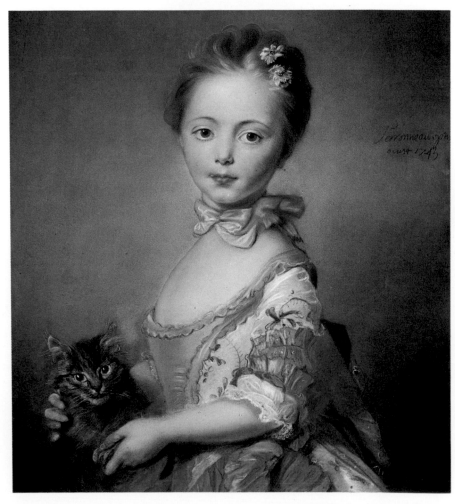

Right **Jean Baptiste Perroneau: Girl with a kitten** *The handling is much freer in the treatment of the kitten and the sleeve of the dress than in the portrait itself. It is likely that the blue background was achieved by treating the paper with gum water and sprinkling this with smalt, a vitreous blue pigment. This would give the paper a tooth as well as colour.*

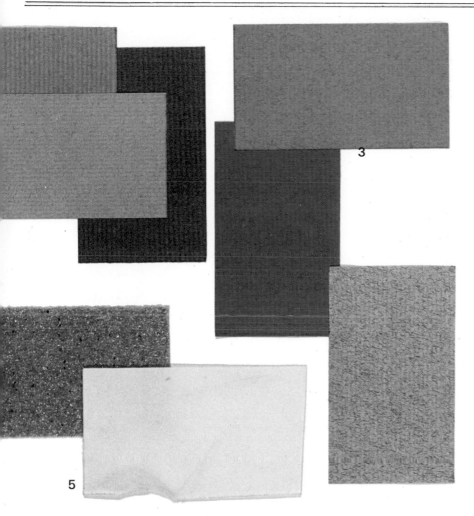

3

5

Above Eric Kennington: The diehards (detail) *Kennington used pastel very much as a drawing, rather than a painting, medium. In this drawing made during World War I, he used charcoal to draw incisive lines, and also turned the stick on its side to create dramatic shadows. His technique relies on the opposition of light and dark, the lights being provided by the pastel strokes and the untouched paper.*

Left J. M. W. Turner: Sketchbook study *This seascape displays the bold lines and blocks of colour applied to dark paper, which characterize Turner's sketchbook pastels. It is thought that Turner used pastels outdoors in the evening, when the light became too dim for him to work in water colour.*

treated blue paper with a light wash of yellow ochre diluted with water and yolk of egg. The hue of a tinted paper can also be varied by a water-colour wash blown over it with a mouth spray. This will partially cover a ground originally select-ed for its colour.

Quentin de la Tour used to apply gum water to his paper and then sprinkle on a vitreous smalt (ground blue glass) which provided a tooth as well as a tinted ground. Supports can also be given a tooth of finely pulverized pumice-stone powder (see illustration). Pastels work well on ordinary glass paper bought from a hardware shop. These have a good middle tone buff tint and grip the particles of pigment well, even if the texture is hazardous to the knuckles.

Canvas Canvas on a stretcher is a good ground for pastel. Muslin pasted to cardboard has a simi-lar quality. Canvases should not be primed with size containing animal glue; this can be harmful to pastels, because it may cause mildew. Pure glycerine, caseine or gelatine sizes are better. The canvas should be protected at the back from blows or vibrations which may easily dislodge the grains of pastel.

Delacroix (1798–1863) experimented with pastel on fine canvas which had been treated with size water and allowed to dry. When the picture was finished it was sprayed with hot steam to soften the size, and again allowed to dry. Hot steam can also be applied from underneath canvas held horizontally, so that the surface of the picture is protected from the spray.

Applying pumice stone powder 1. *Apply wet starch paste with a brush, working outwards from the centre of the paper.*

2. While the paste is still tacky, sprinkle pumice powder evenly over the paper, using a fine mesh sieve.

Spraying pigment 1. *Place some powdered pastel in a jar and add emulsion glaze and water to bind and thin the mixture. Poster colour may also be added.*

2. Fit the jar into the spray gun, stand back and spray a light mist over the paper, which should be propped at an angle. This also gives the paper a texture.

Tinting paper 1. *Crush broken pastels into a powder with a palette knife. Only use old pastel pieces for tinting; it is wasteful to use new ones.*

2. Dip a damp rag in the powder and rub it over the paper. Allow to dry.

3. When dry, tilt the board and tap the surplus powder off the paper.

Staining paper with tea *Rub damp tea leaves or a tea bag over the paper to obtain a warm tint. When dry, brush off any leaves.*

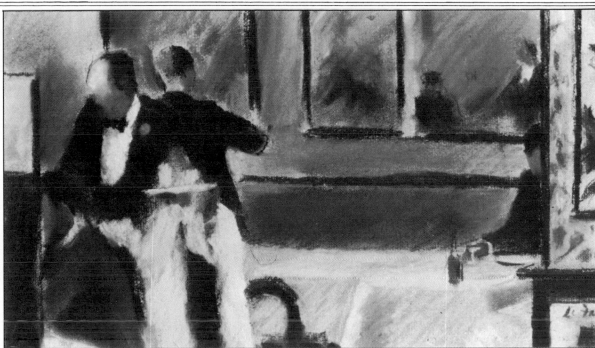

Above left **Edouard Vuillard: The laden table** *The catalogue of the Tate Gallery, London describes this as a gouache/pastel, because the pastel has turned into a paste. It is possible that Vuillard applied the pastel to a distemper base coated on to a cardboard support.*

Above right **Guy Roddon: Parisian restaurant** *The pattern of silhouette shapes is portrayed for the most part with blended and fused pastel strokes. Open work is used in the treatment of the tablecloth and the foreground. The paper is Ingres Canson.*

Right **Edgar Degas: Woman ironing** *Warm-toned paper was used for what is basically a charcoal drawing strengthened with white chalk. Lightly rubbed, fused pastel is used to elaborate the hair and skirt.*

Pigments

Pastel sticks are soft, medium or hard according to the quantity of gum incorporated in the paste. If the proportion is increased to make the stick harder, the brilliance of the pastel is diminished; thus the most brilliant sticks are the softest and most fragile. This is one of the disadvantages of the medium, but on the other hand pastel colours are among the most permanent available to the artist. Treated properly a pastel will retain its strength and freshness for decades—even centuries. The characteristic pale soft pastel shades, particularly the flesh tints, owe their quality to the pipe clay or whiting filler which is added to the pigment to increase its covering power.

Choosing a palette The problem of choosing a working palette from the enormous range of col-

Right **Odilon Redon: Portrait of Mademoiselle Violette Heyman** *Here Redon used a range of pastel techniques, from the tight handling of the portrait, to a variety of linear gestures— blended, cross-hatched, combed—in the flowers.*

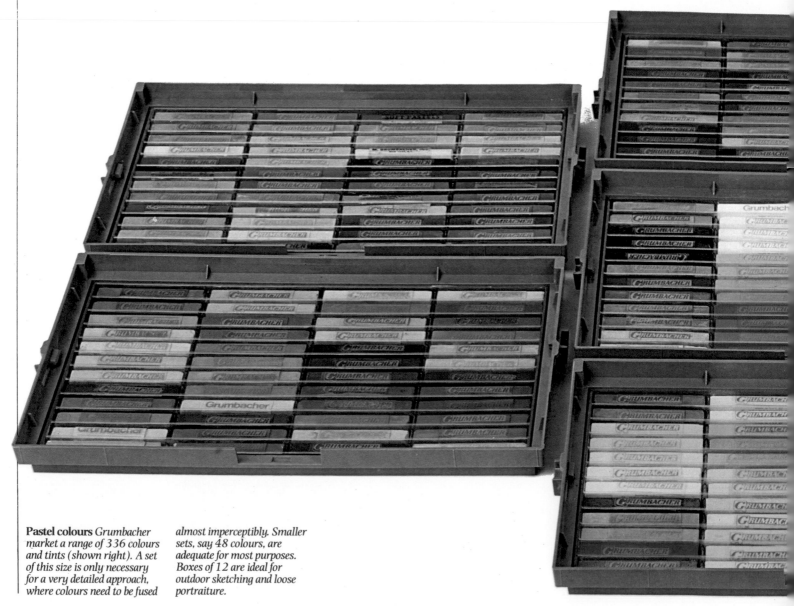

Pastel colours *Grumbacher market a range of 336 colours and tints (shown right). A set of this size is only necessary for a very detailed approach, where colours need to be fused almost imperceptibly. Smaller sets, say 48 colours, are adequate for most purposes. Boxes of 12 are ideal for outdoor sketching and loose portraiture.*

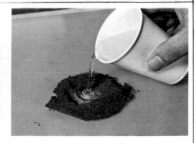

Making pastels 1. *Place two equal piles, one of pigment and one of zinc white, on a sheet of tissue paper.*

2. Mix the white and pigment by rolling them in the sheet of tissue paper.

3. Divide the mixture and place one half aside. This will later be mixed with an equal amount of white to make a related lighter tone.

4. Place the other pile on a slab of ground glass and pour sufficient distilled water on it to work it into a thick paste.

5. Work the powder into a paste with a palette knife and mix in a solution of leaf gelatine to act as a binder.

6. Collect the paste on a palette knife, place it on a sheet of newsprint to absorb surplus moisture and shape it.

7. Wrap a piece of card with newsprint and use it to roll the pastel out into a smooth cylindrical shape. Put it aside to dry for 24 hours.

8. Pastels of graded tone, built up from dark to light, by adding half as much again of white to equal amounts of white and pigment.

ours available may seem insuperable to those who are used to creating their colours from the dozen or so pigments laid out on the oil painter's palette or in the water colourist's box. In these instances the number of tints which can be made from restricted and limited means is enormous. The pastellist is confronted with a completely different problem. He cannot mix new colours as he works; he must have the right colours and tones ready to hand before he starts. From a range of up to 600 tints made by various manufacturers, the artist has to choose a manageable quantity to suit his personal needs.

Using a selection boxed up by a manufacturer is a good way to begin. Rowney, the chief manufacturers in Britain, box up an assortment of 72 pastel sticks and reduce this to small boxes of 12 sticks for portrait and landscape respectively. Grumbacher in the United States produce trays containing 48 tints each. Seven trays—336 tints—are available. They also market small, manageable boxes of 12 sticks.

Tint charts Once he has obtained a selection of colours to suit his needs, the artist should familiarize himself with the colour range either by making a tint chart or, if he has bought a boxed set, by using the printed tint chart supplied with it. The numerical references of the various manufacturers vary; there is no standardized system. Usually the names of the colours are printed in columns, and the strengths of colour ranging from light to dark are recorded by numbers, often zero to eight. The Dutch firm Talens add decimal points to the reference numbers of their colours, denoting the percentage of white added to the original colour.

The charts are arranged roughly in the order of the spectrum, so the artist can, if he wishes, easily arrange his palette to correspond with this. Of course it is not necessary to select a full eight gradations of each colour where this exists: a light, middle and dark tone are often quite sufficient. Remember that colour reference charts are printed on white paper, so it is worth trying out a range of colours on different coloured papers.

Making pastels The artist may well find that some of the manufactured colours—the intermediate greys and grey greens and the half tones for rendering flesh colours especially—are not as subtle in hue as he would like, and he may wish to experiment in making his own (see illustrations).

Oil pastels The effect of oil pastels is altogether different from pure pastels. They relate more to oil painting and are especially useful for preparatory work for oil pictures. The artist starting a picture in this medium is likely to find himself painting straight away, rather than mapping out the shapes in charcoal as most artists in pure pastel do. Oil pastels do not, of course, break or crumble to the same extent as soft pastel and are more readily transportable and therefore useful for sketching and making notes out of doors.

A good way to use these pastels is to combine them with a turpentine wash, spreading the colour with a brush dipped in this medium. Where more precise drawing is required the solid colours can be used. Interesting results are obtained when oil pastels are used in combination with water colour washes (see p.141).

Techniques

Pastels have an intimacy and immediacy of presentation, which makes many people think that they are somehow dashed off in a very short time. This, as any artist who tries the medium will quickly discover, is an illusion. A letter from la Tour to the Marquis de Marigny, the brother of Mme de Pompadour, is reassuring in that the artist lists the same difficulties as anyone working today will encounter. He wrote: "Pastels, my Lord Marquis, involve a number of further obstacles, such as dust, the weakness of some pigments, the fact that the tone is never correct, that one must blend one's colours on the paper itself and apply a number of strokes with different crayons instead of one, that there is a risk of spoiling work done and that one has no expedient if its spirit is lost. . . ."

The difficulty of having to apply a number of strokes with different crayons instead of one, is very real. For this reason it is important to lay the pastels out in a methodical order on corrugated paper, rather than in the box, and to replace them in their correct positions. There is nothing more irritating for an artist in full spate, than having to stop work and search for a missing colour.

Key drawing Most pastellists—especially those who value the graphic quality of pastels—make an outline, or key, drawing in charcoal before beginning to apply their pastels. Even those who regard their pastels much more as paints than as drawing instruments, often find a key drawing useful.

Pastel strokes Experience will familiarize the beginner with the different angles and ways of handling the pastel sticks which produce different marks. Strokes should always be confident and free, since any timidity of gesture produces an image which lacks definition. Too much rubbing in with the finger, the stump of a pastel or a torchon—a length of tightly rolled paper—in an effort to blend the colours, can result in a slick surface which rarely gives a pleasing finish.

The pastellist should be familiar with the effects produced by: alternating thick and thin strokes; using the sharp edge of the pastel; laying the pastel flat on the paper; using the pastel at all angles between the above-mentioned extremes. The amount of pressure applied is vital to achieving different effects. If a lot of pressure is applied, the pastel will be pressed into the grain of the paper, so that it is filled; this effect can be contrasted with strokes that pass lightly over the surface.

It is wise to make preliminary strokes tentative but firm, because too much pressure to begin with can cause the grain of the paper to become overloaded so that further layers of colour tend to clog and slip over a smeary surface. Cross hatching and open work are the most practical ways of gaining tonal and shading effects. Pastel pencils, such as the Othello range, can be sharpened to a point and are helpful where precision is required—to delineate an eyelid or the delicate highlights of a pupil, for example.

Impasto with pastel This is a specialized use of pastel and requires a lot of practice and experience. Degas evolved the technique and was its chief

Holding pastels 1. *Using the edge of a medium pastel to obtain a precise line.* **2.** *Using the front tip of the pastel to make quick, free strokes.* **3.** *Holding the pastel flat on the paper, to obtain a flat area of colour.* **4.** *Holding the pastel vertically.* **5.** *Making quick strokes, giving a fat line which finishes thin.* **6.** *Cross-hatching with a medium pastel, one of the best ways to achieve tonal and shading effects.*

1 △ 2 △ 3 ▽

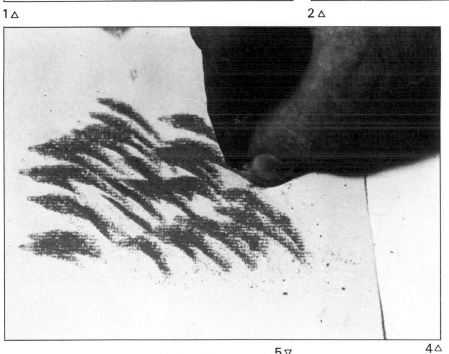

5 ▽ 4 △ 6 ▽

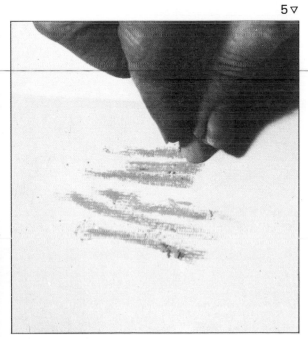

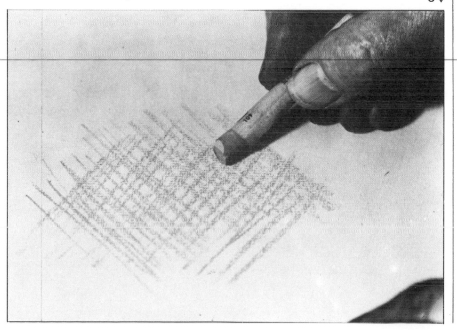

157

practitioner. He would begin by drawing the outlines of his composition in strong colours. He would fix this in the usual way, and then draw over the fixative with more pastel, fix again and add a third layer of pastel. He would go on adding layer upon layer until he had the effect he wanted. By the time he had finished, he had built up a considerable impasto. To allow the colours underneath to show through, he had to apply the upper layers in patches. The surfaces of his later pastels are therefore very uneven, but, if anything, this adds to their impact. Although each layer was fixed, Degas left the final layer with touches of pure pastel the powder from which has often been found at the bottom of the frames of his pastels. The strokes were applied openly by cross hatching, and superimposed touches of colour added to the final effect.

Pastels with other media Used in combination with water colour or gouache, pastels can be lively and effective. They can either be superimposed on the water-based paint, or water colour can be laid on to pastels, because pastels do not destroy the tooth of the surface to which they are applied.

Degas, who initially used pastel in a conventional manner, experimented with the medium and used it very effectively with various combinations of other media. His innovations are still a rich source of ideas. The simplest are charcoal drawings heightened with pastel on toned paper. More complex are his charcoal and pastel drawings where he gave the two media almost equal weight.

Degas combined pastels with distemper paint (made by mixing powdered pigment with animal size). He would heat the pigment and the size as he mixed it and apply the colour to the canvas while it was still hot. This enabled the distemper to work its way into the weave of the canvas leaving a tooth to which pastels could be applied.

Another technique used by both Degas and Vuillard (1868–1940) was to apply oil paint thinned with turpentine to Bristol board. They then drew over this with pastels. Degas also used pastels on a printed base—oil paint was applied to a smooth surface, such as copper, and transferred to paper through a press. The potential for combining pastels with other media is virtually infinite. In one of his drawings for his oil painting, "Harvesters Resting", Millet combined pastels, oils, water colours and black crayon.

Steam and brushwork This is another very effective technique pioneered by Degas. After laying his subject down in pastel, Degas sprayed boiling water over it so that the pastel dried into a paste which could be worked into with a brush. He would spray the water vapour selectively over the picture, so that the original surface of the pastel was retained in places to give the picture variety.

This is of course using pastel for painting rather than drawing. Degas combined both possibilities of the medium, and recalls the term *pastello*, or "little paste" from which "pastel" is derived.

Degas used his various methods separately or combined. The recipes, as with so many artists' manuals, read like a cook book and may offend the sensibilities of purists, but familiarity with them will give the pastellist greater scope in the handling of his medium.

Edgar Degas: Woman combing her hair *Degas has organized his marks to emphasize the vertical nature of the shapes. He has superimposed vertical charcoal strokes over the pastel on the torso and in the bottom right corner.*

Fixing pastels Before removing a pastel from the drawing board, tap the board to remove all the loose particles of pigment. If a pastel is stored under pressure—and this is a good alternative to using fixative to keep the particles in place—loose particles can spread and ruin the picture. Several fixative preparations for use with pastel are available, and they serve the purpose of rendering the powdery particles of pigment immobile, however carelessly the pastel is treated subsequently. Many painters, though, prefer to leave their pastels untouched, because the application of a fixative diminishes the brilliance of the colours. Pastels which remain unfixed must be mounted, framed and handled with scrupulous care.

The arguments against fixing can be summarized as follows: a change occurs in the appearance of the picture and the colour loses brilliance and darkens in tone, particularly if it is oversaturated; the pastel becomes thick and heavy because the particles of colour rearrange themselves as they absorb the fixative and coalesce; the pastel is transformed into a distemper-like painting because an optical change is produced by

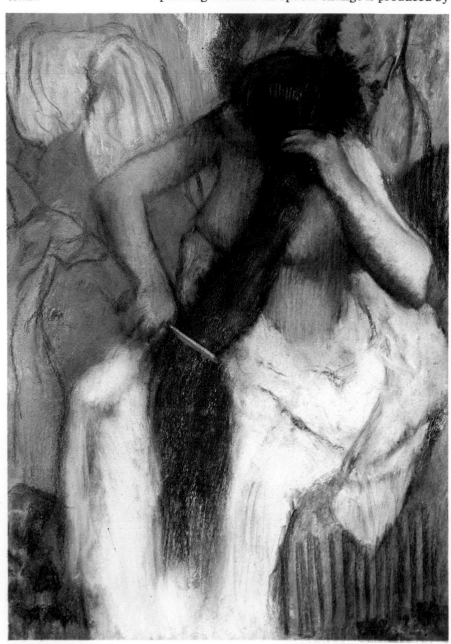

too much wetting. Some shellac or mastic-based commercial fixatives may stain and are not always transparent. The artist who wants to use fixative will do well to prepare his own: rapidly evaporating fixatives are best and for most pastels there is nothing better than two per cent damar varnish dissolved in benzine.

Clearly the artist has to choose between freshness and durability. He may decide to preserve the freshness of the picture instead of ensuring that it will last in a less than ideal form for centuries. There is a theory that a pastel partly fixes itself in the course of time under the influence of the moisture in the atmosphere, and that the older a picture is the more solid it becomes. A degree of fixing can be achieved by laying a board over a pastel, or pile of pastels—each pastel to be covered by a sheet of smooth paper, tissue, cellophane or grease proof paper—and applying firm pressure to the board. The pressure should fix the pastel more firmly into the grain of the paper without affecting the surface.

If the artist chooses to use fixative, he has a number of options. He can fix the finished pastel, or

the first layer only, or he can adopt Degas' practice of fixing between each layer and leaving the top one free. The fixative in these cases should be applied to the front of the picture with a mouth spray or atomizer. It should be sprayed on in the form of a light mist blown in the air, otherwise blobs of liquid may run down the paper causing ridges. When spraying fixative the artist should begin spraying to the left beyond the picture and move evenly across and stop spraying only when he has got beyond the picture to its right.

Pastels can also be fixed from the back, combining a mounting and fixing process by pasting the pastel to card so that some of the paste soaks through the paper fixing the powder from behind. The French chemist Loriot's method for la Tour, who consulted the Academy of Sciences on this subject, was to apply a mixture of fish glue and spirits of wine diluted with more wine to the back of the support.

Pastels may be preserved against "foxing"—the growth of fungus—with a ten per cent solution of formalin brushed over the entire support before drawing begins.

Below **Drawing with a torchon** *Delicate effects may be achieved by drawing with a torchon dipped in powdered pastel, here shown on tinted paper.* *Bottom* **Pastel on various textures.** *From left to right: flock, glasspaper, canvas, and Ingres paper.*

Spraying fixative from the front *Stand away from the picture and spray it lightly, using a mouthspray.*

Spraying fixative from the back *Hold the picture in one hand and spray a light mist over the back.*

Chapter Eleven
Charcoal

Charcoal is made by sophisticated methods nowadays, but it is basically just burnt wood and is the oldest drawing medium. It has been in use since early cavemen covered the walls of their caves with drawings of the animals they hunted. Using burnt sticks and the soot from fires and charred bones the cavemen discovered the pleasure of the large sweeping gestures the burnt stick permitted them to make. Charcoal is ideal for covering large areas, as the fresco painters of the Renaissance were not slow to discover.

Artists' charcoal has to be burnt in a special way, so that the wood is charred throughout and will produce an even line with a consistent intensity of black. It is made by heating wood while excluding the air. Ancient recipes describe how bundles of twigs were placed in clay pots with air-tight lids and heated until charred. Nowadays twigs of vine or willow are heated in kilns.

Until fairly recently art schools and academies throughout the Western world trained their students to produce highly finished charcoal life drawings. The highlights were picked out with bread or put in with white chalk. The contemporary American artist Jim Dine (born 1935) continues this tradition with drawings that take up to six months to complete.

Much freer charcoal drawings, exploiting the graphic qualities of charcoal, were made by Daumier (1808–79). Millet (1814–75) was a master draughtsman, whose charcoal drawings of peasants and the landscape near Barbizon show that atmosphere, light and even colour can be portrayed with charcoal. Degas' (1834–1917) charcoal drawings whether as bases for pastels or as drawings in themselves, show the importance of line and form in charcoal drawings. The rapid line drawings of Rodin (1840–1917) and Matisse (1869–1954) reveal a brilliant observation of the figure in action for which the medium is so suited.

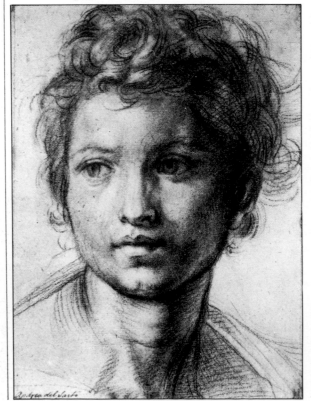

Left **Andrea del Sarto: Head of a boy** *Del Sarto employed cross-hatching, fine lines and delicate shading, possibly using his finger.*
Above **Cave drawing, Lascaux** *Probably drawn with sticks of burnt wood, the rugged lines of this ancient drawing reveal the texture of the rock.*
Right **James McNeill Whistler: Maude reading** *Drawing on brown paper, Whistler used white chalk to highlight the subtle tones of charcoal shading.*

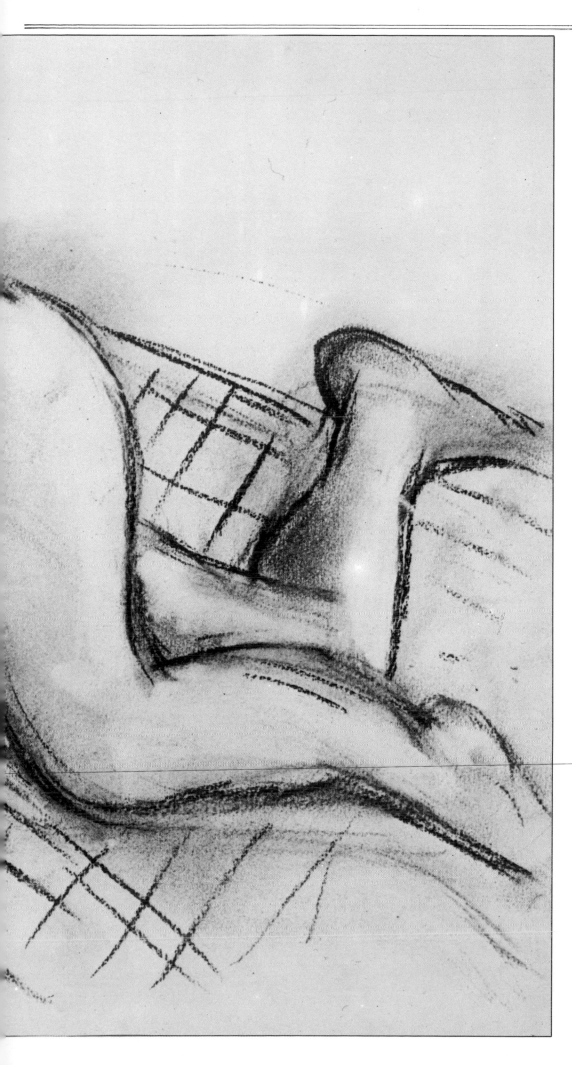

Henri Matisse: Study for pink nude *Here Matisse softened the contours of the body in places to express the langorous curves of the pose. The torso has been modelled with a light middle tone, and bread or putty rubber has been used to pick out the highlights of the drawing.*

Paper

Charcoal has a strong tendency to reflect the grain of a paper, and it is best to exploit this, because it is almost impossible to avoid. The best paper for charcoal therefore has a prominent grain that will stand up to erasures and rubbings and not lose its bite.

The brilliance and intensity of the blacks look effective on coloured papers. Smoother papers are suitable surfaces for compressed charcoal.

Papers for charcoal *Char coal reveals the grain of even the most highly textured paper, and this is a quality which should be exploited. Illustrated (starting at top) are a smooth Fabriano, a medium Saunders, and a rough Arches.*

Types of charcoal

Stick charcoal The common form of charcoal is called stick charcoal. It is made in various thicknesses and in different degrees of hardness. The finest charcoal is vine charcoal; this can be dusted off the paper if mistakes need to be erased.

Stick charcoal is usually boxed up in six inch lengths and the thickest sticks are about a quarter of an inch in diameter. With care these can be sharpened to a point with a blade. Thinner sticks have to be sharpened with fine sandpaper.

Stick charcoal is also made from thin slabs of wood, or shingles. These are split and then combusted in a kiln. The sticks are squarer with harder edges and can be sharpened more easily.

Compressed charcoal Small sticks of compressed charcoal, between three and four inches long and a quarter of an inch in diameter are also available. These are made from powder ground from charcoal and compressed into sticks with a binding medium. They do not break as easily as charcoal sticks, but are less easy to dust off. They are often marketed as Siberian charcoal.

Charcoal pencils Thin sticks of compressed charcoal are coated with wood and thereby made into pencils. They are also available with a rolled paper, instead of a wood, coating. These are less messy than sticks and handle easily, but only the point can be used; they cannot produce a broad side stroke. They come in a range of extra soft 6B, soft 4B, medium 2B, and hard HB. This is the best form of charcoal for small scale, or detailed, drawing.

Forms of charcoal *Vine and willow charcoal are made in various thicknesses, thick, medium and thin, 1, 2, and 3. For small, detailed work, charcoal pencils, 4, made from compressed charcoal, are ideal. They are available in varying degrees of hardness and are easy to sharpen. Powdered charcoal, 5, may be used for drawing in conjunction with a stump, while compressed charcoal, 6, is especially suitable for laying broad sweeps or blocks of tone.*

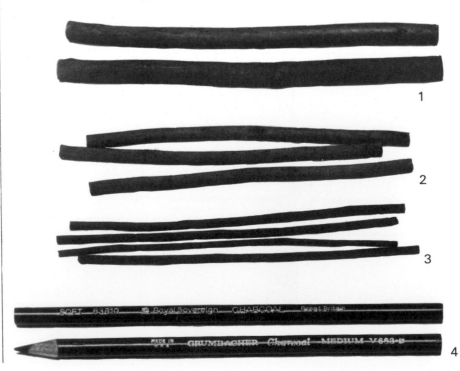

Techniques

Charcoal is equally suitable for line or tone drawing. It is an excellent medium for working on a large scale, and is especially good for preparatory drawings for mural projects and preliminary studies for oils and acrylics. Because of its fragile nature mistakes can be dusted off easily with chamois—if they cannot be blown off—and highlights can be picked out with kneaded rubber, or, more traditionally with bread.

Charcoal can be used with pastel at any time in the development of the picture: for a preliminary key drawing in line, as a tone used to darken the pastel colours, or as a final crispening of the detail of the picture.

Charcoal does however, tend to flatter a drawing and make a weak drawing appear better than it really is. For this reason it is good for the confidence of those learning drawing, but they should be aware that it is more difficult to achieve a satisfying result with pencil or ink.

Charcoal is of course messy to handle, and strokes may be accidentally dusted off with the sleeve; it is advisable to use the fixative fairly liberally. As with pastels large areas can be covered by laying down charcoal and then spreading it with a stump of rolled paper, or torchon, or with the hand. Intermediate grey tones can be obtained with harder sticks of charcoal, or by applying the stick lightly and with less pressure over the grained surface of the paper. Tone can also be added by using a wash in the manner perfected by Daumier.

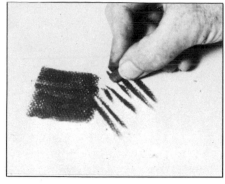

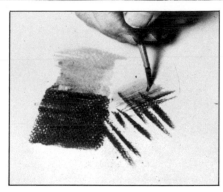

Charcoal with wash 1. *Apply charcoal, in this case a solid shape, drawn with the flat of the stick, with lines radiating from it.*

2. *Work over the design with a brush dipped in clean water. The tones of the wash soften the fierceness of the black line. When dry, the wash may be worked over with more charcoal.*

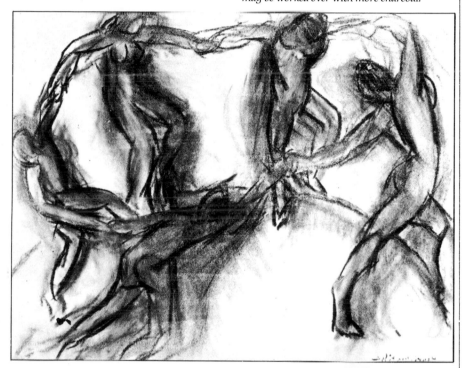

Henri Matisse: The Dance
To express the vigorous, whirling movement of the dance, and the unity of the dancers, Matisse applied charcoal and rubbed it to produce formless shapes. He delineated the figures with rapid, forceful strokes on these shaded areas and picked out the highlights with bread or putty rubber.

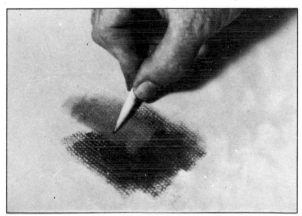

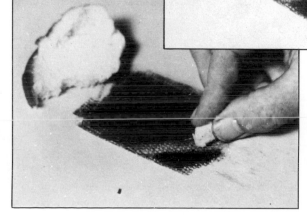

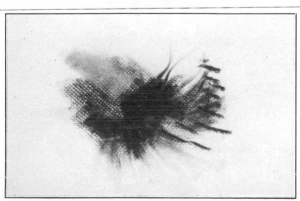

Spreading charcoal with a stump *Lay the design (top). Then spread the grains of charcoal over the paper with a stump (above), to achieve subtle gradations of tone. A stump can be used for drawing with powdered charcoal.*

Above **Rubber highlights** *A kneaded putty rubber should be used. Break off a small piece and rub into the charcoal to obtain precise highlights.*
Left **Bread highlights** *Lay down the design. Knead a piece of bread into a soft pellet and rub lines into the charcoal.*

Chapter Twelve
Pen and ink

Ink as a medium for drawing has been in use in many parts of the world for well over two thousand years. The ancient Egyptians, Greeks and Romans used pens made from reeds to draw and write on parchment and papyrus. The Romans also made pens out of bronze, some of which had nibs shaped very much like their modern equivalent. Quills were being used in Europe in the seventh century A.D., and they remained the most popular form of pen until the steel nib, also known as a point in North America, was invented in the early nineteenth century. In the middle of that century good quality paper began to be produced in bulk, and this allowed artists to experiment, with the result that nibs with many different types of tips were developed. The fountain pen has now largely replaced the traditional holder and nib, but already this is being pushed aside by the more modern reservoir pens.

Many of the great masters drew with quill and ink. Leonardo (1452–1519) filled countless notebooks with ink drawings and notes. Rembrandt (1606–69) made rapid ink sketches as he developed the compositions for his oil paintings. Of the old masters, Dürer (1471–1528), Holbein (1497–1543), Watteau (1684–1721) and Hogarth (1697–1764) are perhaps the finest exponents of the medium. Ink, of course, lends itself to a graphic 'approach, and some of the best examples of this are the book illustrations produced by Aubrey Beardsley (1872–98).

Right Aubrey Beardsley: The mysterious rose-garden *Drawn in Indian ink with fastidious precision using a metal-nibbed pen, this is a typical example of Beardsley's bold use of solid black contrasted with spare line.*
Far right Vincent van Gogh: View of Arles *Although the overall effect of the drawing is of tone and line, this is only evident on the willow trees. The sharper lines on the distant buildings may have been made with a reed pen. The short strokes of the foreground are quill lines of low intensity intended to create an illusion of depth.*

Below Rembrandt van Rijn: Seated female nude from the back *Drawn on brownish paper, the simple feel of this drawing is belied by Rembrandt's mastery of technique and slow, intense draughtsmanship. Here, he used a reed pen, with tonal washes and drawn brush strokes. Untouched paper provides the highlights.*

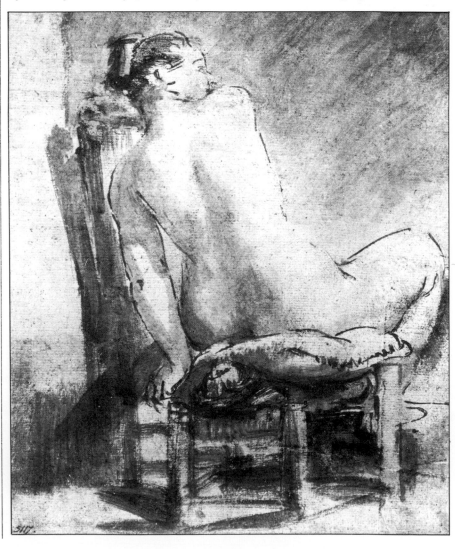

Traditional pens *Dip pens and their attendant ink wells,* **1** *and* **2,** *have been in use for several hundred years, and are still popular with artists. Reed pens,* **3,** *bamboo pens,* **4,** *and quills,* **5** *and* **6,** *have very long histories, but are still made today.*

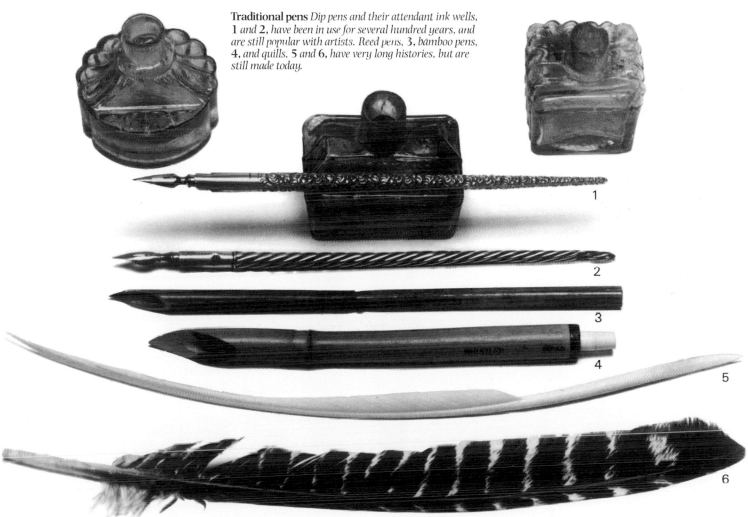

1

2

3

4

5

6

Pens and nibs

Dip pens Dip pens are cheap, will take an enormous variety of nibs and can be used with any kind of ink. Pen manufacturers and suppliers refer to dip pen nibs as "pens", and call the holder a "penholder". "Slips" are nibs with an open oval-shaped barrel; "mapping pens" and "crow quills" are narrower overall, produce finer lines and have tubular barrels.

Small brass reservoirs can be fitted to penholders, but they hold very little ink relative to a fountain or reservoir pen. Nibs should be cleaned frequently—at the very least every time a drawing is finished—to avoid clogging.

Fountain pens Most fountain pens will work only with non-waterproof and writing inks, although the Osmiroid will take waterproof drawing ink. Good ranges of nibs are available, but the choice is small compared to the vast array of dip pen nibs.

Reservoir pens Reservoir pens differ from fountain pens in that the ink is poured into the reservoir, instead of being sucked up through the nib. Special ink is made for these pens in a wide variety

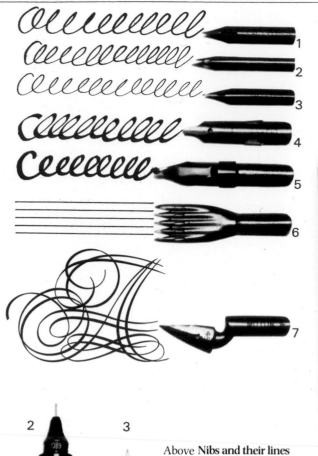

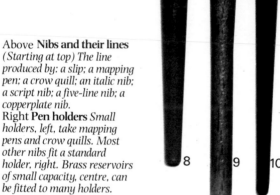

Above **Nibs and their lines** *(Starting at top) The line produced by: a slip; a mapping pen; a crow quill; an italic nib; a script nib; a five-line nib; a copperplate nib.*
Right **Pen holders** *Small holders, left, take mapping pens and crow quills. Most other nibs fit a standard holder, right. Brass reservoirs of small capacity, centre, can be fitted to many holders.*

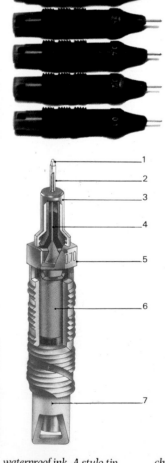

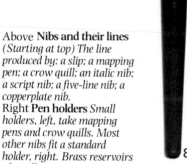

of colours. It has the waterproof qualities of drawing ink, but flows more easily.

The Graphos reservoir pen is designed for use with a wide range of swiftly interchangeable nibs. Other reservoir pens are made for use with stylo tips—narrow metal tubes which produce a line of constant thickness and density, regardless of the direction in which the pen is moved. These were originally developed for precision draughtsmen, but are now commonly used to great effect by commercial illustrators.

Reservoir pens must be cleaned regularly with warm water. They should not be left with the nib or tip uncovered, because the ink will dry in its channel. If they are not to be used for some time, they should be emptied and cleaned.

Pens for practising Beginners may find it best to start practising with a dip pen and a good selection of nibs. Experiment will reveal which nibs best suit the individual's hand movement and style of drawing, and a reservoir pen with appropriate nibs can then be bought. Many artists actually prefer dip pens: the nibs don't have to be changed constantly (holders are very cheap, so each nib can have its own); they don't clog up; and the amount of ink on the tip can be varied.

Reservoir and fountain pens and nibs *A Graphos reservoir pen, 1, will take a range of nibs. An Osmiroid fountain pen, 3, can be filled with* waterproof ink. A stylo tip reservoir pen, 2, can be fitted with a variety of tips. Inside a stylo tip pen are: the tubular point, 1; steel tube, 2;

chromium-plated mount, 3; cleaning wire, 4; colour code for line width, 5; drop weight, 6; retaining clip, 7.

Inks and papers

Drawing inks Made specially for artists, drawing inks are waterproof. They dry to a hard, slightly glossy film which enables another colour to be laid on top. Finished drawings have a precise "printed" quality. Drawing inks are manufactured in several colours: Grümbacher have a range of seventeen; Winsor and Newton offer twenty-two. Indian ink is simply black drawing ink. Special drawing inks in many colours are made for reservoir pens.

Non-waterproof inks Non-waterproof inks made specially for drawing are also available in several colours, and are similar to diluted water colour. They sink into the paper more than drawing inks and dry to a matt finish. Writing inks can of course be used for drawing, but the range of colours is limited.

Ink left in a jar for some time should be shaken before use, because the pigment tends to settle in the bottom. In warm weather evaporation will occur if a bottle or jar is kept open even for the length of a working day. This will gradually make

Below **Types of ink** *A huge variety of inks are available. These include:* **1.** *and* **2.** *Filler bottles of coloured Rotring drawing ink for stylo tip pens;* **3.** *Quink fountain pen ink;* **4.** *Faber Castle fountain pen ink;* **5.** *FW coloured drawing inks, with eye-dropper caps;* **6.** *Rotring coloured drawing inks, with rubber ball and pipette caps;* **7.** *Rotring coloured drawing inks for stylo tip pens;* **8.** *Rotring drawing inks for film, type K – only for foliograph or Graphos steel-nibbed pens, types T, TT and TN – for stylo tip pens;* **9.** *Filler bottles of drawing ink; suitable for Graphos pens;* **10.** *Higgins Indian ink;* **11.** *Rotring fountain pen ink;* **12.** *Winsor and Newton coloured drawing inks;* **13.** *Grumbacher Indian ink;* **14.** *Pelikan fountain pen ink.*

the ink denser and inhibit its flow. When this happens add a little distilled water to the ink, and shake it up before using it; too much water will dilute the pigment.

Papers For ink drawing it is important to choose a paper with a suitable surface. A fairly heavy cartridge paper – about 60 lbs – is best for most subjects and styles. This allows for corrections without damaging the paper and will also take wash and water colour. Thinner paper is never as well sized, so there is always the danger of an ink line spreading unevenly.

Fluffy absorbent surfaces should be avoided because they are liable to catch in the tip or nib, especially when a quick forceful stroke is made. The ink will also tend to soak through to the other side and eventually the paper will yellow and become brittle. A certain amount of absorption by the paper can help an ink line, but if a very precise sharp line is required, then a hard surface paper such as calligraphers use, or an expensive hard cartridge is best.

If water colour, or wash in a fairly wet state, is going to be applied as well as ink it is advisable to stretch the paper on a drawing board as for a water colour painting (see p.121).

Techniques

To study, and even to try to copy, the pen and ink drawings of some major artists is an excellent way to learn. As well as those of the masters mentioned above, the works of the following should prove instructive: Cruikshank (1792–1878); Doré (1832–83); van Gogh (1853–90); May (1864–1903); Klee (1879–1940); Picasso (1881–1973); Bawden (born 1903); Ardizzone (born 1900); and Steinberg (born 1914).

Applying ink Beginners—even those who are skilled with a pencil or brush—will do well to practise and experiment on smooth paper before beginning a major work. The feel of a nib on paper is quite different to that of a pencil. The secret is to get the ink to flow evenly from the nib on to the paper with a minimum of pressure. If a dip pen is used it is important to be able to draw up the same amount of ink each time, and to know when the ink is about to run out.

Artists who have not used ink before will find it worthwhile to begin by laying in some general proportions of their subject very lightly with a soft pencil. For precise representational drawings, as opposed to sketches, even experienced professionals do this. However, pen and ink sketches work best if the artist is able to draw freely and confidently on to the paper, instead of slavishly working over a carefully prepared pencil drawing.

Tones and shades Ink is a line medium and unless it is applied as a wash, special techniques—such as hatching, stippling and scratching—must be used to convey tones and shades (see illustrations). Colours can be muted by diluting drawing ink with distilled water, or non-waterproof ink with tap water. Neat or diluted ink can be applied with a fine designer's brush. This will produce a very wide range of lines, but because its tip is so flexible, much practice is needed before it can be used effectively. With both brushes and pens the secret is to move the whole of the forearm and not just the wrist.

Special effects Interesting designs and textures can be created by blowing blots, allowing blots to run, drawing on turps and using ink to print textures such as fabrics, wood grains, sponges and human skin (see illustrations). Such effects can be incorporated in a picture or provide a starting point.

Drying times When an ink drawing is complete, it must be left for at least half a day to dry. Ink applied thickly, or on to hard paper, will take even longer to set. Pencil lines should not be rubbed off until the ink is dry, nor should water colour be applied. A yellow water colour wash, for example, will turn slightly green if it picks up black particles from wet ink.

Removing blots and erasing If a blot appears, it must be dealt with quickly (see illustrations). Always keep blotting paper close by. Dry ink can be removed with a glass fibre eraser or a very sharp blade. An erasing shield can be used to protect the surrounding drawing. If a grey stain remains, it can be removed with a soft india rubber. When the paper is clean it will need smoothing to a flat surface.

Left **Guercino (Giovanni Barbieri): Study of a woman bathing** *A metal-nibbed pen was used to obtain the free, flowing line, allowing Guercino to draw easily in any direction. In places, a wash was applied over the ink line to soften it, before it had time to dry. Elsewhere, touches of tone add emphasis and drama to the drawing.*

Below **David Hockney: Nick and Henry on board, Nice to Calvi** *Hockney drew directly with a stylo tip pen to create the delicate precision of line. The restraint of emphasis, with just an accent of dark on the brim of the hat, the hair and the glasses, enliven a study in which the ink line is without variation.*

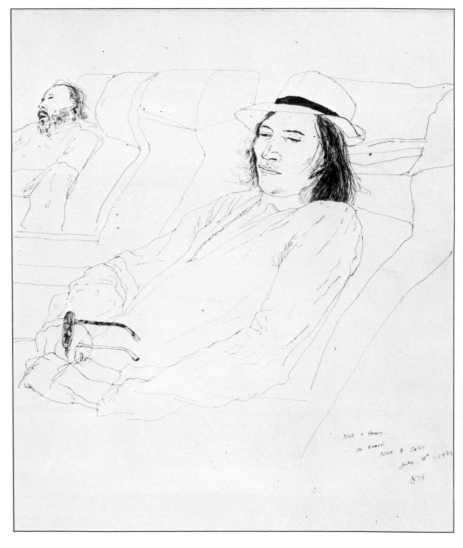

Techniques and effects *A range of tonal effects can be obtained with Indian ink using a pen or brush. These include:*
1. Scribbling 2. Hatching and cross hatching 3. Dashes 4. Stippling 5. Tonal gradation using straight lines 6. Ink and water colour wash 7. Damp paper and ink 8. Wet paper overlaid with ink 9. Wash and pen 10. Ink laid over wet and dry strips 11. Blown blots 12. Printed sponge texture 13. Printed wood texture 14. Fingerprint texture 15. Dabbing ink with a fine sponge 16. Splattering ink using a toothbrush 17. Printed lace texture 18. Ink and wash over candle wax 19. Ink mixed with pen cleaning fluid 20. Ink and white spirit 21. Ink and masking fluid 22. Folded paper print.

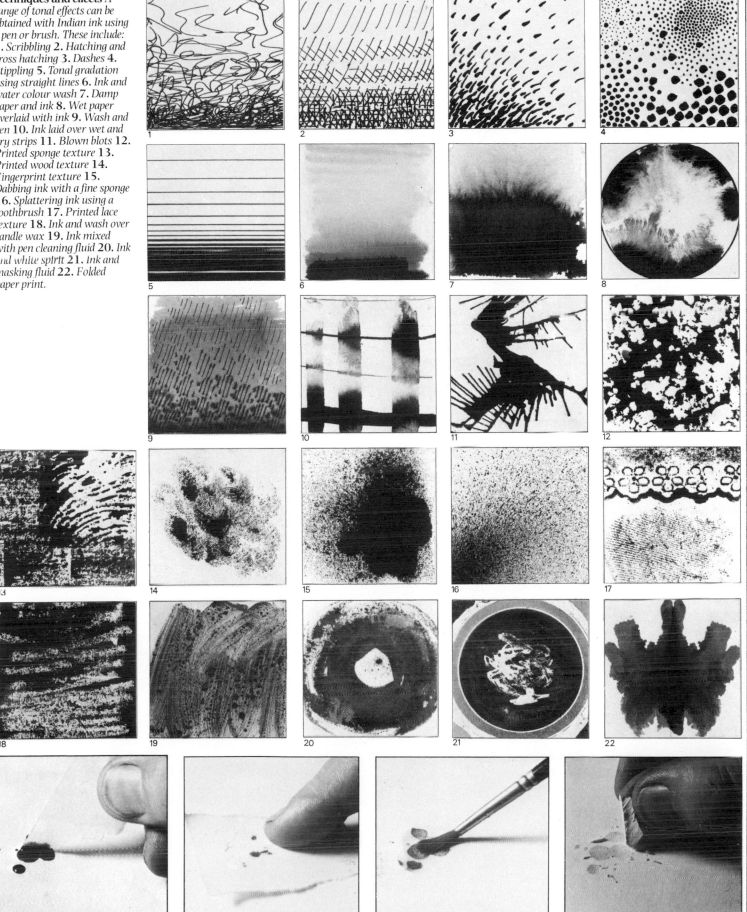

Removing blots 1. *Wet a piece of clean blotting paper between the lips and dip it into the centre of the blot. Repeat with more blotting paper*

2. *Carefully lay the blotting paper over the blot. Just touch the back of the paper sufficiently to make contact. Repeat, and apply more pressure.*

3. *If the paper is quite strong, apply a little clean water with a brush and dab with blotting paper to absorb more ink.*

4. *Remove any remaining stains with a soft India rubber and smooth the paper flat.*

Chapter Thirteen
Pencil

Skill with a pencil can be important not just to those who see pencil drawings as ends in themselves, but to painters—whatever their chosen medium—printmakers and sculptors. A pencil is a convenient and expressive means of evolving a composition, and of recording visual information for translation into another medium later on.

The word pencil derives from the Latin *pencillus* meaning "little tail", which was the name given to the brush used for making marks with ink in the Middle Ages. Artists have always needed a convenient instrument for drawing, a tool capable of great flexibility of mark, from broad generalized gestures to fine descriptive detailing. Albrecht Dürer (1471–1528) used silverpoint—a rod made from an alloy of lead and tin—and the resulting drawings are wonderfully subtle. However, silverpoint had several disadvantages, including its need of a special ground which required time and skill to lay.

So the search for a more immediate and versatile method of sketching continued. Graphite had been discovered in Bavaria in about 1400, but its potential had not been appreciated. In 1504 a deposit of pure graphite was unearthed at Borrowdale in Cumberland, England. At first this was thought to be lead and, because it was used in chunks for marking stones, the earliest references to it as a drawing medium refer to it as such: hence the misleading term lead pencil. It was soon shown to be a separate mineral, but it was not called graphite until 1789.

The first graphite pencil was made in 1662; the scarcity of the mineral made it necessary to devise a means of extending it, and this was done by adding gums, resins and glues. These had the added advantage of allowing the resulting mixture to be pressed into grooves cut into wood, usually cedar. Earlier systems of wrapping included using a continuous length of string, which was peeled off to expose the drawing end; and the use of metal holders, called *porte* crayons, which resembled the modern propelling pencil.

In England, Faber established his pencil company in 1761 and used a mixture of one part of sulphur to two parts of graphite. In the eighteenth century, Napoleon, worried about the need to import the ingredients, asked Conte to develop a substitute. The result was a mixture of clay, graphite, water and paste, which was hardened by baking in kilns and then pressed into grooves in wood. This was the forerunner of the modern pencil. Coloured pencils are made from mixtures of kaolin, waxes and dyes.

Early pencil drawings retained the main characteristics of silverpoint. Such work was usually rendered as a tonal image, drawn from life, using a series of fine lines laid side by side to produce an overall, infinitely variable tone. Van Eyck (active 1422 d. 1441), Botticelli (1445–1510), Leonardo (1452–1519) and Dürer used silverpoint in this way, sometimes on a lightly coloured or toned support which allowed for the introduction of white chalk to pick up highlights and to indicate details. Such drawings were often elaborated with pen and ink or strong dark brushwork.

As the pencil itself became available it was soon found to have a far greater range. Through the

Below **Leonardo da Vinci: Antique Warrior** *Drawn on cream paper, this is a fine example of the quality of line and the minute interpretation of detail attained by the Italian masters of silverpoint.*
Bottom **Hans Holbein the Younger: Jane Seymour** *Holbein used coloured chalks and ink to reinforce the sensitive line and tonal touches applied with metal point.*

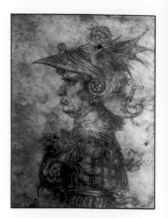

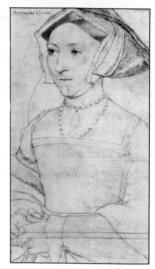

centuries artists have used it in innumerable ways. Notice the differences between the pencil work of Schiele (1890–1918), Ingres (1780–1867) and Augustus John (1878–1961). Compare too the restrained sketches of Degas (1834–1917), the energy in work by Paul Hogarth (born 1917), the reflective studies of the Pre-Raphaelites and the sensitive line of the prolific David Hockney (born 1937).

Any definition of pencil drawing is likely to prove inadequate, for it must include many different approaches: from a highly wrought tonal description of a specified subject to an "idea with a line around it". Between these extremes a huge

Below **Jean Auguste Ingres: Portrait of a lady** *The figure is expressed with a minimum of linear marks. The head displays Ingres' mastery of line and tone.*
Below right **Edgar Degas: Dancer adjusting her slipper** *Degas left mistakes in the foot, thereby retaining the immediacy of his drawing.*
Bottom right **David Hockney: Beach umbrella** *The pure lines of the subject are juxtaposed with the shaded background.*

range of styles is possible: linear, toned, tight or loose, in pencil alone or with the addition of wash, ink or colour.

Pure line drawing is the most difficult approach of all: the artist must resolve the colours, tones and textures of his subject to a few lines. The masters of this technique—among them Matisse (1869–1954), Gaudier-Brzeska (1891–1915) and Hockney—transmit a rare excitement and should be studied by all who seek to draw well.

Scale is an all important element in pencil drawing; the strength of mark is limited by the thickness of the lead. This is why drawings tend to be smaller than paintings.

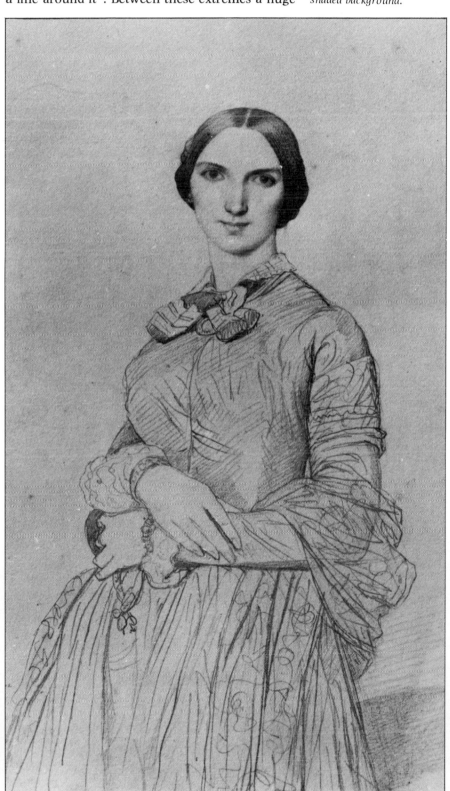

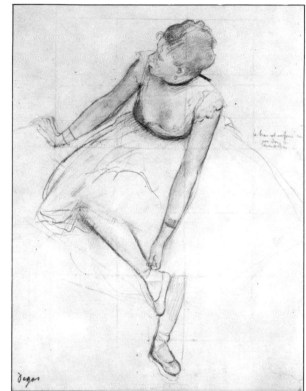

Types of pencil

Graphite "Lead" or graphite pencils are made in several grades ranging from very hard to very soft. The hardest make fine pale grey lines; the softest produce thick black ones. The grades available are usually designated as follows (from hardest to softest): 8H, 7H, 6H, 5H, 3H, 2H, H, HB, F, B, 2B, 3B, 4B, 5B, 6B, 7B, 8B. Some manufacturers now use a numerical system: 1, 2, 3 and 4. 1 is always the softest in the range.

Charcoal and carbon Charcoal pencils (see p.164) make strong black lines. Carbon pencils—such as Wolff's—range from soft to hard, but even the hard ones produce a black line.

Coloured pencils Large ranges of coloured pencils are available. Derwent produce 72 colours; Eagle offer 60. The leads are usually fairly soft, and the marks can only be removed with a blade. However, Venus produce a small range of colours which can be erased with a rubber.

Right **Varieties of pencil**
A thin line of constant thickness can be drawn with a special clutch pencil, 1. A range of leads can be fitted in a standard clutch pencil, 2. These produce the same varieties of line as the various grades of wooden pencil, 3.

Far right **Hard and soft pencils** *The marks on the left were produced with a very soft, 6B, pencil; on the right a very hard pencil, 6H, was used.*

Below **Grades of pencil**
Pencil leads range from 8H (very hard) to 8B (very soft). Each pencil was drawn with the appropriate grade.

1 2 3

Papers

Certain papers suit certain grades of pencil. Smooth paper, ivory card and Bristol board respond well to soft leads, whereas textured paper, rough cartridge, water colour and Ingres papers take the hard leads more successfully.

Pencil can be effective on coloured paper. If the precise colour required is unavailable, paper can be toned with a water colour wash (see p.132).

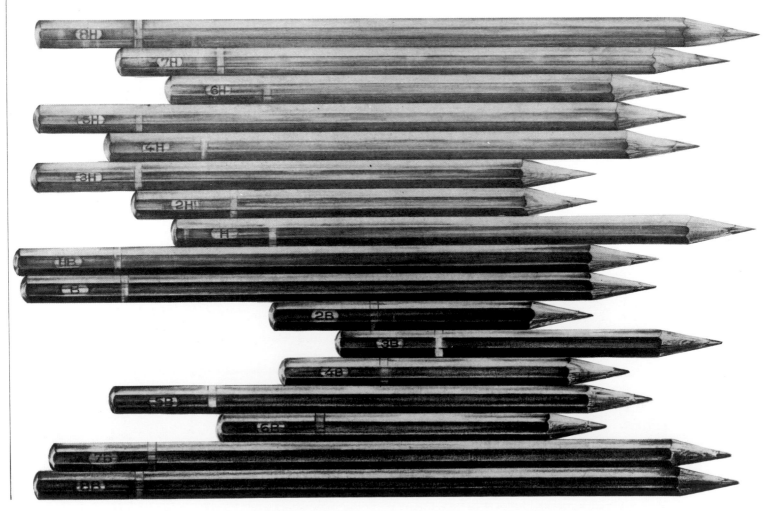

Below **Papers for pencil**
*A soft pencil, 6B (left side),
and a hard pencil, 6H, were
applied to: textured paper, 1;
rough cartridge, 2; water
colour paper, 3; tinted
Ingres, 4.*

Equipment

Erasers Silverpoint drawings were corrected with bread, because this left the surface undamaged. Nowadays rubbers perform the same function. The common India rubber is adequate but tends to retain grey particles and cause smudging. The more modern plastic rubbers and artgum erasers overcome this problem to an extent.

Putty rubbers can be moulded in the hand to any shape, and are useful where precision is required—especially for creating highlights by erasing on white paper. Pencil-shaped rubbers have points, and can be used for the same purpose.

Knives, blades and sharpeners Single-edged razor blades make effective sharpeners, but scalpels and craft knives are safer and equally efficient. Pencil sharpeners are extremely useful, but a point sharpened skilfully with a blade will remain sharp for longer.

Blades can be laid flat to scratch out strong pencil marks which a rubber cannot obliterate.

Fixatives The best fixatives are the proprietary brands which are bought either in bottles to be used with an atomizer, or in aerosol cans.

Pencil extenders Plated metal holders enable partly used pencils to be brought back to their original length. However, the control possible with a two inch length is often greater than with a full length pencil; a circular or flowing line can often be accomplished better with a short pencil.

Right **Drawing equipment**
*Fixatives may be applied
from an aerosol can, 1, or
with a mouthspray, 2, which
is easier to regulate. The
common pencil sharpener, 5,
allows the artist to see the
tip of the pencil as it is
sharpened; the more com-
plex sharpener, 3, lacks this
advantage. A special sharp-
ener, 4, is designed for use
with clutch pencils. A pencil
extender, 6, is useful for
extending the length of a
short pencil. A carpet
knife, 7, or a scalpel, 8,
may be used to scratch out
strong lines that would be
smudged by rubbers. There
are several types of eraser
commonly used. The putty
rubber, 9, a small piece of
which may be kneaded into
a point, is especially suited
to picking out highlights
from shaded areas. Plastic
rubbers, 10, and 11, and
the artgum rubber, 12, will
remove most lines without
smudging. The well known
India rubber, 13, though
more pliable than the
modern plastic rubbers, is
now generally regarded as
less efficient.*

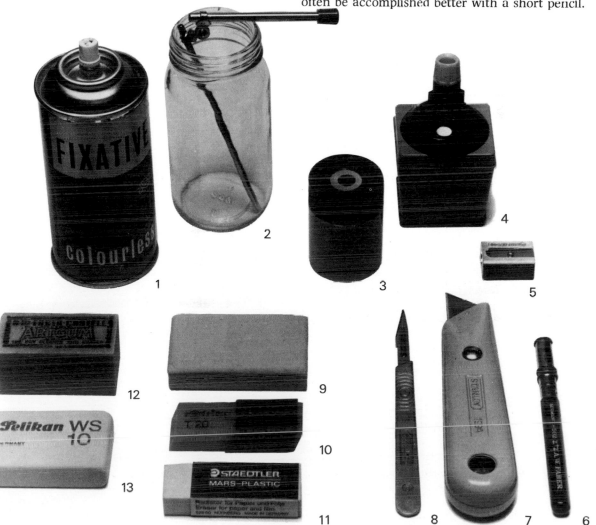

Techniques

Softer pencils are generally good for rapid notes or five minute sketches of moving figures or animals. Harder pencils are better for careful, closely controlled representational drawing, but this is by no means a firm rule. It is often effective to combine different pencils in a single drawing.

The first essential when using a pencil is to make sure it is sharp. This is especially important for the softer grades—from 2B upwards—and for the thick black charcoal and carbon pencils. Working with a blunt pencil is unnecessary and often frustrating; finding the time to pause and sharpen the point is well worthwhile. Fresh, crisp marks tend to work better than smudges, and coarse lines are usually less effective, although this is not an inflexible rule.

Lines The appearance of a pencil line is influenced by three factors: the grade of pencil; the pressure applied; and the speed with which the line is drawn (see illustrations).

Tones The classic method of achieving tonal effects was pioneered by the fifteenth century artists who worked in silverpoint; they used closely juxtaposed lines which became increasingly lighter and finer as they moved out of the shadows towards the light.

Tones can also be expressed by dots, short dabbing strokes or by hatching and cross-hatching—lines crossed in many directions. Subtle tonal effects can be gained by mixing the grades of pencil within the picture. Varying the type of mark is also effective; long trailing lines contrasted with hatching in a thicker lead, or with dotted textures in a hard silvery tone, can be very telling.

Deliberate use can be made of rubbing and deletion. Tone can be pencilled roughly across the

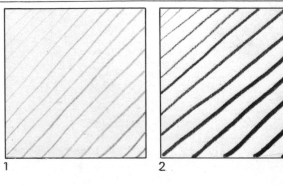

Left and below **Pencil marks**
1. *6H pencil* 2. *6B pencil* 3. *Rowney Black Beauty* 4. *Royal Sovereign chinagraph* 5. *Charcoal* 6. *Charcoal rubbed back* 7. *Several pencils* 8. *Mixed textures* 9. *Cross hatching* 10. *Lines over rubbed pencil* 11. *Scribble over wood rubbing* 12. *Lines over cement rubbing* 13. *Wood rubbing* 14. *Cement rubbing.*

Right **Nick Cudworth: Davenport** *A large pencil drawing in which the artist used the full range of pencils from 6B to 6H. The bottles were drawn with the softest and the finer wood grain with the hardest; the rest of the range was used for the intermediate tones. The drawing was made on 200 lb machine made Kent paper which has a slight gloss. An outline of the design was made on tracing paper. This was transferred to the support by tracing through a sheet of paper coated with rubbed pencil.*

Below **Celestino Valenti: Tug of war** *A tight, almost photographic pencil drawing. This is achieved with delicate shading and several grades of pencil.*

Below **Pablo Picasso: Woman's head** Right **L. S. Lowry: Man's head** Below right **Colin Hayes: Study for a head** *Three profile or near-profile, studies which vary in method. In the Lowry a crisp,* *even line is used to render just the silhouettes of the forms. Picasso modified the silhouette with shallow tonal modelling inside the form, and some darker notes of background tone, which project the profile* *forward. Hayes made a broader use of the tonal surfaces, and these merge with his more open linear structure.*

surface in an approximation of the shape required; highlights can then be picked out of this overall greyness with a rubber—ideally a putty rubber— and darker precise detail can be pencilled over.

Texture A pencil rubbed across paper laid on a textured surface will pick up the natural pattern, whether it be stone, wood or whatever comes to hand. Used judiciously and alongside linear work, this is worth exploiting.

A flat even area—grey and shiny—is unlike any other surface in painting or drawing, and again can be effective juxtaposed with line. Such surfaces, which should be laid down with the softer more fragile leads, need fixing almost at once; otherwise they will smudge and damage the rest of the drawing.

Erasing Obviously the eraser must be used to correct mistakes where a precise rendering of the subject is the objective. However, many drawing teachers believe that to leave incorrect lines and to correct them alongside is a good way to improve drawing skills. Beginners may like to try this and decide for themselves.

Using coloured pencils Coloured pencils have the same graphic qualities as pastels, but the range of colours and therefore the possibilities are not so great. They can be combined with lead pencil, but are especially useful for adding crisp details to water colour work and for contrasting with coloured pen and ink.

Chapter Fourteen
Airbrushing

The first airbrush was developed and finally patented in 1893 by Charles Burdick, a British artist. However, the idea of blowing a mixture of air and pigment on to a surface is at least 35,000 years old: Aurignacian Man created areas of solid colour in his cave paintings by blowing through the hollow leg bone of a deer. In more recent centuries, atomizers as sold in drug stores and chemists have been used by artists for the same purpose.

Airbrushes, however, are precision instruments which can produce extremely fine lines and softly gradated tones as well as solid areas of even colour. They were first used by artists and photographers for retouching, but their full potential was quickly recognized and they are now widely used – principally by commercial artists – to produce paintings and illustrations.

Airbrushed portraits, figure paintings and land-

Below Ben Johnson: Keeper
Here, acrylic paint was sprayed over a gesso ground on canvas, with a spray gun. The air pressure to the gun was reduced, resulting in a spatter effect of varying dots which mixed the colours optically. In places, negative dots were made by spraying over masking fluid, which was later washed off. Masking was done with stencils and masking tape. The painting was washed down frequently to remove grease, and drying was accelerated with a hair-drier.

scapes are easily recognized: tones and colours blend softly and almost imperceptibly into one another in a way which can only be achieved with an airbrush. A sky, for example, can be represented by a white horizon gradually darkening to a deep blue all in one gradating tone.

A skilled airbrush artist can reproduce tonal gradations with almost photographic precision. For this reason airbrush drawings are often used for cutaway pictures of machines and precision instruments to show the working parts, which the camera cannot reach.

An airbrush looks like a fat fountain pen connected by a long flexible tube to a cylinder of compressed air. It has intricate finely engineered working parts, and is therefore expensive, at the least about the price of a cheap air ticket from New York to London.

Types of airbrush

All airbrushes work on the same principle and contain the same basic parts (see illustration). They only vary according to the scale of work for which they are designed. Those intended for precise intricate work have small nozzles and open reservoirs, sometimes let into the barrel, to take the paint or dye; this is filled with an eye-dropper or paint brush. Airbrushes for larger illustrations have bigger nozzles and larger reservoirs into which the colour is poured. The different types are designed so that the rate at which they expel the air relates to the size of the nozzle.

An air gun is simply an airbrush with a large nozzle and separate screw-on reservoir, operated

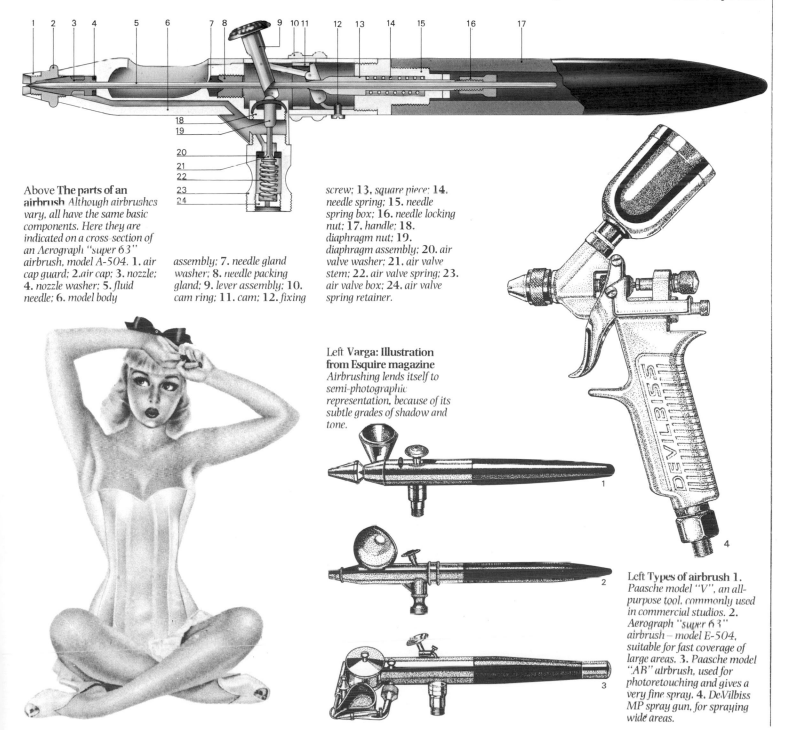

Above **The parts of an airbrush** Although airbrushes vary, all have the same basic components. Here they are indicated on a cross-section of an Aerograph "super 63" airbrush, model A-504. 1. air cap guard; 2.air cap; 3. nozzle; 4. nozzle washer; 5. fluid needle; 6. model body assembly; 7. needle gland washer; 8. needle packing gland; 9. lever assembly; 10. cam ring; 11. cam; 12. fixing screw; 13. square piece; 14. needle spring; 15. needle spring box; 16. needle locking nut; 17. handle; 18. diaphragm nut; 19. diaphragm assembly; 20. air valve washer; 21. air valve stem; 22. air valve spring; 23. air valve box; 24. air valve spring retainer.

Left **Varga: Illustration from Esquire magazine** Airbrushing lends itself to semi-photographic representation, because of its subtle grades of shadow and tone.

Left **Types of airbrush 1.** Paasche model "V", an all-purpose tool, commonly used in commercial studios. 2. Aerograph "super 63" airbrush – model E-504, suitable for fast coverage of large areas. 3. Paasche model "AB" airbrush, used for photoretouching and gives a very fine spray. 4. DeVilbiss MP spray gun, for spraying wide areas.

with a trigger instead of a button. It is for painting large areas, such as posters, panels and walls.

Cleaning and maintenance Whenever an airbrush is not to be used, even for a short period of time – minutes rather than hours – it should be cleaned thoroughly (see illustrations).

From time to time check the various parts in case they have worked loose through vibration: finger tighten only. Never remove or replace the nozzle without first partially removing the needle.

Air supply Air can be obtained from a foot pump, an aerosol can, a refillable canister of the sort used by divers, or an electric compressor. Foot pumps are rare nowadays. Most artists find it difficult to airbrush to the best of their ability with one leg working hard at the same time. Aerosol cans and divers' canisters are efficient, if expensive, and of course, may run out at a crucial moment.

Air compressors are expensive initially, but a serious airbrush artist will find the investment worthwhile. It is best to get one with an air reservoir, which the machine keeps filled with com-

Above **Types of compressor**
A supply of air at a constant pressure is essential to the airbrush artist, and in commercial studios this is often provided by a diaphragm or piston compressor, 5 and 6. These automatically maintain a constant level of pressure in the reservoir. They should be fitted with a condensation trap, 1. Compressors which pump and compress air at the same time, 4, have no reservoir; they are smaller and cheaper, but less likely to produce a constant air supply. A carbonic air cylinder fitted with an air gauge and regulator, 3, is quiet, portable and cheap to refill. For spraying small areas, an aerosol can, 2, may be used in conjunction with a special valve.

pressed air. These will always provide a constant supply of air at the right pressure. The motor starts up when the pressure in the reservoir drops, and cuts out when it reaches its maximum.

Compressors which pump air through as they compress it sometimes produce an uneven, pulsating air supply which causes an inconsistent line or patchy areas of colour. Motors contain either a diaphragm or pistons. Both work efficiently, but a diaphragm tends to be quieter.

Large compressors are specially designed to supply a number of airbrushes. An individual artist works with one airbrush at a time, but these are ideal, if noisy, for studios which specialize in airbrush drawing.

Air reservoirs must be drained regularly because condensation builds up and will enter the airbrush unless it is removed. A condensation trap is a useful way of dealing with this (see illustration). Compressors should be serviced periodically and given a safety check. Those with pistons should be oiled as described in the manufacturer's instructions.

Cleaning an airbrush 1. *Remove excess paint from the reservoir with a paint brush or eye-dropper. Spray through the remainder.*

2. Place clean water in the reservoir with a brush or eye-dropper, and remove any paint from the side with a paint brush.

3. Spray clean water through the airbrush and repeat the process if necessary until all paint has been removed.

4. Remove excess moisture from the reservoir with a dry, clean brush.

Media and surfaces

Gouache and water colour Concentrated designer's colour (gouache) and concentrated liquid water colour are commonly used in airbrushes. It is important to choose brands in which the pigment is finely ground. Dr Martin's and Luma water colours, and Pelikan designer's colours are reliable. Coarsely ground pigment will cause spattering.

Certain colours are of their nature less finely ground than others. Bright pinks, violets, dark blues and dark browns fall into this category, and it is sometimes necessary to mix these from two other colours. For example, turquoise and red will make a violet containing finely ground pigment.

Oil and acrylic paints Artists oil paints contain finely ground pigments, which can be used in airbrushes. A little paint should be put on a dish and white spirit added until the consistency is as thin as milk. In effect the white spirit is dyed with oil colour. Acrylic paint can be used in the same way, but must be diluted with water.

Photographic dyes Airbrushes were originally designed for retouching photographs, and therefore work well with photographic dyes. These are manufactured in an extensive range of colours. Airbrush artists use them to colour and elaborate black and white photographs.

Inks All kinds of ink (see p.168) can be used in an airbrush, but great care must be taken and the airbrush must be cleaned frequently to prevent the ink drying inside it.

Designer's colours and water colours work best on a smooth paper or board—Schoellershammer board is ideal but very expensive. If a thin paper is to be used, it should be stretched as for a water colour (see p.121). A reasonable result can be obtained on all but the softest papers, which are liable to release their fibres and "go hairy".

Oil and acrylic paints can be airbrushed on to board, canvas, metal sheets and suitably prepared wall surfaces. They can also be used to decorate cars and all forms of coachwork.

Holding the airbrush *To release air, press the button with the index finger,* **1.** *To release paint, pull the button back,* **2.** *After spraying, push the button forward,* **3,** *and remove index finger,* **4.**

Techniques

Successful airbrushing requires skill with the airbrush, an ability to cut masks, and a good memory for colours and tones. The first two require much patient practice. A good visual memory may already exist, or it may be developed through practice. It is necessary because, when colour is applied to one area of a painting, the rest must be covered or masked. The artist cannot see it, so he must remember not just the colours, but all their subtleties of tone.

Preparation Cleanliness—especially clean hands—is vital to airbrushing, because the artist is constantly touching the paper as he cuts, lays and removes masks. Paint is likely to spread beyond the borders of the picture, so white paper should be positioned appropriately.

Before putting any paint in the reservoir, switch on the compressor and blow a little air through the airbrush to make sure it is absolutely free of dust and moisture.

Operating an airbrush The brush should be held comfortably at somewhere between 45 and 80 degrees to the paper—practice will show that different angles between these figures produce a whole range of different effects.

The control button is operated with the index finger. It has two movements: downwards to control the air supply; backwards to control the paint supply (see illustrations). Some airbrushes have an adjustable ring, which can be used to set the paint flow at the required level.

Changing the colour Removing one colour and replacing it with another can be done extremely quickly. Paint should be poured out or removed with a paint brush. Then water (for water-based colours), white spirit (for oil-based colour), or methylated spirits (for dyes), should be put in and sprayed out, until a clean jet emerges. The reservoir can then be refilled with another colour.

Fine lines To create a fine even line, the airbrush should be held close to the paper with only a little

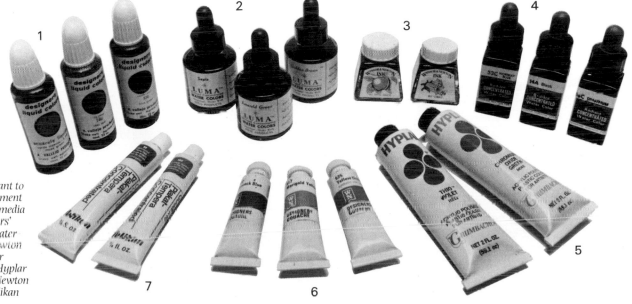

Right Media *It is important to use paint in which the pigment is finely ground. Suitable media include:* **1.** *Vallejo designers' liquid colours;* **2.** *Luma water colour;* **3.** *Winsor and Newton inks;* **4.** *Dr Martin's water colours;* **5.** *Grumbacher Hyplar acrylics;* **6.** *Winsor and Newton designers' gouache;* **7.** *Pelikan gouache.*

backward pressure applied to the button.

Patches of even colour To airbrush an area of even colour, hold the brush about four inches above the paper and make a series of consecutive horizontal strokes, allowing each stroke to overlap the previous one. Spray out air at the end of each stroke to prevent paint collecting in the airbrush nozzle and causing blobs.

If the colour needs to be intensified, go over it again with horizontal strokes. Vertical strokes laid on top will produce a chequered effect, especially noticeable if opaque colour is used.

Graduated tones An area of graduated tone should be made with a series of parallel strokes. The first stroke can be a light tone, achieved by applying a small amount of backward pressure on the control button. The pressure should be intensified with each stroke. To increase the pressure by the right amount each time requires practice. Too small, or too great, an increase will produce a final stroke which is lighter, or darker, than intended.

Large areas of graduated tone can be achieved with opaque colours by mixing and spraying a tint of the lightest value required, and then applying progressively darker tints with every stroke until the required density is reached.

Graduated colours Colours can be graduated like tones, with a series of horizontal strokes. A sky, for example, can begin with a turquoise stroke, followed by increasingly darker blues, and finish with a stroke of deep ultramarine.

Spatter A spatter effect, similar to that achieved with a toothbrush by water colourists, can be produced in three ways: by fitting a specially manufactured "spatter cap"; by dropping the air pressure; by pressing back, but not down, on the control button.

Masking Masks are a central part of airbrushing. They are constantly required to protect the rest of the painting from colour applied to specific areas: any shape which is to have a precise, or even a soft, edge needs a mask.

Sharp edges are usually made with masking film, which is transparent adhesive plastic (see illustrations). A soft or fuzzy edge can be made with a mask cut from card (see illustrations).

Masks can also be painted on with masking fluid. This forms a thin coat of latex which can be peeled off or removed with an india rubber. The fluid is especially useful for masking intricate shapes. Fine lines or dots can be scored into a patch of dried masking fluid, and when this is sprayed over, the marks will appear on the paper. In this way the airbrush can be used for hatching and stippling.

Ready-made stencils, suitable for masking, are manufactured in a variety of geometrical shapes. Irregular shapes can be created by masking with pieces of cloth or cotton wool.

Problems with airbrushes An airbrush is a very finely balanced instrument, and even if the greatest care is taken, such things as dirt, dust, moisture, or coarsely ground pigment can prevent it working smoothly and accurately.

Spitting Perhaps the commonest problem, spitting is often caused by the needle sticking on coarse particles of pigment. Rotating the needle usually shifts the obstruction. Spitting can also be caused

Airbrushing effects *From top left to bottom right; fine lines; flat colour; graded tone; graduated and merging colours; spatter. Colours with finely ground pigment are most consistent for fine line work. To spray a flat colour, spray opaque paint over the area in parallel lines. For a graded tone, it is best to* *work from the lightest tone to the darkest. Transparent colours are best for graduated and merging colours, because two colours can be merged to make a third. There are three ways of achieving spatter: by fitting a special cap to the airbrush; by decreasing the air pressure; by pulling the button back before depressing it.*

Obtaining a gradated tone *1. Mix white with the colour in a palette. Load the airbrush and spray the area with the lightest tone. Allow to dry.*

2. Intensify the colour in the palette, load the airbrush and spray over part of the area to build up a gradation of colour. With transparent colour, increase the amount of paint.

3. Spray the darkest tone by using the full intensity of the colour, or a different darker colour. For example, ultramarine may be used as the darkest tone for a graded area of turquoise.

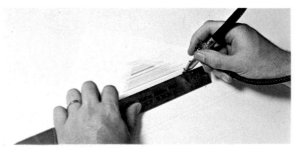

Drawing straight lines *Bunch the fingers under a steel ruler, keeping one edge flat on the paper. Use the thumb to steady the ruler. Rest the* *nozzle of the airbrush on the raised edge of the ruler and spray, sliding the nozzle along the edge.*

Fitting a spatter-cap *Unscrew the handle and loosen the needle. Remove the air-cap and fit the spatter-cap, leaving the nozzle in place. Then, reset the needle.*

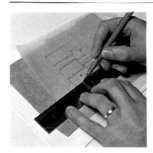

Using masking film 1. *Place the film on the board, ensuring that air-bubbles are removed. Trace down the image on to the film by placing a sheet of rouge (artists' carbon) paper between the image and the film.*

2. *Cut the masking film with a scalpel. Do not cut too deep or the surface will be scored.*

3. *Lift one of the cut masks and spray. Replace the mask before repeating the process over the rest of the painting.*

Removing the air-cap 1. *Unscrew the handle, loosen the needle locking nut and withdraw the needle about 1 inch (25mm).*

2. *Unscrew the air-cap and remove the nozzle. When fitting a new nozzle, ensure that the needle is partially withdrawn, and that the air-cap is not screwed too tightly.*

Using a card mask 1. *Cut a shape from a thin piece of card.*

2. *Hold or rest the card slightly above the area to be sprayed. The height of the card dictates the softness of the edge; the closer the card is held to the surface, the harder the edge.*

3. *Hold the airbrush at the desired angle and spray. By varying the angle the edge can be made softer or harder.*

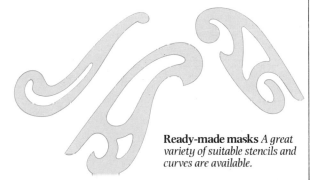

Ready-made masks *A great variety of suitable stencils and curves are available.*

Using masking fluid 1. *Mask the area as desired with fluid. Fine lines may be scored through the fluid.*

2. *Spray over the area and the fluid.*

3. *When the paint is thoroughly dry, remove the mask by rubbing it gently, and peel it off the surface.*

by paint which is too thick for the air pressure to atomize. If the pressure cannot be increased, the paint must be removed and thinned.

Spitting which occurs only at the start or finish of spraying is almost certainly due to the artist releasing the control button upwards before he releases it forwards. The paint flow must always stop before the air flow; otherwise paint is blown out in blobs at low pressure at the end of spraying, and remains in the nozzle to emerge in more blobs at the start of the next spraying.

Irregular paint flow If the needle sticks and cannot be released smoothly, it is probably fitted too tightly, and if there is a sudden rush of paint from the nozzle, the needle is almost certainly out of place. In both instances release the locking nut and reseat the needle.

If the amount of paint released increases without any extra pressure applied to the control button, the nozzle is worn.

Paint leaking through the nozzle when the valve is closed usually means that pigment has dried in the fluid passage of the nozzle. This can only be removed by long saturation and cleaning. Immerse the nozzle only; liquid must never be allowed to enter the lever compartment.

Lop-sided spray A bent needle often causes lop-sided spraying, but this can also be due to an obstruction in the air cap, which should be removed and cleaned.

Paint build-up When paint builds up inside the nozzle cap, remove it by putting the tip flat on a piece of paper and blowing. If the cap becomes badly clogged, unscrew it and clean it inside and out with a stiff brush, or a moist cloth which will not shed fluff, or if necessary a wooden toothpick.

Rotating the needle 1. *Unscrew the handle and loosen the needle locking nut.*

2. *Rotate the needle to clear the nozzle of paint, then tighten the needle locking nut.*

Blowing the tip on a flat surface *Paint may build up in the air-cap and air-cap guard when large areas are sprayed. To clear this, hold the airbrush vertically on a flat surface and spray a short burst of air.*

Drawing aids

Graphic artists and draughtsmen have to draw with absolute precision and therefore use a variety of instruments and other aids. Many of these can also be used by painters and pastellists for planning a design and underdrawing, and by those who draw more loosely with pen and ink, charcoal, pencil and crayons.

For example, an ink line of constant thickness is best drawn with a ruling pen; a design for a painting can be transferred from paper to support with tracing paper; a stencil can be cut so that a precise shape can be repeated throughout a painting or drawing.

1. Pantograph *A simple adjustable copying instrument, which will make enlarged or reduced copies. The original is traced over with a point and a lead makes a copy at the same time.*

2. Set of drawing instruments *This set contains the tools necessary for most types of accurate drawing: compass; small compass; small radius compass; dividers; beam compass attachment; compass ruling*

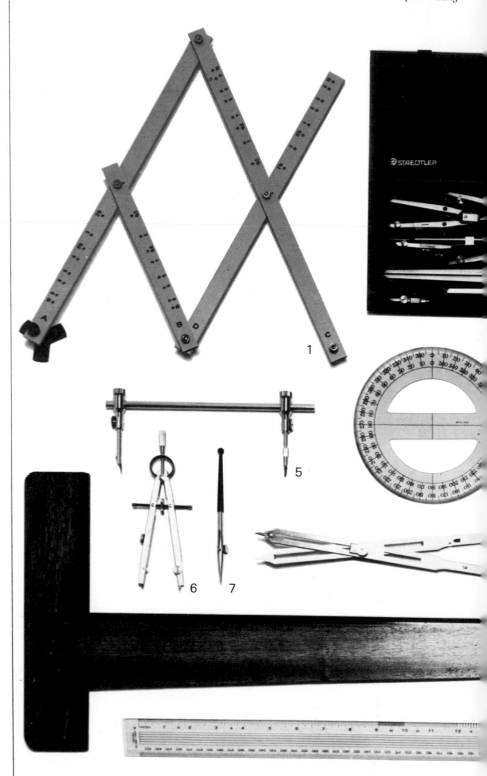

pen attachment; ruling pen holder; ruling pen nib; box of leads and points.
3. Light box Drawings, photographic transparencies or negatives, can be laid on the perspex, or plexiglas, lid of a light box. Fluorescent tubes inside the box illuminate them from behind.
4. Ellipsograph This enables ellipses to be drawn to specific dimensions, set by sliding the small central disc along the two scales.

The ellipse is then drawn by turning the outer disc through 360 degrees.
5. Beam compass Circles and arcs, too large to be drawn with an ordinary compass, can be drawn with a beam compass.
6. Compass This can be fitted with two points and used as dividers for transferring measurements when copying.
7. Ruling pen Sometimes called drawing or bow pens, these are for drawing ink

lines of constant thickness. Parallel lines can be drawn with a double nib attachment.
8. Proportional dividers Drawings can be copied on a larger or smaller scale with proportional dividers. The scale is set on the central slide.
9. Protractor Angles can be measured to an accuracy of a quarter of a degree on a large 360 degree protractor.
10. Stainless steel straight edge This may be used for

ruling straight lines, but it is designed to be used with a knife for cutting board for mounts.
11. Parallel ruler Basically two rulers hinged together, this is an aid to drawing series of parallel lines.
12. T-square The top of the "T" is fitted over the side of a drawing board; parallel lines can then be drawn by moving the T-square up and down the board.

13. Ruler A common plastic ruler for measuring and drawing straight lines.
14. Speedliner Another device for drawing parallel lines. This can be rolled up, down or across the paper. A white line on the roller can be read against the scale to reveal how far the ruler has travelled.
15. Triangle Sometimes called set squares, these serve as templates for the angles they represent, and are frequently used with rulers or T-squares for drawing parallel lines.
16. Adjustable triangle Any angle between 0 and 90 degrees can be set and drawn.

2

3

4

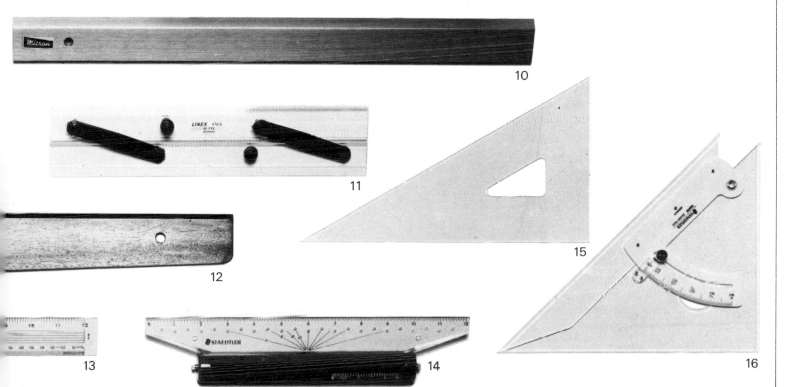

10

11

12

13

14

15

16

Drawing aids

1. and 2. Ellipse templates
Plastic templates are made in innumerable shapes — circles, squares, triangles, hexagons and so on. For graphic artists, ellipses are probably the most useful of all, in that they enable circular shapes — the top of a jar, the wheel of a car, the end of a tube — to be drawn accurately in perspective. Ellipses are arranged on templates according to two measure-ments, their major axis (longest dimension) and their angle (the degrees through which a true circle has been turned to form the ellipse).

3. Ellipse wheel Artists often judge by eye which ellipse should be used to portray a particular circular shape from a particular angle. However, if the appropriate angles are measured, they can be set on an ellipse wheel, a revolving plastic disc, and the angle of the correct ellipse can be read off.

4. Stencil paper Shapes can be cut from stencil paper, which is usually an oiled manila; this is imporous and resists ink and water-based paint. It is frequently used for pro-ducing precise repeat images.

5. Acetate sheet A stencil can also be cut from a sheet of clear acetate, often marketed as drafting film. This can be drawn on with ink or wax pencil; an image can be traced on to it and a stencil cut. Sheets of acetate are also used to cover and protect finished drawings.

6. French curves Made of clear plastic, these are designed to include as many degrees of curve as possible.

They are useful for drawing from photographs or existing drawings. They can be laid over the subject and moved round until they fit the appropriate curve.

7. Flexible curve This is used for the same purposes as a French curve. It can be bent to reflect any curve and has a bevelled edge to facilitate the drawing of ink lines.

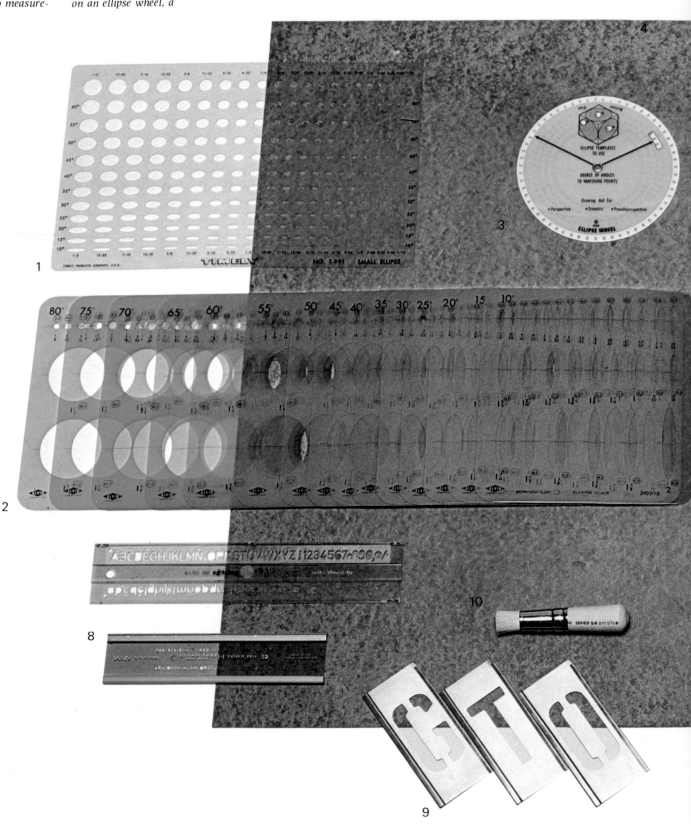

186

8. Plastic lettering stencils
Consistent lettering in many styles can be laid down with any of the wide variety of lettering stencils available.

9. Metal lettering stencils
These are extremely durable, and are designed so that the individual letters can be locked together to form words.

10. Stencil brush *Usually made of bristle, these can* be used with almost any medium. They are designed to apply the colour evenly without brushmarks.

11. Craft knife *Stencils, masks and mounting boards should be cut with a pointed blade. A craft knife is ideal. This one contains several blades in a single indented strip. When a blade becomes blunt, a button is pushed to release the next blade; the* old one is easily snapped off along the indentation.

12. *and* **13. Scalpels and blades** *Fine cutting can be done with a surgical scalpel. Replacement blades are supplied in packets.*

14. Soft "India" rubber *The traditional pencil rubber.*

15. Plastic eraser *This can be used to remove pencil from paper, tracing paper or drafting film.*

16. Kneaded rubber *Also called "putty" rubber, this can be moulded to any shape for rubbing small details.*

17. Plastic ink rubber *This contains oil to ease the removal of dried ink. It works best on smooth, hard paper.*

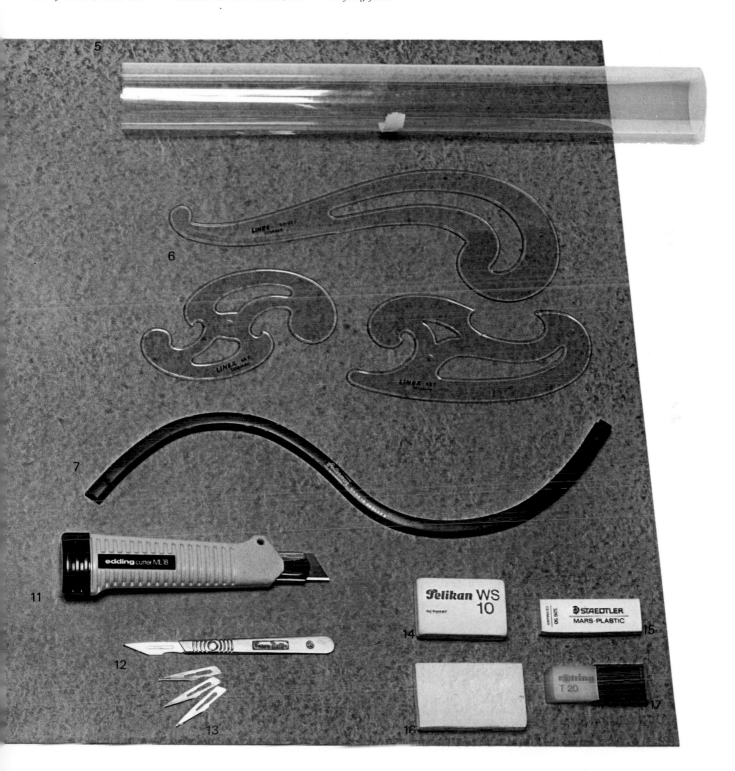

1. Rubber gum *Often called rubber cement, this is commonly used for sticking paper to paper or board. It has the great virtue of sticking firmly, but drying very slowly, thereby enabling the paper to be repositioned even several hours after it was stuck down. Rubber gum is used extensively for mounting drawings and prints. The gum is best applied with a special plastic spatula, but can be laid on with a piece of cardboard. For a permanent bond, both paper and mount should be coated.*

2. Spray gum *This has similar properties to rubber gum, but is sprayed on with an aerosol. The surrounding area should be protected with scrap paper or newspaper. Only one surface should be sprayed; it must be allowed to dry for a few seconds before it is stuck down.*

3. PVA adhesive *This is stronger than gum and forms a permanent bond quickly when used on papers and boards.*

4. Gum strip *A water colour, drawing or print should be attached to its window mount with gum strip, which has to be moistened to make it adhesive. It sticks firmly but can be removed by damping.*

5. Liquid gum *Thin liquid gum is useful for sticking paper to paper, board, canvas or wood. It does not allow for repositioning, but is often used in scrapbooks and for collage.*

6. Art masking fluid *This is applied with a paintbrush and quickly dries to form a mask which can later be peeled away. It is used by water colourists to create areas of untouched paper surrounded by wash, and by airbrush artists for complex masking. It can be painted over large areas, or it can be used with a fine brush to mask details or create subtle textures.*

7. Paper varnish *This is applied with a brush to protect drawings and prints. Most artists prefer to leave such work unvarnished and protect it under glass or acetate sheet. Once this varnish has been applied, it cannot be removed without damaging the original.*

8. Modelling varnish *Sometimes known as water colour varnish, this is for protecting water colours, and gouache paintings, although most artists prefer to use glass or acetate sheet. It can also be used on plaster models.*

1

2

3

4

11

13

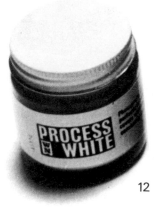

12

14

9. Fixative Bottles of fixative for application with a mouth spray are available, but most fixatives are now supplied in aerosol cans. They are used on charcoal, pencil and pastel work to fix the individual grains to the paper. Many artists prefer not to use fixatives, especially on pastels where they dull the colours.

10. Varnish brush A flat, supple brush, ideal for applying varnish thinly and without brushmarks.

11. Photographic opaque This is an extremely dense rust-coloured paint used for retouching photographic negatives and transparencies. It is so dense that light will not pass through it.

12. Process white and black These are very dense water-based paints, generally used on drawings and diagrams which are to be reproduced photographically. The black can be used to paint large flat areas, or it can be applied by any technique — line, stipple, dry brush and so on. The marks that are made will reproduce as a consistent even black. Process white is most often used for correcting drawings made with black ink or process black, and for covering dirty marks on artwork which is to be photographed. When reproduced, areas covered with process white appear as untouched white paper.

13. Liquid adhesive This is a strong cement-like glue for sticking objects together. It is ideal for mixed media techniques — when solid objects are stuck to canvas or board. It is also good for repairing brushes.

14. Double sided adhesive tape This is adhesive on both sides and has a paper backing. It is a simple means of sticking papers and boards, and is useful for mounting and collage.

15. Adhesive tape The traditional adhesive tape can be used in place of masking tape. First, it should be rubbed over the edge of a table or drawing board to make it less tacky and easy to remove.

16. Masking tape This is ideal for creating areas of paint with straight edges. The paint is applied up to and over the tape; when the tape is peeled away, a hard edge remains. It is also useful for holding tracing paper in place.

17. Mouth spray Ink, water colour, gouache or fixative is inserted at the narrow end, usually with an eyedropper. This end is then directed towards the surface, the blowing tube is snapped into place and blowing can commence.

5

6

7

8

9

15

10

17

16

Drawing aids

1. Self-adhesive tone *This is a quick and easy way of applying texture to a drawing. It is usually used on black ink line drawings. The Letratone range includes 240 different textures ranging from regularly spaced dots and lines, in many sizes, to irregular stippled texture and even brickwork. The other major range is Normatone which offers over 300 textures. The texture is attached to clear acetate sheets, from which the required shape can be cut with a scalpel. It is best to cut out a section slightly larger than the* area required. *This can then be laid lightly over the line drawing, moved into exact position and trimmed with the scalpel to fit exactly. The backing paper, which is supplied with each sheet, should then be placed over the tone, and the area burnished with a special burnisher, a plastic biro cap, or the end of a paint brush. In this way the tone is detached from the acetate and stuck firmly to the support. Useful textures can be obtained by laying one tone over another. White self-adhesive tone is available for use on black paper.*

2. Transfer tone *This is similar to self-adhesive tone. However, the film does not need to be cut before the texture is rubbed down. The sheet is simply laid on the paper or board and drawn over with a burnisher or the end of a paint brush. This is often used on loose pen drawings, and in fact complete pictures can be built up with transfer tone. Textures are frequently laid over one another. The Instantex range contains 20 textures, Normatex over 30.*

3. Pantone paper *These* papers are printed in a numbered range of 500 co-ordinated colours, all formulated from 10 basic inks. Felt tip markers and sheets of acetate backed film, which can be laid down in the same way as Letratone, are produced in the same colours. The system is used by designers to produce illustrations, book jackets and many forms of packaging. The papers can be drawn on with pencil, ink, or felt tip, and instant rub-down lettering can be applied.*

4. Colour aid paper *A range* of 220 coloured papers, printed by silk screen with a pleasant matt finish. These are used by designers for the same purposes as Pantone paper. The range provides a good selection for artists who like to work on coloured papers; ink, pencil and water-based paints can be applied to these papers.*

5. Sketch book *Firmly bound sketchbooks are used a great deal by artists who build up studio paintings from sketched notes made elsewhere, especially outdoors. Such books are durable and can*

provide a permanent record of objects and scenes recorded over many years. Many sketch books contain cartridge paper, but other papers are also bound into books.

6. Cartridge pad *Pencil, pen and ink, and water colour sketches can be made on fairly smooth cartridge paper of reasonable weight. It is this type of cartridge paper which is usually made up into pads. Many other papers, including some good water colour papers, are assembled in pads.*

7. Tracing pad *Tracing paper is useful for transferring designs from one surface to another. This is often done by tracing the design on tracing paper, and then placing a piece of rouge paper (artists' carbon paper) on the support with the tracing on top. The tracing is then drawn over so that the image is pressed from the rouge paper on to the support. Graphic artists producing accurate drawings or diagrams frequently work out the exact design on tracing paper before transferring it to paper or board with rouge*

paper. Pencil and ink are easily erased or scratched from tracing paper. Tracing pads come in several sizes.

8. Scratch, or scraper, board and blades *Scraper boards can be white boards coated with black paper, or vice versa. The top surface is scratched away with a set of special blades, each shaped to produce a different mark – the blades fit*

into ordinary pen holders. In this way a white image can be produced on a black ground, or vice versa. Scraper board pictures have a very distinctive appearance, not unlike lino cuts printed in black.

9. Graph paper *This is ideal for planning a drawing in which measurements must be exact and to scale. Such drawings can easily be*

transferred to another support, and scaled up or down. A grid must be drawn on the support to the appropriate scale; the drawing is then transferred square by square.

191

Chapter Sixteen
Printmaking

There are four fundamental ways of making prints: from a raised surface, a method called relief printing; from a depressed surface, intaglio printing; from a flat surface, planographic printing; and through a stencil, screenprinting.

Relief prints can be made from any surface which can be cut away without too much difficulty. Wood, lino and metal are most commonly used by artists, but of course, soap, potatoes and other vegetables can be effective where precise detail is not important.

The two basic forms of intaglio printing both require metal plates: etching, the most common, relies on acid to incise the plate; in drypoint and true engraving, the artist uses appropriate tools to score and cut his design directly into the metal.

Planographic printing uses the technique known as lithography, whereby the artist draws his image on stone or metal with an ink-attracting, but water-repelling, substance.

Printing through a stencil is done with a fabric screen—traditionally silk, nowadays often nylon or terylene. Stencils for screenprinting can be made from paper, but artists who require precision and uniformity in their screenprints use special materials, some of which come in liquid form.

Equipment A room which is to be used for a process of printing, and not just for making a plate or a block, must be well lit with a water supply and sink, reasonable control of temperature and good ventilation, because of acid fumes.

New presses are very expensive and second-hand ones are scarce. However, art schools and colleges, professional printmakers and commercial printers will frequently allow artists to use their presses for a reasonable fee, and there is often expert advice at hand.

The four ways of making prints *Relief prints, 1, are made by pressing paper on inked, raised areas of wood, lino or metal. Intaglio prints, 2, are made by pressing paper on to inked, incised areas of a metal plate, so that the paper sucks up the ink. Lithographs are made by planographic, or flat surface, printing, 3, using grease which retains ink, and water which repels it. Stencils for printing are usually stuck to, or enmeshed in, a screen, 4.*

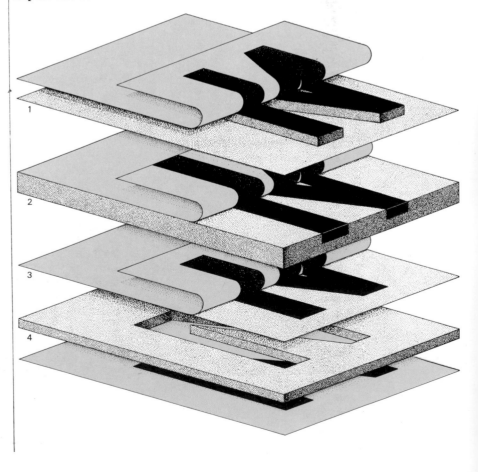

Relief printing

Relief, or raised surface, printing is the oldest method of printing, and involves the cutting away of that part of a surface which is not to print. The raised area which remains is inked up and imprints its image on to paper under pressure.

Lino cuts Apart from potato cutting, which by its nature lacks the precision most artists require, lino cutting is the simplest method of making printed images. Lino cuts are often made by children, but this does not mean that their potential is especially limited. Among others Picasso (1881–1973) and the German Expressionists have exhibited lino cuts. With effort, skill and artistry complex prints in several colours can be made. Alternatively an artist with sound draughtmanship and skill with line can produce effective lino cuts using a single colour.

To make a lino cut, the artist should first paint or draw his design in outline on the lino with Indian ink or pencil. The unwanted surface should then be cut away. Large areas can be removed with a carpet or carpenter's knife. It is usual with lino cutting, as with other forms of raised block cutting, to cut away from the image to be left rather than towards it. The unwanted parts then become

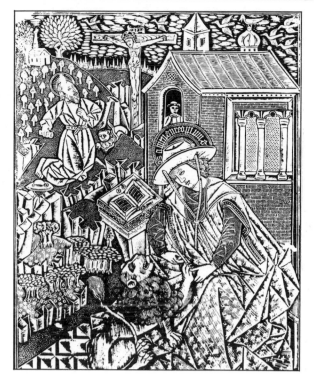

Left **A medieval metal cut (detail)** *Here, a relief print was taken from a metal plate. Large areas of the plate were cut away to leave the relief printing surface.*

"islands" which can be gouged or cut out with less risk of damage to the image.

Gouges are used to remove small areas and to cut any lines which are to appear white. Proofs can be taken whenever the artist feels they will help, because it is not always easy to visualize the results of cutting. This does not impede further cutting away.

Lino which is too hard and brittle can be gently warmed in front of a fire, or lightly oiled with linseed oil and left to soften overnight.

Using card For simple areas of colour, which do not involve fine line cutting, thick card—mounting or matt boards are ideal—suitably sealed with a paper sealer, such as water based varnish, can be substituted for the more expensive lino. The unwanted areas can be cut away with a carpenter's knife. The inking and printing process is the same.

Wood cuts The earliest known prints of any kind are wood cuts made in Japan in the eighth century. With the advent of the printed book in Europe in the fifteenth century wood cuts became the standard method of book illustration. Wood blocks have also been used to print fabrics and wallpapers and

Above **A lino cutting kit** *From left to right, this shows: a selection of inks; four interchangeable cutter heads; a roller for inking up the block; a* block of lino; and a handle fitted with a cutter head.

Making a lino cut 1. *The block may be covered with white poster paint to enable the lines of the design to be easily seen when drawing.*

2. *Cut out the detail of the design with a fine gouge.*

3. *Cut out the large unwanted areas with a medium gouge. Note that while a wide gouge is useful for this, a lot of effort is required to push it into the lino.*

4. *A Stanley knife is useful for cutting fine detail precisely, or removing large unwanted areas.*

are still in use for large display printing type.

Planks of any hard wood which can be given a fine surface, and can be cut across the grain in any direction without splintering, are suitable. Nowadays it is possible to use veneered hardboard or plywood, as long as the veneer is sufficiently tough.

The wood should be cut using the same tools and techniques as for cutting lino. The technical and aesthetic properties of wood and lino are not essentially different, although some wood blocks, until they have been overused, will impose their own natural grain upon the printed image.

Wood engraving This technique is nearly as old as wood cutting. The difference is that wood engrav-

Left Pablo Picassso: Bacchanale *Picasso printed the large area of light colour first. Then he cut away more and more lino to make each successive colour printing.*

Left Hiroshige: Cat at window *This was made with a single printing, using the technique known as rainbow inking.*

ings are made by cutting into the end grain of wood and the blocks are therefore characteristically smaller. The term "engraving" refers to the fact that graving tools like those of the copper and steel engraver are used (see p.000), because of the precision and delicacy of the process. In spite of the name, wood engravings are made from raised surfaces, not incised ones.

Perhaps the greatest wood engraver was Thomas Bewick (1753–1828), who illustrated numerous books, and is best known for his sensitive treatment of natural flora and pastoral scenes. Wood engraving was the principal method of cheap illustration before the days of photo-

Below **Thomas Bewick: Wood engraving**
Meticulously engraved from the end-grain of the wood with tools very similar to those of the metal engraver.
Bottom **Albrecht Dürer: Woodcut block for The small passion** *The image was first drawn on the block, and the background and highlights cut away, leaving the lines of the image in relief.*

reproduction. The large Victorian journals, such as *Punch* and *Illustrated London News*, were illustrated with wood engravings. A number of blocks were assembled and a drawing was pasted on the surface. The blocks were then divided among several engravers and the result was reassembled for printing. These engravers achieved an extraordinary degree of technical skill, with which fine tones could be simulated. Excellent examples of wood engraving as a professional craft are those made of Tenniel's illustrations to Lewis Carroll's *Alice in Wonderland*.

Though they are cut with more refined tools, wood engravings are printed in the same way as

Above **Woodblocks** *An end-grain block (top), used for wood engraving, and a long grain block (bottom), used for woodcuts.*

Below **Wood engraving and cutting tools:** *(left to right) Flat, round, lozenge and burin engravers; large and small "u" and "v" cutters.*

lino and wood blocks.

Relief etching Metal plates are normally used for the various methods of intaglio printing, but they can also be used for relief printing. They can be incised with graving tools in the same way as wood engravings, but more usually the image is drawn on to the plate with an acid-resistant material, such as asphaltum or varnish, and the parts not to be printed are bitten away with acid as they are with an etching plate.

A relief etching can also be printed as if it were an intaglio plate. The surface is rolled up and wiped clean, leaving the ink in the bitten areas, as for a normal etching (see below). Relative to a relief etching inked up and printed as a normal relief print, the inked and uninked areas will be reversed creating a "negative" image.

Combining relief surfaces It is quite common nowadays for prints to be made from a combination of lino, wood and even metal blocks. Used carefully, the mixture of textures can produce a most effective image.

Papers for relief printing A large variety of papers can be used, depending on the individual's preferences, the result required and the number of colour printings. An artist who is using a certain type of block for the first time, or who has devised a new approach to cutting his block, will do well to take proofs on a variety of papers before making a final decision.

On hard-surfaced papers the ink will not dry without the addition of synthetic driers, and this leads to a glossy appearance. Absorbent papers such as rice papers soak up the ink and overprintings may diminish the clarity of the colour, but much depends on the thickness of the paper. Some Japanese papers have an attractive fibrous texture which in experienced hands can be used to advantage.

Printing from relief blocks The same method of printing is used for lino cuts, wood cuts, wood engravings and relief etchings. Prints can be made with or without a press (see illustrations). Printing without a press has the advantage that the artist can alter the pressure on different parts of the print, giving variation to the surface. With a little practice the artist will be able to repeat this variation from print to print.

Experience alone will show how much ink, rolling and pressure are needed. Over-inking will

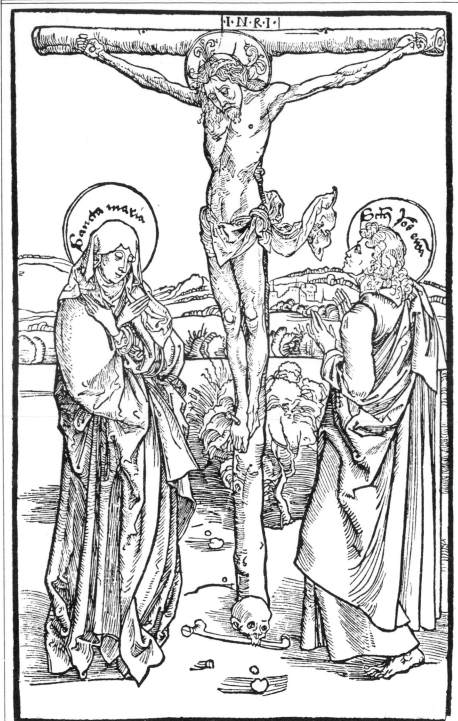

Above **Albrecht Dürer: Canon cut from opus speciale missarum** *Ink is applied solely to the relief areas of the block, which appear black on the print. The cut away areas show as white. Here, Dürer showed the subtleties of tone that may be achieved by varying the thickness of line to obtain a strong black line or delicate shading.*

Making a relief etching 1. *Paint the design on the plate with varnish.*

2. Place the plate in the acid bath. This will bite away all areas not coated with varnish.

3. Take the plate out of the bath with a plate lifter, wash under running water, clean off varnish with turps and degrease the plate (see Cleaning an etching plate, p.198).

Inking up the block 1. *Mix the printing ink on a hard, non-absorbent surface such as an old litho-stone or a sheet of plate glass.*

2. Spread the ink into an even film with a roller. Ensure that there are no lumps or dirt on the roller.

3. Pass the roller, loaded with ink, over the block in all directions until the raised image is evenly coated. Use a brush or pad to ink up small areas.

Dabbing ink *Oil-based ink may be dabbed on small areas of the block with the finger or palm; mistakes can easily be* dabbed off. *A small paint brush is useful for inking up areas of fine detail.*

Taking a print 1. *Place the inked-up block on the bed of the press on a piece of paper which shows the position of the block in relation to the printing paper area.*

2. Carefully lay the paper to the required registration mark on top of the block.

3. Place some sheets of newsprint over the paper for padding.

4. Take a print by winding the bed into the press and pulling the pressure lever.

5. Wind out the bed of the press, remove the newsprint and slowly peel the print off the block. Hold the print down at one end to stop it slipping on the block.

Taking a print by burnishing. *Lay paper on the inked-up block, place a thin sheet over it, and rub evenly with a pad. Ensure the paper does not slip on the block.*

tend to fill smaller hollows and slide ink over the edges of the lines, and this will be picked up in the printing. Under-inking will produce a pale and uneven print. Other methods of inking can be employed such as dabbing or sweeping across with a soft pad. Blended colours, "rainbow inking", can be introduced on a single block. This was a technique much used by the Japanese block printers. Considerable experience is needed to repeat such effects consistently.

A very hard wood block will be able to withstand more printing than a lino block, and will last longer. Prints are still being made from some of the Japanese wood blocks of the eighteenth and early nineteenth century Ukiyo-e school, which included such famous exponents as Hokusai (1760–1849) and Hiroshige (1791–1858).

Intaglio printing

For intaglio printing, lines and areas to be printed are incised into a metal plate which is inked up and then wiped off. Ink remains in the incisions or depressed areas and is taken up by the paper under pressure.

The plates are incised either by etching or engraving—techniques which originated in the middle ages when they were used as direct methods of decorating armour and precious metal.

The metal most commonly used has always been copper, but this is now so expensive that zinc, steel and more recently aluminium have largely replaced it. Each metal has its individual characteristics.

Copper is the most versatile. Acid, which is used for etching, bites into it very evenly, and it is soft enough for drypoint and engraving where the artist incises the metal by hand. It does not have any adverse effects in colour printing, and except in the case of very fine aquatint (see below) it is possible to print up to a hundred prints without appreciable wear. At least 16 or 18 gauge thickness is needed; thinner plates are liable to buckle while being worked.

Steel is much harder to work than copper, but will sustain much more printing. It is thus particularly suitable for fine aquatint (see below) and has no adverse effects on colour printing.

Zinc is very easy to work but wears very quickly.

Above **David Hockney: Portrait of Cavafy I** *Here, aquatint was used to produce soft tones on the tie, in contrast to the finely etched lines of the portrait.*

Cleaning an etching plate 1. *Place the dirty plate in the sink and run water over it. Sprinkle powdered chalk on to the plate and rub with a clean rag.*

2. *Add ammonia, rubbing it over the plate with a rag. Rinse the plate, wiping it down under running water.*

3. *Place the plate on a hot-plate to dry. Wipe it with tissue paper to absorb surface water and residual chalk.*

Etching a plate 1. *Place the clean plate on the hot-plate. Apply wax to the centre of the plate and roll it evenly over the surface.*

2. *Place the plate in the holder, image (waxed) side down, hang it up, and smoke it with tallow tapers. Be careful not to scorch the plate.*

3. *Lay the plate, burnt side up, on a work-top and draw the design into the wax with an etching needle.*

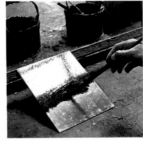

4. *Prop the plate up to prevent dirt settling on the image side, and varnish the back to protect it from the acid.*

5. *Put the plate in the acid bath image side up.*

6. *Take the plate out of the acid bath, wash it under running water and dry it, folding a sheet of blotting paper over it to absorb excess moisture.*

7. *If some lighter areas are required, stop out some lines with varnish. Allow the varnish to dry for 3 minutes.*

8. *Carefully place the plate image side up in the acid bath. As the acid bites, bubbles form; these should be wiped off to ensure the biting remains regular.*

9. *Clean the plate with turpentine to remove varnish and wax. Degrease the plate (see Cleaning an etching plate, above).*

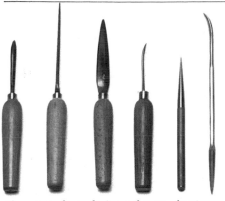

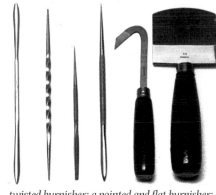

Above **Intaglio tools** *A complete set, showing, from left to right: short and long burnishers; flat, curved and pointed burnishers; a burnisher and scraper; a double-ended burnisher; a twisted burnisher; a pointed and flat burnisher; a dry point burnisher; a draw tool and a mezzotint rocker.*

Making a lift ground 1. *Draw the design on to the plate using a mixture of sugar, water and gamboge yellow (or any water-soluble paint for colouring).*

2. Spread a solution of varnish diluted with turpentine over the whole plate, and allow this to dry.

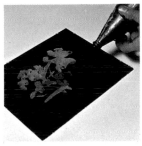

Aquatinting 1. *Shake powdered resin on to the plate through a muslin bag or a stocking. The resin resists the acid which only bites between the grains of powder.*

2. Heat the resin dust to melting point. Do not overheat or the resin will flood and cause an acid-resistant film to form over the plate.

3. Stop out areas not to be aquatinted with varnish. Allow to dry, then place the plate in the acid bath. Take it out, wash, dry, and clean it with turpentine and methylated spirits.

3. Immerse the plate in warm water. Brush the plate, and the varnish coating over the design will flake away. This area is then aquatinted (see Aquatinting, left).

4. Place the plate in the acid bath, then take it out and remove the varnish with turpentine.

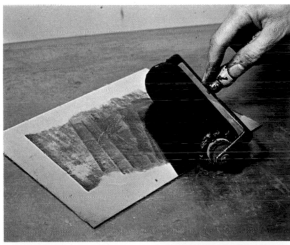

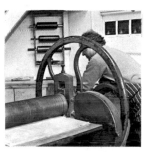

Applying a soft ground to obtain texture 1. *(left) Heat the plate and apply soft ground. If this is unavailable it may be made by mixing hard etching wax with tallow.*
2. Lay pieces of cloth on the plate for texture.

3. Cover the plate with a sheet of glacé paper to protect the blankets of the press.

4. Run the plate through the press so that the texture of the cloth is pressed into the wax.

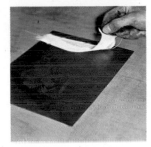

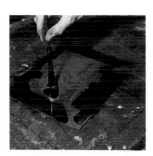

5. Lift the blankets of the press to check that sufficient pressure has been exerted. If this is satisfactory, remove the glacé paper.

6. Remove the pieces of cloth. Use an etching needle or tweezers to remove any pieces too small to be held between the fingers.

7. The plate with texture marks: it is impossible to replace the material once it has been removed.

8. Make the design by stopping out the areas of the plate, which are not to be bitten, with varnish.

9. Put the plate in the acid bath. Take it out and clean off the varnish with turpentine. Thoroughly clean the plate (see Cleaning an etching plate, opposite page).

It oxidizes into colour, and has a particularly bad affect on pale colours, making them look dirty.

Aluminium has similar properties to zinc, but it has no adverse affect on colour.

While they are being stored all metals should be coated in wax or grease, carefully wrapped in grease-proof paper and kept in a dry place. Damp will rot the surfaces. When a plate is to be used the grease must be thoroughly removed with whiting and ammonia.

Etching A plate for etching should be placed on a hot plate and a prepared wax ground applied with a roller or dabber. The ground, which is to be drawn into, should be applied as thinly as possible with no pin holes, because these will cause what is known as "foul biting", tiny holes in the plate which will retain ink.

After the wax has been applied the plate should be smoked (see illustration), giving it a deposit of carbon which hardens the surface wax, making it more acid-resistant and allowing the drawn marks to be seen more easily.

A design can be traced lightly on to the ground with red carbon paper. It can then be drawn into the wax film with an etching needle, knife or any other instrument sharp enough to cut through the wax. The point breaks the wax surface allowing the acid access to the plate; elsewhere the wax resists the acid. This method produces images made up of strong lines. Other effects can be achieved with the techniques of aquatint, lift ground and soft ground.

Aquatint Aquatint is used to produce areas of

*Below **Acids used for etching** The three acid solutions used most commonly for etching bite the plate in different ways. Hydrochloric acid "Dutch Bath", (top) is the most generally used. It is safer than nitric acid, (middle), with no bubbling action. Nitric acid, the most violent, makes bubbles as it bites. These must be brushed off to avoid pitting, which causes irregular lines. Perchloride (bottom) is used for a slow, sure etch. It gives the finest line.*

toned surface on a plate. First, acid-resistant powdered resin is shaken on to the plate. Then areas which do not require aquatint must be stopped out with varnish. Acid will bite in between the specks of powder to form a texture of tiny pits where ink will hold.

Lift ground This is a method used to apply an aquatint to a design drawn directly on to the plate (see illustrations). It differs from a direct aquatint where the artist has to draw a negative, stopping out the areas not to be aquatinted with a coat of varnish.

Soft ground A soft ground is a wax ground that stays soft. The normal hard wax of etching is mixed with tallow. This is used when a design is to be made by pressing textures through the ground or when a soft sketchy effect is required instead of the normal hard etched finish.

Acid bath Before the plate is immersed in acid the back must be protected with varnish, which must be allowed to dry. A plastic photographic tray is the best container for the acid. The depth of bite and blackness of line depend on the length of time the plate is kept in the bath and on the acid used (see illustration). The time can vary from minutes to hours. The artist will learn from experience how much time is required for any given result, although a little experiment will show how quickly the acid bites. This can be done with off-cuts of similar metal with equivalent lines incised.

Once the first lines have been bitten it is possible to wash and dry the plate and then stop out some of the lines with etching varnish. The remaining

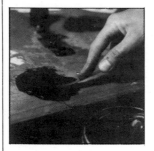

Printing an etching 1. *Prepare the ink by softening it with a palette knife. Powdered ink should be mixed with oil and ground to a stiff consistency with a muller.*

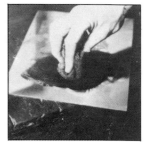

2. Ink up the plate. Warm it on the hot-plate to soften the ink. Work the ink well into the intaglio areas of the plate.

3. Wipe the warm plate with muslin, using a circular movement, so that the surface is cleaned yet the ink remains in the intaglio areas.

4. Wipe the plate with the ball of the hand which should be lightly dusted with powdered chalk to polish the surface of the plate.

5. The inked up plate. ready for printing.

6. Place the plate on the bed of the press on a previously marked piece of paper which shows the position of the plate to the paper size.

7. Place dampened printing paper on top of the plate. The time needed to soak the paper will vary, depending on the type of paper used.

8. Lay the blankets of the press over the paper, ensuring that they are not wrinkled and that the paper is not moved.

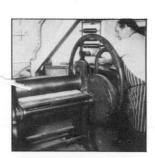

9. Wind the bed through the press.

10. Remove the blanket and carefully peel the print from the plate. This should be done slowly as, if the ink is stiff, the dampened paper may be torn.

work will be bitten for a longer period, producing heavier lines.

Drypoint A heavy drypoint tool is used to score a line straight into the plate. There is no wax (wet) surface laid on the plate—hence the name—and no biting of the line with acid. This produces a heavier line reflecting the way in which the plate has been scored or scratched, but does not produce the fine sharpness attainable in etching or engraving.

Engraving Lines and images are graved or cut into the surface of the plate, not bitten as in etching or scored as in drypoint. The techniques and tools of engraving are the same as those of wood engraving, but a greater degree of skill is required because of the hardness of the medium.

Paper for etchings and engravings Many papers are suitable for etchings, drypoint and engravings. Artists should experiment to discover which papers suit their particular styles. Especially useful are: American etching; Archer's (various); BFK River (various); Copperplate; Crisbrook; Fabriano (various); German etching. Individual sheets should be large enough to leave a wide border round the printed image.

Printing etchings and engravings Etchings are printed on damp paper, which is produced by either sponging for very soft sized papers, or soaking for harder papers. The degree of dampness needed is a matter of experiment and experience. When it is in the desired state the paper should be kept between sheets of plastic until it is needed. No more than is necessary for one day's printing should be prepared.

For colour printing the paper is kept trapped in the press. Corner plates are placed round the printing plate, which is removed and the new plate is inserted; care must be taken to see that the design is the right way up.

Finished prints are placed between dry blotting paper and stacked with a light weight on top to prevent the paper buckling as it dries.

Retroussage With intaglio plates "retroussage" can be applied. Muslin, formed into a cylindrical shape, is stroked gently in all directions across the inked plate which has been heated. This brings the ink to the surface and gives an enriched quality.

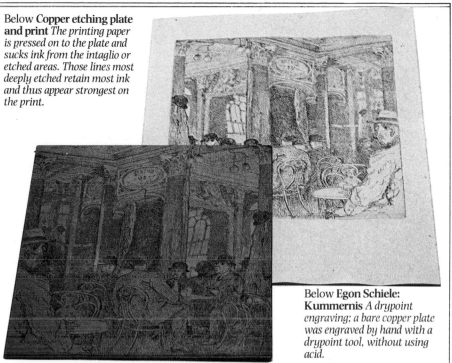

Below **Copper etching plate and print** *The printing paper is pressed on to the plate and sucks ink from the intaglio or etched areas. Those lines most deeply etched retain most ink and thus appear strongest on the print.*

Below **Egon Schiele: Kummernis** *A drypoint engraving; a bare copper plate was engraved by hand with a drypoint tool, without using acid.*

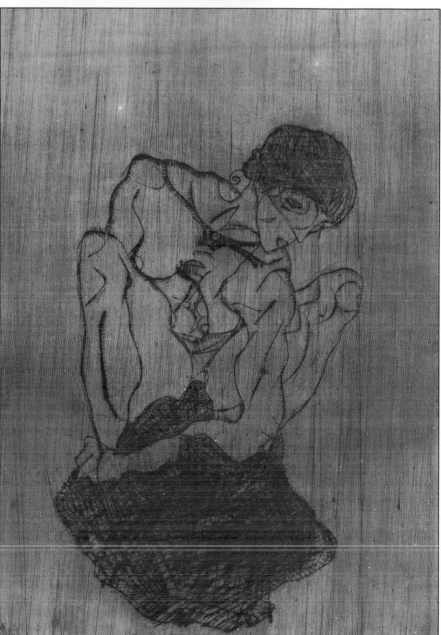

Retroussage *Warm the plate on a hot-plate and wipe over the inked intaglio areas with muslin. This brings the ink to the surface, resulting in a stronger print.*

Screenprinting

Screenprinting is an extension of the idea of making repeat images with stencils. The difference is that the stencils are attached to the under side of a fabric mesh which has been stretched and attached to a frame. These meshes used to be made of silk, but more suitable manmade fibres such as nylon and terylene are generally used nowadays. To print the stencil image, ink is poured on to the upper side of the mesh and is drawn across the screen with a rubber-bladed squeegee. This forces the ink through the mesh on to the paper in the areas not blocked by the stencil.

Liquid stencil materials Screenprint inks are usually oil-based. Most stencil materials are therefore water soluble so that they repel the ink. Designs can be painted directly on to the screen with gum arabic or similar manufactured screen fillers, such as Sericol blue or red filler. Filler can be applied with a brush to block out solid areas or with a sponge to create a stippled effect. Working in this way produces a negative image: the design painted on the screen will not allow ink to pass through, and will therefore appear as white on the paper.

Images can also be drawn directly on to the mesh with oil based inks or soft wax litho crayons, both of which are soluble in turpentine. The screen can then be coated with a screen filler, dried, and the images washed out with turpentine. This method produces positive images.

Solid stencils Paper stencils are the crudest form

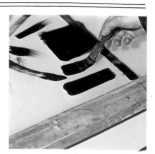

A vacuum screen table *This consists of a flat, perforated surface connected to a vacuum pump. Mounted on the table is a swinging frame to which screens can be attached. As the frame is lowered, the vacuum pump engages and sucks the paper flat. When the frame is raised, the pump disengages, freeing the paper. The frame is constructed so that there is a gap between the screen mesh and the printing surface. This allows the mesh to spring away from the paper as ink is applied.*

Silkscreen with turps-solvent ink 1. *Draw the design on the mesh with oil-based ink or wax litho crayon, dry it with a fan-heater, then coat the screen evenly with water-based filler.*

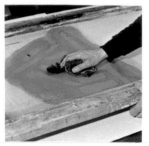

2. *Wash out the image with turpentine or a powerful solvent. Before printing, seal the screen with masking tape to prevent ink squeezing out at the edges.*

Below **Patrick Caulfield: Sweetbowl** *A screenprint in which the flat blues of the background, table and bowl* *intensify the colours of the sweets. Each colour and tone is printed separately.*

Preparing a direct stencil 1. *In subdued light, coat the screen evenly with photo-sensitive emulsion using a coating trough. Dry in a dark room for 20 minutes.*

2. Tape the positive, image side down, to the underside of the screen. Clear adhesive tape must be used or an image of the tape will appear on the stencil.

3. Place the screen in the printing-down frame and close the lid. This is essential to bring the screen and the positive into tight contact.

4. Tilt the printing-down frame and expose the positive to ultra-violet light. As there are no strict exposure times, it is wise to make a test strip.

5. Take the screen out of the printing-down frame, remove the positive and hose down the emulsion surface until the image is washed out. Dry the stencil with a fan-heater.

Preparing an indirect stencil 1. *Place the positive on the printing-down frame. Roll stencil film out over it and cut to size.*

2. Contact the stencil film with the positive in the printing-down frame; tilt the frame and expose to ultra-violet light.

3. Take the stencil out of the printing-down frame and develop, if required by the manufacturer. Hose down the stencil on an upright, flat surface until the image is completely washed out.

4. Lay the stencil, emulsion side up, on a sheet of newsprint placed over a board. Lay a screen on top, which should have been cleaned with degreasing compound.

5. Place newsprint over the screen and roll over it to absorb surplus moisture and enmesh the stencil. Dry with a fan-heater. Raise the screen and peel the acetate backing away from the stencil film.

of hand-cut stencils. Newsprint is commonly used, because a thin stencil is most suitable for printing. The cut image is attached to the under side of the screen with adhesive tape. However, the stencil does tend to shift during printing.

There are several manufactured hand-cut stencil materials which are infinitely superior. Autocut comprises a gelatine film with an acetate backing (see illustrations).

Other stencil materials, Stenplex and Profilm, use the same principle, but methylated spirits must be used instead of water, and a hot iron applied instead of a roller.

Photo-silkscreen Stencils can be made from photographic images. A film positive—made by printing a negative on to film instead of paper—is required. The image must be either a line image or a half-tone—a negative printed through a screen so that the tones contained in the image are resolved into dots on the film positive. The film positive can be used to make either a direct stencil or an indirect stencil.

Direct stencils Direct stencil materials are supplied in liquid form, and often come in two parts which have to be mixed together before they are used (see illustrations).

Indirect stencils Indirect stencils are cut from rolls of photosensitive film which have an acetate backing. Stencils made with this material are called "indirect" because the photographic part of the process (see illustrations) occurs before the stencil is enmeshed in the screen.

Surfaces for silkscreen Silkscreen prints can be made on almost any paper and on many fabrics.

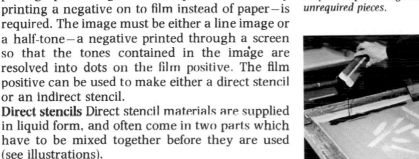

Screenprinting with autocut 1. *Place the autocut stencil film matt side up over the design. Cut through the top layer with a scalpel and peel away the unrequired pieces.*

2. Place the cut film on a board, lay a screen on top and wipe over firmly with a damp sponge, to make the film stick to the mesh. Place newsprint over the mesh and roll over it to absorb surplus moisture.

3. Tilt the screen and dry the film with a fan-heater. Peel away the acetate backing of the film. Ensure first that the film is dry, otherwise the stencil may be pulled off the screen.

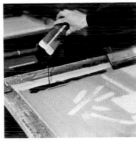

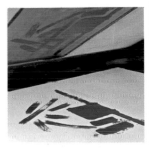

Taking a print 1. *Raise the screen and place the paper under it. Lower the screen and pour printing ink over a filled area at one edge of the screen.*

2. Draw the ink over the screen with a squeegee, holding the blade at an angle of 45 degrees and applying even pressure. This forces ink through the mesh on to the paper.

3. Raise the screen and remove the print. Repeat the process for further prints, aligning them with the registration marks.

Planographic printing

Planographic, or flat surface, printing is achieved by the method known as lithography. From the artist's point of view this is the simplest method of creating an image which will print. He draws an image on a special stone, or sheet of metal, and this will reproduce as a positive image.

Lithography was invented by Alois Senefelder in Bohemia in 1797, and means printing off stone. Nowadays all commercial "litho" printing and most of the lithography performed by artist's printmakers is done with flexible metal plates of zinc or aluminium.

The principle remains the same. Senefelder's idea was to apply to printing the incompatibility of grease and water. Neither will lie on the other. A lithographic stone is a porous limestone with a flat smoothed surface which nevertheless retains a fine grain. If an image is drawn on this with greasy ink or chalk, the stone will hold the grease in its grain. When the whole stone is washed over with water, the grain will also hold this, except where the grease lies: the water at once runs off these parts. If greasy printing ink is then applied to the surface with a roller, this ink adheres to the greasy image, but is repelled from all the water bearing surfaces. An impression of the greasy ink image will then print on to paper when the plate is passed through the press.

Nowadays metal plates are given a granular surface which performs the same function as that of a litho stone. Although the very finest work has been done on stones, they are heavy, cumbersome, liable to break under excess pressure and are laborious to regrain—to clean free of grease to a fresh surface ready for further use. Plates are light, cheap, strong and can be sent away for regraining.
Litho chalks Chalk is the most traditional lithographic drawing implement. Litho chalks are sometimes called litho crayons. They are square-cut sticks of hard grease charged with black to make the drawn image visible as the artist is working. They are sold in various grades of hardness, and must be sharpened from the point backwards.
Litho pen A pen line can be drawn on to a litho plate, using a greasy ink, which is prepared by mixing sticks of ink with distilled water in a dish.

Preparing a litho-stone 1. *Round the edges with a rasp. If this is not done, the edges may flake or the paper be torn.*

2. Place the stone in the sink and run water over it. Sprinkle a coarse grade of sand over the stone.

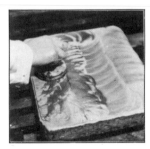

3. Work the sand over the stone with a levigator, using a circular motion to ensure an even texture. Various grades of sand may be used to prepare the stone's surface. Coarse sand is used first and then finer grades, depending on the surface required. Final working of the stone may be done with a muller or small piece of litho-stone. Wash and dry the stone with a fan-heater.

Below **Henry Moore: Mother and child** *A lithograph in five colours. The black drawing was first made on transfer paper and traced through on to a plate. The colours were drawn on to separate plates.*

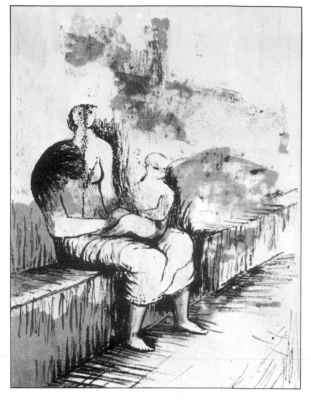

The stick is rubbed on to the dish and the water added in drops until the resulting ink will run from the pen. It must not be so watery that it spreads from the drawn line into the surrounding grain of the plate. Nibs need to be changed frequently because the metal wears away the points.

The greasy litho ink can be melted so that it can be used with a brush. This is a difficult technique to handle. Thick ink will give a full solid printing, perhaps lacking in delicacy; ink which is over-thinned, so that it contains too little grease, may not print at all, because the washing of the plate may remove it. It is possible however, with skilled handling and printing to produce subtle wash-like gradations.

Ink can also be splattered on to the plate with a brush. The areas not to be splattered must be masked out with gum arabic or paper.
Making corrections On a stone it is possible to scratch out part of the image with a scalpel-shaped blade. This is not possible with a plate, on which a preparation called "Erasol" must be used. This grease remover must be flushed off the plate with clean water.
Paper for lithography Many papers can be used for lithography. Soft surface papers are particularly appropriate. Again, the artist must discover which papers suit his own approach.
Printing lithographs When a plate is ready for printing it is best to build up the ink slowly, and to make trial proofs on cheap paper such as newsprint. Once the desired inking level has been reached prints may be taken on good paper.

For colour work, registration marks must be placed on the first plate and transferred to the other plates. The paper must be registered to these.

Preparing ink for drawing on a stone 1. *Heat a mixing tin or saucer over a candle.*

2. Rub the stick ink over the warmed tin. The heat softens and liquefies the ink. Add distilled water until the desired consistency is reached.

Drawing with a pen 1. *Ink up the pen from a loaded brush to prevent it clogging.*

2. *Use a rest when drawing, otherwise the plate or stone will pick up moisture or dirt from your hand.*

Using a brush *Paint the design directly on the surface of the plate or stone.*

Splattering 1. *Place paper mask as desired. Splatter by drawing through the bristles of a loaded brush with a brush handle or knife.*

2. *Remove paper mask to check the result. The mask may be replaced or its position altered and the process repeated.*

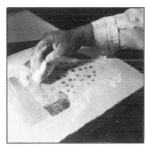

Printing from a litho-stone 1. *Wipe over the stone with French chalk.*

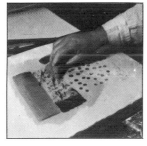

2. *Apply gum arabic to the stone with a sponge. Wipe the stone with a rag and dry it.*

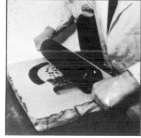

3. *Wash the stone with water and turpentine to remove ink and chalk. The remaining grease image will pick up the ink.*

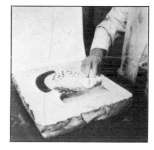

4. *While the stone is damp, roll on printing ink.*

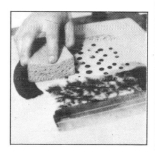

5. *Dry the stone and dust the inked up design with powdered resin.*

6. *Dust the stone with French chalk.*

7. *If desired, part of the design can be scraped out with a scalpel.*

8. *Alternatively, part of the design may be erased with a snakestone – a stick made of pumice and rubber – and water.*

9. *Etch the stone with a solution of nitric acid and water (1 part acid to 40 of water) to clean the surface and open its pores.*

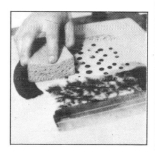

10. *Apply gum to the stone with a sponge.*

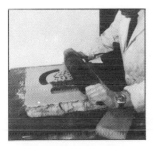

11. *Wash off the gum and remove the old ink with turpentine. Wash the stone clean, and while it is damp, roll on fresh ink.*

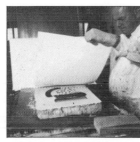

12. *Place printing paper on the inked up stone and lay packing on top.*

13. *Place the stone on the bed of the press and take the print. The pressure of the press should previously have been checked to ensure the stone is not damaged. Stones are liable to crack under severe pressure.*

Using erasol *In order to remove an unwanted part of the image, apply erasol with a fibre-glass brush to the desired area of the plate.*

Using an etcho-stick *This method of erasing is easier to control and thus more suitable for working close to a line. Rub the stick over the desired area of the plate.*

Presentation and storage

Framing

A frame has several purposes: to enhance and enclose a picture; to protect it; and to guard it, when necessary, against warping. Drawings, prints, water colours and unvarnished temperas should be further protected from dust and damp by glass, which must be kept from contact with the surface of the work. Oil paintings are sometimes glazed. Drawings, prints and water colours are usually mounted in a card surround, known as a window mount.

Professional frame-makers are skilled craftsmen who use sophisticated equipment which is not available to the average artist. Gilding is also a professional craft, and although the materials required and the processes involved are uncomplicated, it requires training and much practice to produce a professional finish.

However, good frames can be made by the artist himself. A modest amount of equipment and workroom space is required, although practice is needed to cut well-fitting mitre-corners, and to give a wooden frame an appropriate surface texture.

Much of the "art" of this texturing lies in personal experiment: the great advantage of a self-made frame is that the artist can develop the textures and colours which best suit his own paintings and drawings. Stainless metal frames are easier to assemble than wooden ones (see illustrations), but they are expensive. They are especially suitable for works which look modern or experimental. More traditional paintings and drawings usually look best framed in wood.

There are many picture framing kits available—in wood, metal, plastic or perspex—and most of these are easy to assemble (see illustrations). Pictures can also be framed using various kinds of clips—even stationer's spring clips (see illustrations).

Choosing a wooden moulding A moulding should be used not for the sake of its own appearance, but to enhance the picture. The picture should dictate not only the colour and design, but the width of moulding. Frames for drawings and prints, which will normally be mounted, are usually best kept narrow. Wide mouldings are

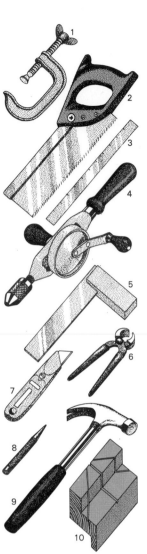

Tools for framing 1. *G clamp* **2.** *Tenon saw* **3.** *Metal ruler* **4.** *Hand drill* **5.** *Tri-square* **6.** *Pinchers* **7.** *Stanley knife* **8.** *Punch* **9.** *Claw hammer* **10.** *Mitre saw guide.*

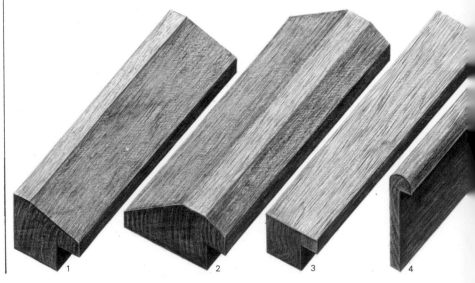

more generally suitable for large imposing oil, acrylic and tempera paintings.

It is important to choose a moulding in which the "rebate" (see illustration) is of adequate depth for the thickness of the work to be framed. Too shallow a rebate will make it difficult to secure a thick stretcher or mount, and the frame, when hung, will be pushed forward from the wall.

Measuring a picture Always measure the four sides of a picture, even if its size is already familiar. The wooden members or stretchers often shrink, or wedges may have been well driven in thereby stretching the picture. In the case of stretched canvases, make quite sure that the perimeter is a rectangle. Follow the craftsman's advice: "Measure twice and cut once".

There must always be a space between the sides of the canvas or panel and rebate of the frame: avoid a tight fit. Changing temperature and humidity—especially in different locations—may necessitate wedging out a stretcher (see illustrations) and room must be left for this expansion. Card mounts and panels also need room to "breathe". For fairly small works add a quarter inch (6 mm) to each measurement. Thus the rebate measurement of a frame for a 20×24 inch (508×609 mm) picture will be $20\frac{1}{4} \times 24\frac{1}{4}$ inches (514×615 mm). For a card mount the addition of an eighth of an inch (3 mm) is generally adequate.

Small cushions or spacers may be cut from cork or softwood and inserted between the canvas and the sides of the rebate to keep the work in the centre of the frame: these can be held in place with veneer pins.

Keeping a record It is a great help to keep a notebook for listing the measurements and particulars of frames before work begins. This is especially useful when a series of frames must be made. Always state the height before the width.

A specimen entry might read like this:

Painting:	20×24 inches (508×609 mm)
Moulding:	$20\frac{1}{4} \times 24\frac{1}{4}$ inches (514×615 mm) 2 inch spoon (or manufacturer's code number)
Treatment:	to be painted or stained

Cutting mitres For ease of handling, mouldings should be rough cut in lengths slightly longer than the frame requires. Take great care when rough cutting to allow for the outer dimensions of the

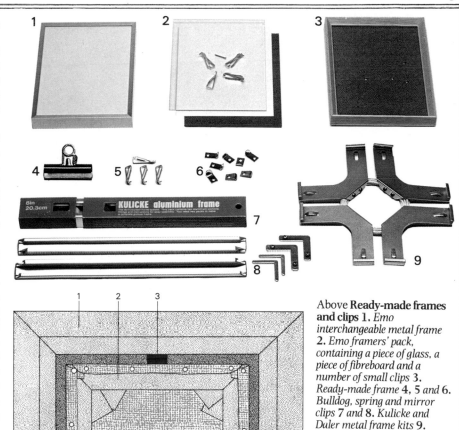

Above **Ready-made frames and clips 1.** *Emo interchangeable metal frame* **2.** *Emo framers' pack, containing a piece of glass, a piece of fibreboard and a number of small clips* **3.** *Ready-made frame* **4, 5** *and* **6.** *Bulldog, spring and mirror clips* **7** *and* **8.** *Kulicke and Duler metal frame kits* **9.** *Hang-it frame kit.*

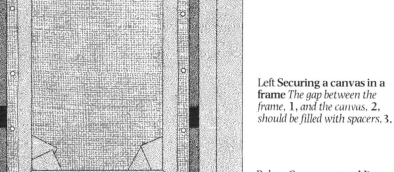

Left **Securing a canvas in a frame** *The gap between the frame,* **1,** *and the canvas,* **2,** *should be filled with spacers,* **3.**

Below **Common mouldings** *(left to right) Box; reverse slope; flat; half round or hockey stick; raised bead and flat; box; spoon; composite made from planed timber and architrave moulding.*

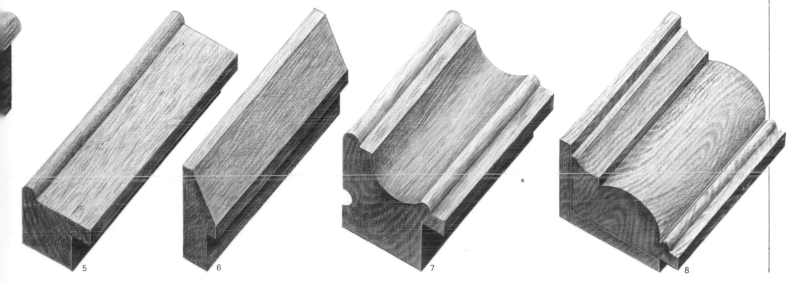

frame, which will be greater than the inner by the width of the moulding. To cut the mitres use a mitre guide and saw (see illustrations). It is a good idea to cut the longer lengths first: if a mistake is made, the length can be used for the shorter side.

If a number of identical frames are to be made, cut one long and one short side, carefully checking them for accuracy, and mark them with the word "master" on an inside edge. Each subsequent length should be measured and marked from them, and checked against them for accuracy after being cut. Do not measure each successive length from the last one you cut, as progressive errors may gradually build up.

Assembling a frame Be particularly careful not to join two long sides or two short sides together. With frame proportions not far off the square, this may easily happen. It is best to check and mark the length of each piece on the back.

A luxury, which speeds the process and may

make two good final joins easier to adjust, is to use two mitre clamps, but this is by no means essential.

The size and number of pins or nails needed to secure a mitre join will vary according to the shape and weight of the moulding, but at least two pins must be used. One pin will only act as a pivot; two will stop movement. Where more strength is required, an extra pin may be driven in at right angles and between the first two. The lengths, angles and positions of the pins must be accommodated to the contours and thickness of the moulding, and the weight of the picture and the glass if there is any. Be very careful never to drive a pin in such a position that the point emerges from the face of the moulding.

Composite mouldings Wider frames may be made up from a number of separate mouldings of either prepared or plain wood.

It is best to cut and join the inner moulding first and treat this as a work to be framed in its

Cutting a mitre 1. *Secure a length of moulding in the mitre clamp. Place pieces of waste wood on either side to prevent bruising, and make the first cut.*

2. Measure the required length of the moulding from the inside edge of the mitred rebate.

3. Mark the next cut. As this mark must be visible when cutting, transfer it to the top side of the moulding, using a set-square to fix the angle of 45 degrees.

4. Adjust the moulding in the mitre clamp so that the saw will cut exactly on the waste side of the mark. Repeat the process for the other three sides of the moulding.

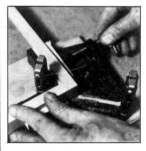

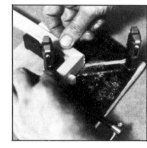

turn by the next moulding. The measuring principles are the same. The outer moulding may be carefully glued under the rebates and further held in position with panel pins driven in at the back at an angle from one moulding into the next. Again great care must be taken not to drive pins through the face of the frame.

Assembling a frame 1. *Assemble an "L" shape in the mitre clamp, a long and short side. Tighten the clamp and check the fit.*

2. Release the clamp and remove the left-hand piece. Spread glue evenly on the mitred faces.

3. Replace the left-hand piece, pushing it firmly against the other piece. Tighten the clamp and remove excess glue.

Composite frames of this kind may be assembled from the standard prepared mouldings stocked by timber merchants and do-it-yourself stores. With a little care and imagination, attractive frames can be made from apparently unpromising material.

Surface finishes Some frames, especially for drawings, need very little finishing apart from the filling of nail holes, sanding and waxing, providing that the wood is close-grained and attractive. Where it is too light in tone, spirit stain can be applied and will not obscure the grain. These stains, which can be obtained from paint merchants and do-it-yourself stores, dry rapidly, and give a pleasing finish when waxed. It is advisable to test a stain or mixture on an offcut of the same wood before treating the finished frame.

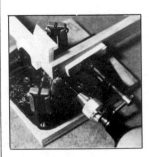

4. *Drill shallow recesses for the panel pins, otherwise the moulding may split when pins are driven in to secure the joint.*

5. *Drive in the panel pins at a slight angle towards the outside of the moulding. This prevents splitting and makes the joint stronger.*

6. *Repeat with the other sides and bring the 2 "L's" together. Raise the frame with blocks to ensure the joints are true.*

Composite frames and wide frames for oil paintings usually need a different treatment. The grain of a wide pine moulding may be distracting, and will need an opaque cover which should be coloured in a way that relates well to the picture. Very strong colours are usually unsuitable: cool or

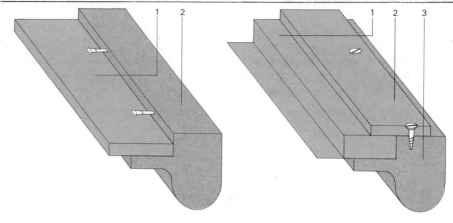

An alternative method of securing a mitre 1. *Make two cuts, place glue in them, and insert pieces of veneer. Remove excess glue.*

2. *Chisel away the surplus wood, and sand with fine sandpaper until the pieces of veneer are flush with the moulding.*

muted earth colours generally, but not always, provide the most sympathetic framing for an oil or tempera painting.

An inexpensive and convenient way of covering a moulding is with ordinary white emulsion paint, modified and tinted with powder colour, and mixed to a thin cream with water. This is best applied fairly thinly, and built up with a succession of coats or stipples, each coat being allowed to dry before the next is applied.

To achieve a more transparent effect, each coat may be rubbed down when dry or wiped with a rag while still wet. Whether a tint is to be laid on the whole width of the moulding or just on one facet, it is advisable to carry it straight round the four sides, even if it is to be wiped down; otherwise the finish may be patchy and lack unity. For this reason, it is worth mixing more paint mixture

than appears necessary.

Another, and more traditional (indeed professional) way of surfacing a frame is with gesso.

For composite frames, it is best to paint the separate members separately, and assemble them when dry.

Using fabric Frames are often enhanced with a canvas "slip", which is a thin moulding inside the frame, and centre sections of composite frames can often be covered with a canvas-like fabric. To cut and stick fabric (see illustrations), the artist needs paste, a "straight edge" and a trimming knife.

If a flat or sloping centre section of a frame is to be overlapped by inner and outer rebates, the fabric can be cut to the exact width of the section. However, when there is no overlapping rebate, but merely one section butting on another, the fabric must be wide enough to wrap round and nip in

Above left **Securing with brads** *A small picture,* **1,** *can be held with brads tapped into the frame,* **2.**
Above **Using battens** *A large canvas,* **1,** *can be secured with battens,* **2,** *screwed into the frame,* **3.**

Sticking canvas to moulding 1. *Use a Stanley knife to cut strips of canvas slightly longer and broader than the moulding.*

Types of frame *A wooden frame can be enhanced with a fabric slip (top left). Plain wooden frames can be made with architrave moulding (centre), plain angular moulding (right), or with a heavily ornamented moulding (bottom left). Wood can be painted (bottom right) or gilded (bottom left).*

2. *Apply paste with a brush to the face and inside of the moulding, one side at a time. Smooth the fabric out on the glued surface.*

3. *Mitre the fabric flush with the moulding, keeping the knife cut as close as possible to the angle of the corner.*

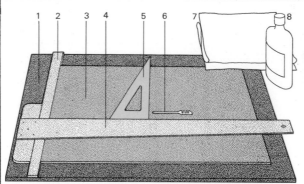

Above **Equipment and tools for glass cutting 1.** *Flat board – Imperial drawing board is ideal – with wooden batten,* **2,** *attached.* **3.** *Picture glass.* **4.** *T-square.* **5.** *Set square.* **6.** *Diamond glass cutter.* **7.** *Cloth.* **8.** *Glass cleaner.*

between one section and the next.

Securing a picture in a frame Small canvases and panels can be fixed in a frame with panel pins or spring clips. Larger canvases should be secured with small strips of wood which are screwed to the back of the frame to overlap the canvas stretcher. If the rebate of the frame is fairly shallow, it may be built up with $\frac{1}{2} \times 1$ inch (1.3×2.5 cm) battening. Alternatively, Z-shaped brackets can be made from soft metal strips (brass, zinc and aluminium are easily bent and drilled).

Drawings and prints should be backed with thin (3 mm) hardboard (see illustrations). Plywood is unsatisfactory because it is prone to wood worm, damp and warping. Cardboard and strawboard are simply not strong enough.

Glass Picture glass is clearer than window glass and is free from flaws. Choose a thickness, or weight, to suit the size of the frame (see illustration).

Cutting glass successfully requires the right equipment (see illustration) and the ability to apply the right amount of pressure and to draw the tool across the surface at the correct speed. This can only be learnt by experience and, if possible, by watching an expert at work.

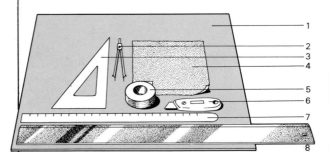

Left **Equipment and tools for mount cutting 1.** *Cutting board.* **2.** *Dividers.* **3.** *Set square.* **4.** *Fine sandpaper.* **5.** *Masking tape.* **6.** *Craft knife.* **7.** *Long steel ruler.* **8.** *Long straight edge.*

Fitting hardboard to the back of a frame **1.** *Place the hardboard in the frame. Drive in brads at a slight angle against the board.*

2. *Cut gum strip to size, and stick it to the back edge of the frame, smoothing it over the brads and the inside of the moulding.*

Mounting

Window mounts Water colours, drawings and prints are usually set in window mounts before they are framed. These provide a border around the picture and also keep it from touching the glass. Window mounts can also be used to display and protect unframed works which are offered for publication or sale. Window mounts are not difficult to make but a certain amount of equipment is necessary (see illustrations).

Mounting boards come in a wide variety of colours, and the choice is of course a matter of personal taste. White mounting board has a tendency to absorb light colours and to make subtly-toned originals appear very washed-out. Similarly a black mounting board will dominate a water-colour or any restrained original. The most suitable mounting boards for works of this kind are likely to be pale cream or a light colour that will not distract from the colours in the picture. Dark coloured boards are often suitable for dark, colourful or dramatic prints and drawings.

The artist must decide if the mount is to cover the edges of the work or if a margin of paper is to be left between the mount and the picture. Prints and drawings are usually seen in their entirety with a slight border round the edges with extra space for the signature and title underneath. Water colour and gouache paintings look better with the mount overlapping just the edges of the design.

Always cut the window so that it is fractionally above the centre of the frame. If a picture is precisely centred within the mount and frame, it will appear to be lower in the frame than it really is.

If a window mount is being used to protect a picture without a frame, a sheet of clear, thin, acetate sheet can be placed between the original and the window mount to give added protection.

Dry and wet mounts Drawings, prints and paintings which have been done on paper can be mounted directly ·on board. Commercial artists often mount their drawings in this way and protect them with a paper overlay.

Dry mounting, the technique normally used for photographs, works very well with any paper surface. A special heated press is usually used, but an ordinary household iron will achieve the same end (see illustrations). Wet mounting can be done with rubber-based gum or aerosol spray adhesive (see illustrations).

Cutting glass 1. *Place a ruler on the sheet of glass, and mark for the first cut near the top and bottom edge with a felt pen.*

2. *Align a straight edge, using a set-square, $\frac{1}{8}$ of an inch to the side of the marks.*

3. *Place the cutter on the far edge of the glass and cut by drawing it down the surface. Press the cutter firmly but not too hard.*

4. *Tap along the cut with the handle of the tool to open it up.*

5. *Place one hand close to, and on each side, of the cut, thumbs on top, fingers underneath the glass. Snap the glass along the cut.*

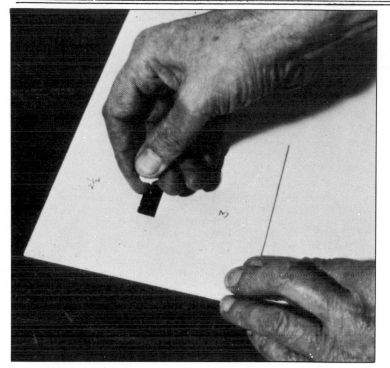

2. The 4 pin-pricks mark the corner of the mount. Reinforce the Stanley knife with a broken blade, and cut from one pin prick to another, holding the knife at a 45 degree angle.

3. Lay the picture under the window to check the fit. Attach the picture to the back of the mount with pieces of card, stuck with gum strip so that they overlap the work.

Cutting a window mount 1.
Having decided on the widths of the borders, in this case 2½ inches (64mm) for the top and sides and 3 inches (76mm) for the bottom, cut the board to size. Make a hole in a

piece of card, mark the border widths outwards from the hole and cut the card to size. Place it flush with each corner of the board and mark through the hole with a pin.

4. The picture in the window mount, showing the angle of the bevel cut. It is wise to practice on waste card before attempting this type of cut.

5. The mounted picture. Prints and drawings are usually mounted with a slight border round the edges, with extra space for the signature and title underneath.

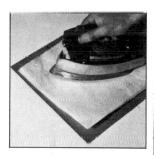

Dry mounting with an iron
1. Cut a sheet of shellac tissue slightly over size, and tack it to the centre back of the print with the tip of the iron.

2. Trim off the edges of the tissue to the exact size of the print, using a steel ruler and scalpel.

3. Position the print on the mount and tack the tissue at each corner of the mount, using a medium heat.

4. Lay a sheet of heat-resistant paper over the print to protect it.

5. Iron evenly over the paper, exerting firm pressure. Work from the centre outwards.

Protection for finished work
A card mount, covered with acetate and paper (far left) provides short-term protection. A loose-leaf portfolio (centre) is ideal for commercial artists. A plan chest (near left) will store large quantities.

Mounting with rubber gum
1. Place the mounting card on a piece of paper. Apply the gum, using a card or spreader, in one downward stroke.

2. Make another stroke to gather up the excess gum from the first stroke. Continue until the whole card is covered.

3. Apply glue in the same way to the back of the print. As rubber gum is an impact glue, both surfaces must be covered.

4. Place tracing paper between the glued surfaces and rub through clean paper pulling away the tracing paper as the surfaces bond.

5. Clean off the excess gum from the borders of the mount with a rubber made from dried gum.

Glossary

A

Acrylic A polymer based on synthetic resin. Acrylic paint, which is pigment dispersed in acrylic emulsion, dries to a tough, non-toxic flexible film. Acrylic emulsion is used principally as a painting medium, but also as a varnish for acrylic paintings.

Alchemical Relating to alchemy, ancient and medieval chemical practice, especially concerned with the attempt to convert base metals into gold.

Alizarin A synthetic coal-tar dye used in the manufacture of pigments.

Alla prima A method by which a passage of painting is completed with wet pigment in one session.

Amyl acetate Obtained from alcohol, and used as a solvent for some synthetic resins.

Aquatint An etching method used for obtaining areas of even tone by applying resin dust to the plate before the process of acid etching.

Aqueous Applied to painting, refers to media and pigments soluble or suspensible in water.

B

Barium An inert white mineral used to extend colours and as a base for dye colours.

Binder In painting, any medium of some liquidity which forms a paint when mixed with powder pigment.

Bitumen A tarry substance formerly used as an oil colour. Now obsolete in painting because of its tendency to crack and darken.

Bloom A white discolouration on the surface of varnish.

Bole A clay, often red, used as a preparatory undercoat for gold leaf.

Bright A flat brush.

Burnishers Tools used for polishing surfaces, such as gold leaf and etching plates.

C

Cadmiums In painting, brilliant and permanent pigments prepared from cadmium sulphate.

Canada balsam See Venice turpentine.

Casein The protein of milk, produced by separation of curd from sour skimmed milk. Dried and mixed with acid, it is used as an adhesive or paint-binder.

Catalysis Effect produced by substance which causes a chemical change in other bodies while remaining itself unchanged. Thus egg will emulsify water and oil by acting as a catalyst.

Chamfer A symmetrical bevel cut in a right-angled edge or corner.

Chiaroscuro Pronounced quality of light and shade in painting.

Chinese ink See Indian ink.

Chinese white See Zinc white.

Chlorophyll Green pigment found in plants.

Cobalt A metal resembling nickel from which a range of pigments is made.

Copal A resin made from fossil trees, used as a varnish and in paint media.

Cover The capacity of a pigment to obscure an underlying surface. Alternatively, its capacity to extend by given volume over a surface.

D

Damar A coniferous resin used as a varnish, and sometimes as part of a mixed medium.

Distemper A water-soluble paint using egg-yolk or glue-size as a binder. Used mostly for flat indoor wall decoration.

Drypoint Method of working directly into a metal engraving surface with a point.

E

Earth colours Pigments made from inert minerals, such as ochres, siennas and umbers.

Efflorescence Formation of white crystals resulting from penetration of moisture through paint-coated walls – especially brick, tile or uncoated plaster. Also produced by soluble materials present in the wall itself.

Emulsifier A substance which acts as a catalyst combining oil, water and varnish into media for painting.

Enamel Made from silicate, enamel pigments are applied to metal plates by various techniques, and fused by firing at high temperatures.

Encaustic Technique of painting either by burning in colour, such as clay into brick, or by the use of hot wax as a medium.

Etching Using acid to incise a metal plate.

Extender, Extending Material used to increase bulk of pigment: the act of adding such material. Often used in cheaper quality paints. Filler, filling, has the same meaning.

F

Fat (adj) Possessing, as in paints, a high proportion of oil.

Ferrule The metal hair or bristle holder of a brush.

Figurative Literally, containing figures. Used loosely to describe non-abstract painting.

Filbert A conical-shaped brush.

Filler See Extender.

Fixatives Thin varnishes, natural or synthetic, sprayed on drawing media for protection.

Flat A flat-shaped brush.

Fugitive Applied to dyes or paints which are short-lived in colour or intensity, due to inherent defects or the action of natural forces, especially sunlight.

G

Gilding Technique of applying gold/silver or gold leaf to a surface, as for frame decoration, for parts of a painting, or in illuminated manuscripts.

Glair Tempera medium made from white of eggs.

Glaze A transparent film of pigment overlying a lighter surface. See, by contrast, Scumble.

Graffito Method in which a line is produced by scratching through one pigmented surface to reveal another.

Graphite A form of carbon. Compressed with fine clay, it is used in the manufacture of pencils.

Grisaille A grey under-painting, laid for subsequent colour glazing.

Grout A mortar used to fill gaps between tiles, etc.

Gum arabic or Gum acacia Hardened sap secreted by acacia trees. Used as a binder for water-soluble pigments.

H

Hatching Graphic technique employing sets of parallel lines to create effect of density or solidity.
Hiding The hiding power of a pigment refers to its opacity.

I

Impasto The thick application of paint or pastel on a surface.
India ink, Indian ink Also Chinese Ink. A dense black ink made from carbon.
Iron oxide Compound from which, in natural or artificial form, many permanent pigments in the yellow and red range are made. See Mars pigments.

J

Japanned Lacquered with a hard resinous varnish.

K

Key (i) In mural painting, the firm wall surface to which paint will adhere without causing crumbling. (ii) Name sometimes given to wedges for canvas stretchers.
Kolinsky Fur of the Siberian mink, hairs from which are used for the finest "sable" brushes.

L

Lapis lazuli A blue stone from which natural ultramarine pigment is ground. Once widely used, it is now extremely expensive.
Lean (adj) Of paint, possessing little oil in relation to pigment.
Levigation Reduction of material to fine smooth paste or powder.
Lightfastness Ability to resist fading on long exposure to sunlight. Denotes permanence when applied to pigment.
Local colour The inherent or self-contained colour hue of an object or a surface, without modification by light qualities, atmosphere or proximate contrasting colours. Thus the characteristic local colour of a lemon is yellow.

M

Mars pigments Artificial iron oxide pigments, yielding strong tints from yellow through brown to violet.
Mastic Gum or resin obtained from certain coniferous trees, used in varnish, employed as a medium and as a picture protecting surface.
Medium (i) Substance mixed with pigment to form paint, such as oil for oil paints and gum arabic for water colours.
(ii) In oil painting, mixtures of turpentine, oil, varnish, wax etc. which are added to paint to facilitate its application to the support.
Megilp Mixture of linseed oil and mastic (or turpentine) used as a medium.
Mica Aluminium and other silicate minerals. Found usually in granite, either in scales or crystals.
Monotype, Monoprint In graphic art, means of producing a unique print from an inked plate – metal or glass – by hand or through a press.
Mottling Appearance of spots or blotches of colour in paint, and on paper.
Mucilage Gum or any viscous substance, derived from plants.

N

Nocturne Painting, usually landscape, made at night.

O

Ochres Natural earths used to make pigments.
Opacity The power of a pigment to cover or obscure the surface to which it is applied.

P

Palette Slab for mixing colours; can be wood, metal, glass, china, marble, perspex or paper. Also denotes range of colours at artist's disposal.
Pigment Colouring-matter made either from natural substances, or synthetically, used in paints and dyes.
Plein-air Painting out of doors.
Polymerization Process of molecular change by which acrylic and other synthetic resins are produced, and by which linseed oil is turned into stand oil.
Polymer paints Paints based on acrylic, or other synthetic, resin.
Polyvinyl acetate A synthetic resin used as a medium or varnish.
Porosity Capacity of material, such as brick or plaster, to absorb moisture through minute surface openings.

Q

Quicklime Lime, burnt lime, caustic lime. Made by burning calcium carbonate.
Quill In drawing and calligraphy, a pen made from a goose's feather.

R

Rabbit skin From which the best quality of glue size is made.
Rebate In framing, step-shaped cut in reverse side of moulding to receive edge of canvas, board etc.
Relief In printing, a raised surface which receives ink.
Render (n)Coat of plaster, cement, concrete applied to raw brick, stone etc. (vb)To apply such a coat.
Resins Substances obtained from coniferous trees, variously used in media and as varnishes. Synthetic resins are now made by polymerization.
Retouching varnish A weak temporary varnish for oil paintings.
Rouge paper Red paper, similar to carbon paper. Used for transferring drawings, the red marks are easily removed.

S

Sable Animal whose hair is used for making fine soft brushes. See Kolinksy.
Sanguine A red chalk drawing medium.
Saponify Turn into soap by decomposition with alkali.
Scumble To apply a thin, often broken, layer of paint over a darker layer, so modifying the underlying paint. A technique developed by the Venetian School. See, by contrast, Glaze.
Shellac Resinous substance secreted by the lac-insect. It is melted into plates and used in the preparation of varnish.
Silicon Common element, whose compounds – sand, quartz (silica), clay, asbestos and glass – possess inert properties, making them highly suitable for inclusion in a painting medium.
Silverpoint A drawing point made of silver, which is used on a gesso coated surface.
Size Gelatinous solution, such as rabbit skin glue, used to prepare surface of support for priming and painting.
Stipple Drawing or engraving method employing series of dots rather than lines.
Stylus A pointed instrument used to grave into a softer surface.
Swatch Manufacturer's sample of range of cloths, fabrics or paper.

T

Tempera, Temper Painting processes or media involving an emulsion of oil and water. Normally refers to an egg emulsion.
Tenebroso Style of painting relying on marked contrast between light and shade.
Terra In painting, earth from which pigment can be made, as in Terra vert (Terre verte).
Thixotropic The capacity of fluids to decrease in stiffness when stirred. Such fluids are produced as oil painting media and are included in oil primers. They tend to be fast-drying.
Titanium An oxide used as a white pigment of great permanency and covering power. Usually extended with other whites to improve its brushing and drying properties.
Tooth Degree of roughness or coarseness in texture of paper or canvas allowing paint film to grip surface.
Torchon or Tortillon A rolled paper stump, or stomp, used for drawing with powdered pigment such as charcoal.
Toxicity Degree or state of poison in a material. Toxic paints include: Flake white (White lead), whose dry pigment should never be handled, and Naples Yellow.
Tragacanth White or reddish gum derived from herbs. Used as a water-soluble binder.
Transfer paper Paper coated with a tint, usually powder, for transferring a drawing to another surface.

U

Ultramarine Blue pigment made from ground lapis lazuli. Rarely used because it is extremely expensive. French ultramarine is an artificial substitute.

V

Value Of colours and tints, the tonal position in the range from white through grey to black.
Vellum Fine parchment, originally calf-skin, used traditionally for manuscript.
Venice turpentine Canada balsam, an oily resin or balsam obtained from conifers.
Viscosity The stickiness of fluids; their resistance to flow proportional to pressure applied.

W

Wax Used in painting as a binder. Either beeswax, vegetable wax, or synthetic wax.
Wedges Small, triangular pieces of wood, driven into the interlocking corners of wooden stretchers to produce tension on canvas support. Also called keys.
Whiting Ground and dried chalk used in plate-cleaning and in the preparation of gesso.

Y

Yellowing A tendency on the part of binding media to turn in tint towards yellow. Most liable to occur when linseed oil is included.

Z

Zinc white White formed from zinc oxide, giving pure cool cover. In oil it needs much medium, and has some tendency to crack. In water colour known as Chinese white.
Zinnober green Another name for Chrome green.

Manufacturers and suppliers

United States

GENERAL
Alvin & Co. Inc., Box 188, Windsor, Conn. 06095; 2418 Teagarden St, San Leandro, Calif. 94577.
Arthur Brown & Bro. Inc., 2 W. 46th St, New York, N.Y. 10036.
Connoisseur Studio, Box 7187, Louisville, Ky. 40207.
Duro Art Supply Co. Inc., 1832 Juneway Terrace, Chicago, Ill. 60626.
Faber Castell Corp., 41 Dickerson St, Newark, N.J. 07107.
Gramercy Corp., 1145 A. W. Custer Place, Denver, Col. 80223.
M. Grumbacher Inc., 460 West 34th St, New York, N.Y. 10001.
Loew-Correll Inc., 131 W. Rugby Avenue, Palisades Park, N.J. 07650.
The Morilla Co. Inc., 43–01 21st St, Long Island City, N.Y. 11101.
Permanent Pigments Inc., 2700 Highland Avenue, Cincinnati, Ohio 45212.
F. Weber Co., Wayne & Windrim Aves, Philadelphia, Pa. 19144.
Winsor & Newton Inc., 555 Winsor Drive, Secaucus, N.J. 07094.
Yasutomo & Co., 24 California St, San Francisco, Calif. 94111.

PAINT
(wide range, unless otherwise stated)
Advance Process Supply Co., 400 N. Noble St, Chicago, Ill. 60622.
Bocour Artists Colors Inc., 1291 Rochester Rd, Troy, Mich. 48084.
Cooper Color Inc., 3006 Mercury Rd South, Jacksonville, Florida 32207.
Danacolors Inc., 1833 Egbert Avenue, San Francisco, Cal. 94124. (bulletin, fluorescent)
Day-Glo Colour Corp., 4732 St Clair Avenue, Cleveland, Ohio 44103. (fluorescent)
Finke Co., 2226 Bertwynn Drive, Dayton, Ohio 45439. (oil)

Harold W. Mangelson & Sons Inc., 8200 J. St, Omaha, Nebra. 68127. (water colors)
Markal Co., 250 N. Washtenaw Avenue, Chicago, Ill. 60612.
Masury & Son Inc., 1400 Severn St, Baltimore, Md. 20730. (bulletin)
Palmer Paint Products Inc., 1291 Rochester Rd, Troy, Mich. 48084.
Salis International, 4040 N. 29th Avenue, Hollywood, Florida 33020.
Sanford Corp., 2740 Washington Blvd., Bellwood, Ill. 60104.
R. Simmons Inc., 510 6th Avenue, N.Y. 10011. (water colors)
Skyline Distributing Co., 1609 12th Avenue N., Great Falls, Mont. 59403.

BRUSHES
(wide range, unless otherwise stated)
Artistic Brush MFG Corp., 103 Central Avenue, Clifton, N.J. 07015.
Burnstone Enterprises, 7205B Lockport Place, Lorton, Va. 22079. (red sable)
Gyros Products Co. Inc., 200 Park Avenue, New

United Kingdom

GENERAL SUPPLIERS
Acorn Art Shop, 28 Colquoun St, Glasgow.
Aitken Dott & Son, 26 Castle St, Edinburgh.
Fred Aldus Ltd., 37 Lever St, Manchester.
Alexander of Newington, 58 South Clerk St, Edinburgh.
The Arts Centre, 71 Causeyside St, Paisley.
The Arts Centre, 583 Fishponds Rd, Fishponds, Bristol.
Art Repro, 8 De-la-Beche St, Swansea.
The Art Shop, 40 Castle St, Guildford.
The Art Shop, 54 Castle St, Trowbridge.
The Art Shop, Great Coleman St, Ipswich.
Binney & Smith, Ampthill Rd, Bedford.
The Blue Gallery, 16 Joy St, Barnstaple.
H. Blyth & Co., 53 Back George St, Manchester.
Brentwood Arts, 106 London Rd, Stockton Heath, Warrington.
Briggs Art and Book Shop, 15 Crouch St, Colchester.

The Chantry Studios, Pauls Row, High Wycombe.
L Cornellison & Son, 22 Great Queen St, London WC2.
Cowling & Wilcox, 26 Broadwick St, London W1.
Daler Board Co. Ltd., Wareham, Dorset.
J. Davey & Sons Ltd., 70 Bridge St, Manchester.
The Dollar Gallery, 22 West Burnside, Glasgow.
J. B. Duckett & Co. Ltd., 74 Bradfield Rd, Sheffield.
The East Anglian Art Shop and Haste Gallery, 3 Great Coleman St, Ipswich.
Falcon Art Supplies Ltd., 26 George St, Prestwich.
Ivor Fields, 21 Stert St, Abingdon.
W. Frank Gadsby Ltd., 9 Bradford St, Walsall.
Greyfriars Art Shop, 1 Greyfriars Place, Edinburgh.
Gordons Gallery, 152 Victoria Rd, Scarborough.
Handyman, 43 Tamworth St, Lichfield.
F. Hopper & Co. Ltd., 48 Market Place, Malton, Yorks.
Langford & Hill, 10 Warwick St, London W1.
Liverpool Fine Arts, 85a Bold St, Liverpool.
Llanelli Art Centre, 31 Market St, Llanelli.
Mair & Son, 46 The Strand, Exmouth.
John Mathieson & Co., 48 Frederick St, Edinburgh.
A. Perkin & Son, 2a Bletchington Rd, Hove.
Reeves & Sons Ltd., Lincoln Rd, Enfield, Middx.
Reeves Art Materials, 178 Kensington High St, London W8.
C. Roberson & Co. Ltd., 71 Parkway, London NW1.
George Rowney & Co. Ltd., P.O. Box 10, Bracknell, Berks.
George Rowney & Co. Ltd., 121 Percy St, London W1.
Studio 10, 10 Edleston Rd, Crewe.
Torbay Art and Craft Centre, 109 Union St, Torquay.
Trinity Galleries, Trinity St, Colchester.
Winsor & Newton Ltd., Wealdstone, Harrow,

York, N.Y. 10003. (oil)
Hopper Koch Inc.,
Box 3249, N. Hollywood,
Cal. 91609.
Hunt MFG Co.,
1405 Locust St, Phila-
delphia, Pa 19102. (oil)
Marx Brush MFG Co. Inc.,
400 Commercial Avenue,
Palisades Park, N.J.
07650. (red sable)

DRAWING MEDIA
Berol Corp. USA, Eagle Rd,
Danbury, Conn. 06810.
(carbon, charcoal
pencils)
Binney & Smith Inc.,
1100 Church Lane,
Easton, Pa. 18042.
(chalks)
Carters Ink Co.,
275 Wyman St, Waltham,
Mass. 02154 (pens)
Charvoz Carsen Corp.,
5 Daniel Rd, Fairfield,
N. J. 07006. (pens)
Eriksons Crafts Inc.,
1101 N. Halstead,
Hutchinson, Kans. 67501.
(charcoal)
Fullerton Sales Co.,
847 Air Way, Glendale,
Cal. 91201. (charcoal)
General Pencil Co.,
67 Fleet St, Jersey City,
N. J. 07306. (pens,
pencils)
Hanover Pen Corp.,

501 Fame Avenue,
Hanover, Pa. 17331.
(wide range)
**Koh-I-Noor Rapidograph
Inc.,** 100 North St,
Bloomsbury, N. J. (pens,
pencils)
Pentel of America,
2715 Columbia St,
Terrance, Cal. 90503.
(oil pastels)
Rich Art Color Co. Inc.,
109 Graham Lane, Lodi,
N. J. 07644. (charcoal)
Stanislaus South West,
1208 Viceroy, Dallas,
Texas, 75247. (charcoal)

**PAPERS (wide range
unless otherwise stated)**
**American Pad & Paper
Co.,** Box 1250, Holyoke,
Mass. 01040.
**Andrews/Nelson/White-
head,** 31–10 48th
Avenue, Long Island,
N. Y. 11101. (hand-made
papers)
Bee Paper Co. Inc.,
100 8th St, Passaic, N. J.
07055.
Cartis Paper Div., James
River Corp., Paper Mill Rd,
Newark, Dela. 19711.
(litho)
Class Craft Div., Box 448,
St Louis, Mo. 63166.
Craft World Inc., Rt 27 &
Hahn Rd, Westminster,

Md. 21157.
Crescent Cardboard Co.,
100 W. Willow Rd,
Wheeling, Ill. 60090.
Fax Corp., 1 Rowan St,
Danbury, Conn. 06810.
**National Card, Mat &
Board Co.,** 14455 Don
Julian Rd, City of
Industry, Cal. 91746.
(hand-made papers)
Special Papers Inc.,
8 Sandfordtown Rd,
W. Redding, Conn. 06896.
Steiner Paper Corp.,
601 W. 26th St, New
York, N. Y. 10001.
Strathmore Paper Co.,
S. Broad St, Westfield,
Mass. 01085.

DRAWING BOARDS
Keuffel & Esser Co.,
20 Whippany Rd, Morris-
town, N. J. 07960.
Swanson, 803 Park
Avenue, Murfreesboro,
Tenn. 37130.
Tara Materials Inc.,
Industrial Park Drive,
Lawrenceville, Ga 30245.
Wolsey Co., 15110 E. Nel-
son St, City of Industry,
Cal. 91747.

CANVAS
Fredrix Artists Canvas,
Box 646, Lawrenceville,
Ga. 30245. (wide range)

Harold M. Pitman Co.,
515 Secaucus Rd,
Secaucus, N. J. (wide
range)
Wolsey Co., 15110 E. Nel-
son St, City of Industry,
Cal. 91747. (polymer)

AIRBRUSHES
**Advance Process Supply
Co.,** 400 N. Noble St,
Chicago, Ill. 60622.
Badger Air-brush Co.,
9128 W. Belmont
Avenue, Franklin Park,
Ill. 60131.
The DeVilbiss Co.,
300 Phillips Avenue,
Toledo, Ohio 43612.
Douglas & Sturgess,
730 Bryant St, San
Francisco, Cal. 94107.
Paasche Airbrush Co.,
1909 Diversey, Chicago,
Ill. 60614.
World Air Brush MFG Co.,
2171 N. California
Avenue, Chicago, Ill.
60647.
X-Acto, 45–35 Van Dam
St, Long Island City,
N. Y. 11101.

PRINTMAKING
**Graphic Chemical & Ink
Co.,** 728 N. Yale Avenue,
P. O. Box 27, Villa Park,
Ill. 60181.

FRAMING
American Moulding Inc.,
Box 1248, Hagerstown,
Md. 21740. (mouldings)
Dax Manufacturers, Inc.,
432 E. 91st St, New York,
N. Y. 10028.
Houston Art & Frame,
2520 Drexel Drive,
Houston, Texas 77027.
(gold leaf)

Middx.
**Winsor & Newton Ltd.
(showroom),** 51 Rathbone
Place, London W1.

PAINT
The Acrylic Paint Co.,
28 Thornhill Rd, London
N1.
Berol Ltd., Northway
House, High Rd, Whet-
stone, London N20.
Brodie and Middleton,
79 Long Acre, London
WC2.
John T. Keep & Sons Ltd.,
15 Theobalds Rd, London
WC1.
Spectrum Oil Colours,
51 Brighton Rd, Horsham,
Sussex.
**A. F. Tunley and Sons
Ltd.,** 12/13 Gloucester St,
Swindon, Wilts.

RAW CANVAS
Kantex (Fabrics Ltd.),
22 Rathbone Place,
London W1.
Russell and Chapple,
23 Monmouth St, London
WC2.

PAINTING EQUIPMENT
Guanghwa Co., 7–9 New-
port Place, London WC2.
(bamboo brushes)
S. H. Cornell Ltd.,
38 Lind Rd, Sutton,
Surrey. (brushes)

J. F. Hill & Co., 1 Towns-
end Close, Cranfield, Beds.
(brushes)
Lion Brush Works Ltd.,
Planet Place, Killingworth,
Newcastle-upon-Tyne.
R. Morrall & Sons,
Trafalgar Works,
Trafalgar St, Sheffield.
(palette knives)
Nailsworth Art Gallery,
Fountain St, Nailsworth,
Glos. (easels)
**Team Valley Brush Co.
Ltd.,** Whickham Industrial
Estate, Swalwell,
Newcastle-upon-Tyne.

**PAPERS
(wide range, unless
otherwise stated)**
H. Band & Co. Ltd., Brent
Way, High St, Brentford.
(hand-made parchment
and vellum)
R. K. Burt & Co. Ltd.,
37 Union St, London SE1.
Compton Russell, Compton
Chamberlayne, nr Salis-
bury, Wilts. (hand marbled
paper)
Falkiner Fine Papers Ltd.,
4 Mart St, London WC2.
(all types of hand made
papers)
**Green, Barcham & Co.
Ltd.,** Hayle Mill, Maid-
stone, Kent. (hand-made
water colour and drawing
papers)

Frank Grunfield Ltd.,
32 Bedford Square,
London WC1.
Inveresk Paper Co. Ltd.,
19 Tudor St, London EC4.
Paperchase, 216 Totten-
ham Court Rd, London
W1.
Wiggins Teape, Gateway
House, Basing View,
Basingstoke, Hants.

**DRAWING EQUIPMENT
(wide range, unless
otherwise stated)**
Berol Ltd., Northway
House, High Rd, Whet-
stone, London N20.
(pencils)
Copystat Cardiff Ltd.,
Repro House, Park Lane,
Cardiff.
Cumberland Graphics Ltd.,
Bearwood Rd, Smethwick,
Warley, W. Midlands.
His Nibs, 182 Drury Lane,
London WC2. (pens and
nibs)
**Mentmore Manufacturing
Co. Ltd.,** Platignum House,
Six Hills Way, Stevenage,
Herts. (Platignum pens)
E. S. Perry Ltd., Osmiroid
Works, Gosport, Hants.
(Osmiroid pens)
Reece, Hartley & Co.,
Building One, GEC Estate,
East Lane, Wembley,
Middx. (Rotring pens)
Royal Sovereign &

Staedtler Ltd., Glamorgan.
(pencils)
Venus Esterbrook Ltd.,
Kings Lynn, Norfolk.
(pencils)

AIRBRUSHES
The DeVilbiss Co. Ltd.,
Ringwood Rd, West Howe,
Bournemouth;
63 Blucher St, Birming-
ham; Glasgow Rd, Kirkin-
tilloch; 12 Charlotte St,
Manchester; Temple
House, Temple Way,
Bristol.

**PRINTMAKING
MATERIALS**
**Hunter, Penrose &
Littlejohn,** 7 Spa Rd,
London SE16. (presses)
**T. N. Lawrence & Son
Ltd.,** Bleeding Heart Yard,
Grenville St, London N1.
(etching and wood
engraving tools, wood-
blocks)
**Henry Righton & Co.
Ltd.,** 70 Pentonville Rd,
London N1. (copper
sheets)
**Selectasine Screen Printing
Supplies,** 22 Bulstrode St,
London W1.
Sericol Group Ltd.,
24 Parsons Green Lane,
London SW6. (silkscreen)

FRAMING
N. H. Butterfield, 6 Priory
Close, Bingley, West
Yorkshire. (mouldings)
Hang It Systems, 48 Royal
Hill, Greenwich, London
SE10.
Streamline Sales,
33/37 Sackville Mews,
Bexhill, Sussex.
(mouldings)
Frank B. Scragg & Co.,
68 Victoria St, Birming-
ham. (picture framing
accessories)

Index

Robert D. Bruce

Acknowledgments

Robert D. Bruce

Numerals indicate page numbers.

9 Med. Ms.: Slide collection, The Courtauld Institute, University of London. 10 Massys: Reproduced by courtesy of the Trustees, The National Gallery, London. 11 Renoir: Louvre, Paris (© S.P.A.D.E.M.). 13 Durer: Photo—Snark/Leonardo: Academia, Venice (Photo—Snark)/ Leonardo: Photo—Snark. 14 Nicholson: Victoria and Albert Museum, London (Crown Copyright)/Degas: Jeu de Paume, Paris (Photo—Scala) (© S.P.A.D.E.M.)/Egyptian mummy portrait: British Museum (Photo—Michael Holford). 15 Derain: The Tate Gallery, London (© A.D.A.G.P.). 16 Uccello: Gabinetto dei Disegni, Uffizi, Florence. 17 Caravaggio: Reproduced by courtesy of the Trustees, The National Gallery, London/ Leonardo: Gabinetto dei Disegni, Uffizi, Florence (Photo—Scala). 18 Samples from Venetian and Flemish paintings: Photo—The Courtauld Institute, University of London/Stages in transferring a painting: Photo—The Courtauld Institute, University of London. 19 Titian: Chiesa dei frari, Venice (Photo—Scala). 20 Titian: Reproduced by permission of the Syndics of the Fitzwilliam Museum, Cambridge. 21 Duccio. Reproduced by courtesy of the Trustees, The National Gallery, London. 22 Lascaux: Colorphoto Hans Hinz, Basle/Mappae Clavicula, f.1: The Corning Museum of Glass, New York. 23 Duccio: Sienna, Museo del Duomo (Photo—Scala). 24 Turner: The Tate Gallery, London. 25 Holman Hunt: The Lady Lever Art Gallery, Port Sunlight/Van Eyck: Reproduced by courtesy of the Trustees, The National Gallery, London. 26 Campin: Reproduced by courtesy of the Trustees, The National Gallery, London/Tindle: Collection of the artist. 32 Rembrandt: Rijksmuseum, Amsterdam. 34 Titian: Reproduced by courtesy of the Trustees, The National Gallery, London. 35 Rembrandt: Reproduced by courtesy of the Trustees, The National Gallery, London. 36 Manet, Gaugin: Louvre, Paris (Photo—Giraudon). 38 Monet: Louvre, Paris (Photo—Snark) (© S.P.A.D.E.M.)/ Picasso: The Solomon R. Guggenheim Museum, New York (Photo—Robert E. Mates) (© S.P.A.D.E.M.). 41 Vermeer: Louvre, Paris (Photo—Scala). 42 Gaugin: Metropolitan Museum of Art, New York. 43 Bacon: The Tate Gallery, London/ Cezanne: Reproduced by courtesy of the Trustees, The National Gallery, London. 45 Grosz: Collection, The Museum of Modern Art, New York (© Mitgliederliste). 46 Hockney: The Tate Gallery, London (© The artist). 49 Kandinsky: The Solomon R. Guggenhein Museum, New York (Photo—Robert E. Mates) (© A.D.A.G.P.). 58 Van Gogh: Jeu de Paume, Paris (Photo—Scala). 59 Van Oost: Reproduced by courtesy of the Trustees, The National Gallery, London. 61 Rembrandt: Reproduced by courtesy of the Trustees, The National Gallery, London. 62 Michelangelo: Reproduced by courtesy of the Trustees, The National Gallery, London. 63 Turner: Reproduced by courtesy of the Trustees, The National Gallery, London/Sutherland: Private Collection (Photo—Marlborough Fine Art, Ltd, London)/Manet: Jeu de Paume, Paris (Photo—Scala)/Cassatt: Photo—Snark (© A.D.A.G.P.). 64 Morisot: Jeu de Paume (Photo—Snark). 65 Seurat: Art Institute of Chicago/ Klimt: Reproduced by courtesy of the Trustees, The National Gallery, London. 66 Degas: Louvre, Paris (Photo—Scala) (© S.P.A.D.E.M.)/Lowry: Private Collection, London/ Hockney: The Arts Council of Great Britain (© The artist). 69 Rosoman, Riley: George Rowney & Co Ltd/Hockney: The Tate Gallery, London (© The artist). 70 Rosoman: Collection of the artist. 72 Rosoman: George Rowney & Co Ltd/Millington: Collection of the artist. 74 Johns: Stedelijk Museum, Amsterdam (Photo—Walter Rawlings). 76 Blake: George Rowney & Co Ltd/Phillips: The Tate Gallery, London (© The artist). 77 Pollock: Metropolitan Museum of New York. 79 Rosoman: Collection of the artist. 80 Botticelli: Uffizi, Florence. 81 Unknown Byzantine artist: Metropolitan Museum of New York/Duccio: National Gallery of Art, Washington DC, Samuel H. Kress Collection. 82 Lorenzetti: Uffizi, Florence (Photo—Scala)/ Piero della Francesca: Reproduced by courtesy of the Trustees, The National Gallery, London/Fra Angelico: Museo San Marco, Florence. 84 Botticelli: Reproduced by courtesy of the Trustees, The National Gallery, London. 85 Wyeth: Collection, The Museum of Modern Art, New York/Palmer: The Tate Gallery, London. 91 Armstrong: The Tate Gallery, London/ Tindle: Collection of the artist. 92 Cohen: The Tate Gallery, London/Tindle: Private collection. 93 Shahn: Collection of Whitney Museum of American Art—gift of Edith and Milton Lowenthal in memory of Juliana Force. 94 Barrs: Collection of the artist. 95–97 Tindle: Private collection. 98 Michelangelo: Sistine Chapel, Vatican (Photo—Colorphoto Hans Hinz). 99 Michelangelo: Sistine Chapel, Vatican (Photo—Scala)/ Pontormo: Chiesa S. Felicita, Florence (Photo—Scala). 102 Fra Angelico: Museo San Marco, Florence (Photo—Scala). 103 Masaccio: Brancacci Chapel, Chiesa del Carmine, Florence (Photo—Scala). 104 Tiepolo: Wurzburg, Residenz (Photo—Colorphoto Hans Hinz)/ Michelangelo: Sistine Chapel, Vatican (Photo—Scala)/Giotto: Scrovegni, Padua (Photo—Scala). 106 Sigiriya, Sri Lanka: Photo—Walter Rawlings. 107 Photo: Walter Rawlings. 108 Photos: Graham Cooper; David Mallott. 110 Photos: Walter Rawlings; Graham Cooper. 114–5 Photos: Graham Cooper. 116 White: British Museum (Photo—Freemans). 117 Durer: The Albertina, Vienna. 118 Klee: Kunstmuseum, Basle (Photo—Colorphoto Hans Hinz) (© S.P.A.D.E.M.). 119 Turner: Victoria and Albert Museum, London (Crown Copyright). 125 Girtin: The Courtauld Institute, University of London (Witt Collection). 126 Cezanne: Private Collection, Paris (Photo—Giraudon). 131 Smith: Collection of the artist. 134 Turner: British Museum/Durer: Albertina, Vienna. 135 Daumier: Metropolitan Museum of Art, New York. 136 Hogarth: By courtesy of the Trustees of the British Museum. 138 Millington: Collection of the artist/Smith: Collection of the artist. 139 Holbein: Stadelsches Kunstinstitut, Frankfurt (Photo—Kurt Haase). 142 Brabazon: Private collection, London (Photo—Walter Rawlings). 143 Sutherland: Private collection (Photo—Marlborough Fine Art Ltd, London). 145 Smith: Collection of the artist. 146 Degas: The Louvre, Paris (Photo—Snark) (© S.P.A.D.E.M.). 147 Leonardo: Accademia, Venice (Photo—Scala)/Carriera: National Gallery of Art, Washington DC (Samuel H. Kress Collection). 148 Degas: The Louvre, Paris (Photo—Snark) (© S.P.A.D.E.M.)/Chardin: The Louvre, Paris (Photo—Lauros—Giraudon)/Manet: The Louvre, Paris/Liotard: Staatliche Kunstsammlungen, Dresden (Photo—Giraudon). 150 Perronneau: Reproduced by courtesy of the Trustees, The National Gallery, London. 151 Kennington: The Imperial War Museum, London/Turner: (Photo—Freemans). 152 Vuillard: The Tate Gallery, London (© S.P.A.D.E.M.)/Roddon: Collection of the artist/Degas: The Louvre, Paris (Photo—Snark) (© S.P.A.D.E.M.). 154 Redon: The Cleveland Museum of Art (Hinman B. Hurlbut Collection) (© S.P.A.D.E.M.). 158 Degas: The Louvre, Paris (Photo—Snark) (© S.P.A.D.E.M.). 160 Lascaux: Photo—Colorphoto Hans Hinz/del Sarto: By courtesy of the Trustees of the British Museum. 161 Whistler: Courtesy of the Smithsonian Institution, Freer Gallery of Art, Washington DC. 162 Matisse: The Baltimore Museum of Art (the Cone Collection formed by Dr Clairbel Cone and Miss Etta Cone of Baltimore, Maryland) (© S.P.A.D.E.M.). 165 Matisse: Musée des Beaux-Arts, Grenoble (Photo—Giraudon) (© S.P.A.D.E.M.). 166 Rembrandt: Staatliche Graphische Sammlung, Munich. 167 Van Gogh: Museum of Art, Rhode Island School of Design (Gift of Mrs Murray S. Danforth)/Beardsley: Mansell Collection, London. 170 Guercino, Hockney: By courtesy of the Trustees of the British Museum. 172 Holbein: Windsor Royal Library (reproduced by gracious permission of Her Majesty Queen Elizabeth II). 173 Hockney: By courtesy of the Trustees of the British Museum/Degas: Metropolitan Museum of Art, New York (© S.P.A.D.E.M.)/Ingres: Colorphoto—Hans Hinz. 176 Valenti: By courtesy of Nicholas Treadwell Gallery, London. 177 Hayes: Collection of the artist (Photo—Walter Rawlings)/Lowry: Private collection, London (Photo—Walter Rawlings). 178 Johnson: Fischer Fine Art, London. 193 Metal cut: Photo—Freemans. 194 Hiroshige: Victoria and Albert Museum (Photo—Freemans)/Picasso: By courtesy of Waddington & Tooth Gallery, London (© S.P.A.D.E.M.). 196 Durer: Photo—Freemans. 198 Hockney: By courtesy of the Redfern Gallery, London (Photo—Walter Rawlings). 201 Schiele: Hunterian Museum, University of Glasgow. 202 Caulfield: Private collection, London (Photo—Walter Rawlings). 204 Moore: Collection Alistair Grant (Photo—Walter Rawlings). We wish to acknowledge George Rowney & Co Ltd for allowing us to reproduce colour transparencies of paintings by Leonard Rosoman, Peter Blake and Bridget Riley.

223

Robert D. Bruce

Printed in Hong Kong

Printed in Hong Kong